HUNGRY FOR LIGHT

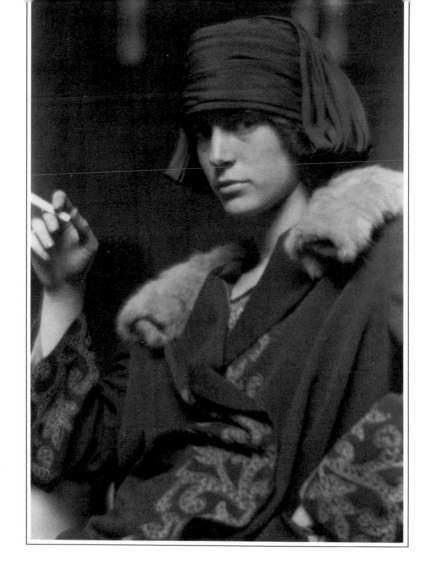

EVERYWOMAN:
Studies in History,
Literature,
and Culture

SUSAN GUBAR,
GENERAL EDITOR

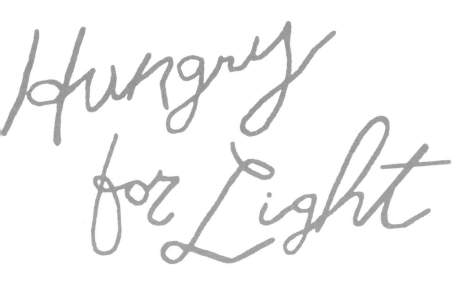

The Journal
of
Ethel
Schwabacher

EDITED BY
BRENDA S. WEBSTER AND
JUDITH EMLYN JOHNSON

INDIANA UNIVERSITY PRESS
BLOOMINGTON AND INDIANAPOLIS

The paper used in this publication meets the
minimum requirements of American National
Standard for Information Sciences—Permanence
of Paper for Printed Library Materials, ANSI
Z39.48-1984.

Manufactured in the United States of America

Library of Congress Cataloging-in-Publication Data

Schwabacher, Ethel, 1903–1984.
 Hungry for light : the journal of Ethel
 Schwabacher / edited by Brenda S.
 Webster and Judith Emlyn Johnson.
 p. cm. — (Everywoman)
 Includes index.
 ISBN 0-253-36367-5 (alk. paper)
 1. Schwabacher, Ethel, 1903–1984.
 2. Artists—United States—Biography.
 I. Webster, Brenda S. II. Johnson, Judith
 Emlyn. III. Series.
 N6537.S3597A2 1993
 759.13—dc20
 [B] 92-15184

 1 2 3 4 5 97 96 95 94 93

"I have never failed to acknowledge the presence of an angel."

—JOURNAL, PART V

CONTENTS

ILLUSTRATIONS

Acknowledgments

We would like to thank all the people who have been moved by Ethel Schwabacher's vision and have devoted time and effort to furthering the appreciation of her work. Without their help in preparing the ground, it would have been difficult to bring to fruition the publication of her journal. We thank Mona Hadler and Greta Berman for the excellent work they did curating the first Schwabacher retrospective and the directors of the museums and galleries who made it possible for the show to travel across the country or put on additional shows: Phillip Dennis Cate and Jeffrey Wechsler of the Jane Voorhees Zimmerli Art Museum, New Brunswick, New Jersey; Nancy Liddle of the University Art Gallery, S.U.N.Y. at Albany; Phillip Linares of the Mills College Art Gallery, Oakland, California; Adrienne Fish of 871 Fine Arts, San Francisco; and Stephen Schlesinger of Gallery Schlesinger, New York. We are also grateful for the ideas and presentations of the scholars who participated in the various conferences on Schwabacher's work: among others, Judith Bernstock, Ann Gibson, Judith Fetterley, Jeffrey Berman, Moira Roth, and Diana Ketchum. Thanks too for the encouragement of early readers of the manuscript: James Breslin, Naomi Bliven, Sandra Gilbert, Carolyn Kizer, Ira Lapidus, and Jayne Walker. Anne Kohs's archival work provided a sound basis for future study.

Our gratitude goes to the museums and individuals who have graciously allowed us to use photographs of works in their collections: the Johnson Museum, Cornell University, Ithaca, New York, the Jane Voorhees Zimmerli Art Museum, Rutgers University, New Brunswick, New Jersey (their registrars, Nancy Harm and Barbara Trelstad, were both enthusiastic and prompt), Sandra Payson, Michael Rosenblüth, and Christopher Schwabacher. The manuscript was typed by Florence Meyers with her usual scrupulousness.

Finally, we acknowledge particular gratitude to Hannelore Schwabacher for her support in all phases of the project and her invaluable help with chronology and illustrations. Christopher Schwabacher has been encouraging throughout and helpful in ways too numerous to catalogue.

Introduction

The journal of Ethel Schwabacher (American artist 1903–1984), written in her old age, as arthritis made it increasingly difficult for her to paint, tells the story of a life lived in art and takes us step by step through the creation of her last, epic works. We also see her painful struggle against suicide and despair. And we join her as she observes her own old age and comes to terms with her approaching death. Schwabacher's meditation makes us eyewitnesses to her development as a woman and as a major artist.

This journal is also the story of a relationship both tormented and nurturing between the artist and her therapist, Dr. Marianne Kris, who had kept her alive for almost thirty years through despair, suicide attempts, and illness. Together these two women struggle to keep the artist productive; together they stumble through the weaknesses and indignities of old age; together they race against their approaching deaths to try to discover the "last little bit of truth" about the mind of the woman artist.

Ethel Schwabacher was a woman of tremendous ambition and energy. Her struggle to make a style and place for herself within the restrictions the twentieth century placed on women's ambitions reflects the experiences of many creative American women of the time. Through this journal we participate in her increasing realization that to create her largest canvases she had to strike out into new territory, abandon the aesthetic that had served her in her youth, and forge a new style at odds with the styles of her earlier work and of her closest contemporaries and associates. In the journal she relives her formative years as woman and artist, contemplating the sources of her creative gift and the obstacles she was still struggling, in old age, to overcome. She examines her own relationship and, by implication, that of other women artists to the history of art and to contemporary art theory. She places her life, her education, her family roles, and her career in the context of twentieth-century expectations about the nature of women's creativity and the roles women were expected to play. And she observes, with painstaking accuracy and attention to detail, the approach of her own death, the memories of great works of art that have been her inspiration, and the small, day-to-day details of beauty still left to her— the play of light on the surface of a leaf, the flowering of a plant, the

growth of her grandchildren's own artistic abilities. The resulting journal, written in a beautiful, flexible, and eloquent prose, is a contrapuntal, poetic flow of image, event, and insight, which interweaves day-to-day accounts of work on paintings with the play of memory and observation in the culmination of a lifelong search for truth in art.

Ethel Schwabacher's life spanned and exemplified the development of twentieth-century art from the end of the Victorian age through the years of high modernism to the postmodern revolutions of feminism and a rediscovery of the possibilities of representation in art. Her search for personal, sexual, and creative freedom was lifelong. In the 1920s she went to the South of France to paint. Later, Ethel studied painting with the important abstract expressionist artist Arshile Gorky. After his suicide in 1948 she wrote the first critical biography to establish his central place as a major artist.

Her own art until the late 1960s paralleled and was part of the central preoccupations of American art of the first half of the century, in its progression from an early representational fauvism through increasing use of abstract elements to the high period of full abstract expressionism and the great popularity of the Abstract Expressionist movement, with which she was closely associated. During the fifties and early sixties she was among the artists regularly exhibited by the influential Betty Parsons Gallery, a group that included Hans Hofmann, Mark Rothko, Clyfford Still, Barnett Newman, Jackson Pollock, and Richard Pousette-Dart. Willem de Kooning, although not shown by Parsons, was one of these seminal figures whose aesthetic Ethel at first shared and actively promoted. In the early sixties, however, she began to feel her way toward a perception of some of this work and aesthetic as being essentially aggressive, violent, antihuman, and hostile to women. Her own mature creative needs in the early to mid-sixties propelled her back to representation, in advance of her time, at first in a series of paintings of civil rights figures and events, later in portraits and large canvases. Her ambition was to create large mythic works that would sum up her understanding of the profound meaning and continued centrality of such great figures as Orpheus, Antigone, and Oedipus. It was one of the tragedies of her life and of the direction taken by twentiethcentury American art that this unfashionable and prophetic drift in her late work may have been among the reasons Betty Parsons dropped her. Certainly this direction in her work made it increasingly difficult for her to show her late and major representational works. After one show of her civil rights canvases at the Greenross Gallery in 1964, she had no further shows until 1972. Another hiatus was followed by a last show of new work in 1976 and by a 1977 repeat of the 1972 show. Instead of going out in a blaze of recognition and glory, she spent her last years in declining health

and temporary eclipse, trying to capture in the words of her journal the revelations her health no longer permitted her to make with paint.

While she struggled to find a new style, the journal shows her effort to understand the path of her emotional and artistic development, the sources of her gift and its blockages, its intersections with her deepest emotions. This effort to find a little truth produces a mythology of its own: childhood events of abandonment, deprivation, torture, and seduction. She sees herself as child genius, child victim, misunderstood, abandoned, and deprived, but somehow, in spite of every thing, continuing to struggle toward creation. The epic events of mythology parallel her own, and she uses these myths to ennoble and legitimize her own psychology, to make the events of her life take place on a heroic scale. She sees herself as a child Prometheus, tied down, tortured, and deprived of love and recognition by parent gods, as an infantile Oedipus drawn into incest, as an Orpheus deprived or a Sisyphus eternally burdened. She often succeeds in making her emotional story into high literature, by writing it metaphorically, in terms of storms, natural catastrophes, and icons and symbolic figures like angels or, by contrast, by imagining tranquil things like flowers, guardians of imagined and desired peace. Toward the end of the journal she reluctantly allows more personal material to enter, but the final section, with its flowers and light imagery, seems to strive toward transcendence rather than representation.

This movement toward greater freedom and self-definition in the work mirrored a similar movement in the artist's life. Born in New York City in 1903 to a wealthy southern Jewish father and a New York Jewish convert to Christian Science, Ethel Kremer was raised with her older brother in a setting of privilege that encouraged both her art and her brother's mathematical ambitions. She was not the only artist produced by her family. Her first cousin on her mother's side was the objectivist poet George Oppen.

In the twenties, while she was a young student of sculpture sharing a studio with another art student, her brother began to have grave psychological difficulties, which by the thirties would lead to his hospitalization, and, according to one account she gave, her family, early believers in psychotherapy, delegated her to seek psychiatric help for him. (According to other family recollections, her brother's difficulties began much earlier, when his preparatory school, alarmed by his mixture of mathematical genius and excitability, recommended that he receive therapy. Whether or not the therapy helped, he graduated from M.I.T. in 1925 with a degree in engineering.) While seeking treatment for him, she decided to seek treatment for herself as well, and underwent a brief analysis in New York, with a Dr. Gluck, who she later said had been an analysand of Freud's. This analyst, according to one of her accounts, fell in love with her, and she

with him. Because he felt this situation to be unprofessional, he passed her on to another analyst while himself returning to Europe for further analysis. The situation left her feeling that she had been abandoned and proved so upsetting to her that she later attributed her own abandonment of sculpture for painting to this affair.

During the twenties and early thirties Ethel lived the life of the sexually liberated bohemian women of the period, taking lovers from among a group of artists and intellectuals active in New York, Vienna, and the South of France. Among these was Mortimer Adler, the originator of the theory of education based on a core curriculum of great books, whom she referred to, with cruel whimsy, as "Suzy." Adler, in his autobiography, tells his version of this love affair, suggesting that the therapy she sought during their relationship caused difficulties with her work. Like H. D., Conrad Aiken, and other writers, artists, and literary critics of the period, she found Freud's ideas about the human psyche and the practice of analysis liberating and exciting. She later said that her first reading of Freud had changed her life.

Through the circle of American intellectuals experimenting with analysis, Ethel obtained an introduction to Helene Deutsch, the increasingly influential early disciple of Freud, whose work, although it has been seen as antifeminist, has also been central to twentieth-century studies of the psychology of women. After she went to France to study painting, Ethel continued on to Vienna, where she commenced an analysis with Deutsch. Ethel's first analysis had evidently dealt, in part, with her relationship with her brother and her concerns about him. Among the problems she attempted to resolve in this later analysis was her behavior toward her lovers (which Deutsch characterized as cruel and sadistic) and her frequent changing from lover to lover, with the accompanying unwillingness or inability to make a lasting commitment (which Deutsch characterized as Don Juanism). In a later interview Ethel described herself at this period as having an insatiable desire to be loved, and she said that Deutsch cured her of her "sadism" and freed her to consider marriage. Upon her return to New York, Ethel fell in love with, and in 1935 married, the rising young lawyer Wolfgang Schwabacher, a partner in the firm of Hays, Wolf, Schwabacher, Sklar, and Epstein. Their daughter Brenda was born in 1936 and their son Christopher in 1941. The marriage was idyllic and fruitful. Wolf loved her art and provided for her the sense of being loved which she so desperately needed. Unpossessive, unjealous, and essentially supportive of her associations with such artists as Gorky, whose work he bought and donated to museums, Wolf encouraged Ethel to see her creative ambition as valid and appropriate and considered her "the genius of the family." Domestic help made the tasks of childcare less interruptive of her creative work than is the norm for

creative women. Her paintings of this period—landscapes, farm scenes, highly eroticized farm animals, fruit trees burgeoning with fruit—show a contented and productive woman at peace with herself and with the world.

Although privileged, this was not an ivory-tower life. Wolf, in addition to being a successful copyright and theater lawyer representing such clients as Lillian Hellman, Erskine Caldwell (in the obscenity action brought against *God's Little Acre*), and Viking Press, was also a committed civil rights activist, a member of the board of the Urban League, and a fund-raiser for Jewish philanthropical causes. Although not herself personally active in these causes at this time, Ethel shared his interests and concerns.

This period of happiness and love ended abruptly in August 1951 with Wolf's sudden death, at the age of fifty-three, from a heart attack. Ethel's grief and shock at this sudden loss were as extreme as her earlier happiness had been. For more than a year, through her enormous productivity, she fought off an impending breakdown. The final revision of her book on Gorky was completed during this period, as were the glass collages and abstractions on the theme of death inspired by her effort to come to terms with her tremendous loss. Trying to stave off collapse, she resumed analysis, this time with Dr. Marianne Kris of the Yale Child Development Center, whose other patients included Marilyn Monroe. Ethel later said that at one of her early sessions with Dr. Kris she threw her wedding ring across the floor to express her anger at Wolf's death, which at this point she felt as a form of abandonment. Her first one-woman show by Betty Parsons, in 1953, was the culmination of this struggle, and exhibited the paintings done between 1951 and 1953.

But in the midst of all this frantic effort to continue her life, her despair and loneliness were so great that she attempted suicide in 1952 by an overdose of sleeping pills. She was hospitalized in an iron lung for two days and remained in a coma for a week. Upon her return from the hospital she resumed the analysis with Dr. Kris, who she later said had given her the strength to go on living. This last analysis continued for the rest of her life. In a sense, the analysis was her final work, the culminating step of her effort to understand herself as woman, as artist, and as human being, caught up in the ideologies and expectations of her time.

Her journal is an extension of this self-analysis. In addition to containing brilliant art criticism, the responses of the attentive eye and inquiring mind of a major artist to the entire body of art available to her, an analysis of her own creative process, meditations on old age and on the approach of death, much of it reads like a detective story. Ethel patiently examines and reexamines her life, and attempts to excavate buried childhood memories, events so painful that they have been obliterated and can only be guessed at. She fearlessly asks the great questions a woman and an artist must ask:

what made her creative, what made her an artist rather than something else, what made her vulnerable, what made her unable to face her despair when Wolf died, what kept her going, what were the sources of her weakness and of her strength.

Increasingly, in the journal as in the analysis, she uncovers terrifying possibilities that a lesser woman might have chosen to leave buried, such as a violent and sexually charged relationship with her brother. At first during her long Freudian analysis she recovers memories of her possessiveness toward her father and rivalry toward her mother and all other women. Later she convinces herself that she has recovered memories of her father's infidelities and of her own sense of shock and betrayal. In the final stages of her analysis she moves below this layer of memory and reconstruction to posit a love and adoration of her mother and a desire to replace her father in her mother's bed and affections, because she had perceived him as not sufficiently nurturing toward her mother. If accurate, this perception of hers may be an important contribution to feminist insight about the origins of creativity in the woman artist.

We have shortened the journal for publication, and have divided it into sections and added titles in order to bring out qualities inherent in its structure. Otherwise we have tried to preserve the sense of an artist's mind at work by taking material from her journal as she had it with a minimum of editing. How Ethel herself might have edited it for publication, had she had the opportunity, we cannot know.

HUNGRY FOR LIGHT

JANUARY 1967–JUNE 1970

"No distortion, no extortion."

" . . . must find my balance."

"Shall I convey the idea of resurrection?"

THE CREATION
OF ORPHEUS
AND OTHER
MYTHOLOGIES

INTRODUCTION

Ethel's journal begins in a transitional period of her life, with a meditation on the aesthetics of Chinese art. The gallery she had been with for years, the Betty Parsons Gallery, had stopped showing her work and though the Greenross Gallery gave a show of her civil rights paintings in 1964, she had no assurance of a place for her future work. The uncertainty in her career

1

was partially balanced by stability and fruitfulness in her family. Her children had married—daughter Brenda in 1961, son Christopher in 1966—and they both had children in this period. Ethel's first grandchild, Lisa Anna Webster, had been born in 1963. A first grandson followed in March 1966 and was named Michael Wolf Webster after Wolf. Two years later Christopher's son Mark was born, followed by Brenda's daughter Rebecca in 1969 and Christopher's son Roger Wolf in 1970. During this time Ethel was continuing her psychoanalysis five times weekly with Marianne Kris. Seeing her children become parents undoubtedly reinforced her own preoccupation with her childhood.

Because her art and life are interwoven, and the art is being inspired by the daily concerns of her life and by a desire to come to terms with them, it is impossible to separate her personal and psychological concerns from her aesthetic concerns. In this part of the journal, which deals directly with creative process and aesthetic theory and only by implication and indirection with the personal, much of what we say is interpretation. Her own method seemed to justify this. In later journals, particularly sections not intended for publication, she shows clearly the ways she transferred private emotion into her art. We have relied heavily on the connections she herself makes in these later journals. In them it is clear, for instance, that her aesthetic concerns directly reflect what she is dealing with in her analysis. When she deals aesthetically with ambivalence in this section of the journal—toward art, gender, motherhood—we might suspect that she is working on these issues in her therapy too. Fortunately the issue isn't crucial. What matters is that evidence of her ambivalence can be read from her descriptions of the process of thinking about and painting her mythic works and helps make sense of her intentions.

During the time covered by this part of the journal, Ethel completed three major mythic paintings—of Sisyphus, Orpheus, and Abraham and Isaac—and began a Prometheus. She interrupted her mythic paintings at various times during the pregnancies and deliveries of her daughter and daughter-in-law to paint mothers and children (*The Pregnant Woman* and *The First Child*).

She worked in a meditative way, collecting past references to her theme in both literature and art, and speculating on their meaning. Eventually, in the process of painting, she would make her own interpretation of the myth, but her first task was assim-

ilation. She read Rilke, Ovid, Milton, Dante, Shelley, Freud, and many other authors as part of her research, went to museums to find the right gesture or color, looked at Greek vases for the position of Sisyphus's leg when running, did multiple sketches, drawings, notebook studies, and small paintings before beginning the large ones.

Many of the paintings seem to begin with a vision or dream of the subject, often stimulated by Ethel's reading and certain emotionally charged colors. The process of development is often slow, as she tests each detail of the myth and its setting against the inner pattern beginning to form in her mind. For example, her first idea of the Orpheus painting, in November 1967, is its blueness (a vision in blue with the jaws of Hell to the left). Somewhat later she sees a rather traditional image—Orpheus's head drifting on the water with golden hair. (She uses music to stimulate and focus her imagination, at first playing Gluck's *Orpheus,* then [Jan. 12, 1968] changing to Bach.) Finally, on January 24, she has a vision of Orpheus and Eurydice that combines the initial blueness with a startlingly different view of Hell—no longer the classical Hades, the underworld appears as a big black gorilla with a gaping mouth. The idea of a voyage into a giant mouth is joined two days later by a sort of reversed birth image—she has a vision of Eurydice disappearing into a blue tunnel. Whereas in the initial stages her impulse appears to be mainly visual, later images, like mouth and tunnel, are more strongly marked by personal symbolism. In order to make sense of these isolated images we will have to look at the ideas and emotions she associated with a given myth. But first it may be useful to give an idea of the complex interrelations among the mythic paintings.

The paintings of these years can best be thought of as forming a web of associations, variations on her central concerns. This is emphasized by her mode of composition, in which she alternated between paintings, stressing now one, now another element of psychic drama. For instance, Orpheus and Sisyphus are mentioned alternately at the beginning of the journal and are concerned in different ways with the burdens and sacrifices of the artist. The following rough outline of the chronology will provide a frame on which to hang the details of the text. Titles of paintings are different from those finally arrived at:

May 1, 1967. Begins drawings of Orpheus, head and lyre.

May 31. Realizes that the last painting she has done should be named "Sisyphus."

June 1. Describes Sisyphus running downhill, rid of his burden.

Nov. 18. Has vision of Orpheus in blue.

Nov. 28. Talks about last two Sisyphus paintings and researches Orpheus.

Jan. 12, 1968. Changes the music she paints to from Gluck's *Orpheus* to Bach.

Jan. 24. Has a vision of Orpheus and Eurydice with lots of blue. Hades now appears as a black gorilla with open mouth.

Jan. 26. Vision of Eurydice disappearing into a blue tunnel.

Mar. 5. Draws Orpheus with a "suicide edge."

Mar. 21. Finishes a drawing of Orpheus.

July. Interrupts to start pregnancy series (daughter-in-law expecting her baby in August). There are no traces of this series.

Oct. 12. Back with Orpheus and has done sketches and drawings.

Nov. Doing infants (Mark was three months old).

Nov. 6. Begins to think about Abraham and Isaac.

Nov. 26. Three ideas of Abraham and Isaac: Abraham carrying Isaac to altar (one green, another adding red) and Abraham plunging knife into Isaac's breast (no color).

Nov.–Dec. Works on Abraham and Isaac.

Jan. 15, 1969. Has done large crayon pastel of Abraham and Isaac and started acrylic.

Mar. 4. Continues work.

Mar. 11. Decides to call it "Of Abraham and Isaac."

Mar.–Apr. Debates over giving it head of Freud or Einstein.

May 9. Has finished and is going back to Orpheus but interrupts to do mother and child (Rebecca's birth will be in June).

May 24. Has finished mother and child; not sure if wants to do more of them or Orpheus, Abraham, or Sisyphus.

May 30. Works on small Sisyphus.

May 31. Starts large one of Sisyphus.

June and July. Works on Sisyphus; Rebecca born.

June 11. Long break for "drilling"—this refers to construction work.

Sept. 20. Finally begins work on a large Orpheus—pastel on wrapping paper.

Oct. 2. Begins the painting. Long gap with virus.

Dec. Thinks of the painting as "Orpheus I."

Jan. 17, 1970. Starts new version of Orpheus—"Orpheus II."

Apr. 7. Now calls this finished painting "My Eurydice." Considers starting Prometheus with head of Gorky combined with George Oppen.

The Orpheus, Sisyphus, and to some extent the Abraham, have to do with her ambivalent feelings about the sacrifices involved in being an artist. As she develops this theme she is drawn into a consideration of her role as a woman-artist who is also lover and mother, and begins to revise the classical myths according to her own needs. These revisions are often drastic, as with Sisyphus. When she first mentions Orpheus, she has already done a Sisyphus. Her second Sisyphus painting suggests a Jonah-like rebellion against the artistic calling. She describes Sisyphus in June 1967 as running joyously downhill against a red background, relieved to be rid of his burden. In 1969 she interrupts work on Orpheus just before her daughter gives birth to a second granddaughter, Rebecca, to return to Sisyphus (who in one version is pictured holding a stone in front of his head and belly). Here it is clear that though she is not a dogmatic feminist, her insistence on her artistic right to reinterpret myths to follow her own needs was tied to her perception of the way they might be brought to relate to her own experience as woman-artist. The issues of biological and artistic birth are joined here. In an almost uncanny way, her daughter's delivery seems to inspire Ethel's new idea of a deliverance from the sense of artistic burden. It is at this point that she associates Sisyphus's acceptance of reality, including death, with the possibility that he can be released from feeling burdened by his task of rolling the stone uphill if he undertakes it voluntarily. She transforms him from passive victim to active protagonist in control of his life and fate. This interpretation stresses struggle and the possibility that he is released from the burden of the stone only to take up his next burden, the fight for humanity's release from death and fear of death. After her temporary resolution of ambivalence in the idea of voluntary assumption of burden, and after the interruption for "drilling," she returns with renewed strength to face the difficult

emotions connected with Orpheus, finally able to begin the painting she has been planning for two years.

Both the Sisyphus and the Orpheus paintings deal with ambivalence, but Orpheus goes deeper into the reasons for it, relating the artist to the lover and speculating on a possible conflict of roles. Orpheus is the painting most present in the journal; it has the fullest process notes and occupies her intermittently from its conception in 1967 (she says she started in May 1967 with sketches of Orpheus's head and lyre) to its completion in 1970. In the Orpheus treatment, her early studies of the meaning of the myth seem to relate to her attempt, aided by her analysis, to sort out her feelings about Wolf's death. She identifies with Orpheus as artist and as bereaved survivor and because, like Ethel herself, he threatened suicide in an effort to be reunited with his dead mate. On March 5, 1968, for instance, she talks of drawing an outline of Orpheus's figure in which she has what she calls a "suicide edge." But her interpretations add another element. Orpheus is not simply bereaved, he actively abandons Eurydice to her death because she interferes with his survival as an artist. ("To become the artist he felt unconsciously he had to leave her . . . he killed her that he might live.") In terms of her own life, this suggests ambivalence toward Wolf as well as conflict between her role as wife and her role as artist. Her ambivalent identifications in this myth deepen when in the course of studying Orpheus's dismemberment by outraged women she concludes that this was a punishment for his rejection of the female principle and of love, that is, his willed rejection of Eurydice. Insofar as she is still identifying with Orpheus as artist, Ethel may feel that her role as artist has caused her to reject the female in herself. Investigating these feelings was probably extremely painful and partly explains why she took two years to actually begin the painting.

In March 1968 she broke off work on Orpheus to do a pregnancy series because Hannelore, her son's wife, was expecting her baby in August. The pregnancy series formed a psychic bridge to her idea of doing a large Abraham and Isaac—a painting she worked on before returning to Orpheus. The pregnancy paintings represented the positive pole of her feelings toward motherhood and birth—the excitement and joy she felt at the birth of her son's first son. The Abraham and Isaac represented her perception of the violent emotions and conflicts involved in having children. Thinking about birth may have been one of the

factors that brought her to emphasize her identification with Eurydice when she returned to work on Orpheus. It seems as if the positive values of love, the new lives being started, helped her to face her anger at Wolf's dying and abandoning her. Before Rebecca's birth Ethel manages to paint Sisyphus accepting his burden and death, and afterwards she consciously identifies with Eurydice as the woman who has been abandoned—as she felt she had been—by a man. She ends her meditations on Orpheus by saying that she wants to tell Eurydice's story. When she finishes the last painting in the series she says, "Now I have finished my Eurydice." And although up to this point in the journal she has called these paintings "Orpheus I" and "Orpheus II," in the catalogue of her works she called them "Of Orpheus and Eurydice."

Just as Ethel sees Orpheus split between artist and lover, she sees Abraham split between believer and father. After the birth of her son's child, which she celebrates in joyous paintings, she almost immediately begins the Abraham series, in which a father sacrifices his only son. In this too a change occurs in her identification during the process of work. She begins by identifying with Abraham, the sacrificer of the child. At one point she excuses him by saying he had to kill or be killed. Later she widens her sympathies to identify not only with Isaac but with God, who orders the sacrifice. Her ambivalence toward Abraham is seen even more clearly in her choice of models for Abraham's head. She begins by choosing to portray Abraham the father who sacrificed his child as Freud the father of psychoanalysis, but then she gives him the blue eyes of her analyst, Dr. Kris. In a sense this casts her as Isaac in relation to Dr. Kris as Abraham. It is in this context that she questions whether Abraham actually heard God telling him he had to kill Isaac or whether he simply felt he had to kill Isaac. These shifts of identification and point of view are paralleled by shifting views about gender roles. Abraham is clearly male, a patriarch; nonetheless, at one point she turns him into a mourning mother who "blackens her breast" at the loss of her child (quoting Kierkegaard). Interwoven with this, she observes of African sculptures of women in the Metropolitan Museum that their breasts have a jutting, phallic thrust.

When Ethel returns from Abraham to work on Orpheus we see a parallel shift occur. In the end, she turns to a female identification with Eurydice. But the gender issue wasn't easily resolvable. It was tied to the added difficulties a woman had both in

juggling roles and in getting recognition from the art world. This section of the journal ends not with a female identification with Eurydice but with a new idea of doing a Prometheus combining aspects of two admired and successful men, her beloved teacher Arshile Gorky and her cousin, the poet George Oppen.

THE JOURNAL JANUARY 1967–JUNE 1970

January 12, 1967

Yin period Chinese vases 1500–1000 years B.C. at Asia House are a piercing "right." Tang 700–900 A.D. vases, right again in a softer stiller way. They exemplify the perfect meshing of equation to reality. The equation of beauty to the reality of beauty. No distortion. No extortion.

January 17

The Chinese pitcher corresponds to my earliest experiences of nature—wonderment at the overall largeness of the leaf-form and the remarkable relationship of the tracery of veins to this large form. No discrepancy. In fact an acute sense of pleasure. Doubtless nature did not set this equation up for the purpose of our aesthetic pleasure but it turns out so. We are satisfied. So in the Chinese vase the large proportions of the belly, the three pointed legs triangular in shape, the slender handle and the fine tracery fulfill each other. One can feel largeness and fineness simultaneously. Again I was aware of the bird's body as a full large shape, its legs fine and the corrugations on the legs still finer. The feathers, the eyes idem. All in perfect relationship. The allusions to nature drop out of space-time into their ordained place. The rightness. The ordered rightness and hierarchy of all things. Chinese art gives us the most masculine expression I know of in the history of art. A masculinity that is not afraid of sensitivity on the one hand, nor of its own strength on the other. Not brutal not forced but strong. Not wild not passionate but strong. Here the sanity and wholeness that seem to have gone from us today. The rightness of the equation is not limited. But the equation itself is.

In Greek tragedy one does not sense this kind of rightness. The limits of the equation have been extended. Perhaps one should not even call it

an equation. Greek tragedy expresses human thought and feeling. It has its own limitations but broader ones. Its truth lies in the understanding of human nature including fallacies, distortions, perversions—chaos. It speaks not only of order or the ordered relations of an ordered universe: but of life and chaos.

Renaissance art is more like the Greek tragedies. Humanistic if you will. So there may be rightness within more limited boundaries or fullness with less rightness since the effort is so complex. Since then all expressions of either seem weaker. Less rightness in the aesthetics. Less fullness in the humanistic.

My painting is closer to Renaissance art than to the Chinese pitcher. In this mode, as we have seen, the "rightness" lies in the fullness of expression of life and chaos.

The Chinese pitcher has nothing of violence in it. No trace. At lunch I was thinking of more recent paintings and found violent activity in them if not violence. The take-off of a supersonic rocket is a burst of violence, yes. Perhaps its energy is so great a part of the psyche of our time that it comes into our art. Violent combustion is necessary to achieve the speed & thrust & time-endurance necessary to go to the moon. But is this not where the fallacy comes in? Violence is not needed in a work of art. A work of art is still the creation of an individual yet an individual in a given time. Did artists of the past react to the giant explosions of nature such as thunder, lightning, volcano, flood?

May 6, 1967

The Rembrandt "Aristotle Contemplating the Bust of Homer" (Metropolitan Museum) is really Rembrandt contemplating Aristotle contemplating Homer. Possibly even Rembrandt's phantom contemplating Rembrandt contemplating Aristotle, etc. It is an "as if" situation, "as/if" Rembrandt would ensure for himself the same loving consideration of a genius, when dead. The hand of Aristotle rests on the head of Homer so tenderly. One senses in his eyes the depth of communication between the living and the dead—the statement "the dead remembered and contemplated by the living are no longer dead." He has here epitomized his yearning for immortality to be perpetuated in the contemplative mind of a succeeding genius. Rembrandt deals with concrete solidity of form in the heads of both Homer and Aristotle. But there is another dimension—the dimension of the "unknown." The concrete and known—and the "beyond known" or the "unknown." The melting off into golden-brown depths is not the result of vagueness or unwillingness to be explicit. It is enormously explicit in the statement, the poetic statement of a contrasting dimension. Within the

picture a live Aristotle (though in reality Aristotle, too, is dead) and a bust of Homer—thus life and death. But the dead Homer contemplated and made to endure in Art.

May 7

Reseeing (1) the El Greco "View of Toledo" and (2) "The Adoration of the Shepherds" confirmed my idea of some years ago that the latent content is similar in both in respect to "birth." In (1) the stream coming down from the hill on which the city is built broadens into a diamond shape pool in which a stone lies; the hills are a rounded shape (poison green in color): the stream itself descends through a stone arch. In (2) the form of area of the white blanket upon which the infant Jesus is placed is startlingly similar to the diamond shape pool and the Cupola furnishes two round shapes and an arch. Thus we have two round shapes, an arch, a diamond shape upon or in which, in the one instance, a child, in the other a stone, is placed. I feel that El Greco was absorbed by the concept of birth, the birth passage, its exact location in the universe of the body. Whether he painted the "City of Toledo" or "Christ and the Magi," this idea found its way into expression. The symbolism was not overt as in modern painting but concealed under what might be called the shell of representation. As Freudians would put it, my preconscious responded to El Greco's and my mind was the nutcracker that unshelled the symbolic meat of his thought.

May 12

Yesterday resaw Fra Angelico's "The Crucifixion" in the Metropolitan Museum. I had been familiar with the elevation to ecstasy of what would otherwise be frightful pain alone—the pain of crucifixion. I realized then that the figures do not mourn the pain of death, they contemplate a sacred event—the passage of Christ to his Christhood. The stream of blood trickling from Christ's wound is the poignant focus of the dying body. Jesus' spirit will ascend into the Golden Kingdom but his body fluid, i.e., life, is seeping away. The almost childlike fury of passion, the anguish over the dying of the beloved, are here represented with precision and intensity.

I felt as though I could have willed to paint this. The Greeks were "Kinspirits." Strange kinship hands reached out to me over the centuries.

The "unknown" which in Rembrandt lies in the somber glowing depths of the browns lies here in the elevation to intensities of gold that set the heart spinning "upward and beyond."

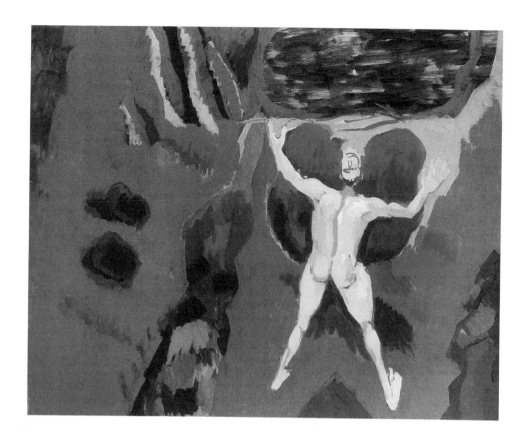

FIGURE I. *Vision of Sisyphus
Bound* (1971). Acrylic,
60″ × 72″. Artist's
estate.

May 23

Yesterday in the museum noted to my astonishment that the "blood image" of Fra Angelico was used more extensively than I had remembered. There are four streams; very fine streams of blood, one from the nail in the foot trickling in three streams over the gold—from the nail down to the ground; one spurting from the wound in the side; and two trickling from the nail in each palm down the arm and beyond. (Not dropping downward along the gold.) I wrote in my notebook, "Blood along the arms

like the death of a butterfly—exquisite." The figure was substanceless. The blood real.

May 31

Yesterday I realized that the title for my last painting could be "Sisyphus." I am adopting a similar credo to the following one from Shelley: "The Greek tragic writers, in selecting as their subject any portion of their national history or mythology, employed in their treatment of it a certain arbitrary discretion. They by no means conceived themselves bound to adhere to the common interpretation or to imitate in story as in title their rivals and predecessors. . . ." ("Prometheus Unbound," from *Keats and Shelley*, p. 225, Modern Library Giants, Random House, New York)

And again my idea resembles or agrees with Shelley, "The imagery which I have employed will be found, in many instances, to have been drawn from the operations of the human mind. . . ."

June 1

About Sisyphus: now I will free Sisyphus fated to push a rock up a hill and as it rolled back to push it up again, endlessly. Finally the rock will plunge to destruction in the sea.

So, I show Sisyphus running down the hill for the last time shouting farewell to the rock. . . . I had not understood why my colors seemed to move upward when the figure was moving downward. It was due exactly to this—the assertion of a desire for freedom from imposed work. In the Greek myth, of course, the work was a punishment imposed from without. In my painting it is modernized to the point of realization that work is really inner-imposed; therefore, can be shaken off without decree by the gods. After all, Sisyphus' original crime was to have tried to shackle Death (for this Pluto punished him). Actually he could (in the modern version) terminate his guilt by accepting Death, since it must exist—(acceptance of reality).

October 20

Once more studied the Chinese vases in the Metropolitan. Vases from the earlier period 1500(?)–1000(?) B.C. . . . the style is already highly developed in the Neolithic, undated examples presented in the Metropolitan. The form of the vases, very powerful. The surface completely covered with ornamentation, incised into a slightly raised surface. Encrustations of ornamentations as well as handles (which are small), a flavor in some ways

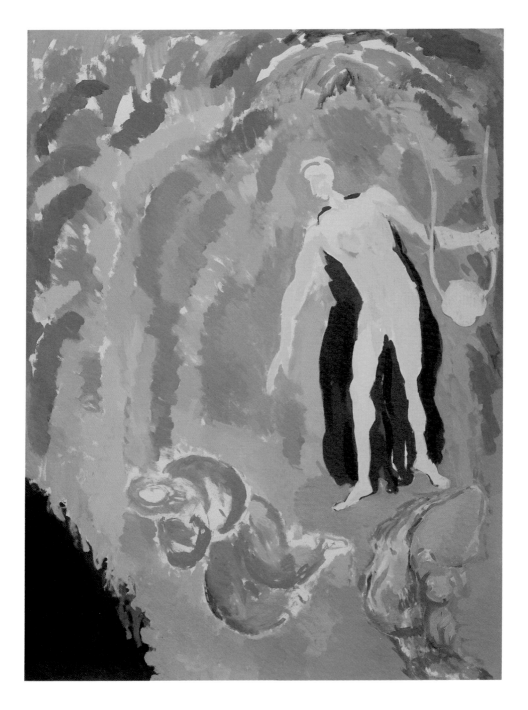

PLATE I. *Of Orpheus and Eurydice 1*
(1969). Acrylic,
80″ × 60″. Jane Voorhees
Zimmerli Art Museum,
Rutgers, The State
University of New Jersey.

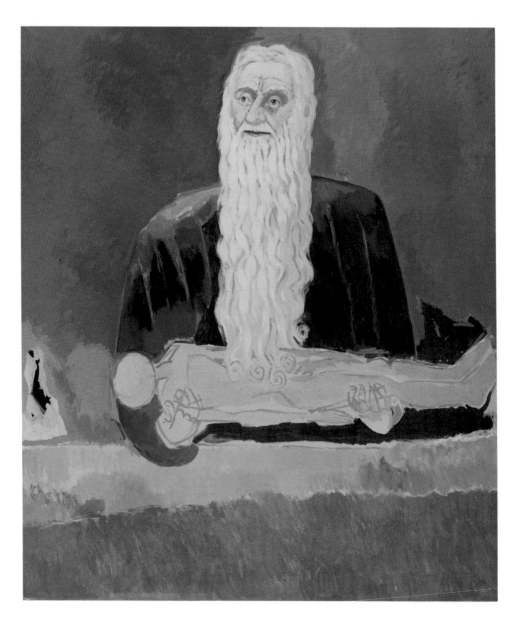

PLATE 2. *Of Abraham and Isaac*
(1969). Acrylic,
70″ × 60″. Artist's estate.

PLATE 3. *Wild Honey* (1961). Oil,
84″ × 70″. Artist's estate.

PLATE 4. *Of Orpheus and Eurydice II* (1970). Acrylic, 72″ × 60″. Artist's estate.

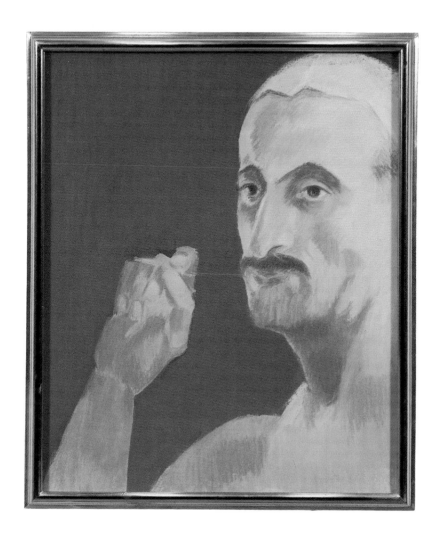

PLATE 5. *Portrait of Arshile Gorky*
(1972). Pastel and Acrylic,
24″ × 20″. Collection of
Christopher Schwabacher.

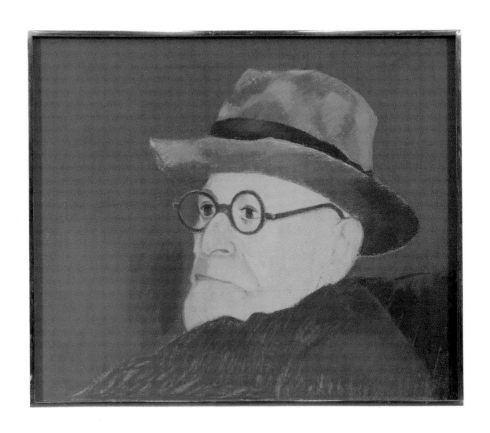

PLATE 6. *Of Freud II* (1972). Pastel, 20″ × 24″. Collection of Christopher Schwabacher.

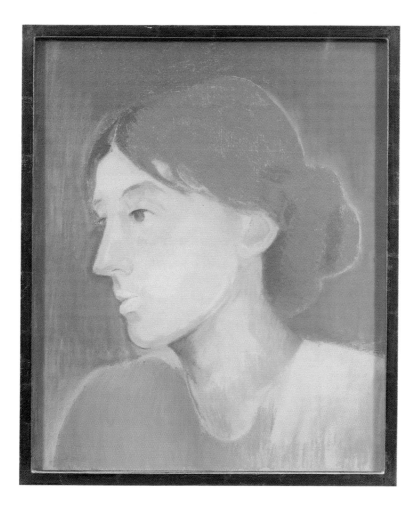

PLATE 7. *Of Virginia Woolf* (1972).
Pastel, $24'' \times 20''$.
Collection of Brenda
Webster.

PLATE 8. *Et in Arcadia Ego III*
(1955). Oil, 50″ × 40″.
Artist's estate.

similar to French Gothic. Flowering. The flowering of the earth's surface, not nude bone of the earth, as in Art today. This finely incised ornamentation maintains the feeling of power, wholeness from within/out. Klee would have loved to do this (and did at times). But the ethos of today is unfortunately obsessed by demonstration of power. Today, art attempts to force or impose power, to manufacture power as a substitute for the natural power outflow which has somehow been aborted. In Chinese Art the line moves and is. Proportions come to be and are not made. Moving from the Chinese I came to Rodin sculptures—how weak they are! What has happened to creative man?

November 18

Picasso (in his sculpture of a "Pregnant Woman" at the MOMA) falls into ugliness, brutality and violence along with the world he has faced. This has the fault of the "fallen state." In the one instance I feel limited beauty, in the other, limited reality.

Planning to do a painting of "Orpheus and Eurydice." [See plate 1, *Of Orpheus and Eurydice* I.] I imagine the painting in blue, the jaws of Hell to the left. Orpheus has descended to bring Eurydice up from the Elysian Fields. He turns to speak to her in disobedience to the Gods, loses her and she sinks back into Hell. The passage back dark, dark blue, perhaps even black. At this time he is facing her and sees beyond her the opening to Hell and the words, "Abandon hope all ye who enter here." Rocks, tunnel, flowing garments. Orpheus cries out. "Che Faro Senza Eurydice?"

November 25

My first thought on the Orpheus legend was of the descent into hell. . . . Orpheus has given in to Eurydice's pleas, has turned around. She falls to the ground, dissolving into the shades. All blue, a strange mystic blue recalling van Gogh's painting after Delacroix.

November 28

As to myself & the attempt to handle greater range & complexity to include life, love and chaos. Will I break down? Crushing strain of isolation. Self-imposed to protect myself from criticism & rejection. Where could I find friends for my work: Emily Dickinson remained isolated. Terrible suffering, saved herself by keeping her eye on immortality. Rejected what would reject her. ILL. Early death. But great. Very great.

Those last two of Sisyphus should be my last works. I had planned to

FIGURE 2. *Sisyphus Unbound II*
(1969). Acrylic,
80″ × 60″. Collection of
Sandra Payson.

do them larger. Is there need for this? I feel my Sisyphus has all the qualities of life—responsiveness. It is there: it is there. Once I said of Gorky "I wish I could paint like that!" Now I must say this of my red Sisyphus. Or is this a passing euphoria?

November 30

In much modern painting I find not mastery of turmoil, life, chaos, love, but only mastery of what is left after their avoidance. Mastery of some state that is left after most of life is dismissed. A delimited state.

December 2

I just came on "The Orphic Voice" by Elizabeth Sewel on my shelves. It tells the story of Orpheus in full. At the end Orpheus is actually torn to pieces by the Maenads, his head floats down the river still singing. The head comes to rest in a cove, where it prophesies day and night. Apollo himself bade it to be silent. The lyre was taken up to heaven to become one of the constellations. This suggests images to me.

New interpretation of Eurydice in Rilke as wanting to die. Orpheus & Eurydice as parts of the self male/female, reason/drive, love/death. Why was Eurydice reluctant to leave Hell? Did she unconsciously seek her own Death?

Might paint Orpheus' head floating down the stream. The lyre alongside him. Marvelous image of Orpheus' head drifting on the water. Blue, blue & the golden hair and the golden lyre. Or perhaps the lyre black or purple like the fields of water lilies by Monet.

December 3

Have just brought home Ovid's *Metamorphoses* and Rilke's *Sonnets to Orpheus*. With a sense of joy!

According to Ovid Eurydice, bitten by a serpent, dies. Orpheus begs for enjoyment of Eurydice. Threatens suicide if he does not get it. Valuable images: "Up the sloping path," "the steep dark track," "lyre growing out of trees and grasses." (Ovid, p. 226)

December 4

Why not the myth of Orpheus as a journey into the self—a symbolic way? And the pregnant idea, "the mind becomes its own subject matter" as the central theme?

Milton gives us Orpheus' descent into Hell in search of Eurydice, the search of the Ego into the life of the Id in hidden or Freudian terms.

In Rilke's version of Eurydice coming up from Hell, I find rejection of sex & fertility, death wishes, apotheosis of death. This differs from my version of Eurydice as the pulse of life though later rejected and returned to suppression.

In my terms Orpheus as poet goes down into Hell in search of love. His "other half." The completion of the self. He gains love (Eurydice) and then loses her once more and finally his life.

Ovid (*Metamorphoses*, pp. 225–28; pp. 246–48): The original story. Don't forget the snake. The snake kills Eurydice. And at the end is about to bite the dead Orpheus' head when checked by Apollo who petrifies it. Also don't forget that Orpheus rejoins Eurydice in the fields of the blessed and can here safely look back. (In Gluck Eurydice rejoins Orpheus in life.)

By their howling the women drown out the music of the lyre (orgy destroys Art).

December 10

Shelley ("Orpheus") picked the time "after" Orpheus had lost Eurydice. He chooses "anger" not grief, "angry grief" as the summit of Orpheus' mourning. The conversion of anger to song. Fascinating description of the way up from Hell. "Where she is. It is dark." Anger at her fate.

Wrong relationship of lyre to head in May 1st drawing. Lyre is much larger. Restudy Greek vase. Proportion good. Art outsizes Life (the head). And the waters, the blue waters (life also—not individualized into human form).

December 12

The death scene. The women tear the animals apart using the abandoned plough shares, etc.

1st part of this: the women throw rocks which bound away without hurting Orpheus as he plays his marvelous music. Later the shrill clamor of the women drowns out this singing and he becomes vulnerable. Noise drowns out music. Instinct of sex destroys Art—fury over rejection is sufficient cause to kill.

December 30

Read in Troyat's *Tolstoy* valuable comments on protecting himself from criticism. . . . This is what I must learn, not to be stopped by criticism either in painting or writing.

January 9, 1968

In the end Orpheus is killed not as punishment for excess of desire but for nondesire. The horde of women kill Orpheus for his sexual rejection of them (interesting alternative to Freud's horde of young men killing the primeval Father, in that case an urge for power, i.e., to replace him). To return to the women: they kill Orpheus but his lyre continues to sing. (Art cannot be silenced—is eternal.) Finally Orpheus recovers Eurydice in the fields of the blessed (in the underworld). Art triumphs, i.e., the lyre continues to sing. Life and love triumph, i.e., Orpheus recovers Eurydice in the underworld.

The women also must expiate their crime (according to Homer they are frozen into tree trunks).

January 10

Bright peaks on the hill where Orpheus sings, glittering colors, birds, leaves, all of nature. Yet here occurs the horror of his slaying. Women defeat his song! Turn beauty into pandemonium. They tear the bright shreds of clothing and flesh from his body and fling them far and wide, use stones and the sharp-edged ploughshare to kill.

Finally the barren evening comes. Orpheus childless by choice (by choice rejecting women), now, lifeless through their anger.

January 12

Decided to shift from Gluck's "Orpheus" to Bach. What a relief! So I will take the story from Ovid, the music from Bach, and hope to work out of that background to my present—the now of today and my inner reactions to it.

The contradiction between the juxtaposed ideas of Art (life eternal) and death fascinate me in relation to my theme of Orpheus. Also love/death. Love rejected, punished by self-inflicted death. But above all I seek the "place where" there is a sharp clashing line between perfect beauty and death.

January 15

Continue reading Dostoevsky's *The Idiot*. The characters talk or act out their feelings in full before the family group (almost as in group therapy). This causes a feeling of ambiguity as such violent intensity and fullness of expression rarely occur in real life. Dostoevsky develops the story by a "series of storms" approach. As in a storm, that which seems permanent

and still is found to be mobile and destructible. D. proceeds by a nearly pure intensity of primary emotions in which reality appears intermittently. Nowhere but in psychoanalysis would such uninhibited surges of revelation appear. And possibly in Dostoevsky more unencumbered, as they are not checked by the evaluations of the analyst. However, the members of the group do act perhaps in that capacity (as with the Greek chorus). They produce a many-angled series of evaluations of the main emotion-action.

My painting method similar. The primary or deep reality only evident under the condition of storm.

January 24

Vision I: though still indefinite, of a large canvas much blue, and out of this Eurydice returning to the underworld and Orpheus holding his lyre in one arm, stretching the other out to touch her, gone. Vision of a beast— gorilla large and black with gaping mouth. Death image. The death of Orpheus on the other hand will be red.

January 26

The whole scene of Orpheus turning—then the return of Eurydice to the depths of the underworld occurs in the underworld, not as I was imagining it in the outerworld.

Vision II: Eurydice disappearing into a tunnel, the whole space is a tunnel. A tunnel within a tunnel. Question of turbulence. Blue. Eurydice disappearing, the physical presence merging into blueness presence/non-presence.

February 5

The orthodox point of view has been to sympathize with the grief of Orpheus. But consider the anguish of Eurydice on returning to the under-world. Looked at from the modern point of view Orpheus, in turning around, enacted an unconscious wish to get rid of Eurydice. Did she not divine the inner or "unconscious" intention and suffer from it? Feel forsaken?

February 10

In connection with the show of Turkish Art at the Met—some pieces of sculpture and pottery go back to 6000 B.C. or 2000 B.C.—note again that, if the primitive people have hostility within them, they do not show it in their art. No aggression, kill or "overkill."

February 14

Orpheus' separation from Eurydice as I see it is symbolic. To become the artist he felt unconsciously he had to leave her even though this separation meant death to his beloved. He killed her that he might live forever in art. In the end he was killed (revenge of the women). But still he lived on in his music and song. Death seemed the only possible means of separation. Death of "the other." He seemed to seek her but he sought (unconscious hate) only her death.

Orpheus rejected women throughout. First Eurydice, and then "the Grecian women." Eurydice died (her revenge for his rejection). The "women" killed him. Ambivalence. He went down into Hell to get Eurydice (love) he turned around (hate). Love/hate—not fulfillment, not freedom from attachment.

In the first instance his (Orpheus') refusal of love caused her (Eurydice's) death. In the second instance, his own. (Through the women.) What if turning around had meant Orpheus' death instead of Eurydice's? He would have died earlier. —He was to die of rejected love in any case.

February 17

It is not possible to express the "unlimited" in Art. In poetry it can be described. In Art it is impossible to express such extremes as black or white in quantities even approaching the unlimited. The modern artist, like Rothko, Newman and others who attempt to suggest "unlimited extent," fails badly. And as that is their chief concern, it means that in large part their paintings fail as Art. Their intention is nullified by the undeniable reality of the "fixed" edge of the canvas which one can neither ignore nor expand.

These thoughts came to me on reading Milton's description of "the underworld." He describes the "limitless deep"—etc. The "unlimited deep." The "vast extent of night." But it works here. The concept and even the feeling may be grasped unhindered.

March 5

Why do I think of Michelangelo's "Adam" (from "The Creation of Adam," Sistine Chapel, Vatican, Rome), the gesture of God, his arm and hand outstretched to touch Adam's extended finger in an act of creation? Should I use this gesture in Orpheus' Farewell to Eurydice? From being an act of creation it would become an act of farewell. Why do I have Eurydice engulfed in flames? Are these the shadows of flames? Do they come from within? Are they without? Eurydice was not returning to Hell. Though she

was returning to the underworld it was to the Elysian Fields. I had thought she must first pass through the flaming passageway to the underworld before reaching the "Blessed Fields."

Are these ambiguities? Shall I retain them or eliminate them? They came from I know not where.

For instance in the outline of Orpheus' figure I felt the "suicide edge" I had had in my Sisyphus painting (edge of hill). Why? Why? Life and Death?

I had meant Eurydice to smile, to turn her smile in the direction of Orpheus as she descended into the underworld.

Should I not have made a sloping path?

March 21

> "O! that this too too solid flesh would melt,
> Thaw and resolve itself into a dew."

Eurydice dissolving. Could I draw this—again blue? Does this become suicide? Or Orpheus' death wish against her magically fulfilled?

The drawing I have just finished is much clearer than I had at first imagined it. The parts dissolving from realistic human form but still clear forms. Boccioni used melted anatomical forms to suggest movement of flesh. Their visual truth was later clearly verified in war photos of fliers blown by high speed wind.

April 4

In recent times the tendency has been to lose distance, to become immersed, to immerse the spectator, to consider him not as a viewer but as an actual participant. Illusion about the true nature of creation. To me, an illusion as to the possibilities of actual experience. Confusion as to the nature of Art. Art is distance from immediate emotion and involves assimilation, sublimation, comprehension. It is the history of the event (not the event).

July 3

Long gap.

Manet: "Christ with the Angels" (Metropolitan Museum, New York). Suddenly, as happens to me so often these days of my older age, I saw the Manet in a new way. The body of Jesus passive, no sense of strain or anguish, the wounds dry, no blood (shall one imagine that the body has

been washed?). But, and here is the astonishment, the movement of the angels' wings gives a rising, swelling musical movement of resurrection heightened by the angels' robes. The tones of the dead body naples yellow, the tones of death. Shadowy planes on the chest, somewhat grey, contribute to the musical effect. As I sat there it seemed to me yes, the material presence was there, Christ's dead body, angels. But a great swell of sound was the true content of the painting, life out of death. The artist's imagination did not conceive of the static condition of death, rather of death transcended. The stones and snake in the foreground conventional. A weakness in the picture. Strange foot. Swollen? Or incorrectly drawn?

July 5

Monet: Color/form/mood compose the song of the self. Whitman "Myself I sing." The eroticism of an old man looking back on youth. No. Refeeling youth, the unquenchable spring. A waterlily is a breast, green, encircled in red (deep). Tipped with bright red. A full, luxurious surface. Passion, mastered, turned to honey. Streaks of white for light (oh so modern, i.e., Expressionist).

July 6

The colder intellect of Picasso "The Women of Algiers" (after Delacroix) interesting too. Mind as mind. A game of chess. Game of plays. Progressive elimination of possibilities, "this move" instead of "that." In the wake of "this" move follows inevitable series of moves. Four women in a room, sharp demarcation between vertical and horizontal; the ceiling, the floor. The delimited space. The women, their posture & apparel. The smoker, the dish of fruit. The rug. The table. That is it.

How would Delacroix have had it? The surface nuances. The surface nuances where they might be expected; namely, on the surface—the structure understood as is the bone within the body. But Picasso "defleshes." He establishes the structure of the picture as the primary subject matter. The emphasis therefore on Art rather than "life." The divorce of Art and life has begun.

In the case of Monet Art is still life. A form of it. With Picasso life is Art. With Monet Art is used to express life.

Picasso uses life to express Art. In the gymnasium of the mind the mind flexes its muscles and turns handsprings.

Found photos of Delacroix's "The Women of Algiers." As I suspected, Picasso's "Woman with Her Legs in the Air" is pure invention. Nothing of this in the Delacroix. The Delacroix women languorous full & soft. Sub-

tleties of surface, "understood" architecture. While the Picasso is hard. Architecture foremost. Either surface is eliminated or could I say "understood?" In either instance the mind leaps to fulfill a total experience. Rounds it out.

Picasso's tenderness exists for itself displaced from the representational object but connected with the architecture. His surface is fine (the very canvas is fine), the color relations in themselves, subtle. They conform to his creation not to the women themselves (who are the subject of the Delacroix).

In this sense Picasso's painting resembles music. It is its own subject matter. And relates only indirectly to "life."

July 19

The full world is around me—I must seize it—no welcome it.

Walking pregnant women everywhere. On the streets, in the park. Fruit & flowers, yellow flowers in the zoo. Trees, sky, men carrying babies on their backs. Women too—the carry-cradle. Even the ugliest of these women is beautiful. The expanded belly. The expanded vista of productivity. Fullness. Not rape-pregnancy as with Picasso. Just the fullness (as the apple of Cézanne). Life intersecting my dream.

July 27

The Manet "Christ with the Angels" astonishes me once more. Again differs from my naive early view. The non-literary quality of certain aspects of the work. On July 3 I wrote of transcendence, today I write of compassion—a Pietà. The color of the hands dark (could these areas have darkened for some technical reason?). The wound painted of brown madder. Tender. Incredibly tender. The gesture of the left hand, cupped—inert. The thumb almost indiscernible, lost as a shadow tone. The tones around the hand tender. I know that tenderness as though he touched the hand with pity in his brush. Like a last kiss for the beloved. The foot (do I imagine this?) as though swollen. Big toe painted. Other toes a plane, a mass. The instep & joint swollen. Somehow agonized. As torn & twisted as Picasso's "Guernica" but more subtle. Is this not better? The idea "penetrates" rather than "assaults" one. The stones & snake at the bottom of the canvas lapse into conventionality but how much glory can one expect from one work?

July 27 (at the Guggenheim)

Must develop more differentiated drawing of the "Pregnant Woman." The series started. "The First Child." Pregnant woman and man looking

on. Birth of the child too schematic. Remember the color of cantaloupe—salmon & spring green.

August 8

My forms preserve a containment. Closed surface. Definition. But the throb of the inner pulse? In the back of my mind a feeling of the swelling form. Not yet in the painting—

September 23

Have finished "The First Child." At first intended to do it in a larger version. But my mood is gone. The school strikes make it difficult to sink into the mood of fulfillment that was at the heart of this painting.

It has occurred to me "could I paint a young infant?" This has virtually not been done. The infant Jesus has usually been painted as an older infant.

What I see in the face of little Mark* is eagerness. C. leaning over the carriage eager, too, joyous. How could one paint this? The infant Jesus was usually painted with a calm closed-in expression. How much more beautiful the actuality! Eagerness in such a pure form, as desire to live and reach out for nourishment. The simultaneity of desire or urge and fulfillment. Suckling, then relaxation & sleep following so closely.

The baby feels the need for motion. He has known it in the womb & wants it, needs it. Is there not even at this date the desire for repetition of an earlier experience and the same biological need for motion as there is for food?

September 25

Natural for a woman to paint a "man in relation to an infant." The young seedling, eager green, young green, peculiar purity, intensity. Spring green cutting through the crackling earth.

September 26

Went to the Met to search for infants. Of course a long list of Italian masters painted the "Child in the Manger," "Nativity," & "Madonna & Child." And angel putti. But usually the infant appeared to be at least five

*Ethel's grandchild, son of Christopher (C.) and Hannelore.

months old, rounded, able to support his own head; even in the manger they used an older infant.

Exception: Fra Angelico. El Greco. Even here possibly more like a four- or five-month-old child.

There is a wonderful Louis Le Nain, "Mary, Infant Jesus, & Shepherds." The infant head might be a quite young infant, perfectly painted, head solid; expression, pure innocent. But nowhere the eagerness which I have perceived as so fascinating.

In El Greco's "The Adoration of the Shepherds" the gesture of the shepherd on the left of the infant has almost exactly the quality I noticed in Chris, "eager adoration." Only C. expressed much more joy. Sheer joy. Not so much of the contemplative. That's it, sheer eagerness in the infant. Sheer joy in the young man. This is the "immediacy" of which D. H. Lawrence wrote. Hard to capture in Art, yet so beautiful a part of life.

Actually, the infant in the El Greco is very strangely drawn, the lips too full. The eyes not seen. It is really more of a token baby. The picture is really about the adoring shepherds.

October 12

Now that I have done a number of notebooks, small drawings, and several small paintings, I'm thinking of doing the "Orpheus" in acrylic, possibly large. A new shift of emphasis. In my first drawings and studies Orpheus sad, disconsolate when he loses Eurydice (Gluck: "thou art gone & lost forever!"). But if I follow the idea that Orpheus turned from an unconscious (deep) desire to lose Eurydice then he might not be sad, turning swiftly to his music to live in a solipsistic universe of divine sound. (Also involved is the idea of young men as primary choice.) And what of Eurydice? Did she return to the shades (Elysian Fields) with a sense of inconsolable loss? Or was she satisfied with the separation?

Even if I accept this version I think that the first moment when Eurydice slips away from Orpheus into death must be a moment of anguish.

In that moment despair at separation. Sense of loss & aloneness. Acute. Likewise, Eurydice. The reality of the feeling is independent of the extension in time. Use blue as in Prometheus.

November 4

The marvels of the infant. Flower petals—newness, thin almost trans- parent. Aim: to be. Aim: to grow. Pleasure/un-pleasure. Can this be painted?

November 6

Possibly will do "Abraham & Isaac" following Kierkegaard's *Fear and Trembling* (p. 45, London, Oxford University Press, 1939). [See plate 2, *Of Abraham and Isaac*.] "It is repugnant to me to do as so often is done, namely, to speak unhumanly about a great deed, as though some thousands of years were an immense distance; I would rather speak humanly about it, as though it had occurred yesterday, letting only the greatness be the distance, which either exalts or condemns."

Strangely Kierkegaard uses an absolute minimum of description (visual) of the scene so I would have to imagine the whole thing myself. Bible idem: Genesis Chap. 22.

Perhaps because there is so little visual imagery except for the actual act of sacrifice at the altar, the image comes to me as sculpture. Though in full color. Abraham holding Isaac in his arms. (Picasso sculpture of the "Shepherd and Lamb.") Abraham raising the "glittering knife" is the only other image one could use in a painting. Remember that Abraham was supposed to be old. One hundred years.

Abraham's sacrifice of his son is to be the sign of his faith in God. Varied emotions: the joy of his obedience to God, the anguish of losing his son, the agony of separation. Then God sends the ram and terminates his demand for Isaac's sacrifice. Abraham's belief in God's goodness proves justified. But in one of Kierkegaard's versions Abraham is depressed, cannot forgive God for the torture he has endured.

My vision of it is that Isaac (having heard he is to be sacrificed) fainted. Abraham carries him to the altar and he is already as though dead. Alas! Abraham's beard flows over Isaac's body (remember the rippling mane of the Chinese horse) giving a feeling of weeping, tenderness.

November 26

A few days ago thought of (1) a large painting of "Abraham & Isaac" in green, abstract green. Abraham carrying Isaac to the altar. He would be facing the spectator. (2) A second idea of Abraham plunging the knife into a "bound" Isaac—without color. (3) A third idea the original (1) but adding the color red as a plane.

Homosexual component in the Abraham/Isaac story of Kierkegaard (*Fear and Trembling*, version 1. p. 27). Abraham says, "Stupid Boy, dost thou then suppose that this is God's bidding? No; it is my desire." Isaac then obliterates (kills in thought) his father & turns to God. ". . . be thou my father." Curious, Abraham in another version takes on the mother's role (does not Kierkegaard intend it so?), "The mother blackens her breast."

Exactly as Abraham . . . "Above all it is better for him (Isaac) to believe that I am a monster rather than that he should lose faith in Thee."

In the story of Jesus on the other hand the son is actually sacrificed. Killed before redemption can come.

(4) Abraham bends his head backward to gaze in the direction of God—the knife in his hand—(in this way he will not see the ram). The body of Isaac is at some distance down just below Abraham's long flowing beard. Interval of expectation (FAITH). Red. Below pyre area of blue. Recall green & fuchsia of Piero della Francesca.

Kierkegaard only once considers the feelings and thoughts of Isaac. Everything is concentrated on Abraham.

Or would Abraham ask Isaac to lay himself voluntarily upon the prepared altar?

December 2

If Abraham had faith why could he not have gone joyously to the mountain with Isaac to do God's will? Would he not have felt that God could not ask anything of him but something good? (These thoughts come to me while listening to Beethoven's "Ode to Joy." Apparently not to Kierkegaard.)

Kierkegaard omits the "fear" "reward" elements in the Genesis story of Abraham.

Could it not be that the whole picture plane would be red—and the figures in white outline? (Ghostlike) 1st meaning—celebration; 2nd meaning—anger.

Does Abraham lean over to press a kiss on Isaac before lifting the knife? (Kierkegaard calls it the "glittering knife"—his one visual reference.) Or could the background be black—the "glittering knife" splintering the darkness (icicles on trees in midwinter night splinter space). As the spider according to Kierkegaard drops into space, the only "known" world behind him—so Abraham drops into time on the journey. The journey may be endless though the time given was three days. I mean the psychological time. Possibly Abraham's back might be turned to the spectator.

December 7

At Natural History Museum "African Art." Aggression in their conception of woman, the breast = phallus. It juts out. Not as in Greek Art an object of enjoyment, an aesthetic object for the enjoyment of hetero or homo love but as with the male genital a tool or weapon, an aggressive

part of the self. So woman had a self quite as definitely as man. In Greek Art woman's self was for the lover. In African the self was for itself.

I had noted that in Chinese Art (vases) the line came into being, contained no aggressive quality. This is not true in African Art. As I have suggested above the quality of aggression is very powerful equally in the woman and the man. Does aggressiveness in Art belong to a primitive stage? Perhaps so.

December 10

Possibly Abraham had to kill Isaac divining that Isaac would in the end kill him. Kill or be killed. Oedipus killed his father—"the primal horde" (Freud). Why did I not include the blackened breast in my visualization?

Perhaps the cord that binds Isaac should be a single strand as in Michelangelo's "Slave," the willing slave, the willing victim bound by love, the slender, easily broken bondage. Easily broken on the physical, material, not on the psychological side. Isaac could have escaped. Isaac could have turned on Abraham and with his youthful strength thrown him down, killed him. Why was he passive?

Of course as Kierkegaard states it Isaac refers himself to God just as Abraham does. He gives himself up to the will of God.

December 11

Still dreaming of the painting "of Abraham and Isaac." "Saw" it as in the round, but not sculpture. Scale very large, unbelievably real. Menacing. Much space, little color. Abraham facing spectator holding Isaac in his arms. Much use of space around and around. Some soft dark blue around or to the right of figure of Abraham.

Michelangelo "Moses" ([San Pietro in Vincoli] Rome) enormously real but this is in a way an illusion. It is essentially idea/real, i.e., such a man is not actually to be seen except as one sees him in Art and yet one would recognize him as absolutely solid, clear, knowable. And one believes for a moment that he actually exists or must exist.

Yes, Abraham might have blue eyes—something of M's expression*— the expression in the eyes looking backward/forward at death/immortality.

What engulfing tenderness Abraham must have felt as he yearned toward Isaac and longed not only that he might live but that he might live on forever. How could he kill him?

*"M" is Dr. Kris.

January 7, 1969

According to Lowrie *A Short Life of Kierkegaard*, p. 51 (Princeton University Press, Princeton, N.J.)—Kierkegaard thought that his father had cast him in the role of Isaac, i.e., to be sacrificed in atonement for his father's guilt. Also p. 53 . . . his father looking at him steadily says: "Poor child, you are going into a quiet despair." Despair is but another form of death.

January 15

Have done a large crayon/pastel drawing of "Abraham & Isaac." Abraham very distinct. Isaac still indistinct. Must make some studies of him. Then go on to a large acrylic painting.

What age should Isaac be? I have made him a child in the drawing. Abraham holds Isaac tenderly. He is silent—his eyes fixed in attention, concentrating, straining, hoping to hear God say "stop." Sadness and strain but firmness in the mouth. Eyes blue. Flames already rising from the altar. How ghastly—should I reduce this out making only red cloth which might still convey the suggestion of fire? The body nude in my drawing. Should it be—what of the binding? A single strand? And the knife, should it be seen by the altar? And the drawing of the hands? I must make some studies.

January 21

Thinking of Einstein's head for Abraham. The white hair floating upward & outward, fine, not heavy, snake-like coils as in Michelangelo's Moses.

The weighing out in Abraham's soul, does he really hear the voice of God asking for a sacrifice? Or is he in truth a father killing his child? This opens up the possibility of parricide. The horror of it.

The body would sag, the head falling backward from the shoulders, buttocks sinking down. And yet I had wanted a more rigid pose. As though the body had been bound to a board, and thus could be lifted in a rigid (catatonic) position. Perhaps the already dead idea. Egyptian mummy.

January 28

M's eyes from behind her glasses. The blue is flattened & expanded. The upper form of the lid rounded as in Ingres. The hair some yellow some grey. The face is as in my Isaac naples yellow; the lips soft, without concentration—loose. Concentration diffused.

February 17

Started a large "Abraham" last week. Acrylic on canvas. Now I find the hands too small. What color? Question of the width of the shoulders. Color of Abraham's robe. Should I show the flames? The head is now indicated in very light tones. Shall I make it more solid?

March 4

Continuing "Abraham," nearing finish.

Saw De Kooning show at the MOMA last night. The 1948 black and white paintings have something of the Pollock running line. Restlessness. Don Juanism, i.e., search without fulfillment. Then 1956 De Kooning's women more indebted to Soutine, powerful. Love of a woman's breasts, hatred of her soul expressed in her physiognomy. Always love of painting itself, weakness as to structure and form. Too much dependence on sensuality. Tremendous sense of masculine force on that level. The landscapes 1950s(?) beautiful color but vague, unspecific again, more brutal than loving. In sensuous strength similar to the late Monet. But Monet had studied nature so he had a true base for the painting. De Kooning has sunk into a sea of sensuality, tactility, narcissistic isolation, loss of the true object, reduction to the subject of "self." In this sense very unsatisfactory. His women express "hate" or "satire," and thus do have a certain content.

By contrast the large Pollock looked more unified, more satisfying— and I do not usually like Pollock particularly.

If our "great" ones are as lost as this, how lost we are! Autoerotism, solipsism instead of love. Satire instead of exultation.

March 11

Have found the title "Of Abraham and Isaac"—I think this will hold.

May extend the strong green of the background reducing the "no" color. Also strengthening the head.

March 12

Abraham's head off in a "no color" land, vaporous, abstract. Isaac in the intense light of fire. Are these two moods possible within a single painting?

March 13

Hoping to go forward with head of Abraham—based on Freud (age 83). Never realized how extremely sensitive his mouth was. Fine. Thin lips

in almost straight line. Slight curve-round of lower lip. Nose rather heavy. Muscles on either side defined forms. Will use all this. But not Freud's eyes. More the eyes of Rembrandt's Homer. Deepset. Away from nose. Also forehead and hair of Homer. But eyes will be blue. Beard will be long as in Michelangelo's "Moses." But not so heavy.

Thus: Moses as seen by Renaissance Michelangelo; Homer as seen by Rembrandt (from Greek statue).

"Theme" also as seen: Bible "Genesis"; Kierkegaard *Fear and Trembling.* As reseen by me in light of Freud?

March 15

Strange thoughts came to me about my "Abraham." By doing Abraham over, using the image of Freud. Have I been assimilated in the Hebrew or Jewish tradition? Freud was a great Jewish leader but not a religious one. Through him identify with Jewry. (Einstein also [I had almost forgotten].) Curiously, my also using Homer suggests that I am here fusing or trying to fuse these two great ancestral streams: Greek and Jewish. They have made up my life. One by birth, the other by choice.

May 1

Jesus is a sacrifice just as Isaac—his father's "beloved" son, "only begotten" son. But Jesus is to rise again and will sit at the right hand of the Father and enjoy eternal life. Isaac perishes and Abraham enjoys eternal fame (Kierkegaard). In the Isaac/Abraham myth there is a "grandfather." In the Jesus myth there is only a father; i.e., God. In the Jesus myth the father knows no doubt, no guilt. In the Isaac myth the father suffers as well as the son.

In the Jesus myth the father, being omnipotent and perfect, does not suffer. Only Jesus suffers.

In the Isaac myth the father suffers in relation to his father, i.e., Isaac's grandfather. He also is subject to a "power" figure.

There is a distinct difference between the two myths despite the similarity of a sacrifice involving the death of an only son.

May 9

Finished large "Abraham" begun first week of February. Thinking of returning to theme of Orpheus. I wrote on this from November 1967–November 1968. Also did many small drawings Nov. '67, December '67, Jan. '68. February 1968.

Theme: Separation. Natural Death (lst death of Eurydice). Death as the "choice" of Orpheus (2nd and final death of Eurydice). Death as a consequence of his rejection of the Greek women and the hostility this aroused in them (death of Orpheus).

Art and Love. Choice of Art (Orpheus). Even after Orpheus' death his head lives on (eternal fame).

May 13

The fundamental hideousness of the "primitive sculpture" (Met. Mus.). Also the fundamental reality. Unreal in regard to human proportions. Real: Phallus. Comparatively real: face. Body diminished to an abstract form or sign or indication. Legs completely distorted (technical reasons) arms used as a form. So, combination of "representational" or "real," "abstract," and "distorted."

Yet occasionally soft geometric pattern. Desire for order, control of surroundings. Beautiful shapes. I begin to find that, after all, beauty was present from the beginning. Some of the females with aggressive breasts, others soft.

To continue. Some of the African almost cubistic, abstract heads. Others, as the ancestor poles, realistic. In these latter the phallus completely realistic. Some distortion, however, the shoulders body and legs distorted for technical reasons? Or for subconscious reasons?

May 15

May begin a mother & child. Mother seated, child on lap facing her, legs around her. As in African sculpture. Saw such a mother/child in playground at 70th. Lovely young mother, neither Raphael nor African. Must find my balance.

May 24

The "ageless myth" remade "today." That is my wish.

Now on to a new painting. Not certain yet. What? The Orpheus prepared over such a long period? Women & children? Another version of Abraham?

I may do the "Sisyphus" on a large canvas. The rock will plunge. Sisyphus shall be free. Reread Shelley Prometheus.

May 30

"Sisyphus." Working on the small one 42 × 56, started May 1967. The hills of Gay Head sand bone pink. Clay, pottery-pink. Find the colors.

May 31

Started large "Sisyphus."

Sisyphus separated from his stone as it plunges (inert matter) into the sea. How does he escape the same destiny? In my early version (May 1967) there is calm. Sisyphus almost dances down the hill. (Nietzsche's "Dei Fröhlische Wissenshaft.") In the large version (June 1, 1969), there seems to be some turmoil surrounding the stone.

The anguish of separation even if it be from one's burden (the burden has become part of the self-destiny). The "burden" identified as the act of love. Sisyphus in a way a Christ figure (suffering for mankind), Sisyphus had tried to rid mankind of death—he had tried to kill death—it was for this he was punished. He was rebelling against the father figure, Zeus, or the Gods.

Abraham differs from these. He accepted God's will—had faith. Or at the worst, attempted to reach fame as a goal.

June 7

Finished "Sisyphus" 40″ × 56″ on May 30. Now the large one. It is not to be as seraphic and utopian. Rather, now that he is free of his burden, he looks to take up his battle for mankind freeing it, if possible, from Death and the fear of Death.

June 14

But why do I always make him a youth? Could I say that just as he was fated to push the rock up the hill eternally he was also fated to remain eternally young? And prevented from reaching old age and death (he who had tried to kill Death)? As though Pluto had said "So you want to deprive me of my kingdom of the dead? You shall suffer from eternal life (no release in Death)."

June 16

Worked on Sisyphus yesterday. Movement in sky. Sky and sea interchangeable. Mountain quiet. Would like to leave it at this state. Keep longing to do an even larger canvas. Sisyphus life-size. Ancient hill. Bone

and pottery colors. Ghost valley, Taos. Thus giving sense of time. Gay Head. Time of day early morning—small or no shadows. Running water from upper lake.

June 18

In my notebooks I had the rock plunge off; first, off an upper cliff with Sisyphus running down beyond the plunging rock. In this sketch I had a bird hovering in the sky. The cliffs at Devonshire the curling waves (Japanese prints).

Ran into questions about Sisyphus. His posture is that of a leaping dancer. Can this hold? If he were leaping a chasm or from rock to rock. Yes. Otherwise, of course, the leg would be bent to resist the speed. The body weight would be over the forward foot. Shall I indicate the chasm? Need he jump? Why could he not start his downward course with a leap of freedom? Perhaps so. Credibility gap? Close it. The purple gorge at Santa Fe. The pale light of dawn when the colors of the hills are strong, not soaked up in sunshine.

June 24

May change the posture of Sisyphus from a sheer leap to a modified jumping or even walking/running posture. Perhaps this is somehow artificial. Retain the speed & flying feeling without this amount of artificiality or exaggeration. The straight leg conditioned by the idea of phallus?

What about my idea that he is leaping over a crevasse? Even so he would land with bent legs would he not? Especially on a steep grade. For a moment while in the air might not his legs be in the position I have indicated? Would his arms not be up high to balance him?

June 25

Astonished to find at my 8th and 9th visit to the African show at the Met that the aesthetic quality I had at first found lacking is very much present. How I admire the round forms. (Delacroix spoke of the Greek forms swelling out to their defining edge.)

June 26

Studied Greek vases today. Running figures frequently have either forward or back leg bent—weight is, as with my Sisyphus, in middle (not over either leg)! In one figure straight limb is as straight or almost as

straight as in my Sisyphus. I saw no example where the figure had the forward straight limb on toe and the back limb straight in air. There was an example where the straight back leg did touch the ground; the forward leg was high and bent. In the running posture the arms express energy. Not in mine. A resting or floating quality. Think I have found the body color for my Sisyphus. Attic red. That red is combined with black!

July 3

Painted in rock yesterday (large Sisyphus painting). Warm and cool black/white/grey. The ineluctable frugality of the spirit.

Had originally intended a somewhat violet blue sky. Unified. Present sky is movemented. Shall I leave it? Also have eliminated shadows as time is dawn. Shall I strengthen the "lion-colored sand?" (Ezra Pound). Perhaps, yes. The stream? Sisyphus himself?

July 5

Memories of the last summer with Wolf at the Cape: salt air and honeysuckle! The "lion-colored" sand, the milky lavender blue ocean. [See plate 3. *Wild Honey* came from memories of this summer.]

August 20

Long break. Hope soon to begin large Orpheus. It looks as though the drilling might be over. And the bursitis hopefully will not prevent.

September 11

Long break. But finally it appears the drilling is over and I will be freed of the little "monster!" Difficulties over idea of Orpheus too painful perhaps—separation, death, A. K.* haunt my mind.

Felt yesterday as I sat in the Park that Art suffocated me, the flatness, the constricting tie to canvas—longing for the great roundness and disengagement of reality. The ultimate fact that it is, it breathes, it moves, whereas art functions in illusion, is modified, restricted. Its only advantage: that it endures longer than the moment. So it is the ability to stay the moment that justifies Art. Can I return now to Orpheus? A vision did go through me yesterday: a "bolt" of green in the blue.

*Agnes Kremer, Ethel's mother.

It is true that I had thoughts of Orpheus in Hades as in a blue environment.

September 20

Thought all yesterday morning about Orpheus. Saw a "vision": Orpheus turning to speak to Eurydice. Orpheus at right of canvas. Confused about the scale. Longing to show the great, even "endless," space of the underworld. . . . saw O as large color of fresh cut wood (naples yellow pure) occupying great part of space. Eurydice already melting into the underworld. Gap, disappearance, then reappearance. So in Orpheus and Eurydice legend— (1) Death of Eurydice, disappearance and gap. (2) Orpheus in underworld seduces the gods, reappearance. (3) Orpheus turns, Eurydice disappears for 2nd time to Elysian Fields (again gap). (4) In the end Orpheus returns to Elysian Fields, 2nd reappearance.

Confused, too, about the placement of the harp. Will he hold it—is it strung from his shoulder? Does he put it down as he turns stretching his arms out toward Eurydice? Thought of Orpheus as lying down stretching his arm downward—this would perhaps be the next stage when he had lost Eurydice.

Blue robe?

Made a large study of Orpheus on wrapping paper with pastel. Very tentative. But at last off to a start.

If Orpheus' turning was an unconscious wish to return E to Hades was it due to his rage that she had left him in the first place (although by Death)? Removal from painful human emotions—the risk of pain?

September 23

Must think more about Eurydice. Rereading Rilke "Sonnets to Orpheus."

September 26

Raw wood!—The men are working at 95th Street. Raw wood in the sun. To me, perfect for flesh. And since Orpheus was fetching Eurydice up from the Elysian Fields, not Tartarus, one can think of a sunny land or at any rate of a bright light. Vide Homer's Aeneas in the underworld.

Of course in the Aeneas description the underworld is described as vast—throws me back into the complexity of scale. Longing to portray a vast land. But perhaps this must remain for literature. On the other hand longing to have Orpheus and Eurydice occupy the whole space as in Abraham.

Must decide. The marvelous smell of pine woods. A tree stripped, showing raw and tender wood. Logs, kindling wood.

September 28

Limbo or Elysian Fields. A place of beauty at the first circle of the underworld. So Orpheus only went this far and his return would not be from the depths of Hell.

October 1

Milton, "Paradise Lost"/Regained."

Dante, "Inferno"/"Purgatorio"/"Paradiso." Fit in with my theory of "tragedy and transcendence" as seen in the work of the major artists. The grief mitigated by promise of eventual recovery. Kindness to the spectator.

October 2

Started large Orpheus & Eurydice 60 × 80 today.

Eureka!

October 3

Today Art deals only with the present. Even extension is graspable, within grasp. Cézanne shows extension into space, beyond grasp, although not beyond sight.

Poets show extension, unlimited, beyond sight, or grasp. Present only to imagination.

October 24

Interruption of a virus!

May make the internal river darker as in my vision—now too pink. So the idea of raw wood for the body of Orpheus. The darkness at the bottom, the bed of the river. Reds, browns, the river catching reflections of blue of cave.

Enamel green?

The harp and the willow branch?

Long gap.

December 4

Have been working on the Orpheus I. Nearly finished. The harp more curved. Stronger. The shape of the stream? And the rock formation at right? That whole section (at extreme right)?

Studied Mantegna's "The Adoration of the Shepherds" in Met. Mus. The scene of the adoration placed outside so that the opening at the top, with view of distant landscape and sky, suggests that this distant landscape is truly outside and pushes the remainder of the canvas, due to the dark tone of the rocks and pool, into the feeling of an inside, or "interior." Solitary, lonely.

My painting placed inside—in a cave in the underworld. Yes. But the underworld is, at this point, Elysium. The tunnel leading up from the cave is the way of ascent to the real world. The blue indicates the tone of the underworld but the amount of light, the brilliance of the garments, the patch of "enamel green," indicate Elysium.

January 23, 1970

Started new version of Orpheus January 17. [See plate 4, *Of Orpheus and Eurydice II.*] Want to paint in the faces of Orpheus and Eurydice.

Strange visions of running water as though the walls of the cave were run over with water (Niagara, Chinese Horse). Also vision of dark blue pool instead of the pink red pool of Version I.

Hand gesture different. Imagined that Orpheus, leading Eurydice out, had clasped her hand. His right, her left—then, when he turned, or the second after he turned and realized that she was lost, he drops the hand— the gesture remains.

His robe yellow perhaps shows only the flesh of the arms.

March 8

Orpheus separates from Eurydice by choice (subconscious), Eurydice "suffers" separation. She has no choice but in the manner in which she responds. With turmoil? anger? (turning to suicide), resignation? or mourning and recovery?

Am trying to finish Orpheus II. The gesture of the hands? The clasp barely undone. The hand still in the posture of the clasp. Shall I have the Orpheus vague (departure) or make him clear? Paint Eurydice's feet? In connection with the eyes had thought of B. Parsons, grey, mystic. But the eyes seem to demand blue.

March 20

Still struggling.

A mad desire to push through to the finest detail (Vermeer). Requires immense control and knowledge.

The face of Eurydice. Blue eyes. I see her contemplating her fate. Wide-eyed. Not a question of happiness or unhappiness. Absorption in the act of comprehension. Insight. Acceptance. In a sense the "dumb" acceptance of an animal or child. The mind accepts, yes, but not as an act of an intellectual nature. More faith—faith in being the "I am." Faith in "this is my fate." She has no choice.

I show what might be her turmoil in the depth of the red shadow. The downward sweep. This idea was not in the Orpheus I. (Perhaps, yes, in the green at the right-hand side.) Would like to work further on the eyes and the shape of the face. What of Orpheus? Shall I make him more definite? And the right-hand side?

When Orpheus turned. In that instant, like a flash of lightning striking Eurydice's mind, she knew that she would be separated from him. That moment was an eternity. By the second moment she had arrived at the blind, unreasoning, and almost total acceptance of her destiny. Her arm and hand lingered in the gesture of physical union with him. The body was reluctant.

It is not surprising, then, that Eurydice could have the look of acceptance, contemplation of her fate that I have given her. It was not too soon.

April 7

Decided to call my Eurydice finished. Of course, there is no such thing. Would like to have refined and subtilized the face. Possibly to have solidified Orpheus. But will leave it.

And now? Prometheus?

April 14

Shelley gives virtually nothing of the unbinding of Prometheus. Think of the descent from the Cross and the endless attention given to it. Every aspect considered and meditated upon.

Shelley gives at length the tortures of the bondage and the beauty of freedom from it. Thoughts of Prometheus on his rebellion, etc. (thoughts of others on it). Shall I supply this? Meditation upon the unbinding?

April 15

Suddenly thought of George Oppen as Prometheus. May do just a large head first. Against rock. Possibly red and green.

FIGURE 3. *Prometheus Bound* (1970). Acrylic, 72″ × 60″. Artist's estate.

April 17

Thought of combining George Oppen and Gorky. What a Prometheus!! Middle-aged Freud? Age middle years. Rugged. Deeply thoughtful. . . . A poet . . . humane. Deep-set eyes. Prominent nose. Heavy eyebrows. Sensitive mouth. Rugged bone structure. Strong chin. Heavily lined. The scene winter as in Shelley? No. Rocks? Sea? Sky? Dark? What time of day? Shall I convey the idea of resurrection?

AFTERWORD THE GAP IN THE TYPESCRIPT: PARNASSUS

Ethel went on to do the Prometheus she had written of on April 17—"Prometheus Bound and Unbound"—as well as several other large epic paintings during the following year (1970–71): *Orpheus and Apollo, Vision of Sisyphus (Bound), Antigone,* and *Oedipus and Antigone.* But there is a gap in the typescript of the journal, from April 17, 1970, to 1974. Fortunately there is a handwritten notebook (large black notebook) for November 1971–November 1972 in which it is clear that she was experimenting with using the journal in new ways. This notebook forms a bridge between her use of the journal for process notes and her use of it to meditate on the nature and sources of creativity, as she does when the typescript continues with "Paradise of the Real."

The most striking theme or issue in the notebook is her agonized concern with her relative lack of success in the art world. This theme grows out of her concern with artistic vocation and the handicap of being a woman, which she expressed less directly in Part I. (It is not clear why she chose to leave this section out of the finished journal—perhaps because it was too revealing of both the extent of her ambitions and her vulnerability.) She also begins to admit more material connected with her analysis into the journal. This leads to a fascinating glimpse into the emotional origins of the portraits she is working on at the time. Most of her images are multi-determined in ways that could not be guessed without the notebook's help. They not only are composites of various figures but also serve various compel-

ling needs connected both with her approaching death and with the threatened termination of her analysis. The threat of separation from Dr. Kris seems to evoke other separations in the past. Attempting to deal with her pain, Ethel imagines painting herself with beloved or admired figures as a way of keeping them with her. Then when she later actually paints the pictures, she leaves herself out, painting only the "Other."

The notebook begins on October 31, 1971, as she is completing a large Oedipus and preparing to visit her daughter in San Francisco. She opens with the statement "Everything goes well except my contact with and success in the art world. . . . Is it madness? And yet the work itself goes. I love it. I love the writing too. Things fall into place." It seems strange that she should write this as she was preparing for her first show in eight years (Buffalo). But probably the upcoming show made her think openly about success and failure in ways she might not have done earlier. Reflecting on Betty Parsons's failure to respond to her portraits in 1964, she wonders about how an artist gets validation. If Betty had liked them, mightn't this have made all the difference to her acceptance? At the time when she was writing this notebook, her friend, the artist John Ford had been praising these same portraits. John Ford's praise meant a great deal to her because she felt she had discovered him the way she had Gorky. She wrote a short book about him, *John Ford: Conquistador,* in her effort to make him known. But what is his praise worth in terms of validation? He too is neglected by the art world and Ethel wonders anxiously whether he will "succumb to desire for success and repeat himself." One senses that she is asking herself the same question. She tries to keep her desire for success within bounds by reminding herself of the integrity she values. Her cousin George Oppen never sold out, yet he succeeded. Maybe she will too. Even though she concludes that success and failure are determined by Fate, at the same time she wishes her friends would exert themselves more strongly on her behalf. She finds that the difficulties of being a woman are compounded by her being an old woman. Her friend Jeanne Reynal, who in the past had eagerly helped attractive young men like Gorky and de Kooning, seems to Ethel insufficiently active in helping her (Nov. 5, 1971).

But she doesn't just brood on the vagaries of fate, she also makes practical efforts to improve her position. While preparing for her Buffalo show she does a whole new series of pastel por-

traits. She corresponds about an article she has written on her epic paintings for *Leonardo,* then writes a second article, also for *Leonardo,* on her portraits, "Portrait as Image" (Aug. 1972). The Buffalo show of her epic works, which took place in the spring of 1972, seems to have been a success. It was extended for a week and was well reviewed in the *Buffalo Enquirer*: "It is hard to say which is more remarkable, these paintings or their creator." She was encouraged enough to consider finding a gallery for the pastel portraits she had been doing during this period. John Ford suggests Avanti and she considers it (May 19).

Her efforts to reinsert herself into the art world (which, except for this Buffalo show, had ignored her since she was dropped by Betty Parsons in 1964) took on particular intensity because of her aging and the worsening condition of her hands. She asks (Oct. 31), "What am I given in terms of time . . . will I be able to paint on?" On November 6 she wonders whether, if her arthritis continues, she should try doing smaller paintings and getting a small electric typewriter. A few days later she says that once she has seen the doctor about her hands she will know whether she can order canvases. The doctor tells her to drop aspirin because of an allergic reaction and apparently prescribes a brace. She is in pain but continues trying to find ways to circumvent it and keep working. "Even if I wear the brace I can operate this machine and the mind can summon its words."

While she was struggling to keep working and to make her presence felt in the art world, she was threatened by the loss of one of her main emotional supports. Dr. Kris was not only talking of terminating the analysis but was refusing to look at Ethel's most recent paintings. Though this refusal had a practical purpose—Dr. Kris felt that looking at the paintings interfered with the analysis—Ethel experienced it as rejection. This may explain why Ethel started a list, running to forty pages, of friends' praise of her work. The lavish adjectives she records form an idealized portrait of herself which she uses to neutralize her self-doubt and vulnerability. On April 2 she writes "Don't paralyze self (1) because Dr. K. doesn't come to see the paintings [the epic paintings that were going to be shown], (2) out of fear over Buffalo or (3) over fear of end of the analysis." When Joe Fischer, possibly a curator, comes to see her about the Buffalo show, she writes "if only K were here." She wants to do Dr. Kris's portrait.

Ethel's practical efforts to assume her rightful place in the art world were paralleled by her creative imaginings of herself already there. She begins by having a "vision" of several figures whom contemporaries regarded as great—the people, that is, in whose company she would want to find herself (Nov. 5). "Resurrection of the dead to be present with the living. Visions of immortality. Gorky? K?" This is where the wish for immortality seems coupled with the wish to be permanently attached to a loved and revered figure or guardian (parent, lover?). What comes to her mind is her teacher Gorky and her analyst Dr. Kris (who interestingly is not yet dead). She gives as a precedent for her wish to create a pair Dante's coupling himself with Virgil. Somewhat later she thinks of the creation of a paradisal place of honor as the natural next step. But though she wants to create her own Parnassus, she can't seem to feel the confidence to actually put herself in it (Nov. 5): "But of course that would not be a way of including myself."

She moves next to considering a portrait of her father. Implicit in this is the idea "my father and me" or maybe "my father in me." Although she wants to think of her father as having a strong, square-chinned face—being someone who could protect her—she is astonished to find when she studies his photograph that his face was more sensuous and artistic. She also notes his stiffness and passivity. "Will I do a portrait of my father? A corrected father?" In this way the "Other" alternates between being a source of outside strength and being a mirror of herself. Correcting him also corrects her. "How totally extraordinary the whole thing is . . . my identification with my father: even to my shopping swiftly, swift clean decisions . . . fits of rage ending in loss of control" (Dec. 1). As she thinks about her father, a contrasting image of Freud springs to her mind, the type of father, ideal in understanding and compassion, she longed for. She decides, instead of her father's portrait, to do the death of Oedipus, giving Oedipus Freud's face. "My Oedipus—'corrected' father—shows no rage or cruelty . . . my father's rages were like storms, sporadic . . . they left marks on his children" (Nov. 12). On December 7 of 1971 or 1972 she specifies that the rages were vented "on the body of his son," her brother John. "My father thought of himself as the unglamorous member of his family . . . the fury came from the frustration."

In December, the Oedipus finished, she begins a pastel of her grandson Michael, "Songs of Innocence . . . to restore a certain

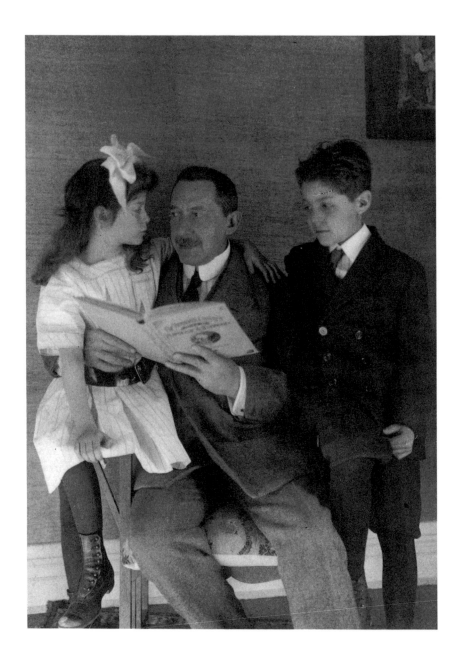

FIGURE 4. Ethel with her father and her brother, John.

inner calm." At the same time she works on small drawings of her father. Children and grandchildren are of course another form of immortality ("Cézanne's son like an apple—an apple that will live forever"), but in Michael she also seems to see herself as the boy genius she should have been. He was only a child of seven but she describes him exultingly as "a spirit, a poet, a scientist, a creation of the twentieth century, a creator of the twenty-first." Again, then, the portrait had a sort of invisible second term: herself.

In January (returning to her original idea of being paired with a loved and admired figure) she takes courage and begins to think of painting Gorky with herself. She is in a sense already bearing his light within her: "When Gorky died he gave me, as I later saw it, the torch he had laid down . . . I would like to give it to John Ford" (Dec.). The painting was one of her strongest, but she left herself out (see plate 5, *Portrait of Arshile Gorky*). In February she began a portrait of her first cousin, the poet George Oppen, whom she considered the spiritual head of her family after the death of Wolf.

From this point she expands to include other members of her family, her daughter Brenda, her grandchildren Mark, Roger, and Lisa. At a time when she is waiting to hear how her paintings in the Buffalo show will be received by the critics, she makes her own critical judgments, categorizing the figures in her portraits—some (Gorky, Michael) reach her Parnassus, others (John Ford, George Oppen, Brenda) don't.

After her successful Buffalo show she thinks of doing Freud and then again wonders about doing herself: "A self-portrait? Shall I?" Once again she leaves herself out and does instead two Freuds (see plate 6, *Of Freud II*). Finally, in August, just before this notebook stops, she starts some drawings for a self-portrait while beginning a pastel of Virginia Woolf (see plate 7, *Of Virginia-Woolf*). October 14: "A perfect Antigone! Modern Genius. Woman of genius." This was the closest she came to painting herself, unless the painting "Double Image," of an old woman and of a younger face, is a portrait both of her mother and of herself. In any event, the fact that her paintings of this period are built around the concept of herself as an unseen part of the painting transforms them from portraits of individuals to portraits of relationships, a focus that may be characteristic of women's art.

two

"You must do without."

"I did not see the shadows of the things
but the things themselves."

"Oh my mother garlanded through the
hours of the day."

"Not the scientist but the fiction writer.
Evocation not information."

VISIONARY INTERLUDE: THE PARADISE OF THE REAL

INTRODUCTION

When Ethel returns to the typescript for a brief period in
1974 she does so in a highly visionary mode. She speaks of the
relationship of biography to life, but in a generalized way, with-
out complaint or self-pity. Having seen that her creativity is dif-
ferent from the style of the time, she now tries to reconstruct a
history of her own mind to see how she got that way.

Her emphasis in earlier sections had been on her ambivalent relationship to powerful men; in "Paradise of the Real" she turns back to the very beginning of her life and connects her first glimmerings as an artist with her mother. Significantly, the journal begins with an absence—a quotation from Goethe's *Faust,* "You must do without." Her art composes itself around this central void. She remembers how intense loneliness propelled her toward external nature. Visual events filling empty space provided a sense of completion and joy. "Here in Nature I found strange nourishment. The light that pervaded all things . . . was the desired mother's smile . . . more than a pleasure, it was . . . survival." Nature, with its visual events and rhythms, seems to provide an alternative to personal relationship. Psychoanalyst Phyllis Greenacre has coined a term to describe this phenomenon: "collective alternatives."

Ethel describes how Nature became her "alternative," using the image of a cave where she hid as a lonely child and first experienced exultation at what she calls the Paradise of the Real—the sight of a bird moving through space consoles her for her mother's absence and provides the basis for her art, which will fill the space of the canvas with arrested and forever present moments.

This section presents a series of gradually widening visions moving out from the womb-like cave until finally the earth itself is seen as a more inclusive symbolic equivalent of the mother, "the garlanded belly of mother earth." (Though this is a traditional association, Ethel by connecting it to her art makes it personally hers in the same way she reinterprets myth to make it relevant to her life as woman-artist.) When she moves out of the cave, her situation becomes more complex. Instead of being a stationary observer of excited movement, she herself becomes involved. This produces a sort of vertigo. She speaks of a total sensory response that later makes her first experience of painted canvas seem disappointingly restrictive. Perpetual change, which is at once stimulating and threatening, assaults her. "Did not Dante wish Virgil to share his visions with him—could he have borne this terror, the terror of infinite change, without another human soul by his side?" Her task as artist is "to seize the ever-changing visual moment" and commit it to memory. This is an allusion to Faust's address to the moment, "stay thou are so beautiful."

She alludes only briefly to the paintings she is doing at this

time, but the implicit connections are important. She is doing Goethe's portrait, presumably because of Faust's parallel interest in capturing the perfect moment. She is also having pre-painting visions: one of a female figure in white, another of what she refers to as the nurse, asking cryptically whether the nurse went down to the garden (May 2, 1974). In later sections of the journal we will learn that this was a much loved childhood nurse who was abruptly dismissed after an affair with Ethel's father left her pregnant—a traumatic event that Ethel had uncovered in her analysis with Dr. Kris and that they both felt was the origin of her enormous fears of separation. The image of the nurse creates a doubling effect. Ethel's yearnings for her real mother and for this woman overlap. Even if the reader isn't in sympathy with psychoanalytic theories, it is clear that the lost or missing beloved—however explained—was a theme of overwhelming importance in her work. And it does seem as if she reacted to each subsequent loss, including that of her husband, as a repetition of the pattern "you shall do without" which she perceived (exaggeratedly or not) as governing her life. After painting a vision of the nurse, the next painting she considers doing is of a sought-for man (the Guardian "Ich Suchte" from *Faust*). The music she plays while working at this time is Mozart's *Don Giovanni,* a choice that probably connects in her mind with her father's seduction of the nurse.

On May 8 she comes to a definition of her art as seeking "the place where" (mentioned but not developed in section one), and this short section ends with her realization that what she cares about is not objective fact but an evocation of feelings about the past.

THE JOURNAL

April 12, 1974
FAUST:

> "You must do without, you must do without!
> This is the everlasting song

Which rings in every ear, which rings,
And which to us our whole life long
Every hour hoarsely sings."

Thought of the "Song of Solomon": the dark image of the watchman. And of Poussin's words carved on a tomb. "Et in Arcadia Ego" (Even in Paradise I, death). Had a vision of a black garbed figure, his face yellow. Was he the watchman? I asked him if he had seen my beloved. He said he had not seen her. [See plate 8, *Et in Arcadia Ego III*, for an earlier painting on the Arcadia theme.] Then I ran and stumbled on past the honeysuckle, past the thorned rose bushes. I could tell they were red even in the darkness and in the beam from his lamp the red was the color of blood.

I felt the wet grass cool under my feet. She was not there, nowhere, I stumbled toward my cave and huddled there, waiting for dawn, listening for her return. "You must do without, you must do without! This is the everlasting song."

The cave was my refuge and also the place where the first conceptions of visual reality came to me. Beyond its shelter was the world of the garden. Certainly what there lay or spread out before my eyes was my earliest experience of Art. Plato spoke of seeing (from inside a cave) the shadows of things cast upon a wall. I did not see the shadows of things but rather the things themselves. In a sense I did not yet know them, but I experienced them as they awakened me to a sense of joy.

First vision of the "paradise of the real" (phrase of George Oppen's from p. 27, "Seascape: Needle's Eye")—seen from my cave. As the tanager flew across my space, my ellipse, he set in motion a marvelous series of visual events. The red oval of his small body set color planes in motion in a circle around his flight. As he moved to a new position the movement of space and color he set up vanished and the original "empty" space was restored as when a ship passes through water it opens a path which closes behind its course. The stir is stilled and the continuous surface of the ocean is as before. Life and Eternity. Motion and Stillness. So with each new position (discernible to the naked eye) a continual opening up and closing in. [See plate 9, *Red Bird*.]

They were separate events: the tanager flying through my ellipse (yes the shape as seen from the cave was an ellipse) danced across my stage. There was a beginning, continuity, and an end to his brief appearance. The space above him was heaven. The space below was grass. Two expanses; of colors, of space. This was only the beginning of the majestic play that I was witnessing.

I could not find her. I had not found her. As the dawn came I felt hungry. And here in Nature I found strange nourishment. The light that pervaded all things, sometimes rendering them translucent was the desired

mother's smile refound in a symbolic or ideal form of love. More than a pleasure, it was a "beautiful necessity"—survival. It was a bridge spanning the chasm of night and loneliness.

Could it have been that Poussin, who suffused his canvas with ecstatic luminosity, knew a similar longing? And, indeed, are not the swelling forms of Greek Art also love-longing forms? I later thought so. I thought "they are as I" sufferers from longing who have found a symbolic or ideal haven.

April 13

Was it Goethe who gave me the idea of using Greek myths? The repetition of the great Renaissance in Goethe's work—could it not be done again? Past & present united.

Dream of a dark black slender figure leaning over the edge of a rail—beyond a cerulean sea, calm. The balcony yellow—the color of Alabaster. Death and eternity? I would prefer Death to be sudden and painless.

When she turned around from gazing at the sun did she hold a large bunch of violets with a single rose plunged in the center? "She is gone darling. She has joined the Angels, she is with the Angels in heaven—Why not here?—She could not stay. Perhaps, after all, death is the 'beautiful necessity.' A boat a flying boat came for her. With white sails. She sailed away."

I would love to paint this. The images in dreams are so solid, real. The dreaming image is more real than reality. Condensed as it were. Time eradicated. Only meaning presented in the image. Less extraneous material. Great art does this. The figure of the musician (pre-Cycladic Greek) has the condensed reality of a dream. Encompassing art, encompassing life. The genius of the arts delving into the depths of nature and man, daring to search, to discover, to uncover, to face. And then the power to create. Analysis/synthesis. Conflict/resolution. An entirely new vision of the psyche, its mechanism and its destiny. A new vision of art. What it could be.

> "I have but wished, and seen
> My wish come true
> And wished again: and so, existence through. . . . "

> FAUST

April 16

Love and birth. So this opening up of space by the passage of a body through it gave birth to motion in space, to a succession of happenings, which, however, could not endure. The events were in a sense musical.

They took place, penetrated the consciousness, but gave way to further events. From existing as a happening they later retained their existence only in an abstract sense. Their physical being was translated into abstract being capable of being recorded in art. In this sense—due to the moving along of events—time was involved and a correspondence between art and music became evident. Music moves in time. Color and form move in space. In both instances motion was involved. I felt keenly the motion of color & form—even the motion of space which was constantly altered by the intrusion and extrusion of moving forms, even the sky by the ever changing curling spreading clouds or by the passage of the moon in its orbit flooding dark space or leaving it to its darkness.

But the artist must deal, not in moving elements as in music, but with fixed elements. The canvas is a fixed surface, limited, bounded. Paint lies motionless once it has been placed. How then can the artist suggest the movement he has felt in observation of nature?

April 19

Second vision of the "paradise of the real" (as seen from outside my cave—in the garden of childhood, accompanied, as was Dante, by a companion). Now all that had seemed so complex—the tanager, in its flight causing an ever-changing series of exciting and harmonious relationships of space/form/color to take place, was made infinitely more complex by the fact that I was no longer in a stationary position. I, myself, moved and my own motion changed the patterns of the visual scene. Even if, up to that time, all had been stationary it would now have taken on the aspect of perpetual change. I wished to seize the ever-changing visual moment and commit it to the eternal halls of memory. Each moment, then, would be a work of art. Did not Dante wish Virgil to share his visions with him— could he have borne this terror, the terror of infinite change without another human soul by his side? Were these purely sensuous visual experiences having to do with joy in paradise? The joy of the "young lamb"—and her mother?

April 21

Vision three: the widening arc. Widening in time as well as space. Out beyond the garden . . . beyond many gardens. The gardens that hung like jeweled belts around the belly of the earth. The garlanded belly of mother earth. And the gardens were now spring jewels. Now fall. Now winter white. O my mother, garlanded through the hours of the day, the seasons

FIGURE 5. Ethel's mother, Agnes,
 on her wedding day,
 circa 1900.

of the year, the ages, the eternities—(horror of the infinite, the unseizable).
How could I master it? Except through song.

There was the shipwreck—love downed in the storm. Gone under. Sinking to the bottom. And at the floor of the sea covered with strange flora

and fauna hope and love were born anew. Love moved upward to breathe again. Expiration ceased . . . inspiration had its place again in the order of things.

April 24

(There were personages, too.) Coming out of the cave I saw that the world extended in all directions. Walking by my mother's side the curious condition of being a "solitary eye" dissolved, melted away into the sense of companionship. Later I was to call the vision of the world that I experienced in the happy moment of childhood a "peripheral approach." A wide variety of forms were there to be perceived. In order to see it all one really had to look around the edge of a circle (an imaginary one) and then another somewhat smaller one and so on until one came to the center.

April 26

The total effect of what I experienced came about by a four-sense awakening. Perhaps it is for this reason that when I first saw Art in the museums I was not moved. There nature appeared to me fixed while I had sensed nature in motion. I experienced only visual sensations whereas I had grown used to an all-over sensuous response. An amplified response. I felt as if I were suddenly lacking a sense of smell, a tactile sense. I felt impoverished.

But if the art of the museum was restricted it was very strong in respect to the form of things and a sense of order. Possibly the sense of order achieved was greater by very reason of the restrictions. My interest in order was perhaps less strong than my interest in the multiple variations of an ever-changing universe, or world.

April 28

Of my piece "Visions on the Way," commenting on my large mythic paintings (1969–1972), George Oppen said it was too apologetic. Why did I bring in Dante, etc.? He said that I devalued my work thus, that the work itself was "bold and courageous." [See plate 10, *Of George Oppen I.*] Important. So now I intend no longer to bring in such quotations.

April 30

Goethe's autobiography 400 pp. up to age of 21!
"Warum Fragest du?"; "Jacob and the Angel";

Will start portrait of Goethe.

"Ich Suchte des Nachts" (Song of Songs). Would like to do some water colors of these.

Vision I: White figure against black background. Wing, space, shoot off from parallelogram. Flowing night—in curves. The smell of honey-suckle. Shall she wear some sort of light garment or scarf?

May 1

I have felt that in the large paintings, 1969–72, I achieved, not so much a better quality than those of the previous 15–20 years, but the same quality in a more complex structure both plastic and psychological. Likewise the portraits, 1971–73, and the watercolors, 1973–74, and the latest portraits of Einstein, Aug. 1973, and Marie Curie, April 1974. Am I right? Can I approach the feeling and form of the old masters without becoming academic?

May 2

"Ich Suchte." Could it be dawn? Shall I include the watchman, guardian? Warm colors? greys? Then she finds him. Shall I include this episode? At dawn. The first light. Lavender, yellow.

"Ich Suchte," purple & green. Yesterday did 18 by 24 of "Ich Suchte" lavender & green. The lamp should be more defined—? Perhaps she should hold a light too. Candle?—George de la Tour—

Vision II: Perhaps the nurse went down into the garden. Two lights: the guardian's and the light in the window? Or the dawn?

May 4

Vision III: May do another "I sought him"—Figure of Guardian. Figure in window dressed in light gown, holding candle lamp. Earth—Venetian red? Stars in the sky? Moon? Jewelry? Myrrh? The sky weighs heavy—a great plane, studded with stars. Moon more dramatic?

May 6

Geo. Oppen said to me "You risk being outside Art—But of course that is the only place to be and the only risk worth taking."

Let the music (Mozarts's "Don Juan") flow through you. Don't stop the stream—allow yourself to be transparent as the leaf that becomes trans-parent to the sun. Transparent leaves, the sun fills them. Light is the music

of painting—it penetrates directly, it flows through time as well as space. So I will suggest, if I can, the light that has come from outside the scope of my eyes. But, perforce, I must limit it within the frame of my space. I set out a circle or a parallelogram as a limited space. But I indicate that there is space beyond. The light pours into and across my space. Of course there are solid bodies, events, realities. But they are understood within the context of time. Space in motion—time. Much as the leaf to the sun I am the medium. The leaf has form, substance, life, existence, identity—but a strange substance may flow through it (light) without changing its form, except in the sense of making it grow, and out of it again, undiminished. Light loses nothing in giving of its strength to the growing leaf. Its movement occurs in time and suggests the "beautiful necessity" of Goethe. The form of things was beautiful even in the dawn. But suffused with light, became glorious.

The reality of substance. There is no less reality to light.

May 8

(With George Oppen editing my lines.)

"I have sought in my work the 'place where': that non-abstract element in Art which expands inward and outward: and wherein coexists the formal definition and the mystery."

Kierkegaard wrote a whole book on Abraham & Isaac, i.e., one story. Contrast this story with the story of Adam & Eve. Abraham's decision to obey God; Eve's decision to disobey. Abraham's Love of God greater than his love of his son; Eve's thirst for knowledge more urgent than obedience. Adam's desire to be with Eve greater than his will to obey God. Mankind's existence depended on this decision.

This is fiction, the telling of a story. Philosophic, poetic, overtones. Pure aesthetics. Fiction is a way of telling about life. It is a mode of description. Even Mondrian is essentially adopting a mode of description. What else? Describing or evoking? Fiction gives the illusion of reality. The picture on the canvas is not reality. The painted version is a fiction—a story about reality.

I will seek; more of the fictional element, more immediacy in this writing as in the paintings, recapture the shifts of consciousness, show the shift from being alone, "the solitary eye," to the "communicating eye."

The "eye" (I) in childhood, relished the paradise of the real. Nonetheless the body needs food, the heart needs love, the mind needs ideas, the soul needs essences. But, as a child, I was too lonely, thus the natural powers of assimilation and enjoyment were anaesthetized at times.

Yet I did find sustenance in the rambler roses spread over the stone

wall, and in the garden with its babies'-breath, bleeding hearts, pansies and, in the grass, dandelions which the gypsies loved to pick in the spring-time to use for salads.

May 21

Van Gogh wrote of sitting in the hot, burning fields of Aix paint-ing . . . and that he would like to get the rich smell of hot loam, the mar-velous wild perfume, the feeling of heat, the enveloping sensation into his picture.

So it was a question, not only of giving an account of nature, an objective account, a report, but of giving the sensations and feelings of a human being, the artist, evoked by nature, an account of his intellectual reactions, and associations to the past. The total experience of the artist before nature. In this sense, then, the autobiography of the artist in terms of his immediate experiences. Not the scientist but the fiction writer. Evocation not infor-mation alone. Did not van Gogh feel Rembrandt looking over his shoulder? Did he not consider how Rembrandt would have plunged this scene into his golden lights and shadows? And did he not think of the Japanese who set everything out into a pure clear light? He might well have asked himself which was more beautiful.

AFTERWORD FAUST, A SECOND GAP IN THE TYPESCRIPT

The "Paradise of the Real" section ended in May 1974. Though the typescript doesn't pick up until 1976, a handwritten "Notebook II," from which parts of "Paradise" seem to have been culled, continues from May 11 to July 27, 1974, and another, "Notebook III," goes on from July 27 to December 29. An unnamed section bound in with the earlier handwritten material on the portraits deals with April 1975.

This material, like that in the earlier "gap," continues to show the relation of Ethel's biography to her art. The brief portion of the handwritten notebook that overlaps with the "Paradise of the Real" typescript also shows how she manipu-

lated the journal form, changing dates (entries originally marked May are changed to April), revising for dramatic effect. For instance the quotation from Faust, "You must do without," which starts "Paradise" is not in what seems to be the original draft in the notebook, which begins with a more personal reference to her increasing fragility: "not blind yet, but deaf—closed in. trembling. fading." Also removed from the typescript is her memory of reading Goethe and later Dante with her best friend, Justine Pollier (daughter of Rabbi Stephen Wise) in 1917. Other deletions include a discussion of Freud and Goethe and a section of art criticism. From these small samples it is clear she shaped the final "Paradise of the Real" section away from the narrowly personal toward the visionary, in the process elevating and purifying both tone and substance. Elements that fit in with this, like the three visions from her cave, were retained from the handwritten notebook. At the point where the typescript ends, on May 21, she contemplates, in her handwritten notebook, moving the journal away from objective fact toward fiction.

It would appear that she decided not to use the rest of the notebook in the typescript, because she thought the personal material, particularly as she had been presenting it, elliptically and without any explanation to the reader, detracted from the visionary grandeur she wanted. Still, this deleted material, which deals much more specifically with the works she was creating at the time, gives startling glimpses into the personal genesis of her images.

During these three months of 1974 she was working on a series of watercolors from Goethe's *Faust,* beginning with "The Mothers" and "Goethe's Hand" and going on to Faust and Helen. Her chain of associations, as she works on these paintings, clarifies the visionary interlude's connection of loss, separation, and search for the mother to the artist's attempts to grasp and reproduce nature.

Ethel sees Faust's evocation of and loss of Helen as repeating a theme that she had dealt with earlier in the Orpheus and Euridyce: "It is different from the Orpheus and Euridyce. . . . But it is a bringing back and a losing . . . Death.remission.Death. Separation.remission.separation . . . why do I veer to these?" (June 1). An obvious answer is her own loneliness. Friends "spoke of my 'effortless creation' and here I sit sobbing. The flesh sobs. The psyche has wings" (June 1).

These paintings seem to be serving two contradictory func-

tions in her mind: to repeat some traumatic loss and to correct and undo it. Maybe, she writes, she should forget her dream (most of these paintings originated in a dream or vision) and make the mothers bright colored: "the forms of life need not be sad ones." She suggests that perhaps like Dante and Milton she will depict "Paradise regained" (June 1). That this has something to do with a reunion with beloved figures is suggested by the parenthetical K, her usual sign for Dr. Kris, that she places after a notation that she is painting "the mother in a dark blue" (June 18).

By painting different aspects of Goethe's drama at the same time, she can project different sides of her feelings toward the same person. "The Mothers" seems connected with dreams of reunion and even merger. (She herself connects it with a vision or memory: "It seems more as though I were remembering: the mothers: my death.") On July 5 she has a vision (called "Paradise of the Real") of climbing upward into Paradise "Lost in the immensity. I did not feel lost . . . melting into the immensity of Paradise." The Faust and Helen paintings deal instead with loss. But it is loss of a particular kind. In the Orpheus and Euridyce there was only the couple; here there is a jealous triangle. Faust calls up Helen only to see her followed by Paris, who wants to rape her. To save her from rape, Faust makes her vanish. What to make of this? Ethel, wondering at her own fascination with the scene, suggests that there is something similar in Orpheus— that perhaps he was saving Eurydice from himself as rapist; "sex caused her death" (June 28). This odd suggestion becomes clearer when Ethel connects it with her own wish to kill a loved person rather than lose her to a rival. "Did E.G.K. [Ethel herself] feel that way about M?" Wish not to lose her to "Paris, rather kill her" (June 29). (It is unclear who "M" is, possibly Mother or Marianne Kris, possibly both, although usually she uses A.K. for her mother and K. for Dr. Kris. Later in the typescript she will discuss the triangle of herself, mother, and father and her wish to supplant each of them in the other's affections.)

She seems to alternate between the ideas of union and loss and also between attempts to realign the sexes, a creative play with bisexuality. This theme continues a revisionary train of thought begun in her earlier meditations (Orpheus section) on Abraham's maternal aspects and the phallic thrust of the breasts in African sculpture. In Faust she observes what seems to her a "birth or rebirth fantasy. Man as woman" when Faust ascends

to heaven, taking the blessed boys into his body (July 6). While still working on the Faust series, she gets the idea for an Adam and Eve series in which she will reinterpret creation, having Adam come from Eve's rib (July 6).

Notebook III starts on July 27, 1974, and covers watercolors of Faust's birth/death, the Eve's rib series, a series titled "Love and a Plant," and the mysterious woman in black. (In a summary she says she has done no writing in the past three months—that is, specifically designed for her journal—only watercolors, sixteen of them.) In this section she seems to be reaching back into her childhood for the sources both of her anxieties about loss and of her creativity. Her clearest connection between fear of loss and the artist's attempt to "hold on" to the specifics of experience comes in September (24): "Anxiety in regard to loss drove the memory forward to exert every effort to seize the true aspect of the innumerable points of experience." She defines memory as "a survival fountain . . . the delight in being able to retain and review" and describes again how when she lay sobbing in her cave "in the Paradise of the Real" she heard "the endless music of the visual."

It may be that these thoughts of loneliness in childhood gave rise to her startlingly original idea of painting Adam's creation from Eve's rib. In this rendition of Genesis she clearly sees herself as the lonely Eve before Adam's creation, longing for a companion. This is accompanied by the idea that in order to love, a woman—particularly if she is an artist—must give up something of herself. In this case, Eve must lose a rib. "Am I afraid to put Eve to sleep? Was she afraid that in sleep something of herself would be taken away? but the loss would mean a companion" (Oct. 5). Earlier she suggests that "Eve's rib becomes Adam's penis, i.e., her penis" (Sept. 24). Does Ethel fear, here, that loving means losing her bisexuality, then, her male and possibly her creative part? Isn't this similar to her earlier suggestion that Orpheus refuses love because it would conflict with his art? Her Eve series, which she keeps comparing to Michelangelo's "Creation," caused her much anxiety, particularly when she tried to envision God taking the rib. "Somehow the figure of God turned out to have the head of A. K. [her mother, Agnes Kremer], god like a nightmare. K. [Dr. Kris?] benign." Though she was often angry at Dr. Kris in the later private notebooks, here she seems to be contrasting her benignity with the mother-god's terrifying removal of an important part of her body. On

October 6 she has a vision of a bone floating in space and afterward asks, "then what? here the act of rape?" Does the removal of the rib leave Eve vulnerable to sexual assault from the creature created from it? None of these questions is really answered, though the anxieties that accompanied them seem to have been intense. "I work as a drowning man swims" (Oct. 12).

The references in the later part of this notebook become increasingly veiled. The themes seem to develop from the idea of love for a godlike female. On October 22 she writes, "In religious works, God is everywhere—for me it was the blessed lady." In line with the imagery of female presence within things (the bird in *Prometheus* was "she"), she notes that a plant at Dr. K's "made me tremble with its power" (Oct. 12). She proceeds to paint a series of plants, #57 "Love and a Plant," "Of Love and Tulips" (two lips), "To Cup the Sun." She says what she is painting is a composite of "Mary and A.K."—Mary possibly being "the blessed lady," her early nurse or her friend Mary Sklar. Next she paints a woman in black with a veil partially covering her face, "shades of A.K. and Eleanora Duse." The whole series of watercolors, Eve's rib, the plant, the woman in black, all have to do with the longing for a beloved though sometimes feared woman. The idea of a male companion is secondary and entails a loss or sacrifice. Perhaps there is the thought that the sacrificed part would have enabled her to gain the beloved woman's love. In any case, she places the original distress in her early life (Nov. 13). "Agony begins in childhood."

This turn toward childhood will engage her in subsequent parts of the journal. Now, after reflecting that she has done enough watercolors for a new show (Nov. 11), she thinks of images of children running, flying a kite, a child somersaulting. Their movement in space, a movement she often tries to capture in her paintings, she translates as a "spinning vortex of insatiable search and not finding. An irresistible force (Desire) and an immovable object (Absence, Death) the soul vorticises.spins in blackness." This notebook ends with her thoughts of doing watercolors of Dante joining Beatrice in Paradise (search for the blessed lady fulfilled).

A new handwritten notebook ("Notebook IV") continues from December 30, 1974, to April 17, 1975. This one overlaps slightly with a section covering the six-month period April 8,

1975, to September, which is bound in with the 1971–72 note-book ("Large Notebook II"). "Notebook IV" covers the period of her Dante watercolors as well as several new pastels, her grandchildren Rebecca and Michael (April 17), Gide (started May 24), grandson Mark (spoke of starting May 17). This note-book is even more fragmentary than the previous one. The beginning is a collage of quotations from Dante. She eagerly searches for clues to Beatrice's appearance, and finds a birth fan-tasy in his ascent to Paradise. From February to April she doesn't write, noting only that she has been ill. In April she notes that she is reading Baudelaire. She also speaks of "the con-stant element of surprise in my relationship to 'X' [April 7]. Surprise of intellectual curiosity. No surprise leading to intellec-tual curiosity—could this be true? Surprises. The placing of the truth—somewhere else—upon recognition an alternation takes place . . . always the shock of surprise." ("X" was probably the composer Roger Sessions, who may have been her lover for many years, starting sometime after Wolf's death and her chil-dren's leaving home.) After this she speaks of a trip to San Fran-cisco to see her daughter and the start of a new painting, probably inspired by seeing her grandchildren, of Michael and Rebecca. She thinks also of doing one of her grandson Mark and afterward one of André Gide and one of Picasso.

The handwritten notebook section, which overlaps with this notebook, begins on April 8. Again it is interesting to see how she changes material from one version to another. This version makes no mention of her painting and cuts down the references to "X," saying only "hang loose re 'X.'" Now her language sug-gests that her "impulse towards alteration" comes from her work in analysis rather than—as it seemed before—from her relation with "X": ". . . the held idea has been frozen . . . as a fossil in a bed of stone. The shock of illumination or perception has the power to blast it free" (April 8). The hidden subject toward which she now feels differently may be her mother. On the next day, April 9, she cites a long passage from Henry James about his mother's death and her perfection. Ethel's last entry in Sep-tember has to do with the split between "ideal" and hated mother (terrifying female God-mother and benign Dr. K?).

Her other preoccupation in this six-month stretch of note-book is the future form of her writing. "Shall I keep to the notebook form? The notebooks go from 1967–75, a goodly

stretch. . . . Have just written up notebooks I and II to a 15,000 word piece at 4th writing (running from 1967–1971); can I continue in an unself-conscious way? without thoughts of an audience." The answer was yes. She will continue with her typescript in 1976.

three

"The tortured sequences of life . . ."

"I do not paint everything I experience
but I do experience everything I
paint."

"A light wind blows through the
window."

UNDER THE SIGN OF THE STORM: PAINTING THE DEATH OF SOCRATES

INTRODUCTION

The journal from June 1976 to April 1977 is shadowed by a new loss. Ethel's mother died in April 1976 and this section of the journal is dominated by her attempts to come to terms with pain and anger. Though her mother was in her late nineties and Ethel had been expecting her death for years, it was still a shock. They had had a difficult relationship. Ethel's father,

Eugene Kremer, had died of a painful and lingering illness when she was in her teens. About ten years later, her mother, Agnes, remarried. The new husband turned out to be an adventurer who made off with what would have been Ethel's inheritance. Ethel could not forgive her mother. For decades they were estranged. Aided by her psychoanalysis, Ethel became reconciled to her mother, supporting her generously until her death. The paintings and dreams of women described in "Paradise of the Real" and in the 1974 notebooks seem to have been intended, in part, to recapture positive childhood feelings toward her mother, suppressed during their long estrangement. But death, as this portion of the journal shows, awakened old feelings of deprivation and probably made it difficult to go on exploring and creating the female images of the previous section. Instead, Ethel turns again to consider painting a strong male figure.

The first entry in June discusses the survivor's anger in the face of death. Though she doesn't say directly that she is angry at being abandoned by her mother, it is more than likely that she felt angry at her mother for dying, as she had felt angry at her husband. Her train of associations leads to related thoughts on anger in art and literature. She concludes with Dostoevsky's depiction of the brutal murder of an old woman in *Crime and Punishment*. Again, she does not directly express her own anger or murderous wishes, but they are suggested by the fact that her train of thought next takes her to her mother. She tells about how angry she felt after her father's death, when she could not be her mother's sole comfort. Every night during the mourning period she would lie with her mother and try to comfort her. In the morning her mother would turn to her son and sisters, leaving Ethel feeling unappreciated and abandoned. This journal section, then, begins with a dual anger, at death and at not being loved enough.

In subsequent entries in September Ethel adds another major, and emotionally linked, reason for anger: not being sufficiently recognized as an artist. She had decided, for aesthetic reasons or reasons of pride, not to include in her typescript her 1974 notebook account of her frustrations with the art world. So, here, she does not speak directly of herself but speaks of van Gogh's rage, suffering, and suicide. She suggests that his anger at lack of recognition might have been a strong reason for suicidal impulses. She herself attempted suicide almost a year after her

husband's death, when her Gorky book had been rejected. This section is full of bitter comments about contemporaries who were receiving the recognition she felt she deserved. She speaks of Jackson Pollock's "jagged impotency" and Georgia O'Keeffe's dullness. From her later private notebooks it seems clear that her analyst, Dr. Kris, kept trying to convince her that success seemed so important to her only because of her earlier feelings about not being loved enough by her parents. Though this is a classical psychoanalytic interpretation, it might have been more helpful to urge Ethel to struggle actively for recognition. In any case, the summer and fall of 1976 saw her connecting three types of deprivation—death, lack of love, and lack of recognition. All three generated enormous rage and one of the functions of the journal and her painting during this time was to help her transcend it.

In this ten-month period, she moves from anger and pain at her mother's death to resignation and new hope in her art. Her art will preserve her mother and the others who have died or been lost to her. However, this movement is not entirely obvious from the text itself. One key element in the struggle with anger is that it is never presented directly as hers. She always uses impersonal constructions. In her opening statement of anger at her mother's death, she doesn't say "I feel angry" and then "I paint using myth"; she says "The tortured sequences of life that occur at the time of the death of someone near . . . may arouse, after awhile, some disposition to anger" which perhaps later might be "expressed in the veiled form of mythical subjects." This passage is as far from direct statement of personal feeling as it is possible to get. She does not even say "one may feel anger"; the subject is literally "the tortured sequences of life" that arouse in some passive, unspecified object these terrible feelings. In this sense there is a missing subtext of first-person experience running beneath a very impersonal text. Even the story of her anger at her mother after her father's death is expressed impersonally. "Imagine a daughter," she tells the reader calmly, who because of her anger decided to go away forever. Without a gloss the reader would not even be sure she is talking about herself. After the poignant expression of loss and yearning for her mother's love in "Paradise of the Real," Ethel's distance and impersonality come as a shock. It is as though her mother's death temporarily halted her interior movement. Throughout this

1976–77 journal there is a feeling of emotions being held down and only gradually emerging from beneath the emphasized surface calm.

Her notes on the watercolor *Socrates Takes Poison,* the main work she did during this period, stress calm. She mentions on September 23 (after her opening discussions of anger) that she is "painting a few studies of Socrates as he reaches his final hour." The process notes for this painting are unusually full. It is clear that what interests her most in her source, Plato's account of Socrates' death, is Socrates' lack of anger. She wants to stress his calm resignation, which contrasts with her own rage at abandonment by a loved person's death. With Socrates, "anger has given way to grief and to the finality of death."

The figure of Socrates was multidetermined. She thought of his calm death in her first June entry just before she recollected her father's dying in terrible, long, drawn-out pain. In one of the notebooks she excluded from the typescript, she wrote of the violent temper she felt she shared with him and which he undoubtedly exhibited in his illness. Later notebooks will speak about his drinking and loss of control. On one level, her painting "corrected" her frightening memories of her father's death. It also "corrected" her own anger at both her mother and her father and showed her a model of how things should be. It also gave her hope that she would not have to keep on imitating her father's turmoil. In meditating on how she is going to paint the death scene, she notes Plato's emphasis on Socrates' gentleness even with the jailer who brings him the poison. In this sense he is a type of Christ-figure, and in thinking further about how to draw him, she thinks of a Gothic saint on her slab. It is no accident that the saint is female. Socrates, unjustly condemned and poisoned by his peers for speaking the truth, must have appealed to her own sense of being punished by rejection for following her own artistic path.

On September 21, just before she mentions her first studies of Socrates, she writes about van Gogh's anger and suicidal despair, which she attributes partially to lack of recognition. In that entry she points out that in spite of van Gogh's rage and acute anxiety his paintings have a quality of "glory" coming from the triumph of his genius over terror and difficulty. On October 3 she creates a link between the figure of Socrates and van Gogh by saying she wants her color to suggest "the quality of glory" and her painting as a whole to bring exaltation and

consolation. She reminds herself of George Oppen's thought that if people don't understand this function of her art it is their own fault. Because Socrates in a sense represented her own imagined triumph over pain, as she worked on the figure she had endless difficulties with its gender. On October 8 she notes that it drifts away from being a man, continually becoming smaller and smaller. On October 9 the figure appears to her to be almost more of a woman than a man. At this point she speculates that she is thinking of herself "and perhaps exhorting myself to take the role I have attributed to Socrates."

From what she writes in the journal, it appears that in her painting of Socrates she projected an ideal form which she then could try to take back into herself. The journal itself seems at times to serve a similar function, particularly in helping her move away from anger to a more positive and free state. In mid-October a bridge passage on painting leads her to love and, implicitly, to her mother. She decides that art, through its depiction of beauty, is more suited to expressing love than literature is. This puts art on the side of life and health in her struggle against her anger and destructive impulses. Also, in this elliptical way, through recollection of the beautiful women painted by other artists, she returns to the subject of her mother, the woman she loves and wants to capture symbolically on her canvas.

Her symphonic structuring of the journal leads her from the topic of the artist's pursuit of feminine beauty into a description of what she calls "light images" or miracles. The next months, up to the anniversary of her mother's death in April when this portion of the journal stops, are filled with these visionary experiences in which she perceives nature with a heightened intensity. If we look back at "Paradise of the Real" we see the importance of her statement that, for her, light was the equivalent of her mother's smile. At this point in 1976–77, she does not at first make the connection. Instead, she concentrates on loving descriptions of a little plant on her windowsill whose leaves catch and reflect the sunlight. She seems to go out of her way to deny any connection with personal emotion, insisting that the light images are abstract, "containing nothing of the individual . . . sheer fact, sheer beauty." She adds that such images are possible only when "an artist overreaches his own personality." Even though she denies a personal meaning, her visions express and symbolically gratify her wish to be essential

to her mother. She makes a crucial distinction between two kinds of light. The broad play of light over a surface brings a sense of well-being. Light's singling out of an object, however, is a miracle. Given her own equation of light and smile, this strongly suggests a visual enactment of her wish to be singled out. She associates her need for "miracle" with her frustrations in love. "Perhaps I had a need for the extraordinary, for something so beautiful that it would compensate for the continual loss of those I loved." Her insistence on transcendence of conflict, absence of emotion, and the need for personal calm in order to receive the "miracle" all suggest how strong were the countering forces of disorder and despair. In another cryptic entry, she names them herself. "Incoherence. Clutter. Whirling confusion. Misery. Anger. Anxiety. All these occur in the human mind but they are quite the contrary of joy producing." Joyous concentration on the images of light meant temporary escape from pain. But it was only temporary, and this discontinuity itself provides another source of anguish.

She suggests she finds it almost unbearable to go from heightened perception, what she calls miracle, to an area of time relatively empty. During this ordinary time the world seems empty of joy and meaning and what she looks at seems dull or gray. This loss of heightened visual perception affects her as separation from her mother affected her after the intense closeness of lying in bed comforting her during the night. Even the music she plays while painting may relate to this need for continuous presence; she writes that she does not listen to it exactly but leans back on it as a swimmer would on the evenly surrounding water.

The visionary moments then would seem to represent the wish for her mother's illuminating presence, and the surrounding moments the pain of being without her mother. The intolerable nature of the repetition seems to force her to try to think her way out of it. She begins to realize that her perceptions of dullness or beauty are in her own mind: "Everywhere I walk I sense 'the place where' something wonderful is in the process of becoming, if I could only perceive it."

The possibility of a new show of her mythic paintings at St. John the Divine may have helped her work her way out of the impasse. While the show is being arranged, she turns to thinking about the technical side of her art and perceptions. The descriptions in her journal show an almost microscopic attention

to subtle detail. It is clear that she looks because she loves and wants to preserve what she sees. And her criticisms of contemporaries (like Kenneth Noland) for negative qualities of aggression and abstraction reflect her own desperate struggle to preserve her art as a place for the expression of positive energy.

Finally her art brings her out of the emotional labyrinth. In April 1977, a year after her mother's death, she concludes that "art may be a vehicle for the externalization of psychic injuries"—that is, a place where the trauma can be symbolized and healed, where only beautiful space, not empty or joyless space, need exist. Beauty is the one thing that doesn't produce pain. Or rather, the only pain is her longing to paint so her vision will endure and what she loves will be preserved. She is not sentimental about the type of gratification involved. She is painfully aware that preserving someone symbolically in paint is not the same as holding that person's warm body. She says that a painful renunciation is required "because the insatiable nature of the emotion requires the actual presence of the beloved" and "the work of art is the affirmation of the permanence of the human spirit rather than the permanence of the body." In the 1920s, however, when she had been in love with her analyst and he left for Vienna, she had stopped sculpting his head; on that earlier occasion she had refused to accept the comfort of the art object and instead tried to kill herself. (Her much later notebook sketches of herself at that time show Dr. Gluck leaving to join his family and herself prostrate on the ground with "cyanide" written underneath.) This time is different. Thinking about her art, she feels a lifting of spirit which she characteristically translates into a sensory perception of awakening nature. "Fresh is the morning. . . . A light wind blows through my window."

THE JOURNAL JUNE 1976–APRIL 1977

June 1976

The tortured sequences of life that occur at the time of the death of someone near may bring in their wake a sense of imprisonment, of being

held in the dust against one's wish to fly, and may arouse, after awhile, some disposition to anger and eventually to furious rebuttal of hard necessity. At some later point, perhaps anger might be expressed in the veiled form of mythical subjects where anger was an appropriate part of the story.

In literature, every phase of anger has been expressed. Perhaps Dostoevsky was the most versatile in this respect. He describes anger in every conceivable form including the kind of ultimate rage that produces the need for killing. This he describes at great length and with subtle penetration into the nature of rage and its effects in action. He describes long contemplated plans to murder, taking into account all forms of imaginary sadistic encounters with the victim. He imagines successive action taken day by day in which his character advances toward the culminating act of murder. He also imagines the constant anguish and sense of guilt that his character must feel as he plans these sadistic outbursts. Dostoevsky weaves alternating plans for the carrying out of the murderous wish and clearly organizes the concomitant feelings of guilt, fear, anxiety, contrary emotions in such a way as to resemble life.

But, shall we say that art cannot convey this kind of complexity? I cannot think of any examples at the moment. An actual rape or murder, yes, but not the planning that passes through successive stages running over hours or days, and goes through a great variety of phases, a great variety of conflicting thoughts and feelings. Many paintings have been done which show the soldiers nailing Christ to the Cross, or pouring vinegar on his wounds, or placing a wreath of thorns around his head. Stages of the story of Jesus have been told so that in an additive sense much sadism has been expressed, through varied additional acts of cruelty. In Michelangelo's "Last Judgment," we see many wretched humans sinking down toward Hell with varying expressions of anguish which indicate the fierce guilt and pain that they are suffering. But this has a very different quality from, let us say, the writing of Kafka, who is able to develop a great many successive changes of mood and types of anxiety felt by one single individual.

In Picasso's "Guernica," he depicts the effects of anger on the victim: the mother convulsively clinging to her infant, the dying horse, the fallen statue, but he does not present what goes on in the mind of the individual who causes this anguish. He does not show the source; rather, anguish is projected into the form of its effect.

<center>*　*　*　*</center>

Although Socrates' students, the beautiful young men, wept at his death as the poison moved swiftly toward his heart, it became a beautiful event because Socrates himself was so accepting of it.

<center>*　*　*　*</center>

But imagine another sort of death, that of a man subjected to the most terrible torment and pain persisting over months. Think, too, of those who stood by, how they suffered, and could it not be that they would feel a tremendous release to think that he would now be free of pain, and they would be free of the agony of going out toward that suffering, of suffering it in a way themselves? Imagine then the efforts of the daughter of this man who died, the great flow of affection, the numerous tendernesses, the effort to pour out love toward the bereaved mother, to lessen the anguish of her losing one who had been at the center of her life for so many years. Can one not say that this stream of affection was an important force, one that caused a bondage of affection, that brought with it an almost total possession of the one so tenderly loved? Then suppose that after sleeping through the night with this bereaved wife as a tender daughter might, the morning came and other people entered in among which the wife's sister, who then took over command of the household, the lawyers, all the details of financial arrangements so that again an enormous reversal of feeling was bound to turn aside this flow. Perhaps there were even feelings of anger toward the one who said, as it were, "You are not enough, I will take over. You cannot assuage, you cannot really care for this bereaved one."

And yet, very shortly another night came, and again the surge of tenderness arose and the daughter woke up during the night to place her palm upon the mother's forehead and listened mutely as she said to her, "Your hand brings me calm just as your father's did," so that once more emotions were brought forth and seemed a natural vent of feeling, but then again the dawn came, and again there were others, always others, friends, relatives, wives, many others, including the brother who came down from school and claimed the right to give directions as to the organization of this, his mother's life. There was a constant turning on and off of emotion. One might say that this should have occurred quite easily as when one switches a light on and one switches a light off; there might have been little friction in this constant reversal of currents, but, it seems to me, that in the case of this daughter and this mother, the daughter felt first longed for, needed, and then displaced and the constant to and fro of contradictory efforts caused a nervous tremor that caused her to say, "No, I cannot continue, I must find a way out. I must go away, I must go away forever."

September 21

Still thinking of the subject of anger as expressed in art. Many years ago the Metropolitan Museum gave a lecture on a show of van Gogh's work in which they projected greatly enlarged images of his paintings upon

a screen so that the petals of the "Sunflowers," for instance, appeared as super-violent, attacking, dagger-like forms. I felt this to be a complete distortion of van Gogh's intention. It is true that, in the smaller painting, he had given sharp, jagged edges to the outlines of the sunflowers, but the effect of the violence was limited by the small size of the painting and in no way assaulted the spectator. Van Gogh's "Pool Room," with its lurid, green pool table and the startling light on the ceiling which seems to spin dizzily, gives one a feeling of hysterical anguish. This again, in the small size, was stirring. It aroused emotions of uneasiness and the realization that there was evil here, and anguish. But in the large size, the effect was that of a madhouse, and probably expressed more rage than van Gogh consciously intended. There is a wonderful van Gogh, the last he did before committing suicide, of ominous, strange blackbirds flying over dark fields, not into the picture, or across the picture, as would ordinarily be the case, but toward the spectator. I felt that these birds made it seem as though death itself were approaching one, and as though here van Gogh had foretold his own imminent death, had really spoken of it and, in a sense, cowered before it fearfully, because it was so threatening. He also painted an extraordinary painting of the sanitarium where he was incarcerated for a while, showing the beautiful trees and walks surrounding the house. But these trees because of their strange, yellowish green, a violently nauseating color, again produced the effect of extreme anxiety.

I have been speaking more of anxiety than of anger. But frequently anger underlies anxiety. Possibly van Gogh was angry with life, angry that with all his genius he was still in the position of accepting funds from his brother who could ill afford it, angry that he was totally without recognition, poor, and allied with a prostitute as a "sort of," "almost" wife. The paintings that he did, though showing both anxiety and glory, were very heavily weighted down with the former. In van Gogh's painting of his bedroom the presence of these opposites is most clear. The walls of the bedroom appear to cave in. On the other hand, there is an intense, brilliant luminosity spread wonderfully over the simple bed, the floor, the small washstand, and the chair. A quality of almost biblical ecstasy is present side by side with the acute personal anxiety. The "glory" might be said to come from van Gogh's genius which functioned in spite of the terrors and difficulties of his personal life and illness.

I have often thought of Paolo Uccello's "Battle of San Romano" in which extraordinary lucidity and structural power were counterpointed by a mysterious, haunting, melodic accompaniment of colors so that the total effect was extremely rich.

Another important instance of "symphonic style" is that of Fra Angelico's "Crucifixion" in the Metropolitan Museum. "The Crucifixion" itself is the

story of the extreme agony of the Jesus memory, but the golden background that Fra Angelico gives to the upper half or two-thirds of the painting completes the full circle of the story, suggesting a Resurrection, in which Jesus becomes Christ and thus gives another dimension, ameliorating the harshness of the tragic site of the event. One might question whether the dual dialectical quality I have noted in all these paintings is the result of the artist's need to express all his feelings, to give a wide parameter to his thought, to state "the place where" he stands; or whether it is to provide a fuller giving of the story itself for the sake of the spectator. I believe that it may well be both, that in his function of "leading" a spectator—the "psychagogical" "leading around" of which Plato spoke, i.e., the longing to "enchant and win men's souls" directing them toward "truth"—the artist may have been drawn to express the more extensive range rather than the more limited one.

September 23

I am painting a few studies of Socrates as he reaches his final hour. But oddly, my memory of the story is quite incorrect. In rereading Plato's "Phaedo" (p. 188), I realize I must alter my conception. There are two important scenes. One where Socrates takes the poison, and he does this standing up (not lying down as I had imagined). He accepts the cup from the jailer and drinks the poison right down with apparent cheerfulness. His disciples burst into tears and make a loud clamour but he bids them to desist. The second scene (p. 189) completes the story: "When we heard his words we were ashamed, and refrained our tears; and he walked about until, as he said, his legs began to fail, and then he lay on his back. . . ."

I should very much like to paint both these scenes. At the very end, the very last moments of his life, when he was beginning to grow cold about the groin, he uncovered his face for he had covered himself up, and said, and I quote: "'Crito, I owe a cock to Asclepius; will you remember to pay the debt?' 'The debt shall be paid,' said Crito, 'Is there anything else?' There was no answer to this question, but in a minute or two a movement was heard and the attendants uncovered him. His eyes were set and Crito closed his eyes and mouth."

I would like to show him lying down with his face covered up as in the scene just prior to this last one. This scene, indeed, could have an epic quality. The robes should completely cover the underlying body. Perhaps one could show the disciples grouped around the couch in attitudes of mourning. Here at this very last hour, or indeed in the very last few minutes, the whole question of anger has disappeared. Anger has given way to grief and to the finality of death. Indeed, this is the way David treated the subject

in his painting, "Socrates," in the Metropolitan Museum. However, this painting, I feel, is exceedingly stiff and academic. The figures are stilted, devoid of true expression. Yet there is a redeeming feature, a certain wonderful, deep, calm and sadness in the large grey shadows on the prison wall.

To return once more to the original subject of anger, it interests me to note that Plato has represented Socrates, in his last moments, as a gentle man, without anger. He describes the jailer as coming in and saying to Socrates that it was now time to take the poison. I quote (p. 187): "'To you, Socrates, whom I know to be the noblest and gentlest and best of all whoever came to this place, I will not impute the angry feeling of other men who rage and swear at me, when, in obedience to the authorities, I bid them drink the poison—indeed, I am sure that you will not be angry with me; for others, as you are aware, and not I, are to blame. And so fare you well, and try to bear lightly what must needs be—you know my errand.' Then bursting into tears he turned away and went out."

How plain, in a sense, these touches are. And how eloquent.

September 26

Shall I paint Socrates at the moment of taking the poison from the jailer, or perhaps at the moment when he was standing there already holding the cup? It occurs to me that his disciples could be standing, not around him, but to the side, on Socrates' side and on the side of the jailer, and that a certain classical quality might be obtained, the kind of quality that one sees in the work of Mantegna. It was a solemn moment, a moment in which this marvelous and yet simple man made his peace with his own destiny. He did not hesitate to move forward into death. He was not afraid. He imagined that either there would be a world of death in which he would meet many friends, many superior people out of the past, historical personages, or else, that if it were not so, death might well be like a "night without dreams," to use his expression. He asked his disciples whether, in their experience, there had been many days when they enjoyed themselves as much as they enjoyed a night without dreams, a peaceful night that could go on interminably.

Though the description of Socrates tells us that he is an ugly man, I prefer to think of him as more like Homer, the Homer represented so marvelously in Rembrandt's painting "Aristotle Studying the Bust of Homer" at the Metropolitan Museum. I know of no face as beautiful as this head of Homer which is taken from a Greek cast. He has the aspect of a dreamer, a gentle dreamer. His face is full of profound thought. It is neither sad nor joyful. The blind eyes lend an interior quality to the poet. One feels that he is in touch with the absolute. I really would not hesitate to change the

aspect of Socrates' physiognomy. Why must I accept the version of his being ugly? It is true that David did paint him as a square-headed, ugly man, but I think this constituted a weakness in his painting. One could scarcely imagine the quality of thought that he put forth coming from this rather plain and ugly person.

The second painting, the one of Socrates dying, or even dead, covered by a drape or cloth, interests me, in some ways, even more. It might well have an epic quality. I think of a certain painting of a saint, a Gothic saint, that I once saw in the Metropolitan Museum. She was laid out, I think probably in her coffin or on a slab preparatory to being put in her coffin, and had a most peaceful expression in her face. It was quite a remarkable sculpture.

To what extent one would show the body as it bulked under the drape, or to what extent it would be lost and only the drape with its many folds apparent, I do not yet know. And whether one might show the disciples in groups, by twos or threes or as a single figure, somewhat in the background but still close to the couch in attitudes of meditation and / or mourning, I do not know. In Fra Angelico's "Crucifixion," the mourning figures stand in stately silence and contemplation, and although the garments are dark there are no wild gestures, but rather an adagio movement, a great solemnity, and what I call the epic quality, a sense of timelessness, as though they might well mourn on forever, contemplating the mystery of the death of Christ.

The Greek youths were described in Plato as being very highly differentiated. One was fiery, another given to jokes, another more serious. They were specific, different youths, all Greek but very much individualized, and of course in many ways this is more suited to the modern conception which rarely turns toward an epic quality, possibly because it is not able to. Strangely enough, in Plato, I have felt that although his thought moves at times in majestic rhythms, it also sparkles brilliantly with the immediate stuff of daily life. It is real and tangible. Again I asked myself how on earth I could paint such a thing. Is this ability to paint epic painting quite gone from our time? We seem to be intent on painting the fullness of the immediate. Frequently that fullness is largely the fullness of personal emotions rather than thoughts of a universal nature.

September 29

Last night at the Museum of Modern Art, post-war paintings. Quite amazing to see the Gorky, "The Plow and the Song," in the environment of two Rothkos, a Clyfford Still, a Pollock and a Newman. The Gorky satisfied me as a full work of art, complete, breathing, sensitive. The

Rothko, while a large painting, seemed somehow to have a sterile surface and little impact. The Pollock gave off a feeling of jagged impotency. It was really a zero factor. In the further rooms were examples of Georgia O'Keeffe which looked very dull. And still further on were the older works of Innes and Whistler which were very beautiful. . . . It confirmed my opinion that Gorky was in truth more of a European painter of the better periods, that his work managed to be complete and to breathe and to have a substantial sense of the plastic quality which is so difficult to describe.

October 3

I have been brooding all day about Plato's Socrates. The story of Plato or rather the story of Socrates is so broad, and so deep in its implications that I am overwhelmed. Even narrowing down to certain definite scenes, I find myself staggered by the difficulties. As to Socrates—if I could imagine him in his fullness as I think I did Abraham and Oedipus—perhaps I would just show him standing there, accepting the bowl of poison from the jailer. Perhaps I should bring in a great deal of color even though this is a scene in a jail where perhaps one would think chiefly in terms of greys, whites, blacks. Also ochres, soft colors, dark colors. And yet I think I prefer the way I treated Oedipus many years ago, following Sophocles' description of his end as glorious; I used much color as a way to suggest the quality of glory. And yet the death of Socrates is also glorious, though Plato does not specifically use such words. He describes the expression of Socrates' face as cheerful. He describes his mood as gentle, as ready for the transition from life to death. Socrates is singularly composed and calm. His disciples mourn uncontrollably because they have lost a friend, a leader—a father figure. But I, as outside witness of the event, see it not so much as the loss of a father figure, but rather as a glorious event. I think of Fra Angelico and the luminous gold that he could use to express such thoughts. The spirit of exultation was frequently present in both the early and late Italian painting of momentous myths and stories.

Here also in Plato is a momentous story, the story of a single man, Socrates, who can stand up alone, singularly firm against the Athenian state, and can fight to maintain his thoughts brilliantly against the antagonism of his judges. I feel a sense of exultation that such a man once existed.

And yet the visualization still eludes me. I think of Rembrandt's portrait of himself standing in his studio at an easel. It is a quite small painting that was shown about a year or so ago at the Metropolitan Museum. I marveled at this painting because it seemed to show this extraordinary genius standing there isolated, but in no way overcome. Rembrandt seemed

to have been able to suggest that he was quite complete in his aloneness. In Rembrandt's picture his means were extremely simple. He painted the studio just as it was, again the sort of reality that I had noticed in Plato, a homely reality; and yet this simple reality coexisted with a sense of grandeur as exemplified by a single person.

In the Rembrandt, there is only a single tonality, from pale cream through to dark brown. It is, in a sense, very plain. How does this help me with Socrates? Could I imagine the scene of his taking the poison, or of his lying down once having taken it, lying down on the couch, covering himself with a robe? Could I imagine this in very simple color tonality from grey to white, or from white to black, as Picasso did in "Guernica"? Is that the answer?

October 5

I am brooding constantly over the death of Socrates. I believe it possible, though a rather wild idea, that Plato has divided the grief (leaving it to Socrates' students) and the cheerfulness or optimism and confidence in the future to Socrates himself. In this way, he gives a certain richness to the total effect that would be lacking if there were only cheerfulness and optimism. It also gives a sense of greater reality. Possibly this was not a conscious thought on the part of Plato, but simply the poetic spirit finding its true form. On the other hand, it is possible that he may have thought of this contrasted assignment of roles as a device for presenting the fullness of the whole scene.

October 8

In the last few days I did three or four studies of Socrates which turned out very badly. The proportion of Socrates simply insisted on becoming that of a young boy rather than an elderly man. I could not seem to control it. But yesterday I did a new study of Socrates receiving the poison from the jailer. And this study, I believe, turned out. In some, to me, mysterious way I have managed to suggest that Socrates stands alone (a quality I had noted in Rembrandt's portrait of himself in his studio), and this in spite of the fact that the jailer is standing quite near him just having handed him the bowl of poison, and that one of his disciples is standing very close to him on the other side. I've also noted far up toward the top of the painting the "black hole." This is a concept that Annie Stein had been discussing with me; namely that far up amongst the constellations there are certain black or empty holes. In the end it appears that out of these

"empty holes" something will come—some creative energy will be released into form.

In this painting of Socrates, I still found trouble in getting him to be in the proportion of a grown man, with the result that the painting is cut off at his knees, or just below his knees. I had intended to have the whole figure in the painting. Nevertheless, the proportions are correct. Again, I clothed him in lovely robes, one scarf going around his shoulder and neck, another scarf around his arm, or perhaps another portion of the scarf around his arm, and I have made no effort to paint a muscular and correct anatomy. But, strangely, there seems to be a certain serenity in the face, and there seems to be the story, the story of the jailer giving the poison, and Socrates accepting it. He does not accept it in a careless way. There is a sense of destiny in the gesture and in the moment, which was chosen, perhaps, from my preconscious, as being absolute in that moment when destiny made itself felt. It is the last one in which Socrates stands up to the world, or in the world. Presently he will lie down, and somewhat later he will die, but at this point he is still in full possession of his faculties, yet with a sense perhaps of being alone and with no desire left to communicate. He had heard that the oracle had said of him that he was the wisest man in all of Greece. Perhaps he contemplates this very point at this moment, this last moment so to speak. And as the wisest man would he not naturally accept destiny rather calmly? Yet there is some expression in his eyes of a looking beyond as if he could see himself in that land of death which he had often imagined as peopled with those great men of the past whom he could enjoy.

George Oppen once said of my large epic paintings, "they bring exaltation and consolation. If people don't like them it's their fault." Naturally, I'm aware that this watercolor is done in such a manner that there is no firm sense of anatomy, no firm sense of form really, but I think it might show some degree of "exaltation and consolation." Here is the man, Socrates, standing close to death, and yet by no means defeated.

October 9

I find today that the Socrates which pleased me so much yesterday now gives me some cause for dissatisfaction. I think that the figure appears to be almost more that of a woman than that of a man. Naturally, I could quite easily emphasize the strength of the jaw, or the bulky quality of the head, and perhaps I will do another study in which I'll make the bony structure of the head more definitely a masculine one. I cannot quite understand why I have so much difficulty about the gender and age of this figure. It might even be that I'm thinking of myself as Socrates, as one who is

about to die and perhaps exhorting myself to take the role that I have attributed to Socrates, the role of calm cheerfulness in the face of destiny. But nonetheless I'm determined to try again, and again, if necessary to get Socrates—the man, the philosopher, the wise Greek—there onto the canvas, and to get him there in full length, not cut off.

Obviously, I could easily control the measurements by using a ruler, or by just using measurement for itself, but I do not wish to do this. I want it to come spontaneously from some deeper source, and so I am not making an effort to control it to too great an extent. Eventually, I believe it will come as I have wished it.

October 11

When I think of Leonardo da Vinci's "Last Supper" and, in particular, about the face of Judas, I realize that here Leonardo has shown an evil and angry face. He has delineated these characteristics very well, but it must be said that one hardly feels anything. This contrasts, again, with what may be done in literature. If we take one of the characters of Dostoevsky we find that he traces every aspect of the man's personality as expressed in acts of hatred, so that it seems that literature is far more capable of projecting any aspects of anger or any aspects, really, of violent emotion that may take place within the human soul.

When a reader reads about a parricide or any violent act whether in the drama, such as the Greek drama, or in Shakespeare, or in Dostoevsky, he has a sharp and powerful impression of these actions and thoughts and feelings, but not at all the same kind of impression that he would receive from a painting which is, in a sense, more actual. Possibly this is one of the reasons why painters invariably maintain the formal qualities, the aesthetic qualities, the beauty of line and color. These qualities will predominate over the subject matter. Painters can give a marvelous gift to the spectator: the calm and serene joy of beauty.

Beauty exists also in writing, of course, in the writing of most great novelists; but I think the impact of the formal side of a work is perhaps even more impressive in the case of painting, sculpture, or architecture. One may think of the early Byzantine works in mosaic where quite a savage sense of grief and cruelty is shown. Here indeed the impression is that the artist really abrogated the prime function of art to some extent, and preferred to externalize his own anguish. This, again, is evident in modern painting, particularly the painting of the Abstract Impressionist* school

*Probably an error in the typescript. It should read: Abstract Expressionist School.

where one cannot but feel that the personal anguish, agitation, thoughts that could not be channelized, emotions that were fierce but somehow alienated, were expressed in full. But there was a lack of this quality I've spoken of, the quality of beauty, of a lasting structure, of a formal reality that seems to be more important than the personal release could ever be. This aspect of formal structure and beauty, whether through line or color or space or scale, "exaltation and consolation." Certainly it seems to me that these qualities are lacking in the Abstract Expressionist school. We find neither one of them nor the other, but rather the expression of acute bursts of energy, of denial, the denial of beauty, really, and in its place an assertion of personal anguish and alienation.

Picasso spanned both these modes of expression. In certain of his paintings there was great formal beauty and a lasting quality, particularly, it seems to me, in the sculpture. He also used art in the way I have just spoken of, as a personal catharsis.

October 12

But if anger can be expressed in greater detail and depth in writing, perhaps love, as expressed in beauty, may be more fully described in art. The varying forms of nature: sky, sea, trees, fields, and the beauty of individual forms, such as the human body and all flowers and fruits and animals, may be expressed in art in a way that words do not bring before the reader as clearly. Who could possibly verbalize as fully the nature and extent of interest that may be found in a group of apples or peaches on a plate by Cézanne?

The wonderful Greek statues of the Gods and the warriors from ancient times, pre-Cycladic times, 3000 B.C. until the great period 500 B.C. of Pericles, certainly gave more sense of all the visual wonders that would be felt in forms of the human body than any poet could. Now why do I call this love? I think it was the "loving" painter or sculptor who could find a correspondence to love in the beauty of these figures. It is true that there are aesthetic qualities, per se, in prose and even more so in poetry—color, assonance. But artists may do as much, or perhaps even more, to bring this somewhat removed or rarified aesthetic form of love to the spectator. The most loving artists were possibly the Greeks; coming in the same category were the great ancient Chinese vases, and much of Oriental art. It seems that only a lover could have thought of such forms.

Much later we are certainly quite aware that artists painted the female form, frequently the female form of their mistresses. Rubens painted Helene Fourment. Toulouse Lautrec painted the females of the brothel, but in some strange way he was able to make even these rather broken-down bodies

convey the idea of love. Writing has frequently conveyed the idea of the reality of beauty—the beauty of women, but I think much more vaguely, with much less possibility of being instantly apprehended. I think the forms of art have a more staying power. Once seen, a Vermeer interior, with a lovely woman in it, resides in the memory very clearly, with great ease. Take the lovely Vermeer portrait of the young woman being read to by her maid, at the Frick Museum. One knows intimately the room in which she is standing. The pearls in her hair and the larger pearl at her ear, entrancingly sensuous in feeling, convey the idea that she is loved. The way the shoulder is rounded, the numerous small touches, give the feeling of a lover, as though a lover were involved, although the actual scene portrays simply this young woman with a maid reading a letter to her. Where in literature could one find such a full description of a young woman, her charm, her desirability? Or take the marvelous portrait of a young woman by Ingres at the Frick Museum. She stands in contemplation before a mirror. One knows not only the form of her face but even the back of her head as it is reflected in the mirror. There is a small vase containing flowers. These too one knows and can never forget. There is a chair. There is so much. The arm of the young woman is rounded and full. The satin of her garment is suggestive. Everything about her suggests that Ingres had caught the loveliness and this loveliness could never fade. The painter gives a sense of who she is chiefly through the forms of her body. Yet what he tells rests very firmly in the mind of the spectator, and leaves to his imagination the words the painter cannot employ.

October 24

I have just come upon fascinating details in connection with Socrates: (1) Alcibiades enters the room after Socrates had done speaking and crowns Agathon with a massive garland of ivy, and violets and ribands. He later begs this garland back. "And I must beg you, Agathon, to give me back some of the ribands that I may crown the marvelous head of this universal despot (Socrates). . . ." (2) "Socrates is exactly like the busts of Silenus which are set up in the statuary shops, holding pipes and flutes in their mouths; and they are made to open in the middle, and have images of gods inside them. I say also that he is like Marsyas the Satyr" (Plato, p. 380, "Symposium").

This double image gives me a whole new feeling about Socrates. The image of a satyr in Freudian terms would represent the "id." The second part of the image—the gods inside the head—one might associate with Freud's "superego." Plato has actualized a full range of the personality of Socrates within this very condensed, visual, and concise image. I should

like to paint further studies of Socrates, possibly entering in these qualities of vigor and Dionysian ribaldry which I did not have in my first studies. Would it not be difficult or practically impossible to get these two sets of qualities, i.e., the Silenus and the God-like, into a painting of a single head? Plato has done it by splitting the personality of Socrates. By bringing in Silenus he gives one set of qualities; by speaking of the Gods within the head of Silenus he endows Socrates with higher qualities. Following these images would have been a fascinating pursuit for a Surrealist in the 1920s, but today falling back upon a pure Surrealist technique might seem a little dull. I will simply allow these images to rest in my mind and see what may come of them.

[later the same day]

I am talking with a brilliant young writer, Mona Hadler. We have before us the watercolor of Marcel Proust #1 which I did in 1976. I realize that I was thinking of the little boy who was sent up to bed alone and terrified, and so in the first study I almost unconsciously painted the hair somewhat as a helmet, constricting. And the violets I had intended as a wreath had become a tone—a nuance. But in later studies I showed him triumphing over his terror. The garden of flowers (his creativity) inside his head just couldn't be contained, they were sprouting out through his skull, and may have assuaged his anguish.

Marcel Proust was thought to be extremely sensitive and subjective. Only later it was realized that all that he wrote was structured, that it was like some great Gothic cathedral (that's the term he used). He said, "I have created a Gothic cathedral." There was an extraordinary structure in his work as in the Gothic cathedrals themselves. Outside they are all covered with saints, flowers, gargoyles, millions of details, but yet there is a geometrical order underneath. To me it was fabulous that Proust could construct a huge cathedral or structure, something very elaborate and very complicated (written over a series of many years) without losing a sense of closeness to life, a response to life in every form.

November 6

These three leaves in the window in the sun produce a sense of powerful form.

Transmigrant—light to image and image to light. The leaf holds the sun long enough to make a "light image." The purity and force of this image is far greater in that it contains nothing of the individual, the personal in it, but remains sheer fact, sheer beauty. Curiously enough, it gives me a sense of style. And I must bow to the thought that not even the greatest

FIGURE 6. *#10 Young Lambs*
Series: Of Marcel Proust
No. 2 (1976).
Watercolor on paper.
Artist's estate. Michael
with a crown of flowers
was partial model for
the child Proust.

artists have been able to create form that has this kind of purity and style. My mind wanders now to a 3000 B.C. Egyptian bowl at the Metropolitan Museum. This little bowl appears to me to have a similar style. It seems not to have been made by any mortal. No, it is not personal. And it has not that particular quality of sensuousness or lusciousness usually associated with the artist. It has more the quality that Gandhi named "Satyagraha," soul force, or the force of truth. Now, when an artist overreaches his own personality and finally comes upon the expression of an abstract force that suggests a possibility of continuing perpetually in its own image, one could say that this force is perhaps the highest expression of beauty.

We who seek for absolutes are apt to cherish those shapes and forms that contain this quality. The little Egyptian bowl made of some material that looks like alabaster is of the utmost simplicity of form. The material itself gleams as though it contained light. One might pause for a moment to wonder. Was this made by a craftsman or an artist? Were Egyptian mathematicians, astronomers, politicians, rulers, behind the creation of such an object? Was it the force of many minds working together that gave one the sense of this being a very special object that expressed and defined the non-immediate as well as the immediate? Why is it that more recent bowls, the very modern bowls that are made in not too different a form, seem to contain none of this mystery? Is it that they are made on a purely commercial basis? And if so, how can one be sure that this is the difference?

I look again at the leaves. I think: "Existentialist." They show a certain specific mode of being. They have to do with being, and that is what, perhaps, I am most interested in. If I look from the green leaves over to the red flowers of the begonia plant, I am not as persuaded by their shapes. I do not feel that they have the quality that I have just been describing. They seem somehow, although beautiful, to be rather too attainable, somewhat commonplace. Now, all of this thinking may be highly individual on my part, and perhaps not to be shared with others. I have moved through many museums looking at still lifes and landscapes, and I can think of nothing that has the majesty of these leaves in the image of light. The nearest thing ever to approach it in my mind is the experience I had when out West many years ago I would walk out every evening to see the moon, and the moon had this quality as seen through the clear air of the mountains: an indefinable quality. Again, "Existentialist." The moon was sort of opalescent white. One cannot even say what the color was. It was more "presence" again the "phantom" of a shape, or the phantom of a form, or the phantom of a color, as an x-ray is a phantom of a bone, a bone seen in a picture, and I am seeing these real objects as though they were x-rays, pictures of themselves seen in terms of light alone. What falls outside their outline is still light, but seems to have no special existence. I cannot bring

it into the same context. It remains quite ordinary. Now, perhaps there are minds that can bring unity into the various separate parts of visual experience, a unity of style, quality and truth. But again, I must say that my experience of art, what makes it so wonderful, is not so much that the artists are able to create the marvels that one may find in nature as that they are able to create at all. It is such an enormous project to try in any way to equal what has actually been created.

November 7

Cézanne was aware of the difficulty of establishing continuity between all the discrete elements of the continuum before him. He was intensely aware of connections, very small connections, within the inch, so to speak, and he was intent on giving to each one of these linked connections its full value in the chain of experience or reality. This was a costly procedure because he had to test at every point whether this or that link in the chain would hold up under any stress. At times he left gaps where he could not be sure of the quality of that particular step or link that he had forged.

Other artists, like Picasso, have leapt over these smaller links and have built on a broader structure, seemingly not disturbed by "leaving out," but giving thought only to what they wished to "put in." If they saw nature in this way it was a question of building something that pleased them out of the multitude of possibilities, and the multitude of visual excitations that they must also have experienced.

But what of time? Some people are acutely aware of time, of every moment, in a sense of every minute and its passage. Perhaps they find the passage of time painful because as it passes into and out of their experience they have, in a sense, constantly won something and lost something else. They have won the moment that comes and lost the moment that just departed. Possibly this very anxiety or acute sensitivity to the holding of an experience whether visual or auditory may have plagued Cézanne. Each experience brought to him an intense, almost anguished longing to acknowledge it in full. He was too acutely aware of it to merely jump over it. I think Picasso was a leaper, a climber of mountains, accustomed to going forward perpetually and rarely looking behind until he reached a top. He is a different temperament.

With Seurat the tiny dots of Neo-Impressionism do not have the same quality as I am speaking of in connection with Cézanne. He simply expressed a rather plain surface in terms of small dots which perhaps he felt gave a certain vibration that he liked. There was not much concern over the exact structure of every interval in space. Nor did Seurat reflect anxiety. He seemed to be concerned with a very tender expression of his

own experience. Cézanne was the man of anxiety. And yet, does not this kind of anxiety suggest a link to a lover's passion? Was not Romeo acutely concerned about whether it was the lark or the nightingale? Because the short night with Juliet was so precious to him. He wanted every moment to be realized.

Perhaps Picasso was more interested in his own intellectual processes, his own vigor, the vigor of the mountain climber who leaps forward to gain the top, than he was in the object, in his relationship to the object. The object was perhaps only a bridge to his own attainment.

Perhaps I am now coming full circle round back to my thoughts on the little Egyptian bowl of 3000 B.C. Here I think the artist was in love with the reality of beauty. He was held by that thought, and so it was possible for him to create in the name of beauty, not as an exercise or as a conquest, but rather as a hymn, an act of devotion, a love song.

November 13

I spoke of Cézanne's preoccupation and intense concern with the strength of each link in the chain of phenomena that he perceived, but I did not mention that this effort was rendered even more difficult by the changing light. As the sun moved in the sky, light fell differently upon each portion of the chain with which he had been preoccupied, thus giving to the individual links new aspects which made it very difficult for him to determine their actual conformation. For instance, when he painted a rock in a forest, which he quite often did, certain facets of the rock under the early light of morning might appear as lavender or possibly ochre-lavender. As the sun rose higher the tones, each tone in succession, changed, throwing him, very possibly, into confusion. He was seeing differing tones or nuances of a tone, although his mind told him that the form of the object he perceived in front of him was unchanging. He was concerned not only with the form of the object, as the Cubists were later, but with the tones themselves, with the music of color, one might almost say. Color took on the function of defining space structure. But it was also sheer music and was to convey mood, a question of quite another nature.

Cézanne had finally to make a choice. Which time of the day, what set of tones could best express both the substance and structure of nature seen before him, and at the same time the quality of tonal nuance that suggested emotions? What emotions? Emotions of confirmation and joy in the wonder of creation, in the marvel of light. Milton had written: "Hail, holy light, offspring of heav'n first-born and of the eternal, co-eternal being." Some such exhilaration and adoration existed, I believe, in Cézanne's mind, and intensified his struggle. He was balancing between being a scientist/

philosopher—interested in the actual structure of nature (truth)—and being a mystic in the sense of Milton.

Think of the late Cézannes of "Mont Saint Victoire." Here he finally reaches the pinnacle of his work. He uses very masculine colors which approximate the colors of the Italians of the Renaissance. A very powerful emotional resonance is achieved simultaneously with the full, intellectually conceived structure of the "reality" in front of him. The result, of course, is a maximum of balance combined with a maximum of expressive force. This is the miracle of Cézanne!

November 18

Early this morning I was thinking of Poussin, "The Rape of the Sabine Women," at the Metropolitan Museum. From a small distance, or even from slightly further away, the general feeling is one of harmony, a very lovely luminous harmony. One sees action as the Roman soldiers carry off beautiful Grecian women under a soft sky, but it is all enveloped in a musical ambiance. The painting is like a lovely piece of music, but startling enough, if one comes closer one notes that every bit of drapery, every form of the anatomy, whether of the men or of the women, is painted in with great strength and firmness, even hardness—the brilliant hardness of a jewel. This is rather astonishing, and makes one recognize the great force that Poussin commanded. He combined the severity of the Roman buildings in the background with the grace of these Grecian ladies. One feels that it is slightly humorous in tone since Poussin painted these women in elegant poses as though he were saying "Well, no wonder the Roman soldiers wanted to rape the Sabine women!"

As usual, I am impressed by the complexity of the thought. My thoughts turn to Leonardo da Vinci's "Annunciation." Here the Angel of the Annunciation, a lovely young woman, appears in a most graceful pose. Mary, a mere child, a Juliet, stands clothed in white before a lectern. At the bottom of the picture there is a garden of small flowers, extremely dainty and lovely. When one comes close one sees that these flowers, as in the painting of Poussin, are drawn in the firmest possible way. The painting is a miracle of precision.

Leonardo da Vinci was a botanist, an anatomist, so it is not astonishing that all his shapes and forms are accurate. He invented a special glass which he had constructed whereupon, placing the glass at arm's length and closing one eye, he traced the forms of either models or bits of nature as seen directly on the glass. This was really a form of photography. Perhaps it was the first idea of photography that had been conceived. He even went so far as to suggest that, having traced the outlines of the objects, he would

place the glass, let us say, at the foot of a tree which he was studying, and then add the color, comparing it very carefully with the color of the actual object. In other words, he had actually invented color photography. He welcomed any means to learn about the outside world, and then used this knowledge in his paintings.

But to return to the painting itself, on the right-hand side there is a formidable-looking Roman building; and in the upper third, or more than third, of the painting, one finds cypress trees. What an extraordinary combination! Why on earth should Leonardo da Vinci paint this charming young Virgin Mary, and the lovely Angel of the Annunciation, and the flowers, and still in the same painting bring forward a heavy, portentous Roman building and the still more portentous cypress trees? Leonardo did not content himself with the story of loveliness alone, but expressed the other and darker side of the story, which was that this lovely young virgin would very soon become the mother of Jesus of Nazareth who was eventually to suffer on the Cross; so that the cypress trees and the building suggesting the terror of the State were by no means irrelevant. He had managed to express both hopefulness and despair, to come around the full circle of emotions, and yet to hold the whole together in the strictest logic, achieving a structure that was complete and harmonious. Again, one might ask where in modern painting can one find such a range of feeling and thought expressed; such a range of imagination combined with strict adherence to reality?

This very complex way of thinking appeals to me far more than the more restricted way of the present time, where one or two emotions are expressed rather simply; and where the visual reality and the measured scientific reality are so far apart.

We today express, perhaps with great force, certain very restricted, almost narrow experiences—narrow in the sense that they are so very personal, or primitive, or generalized in the quality of the emotion. Even if we say that Rothko speaks of the pulling down of the temple by Samson— a large theme of emotional turmoil—we feel that he gives the story only a general sense. His thought is not specific enough to have lasting meaning. The meaning that it has moves one for a while but then fades out. Whereas with the Leonardo da Vinci the more one looks at the painting the more comes to one.

November 25

A couple of nights ago I went to the Metropolitan Museum to look once more at the little calgonite bowl, 3000 B.C., in the Egyptian collection, and came upon a full-length statue I had not noticed the first time. It was

called "Portrait of the Royal Architect," and was sculpted in plaster regularly interspersed with layers of cloth. The surface, grey-taupe in color, was rather worn, and there was a large gap down the center of the body which fortunately the museum had not sought to repair. The head of this young man was most lovely; his mouth pure, rather small, he had a straight short nose. The whole feeling of the head was that of a hopeful young man, a builder. The accident of the material wearing out, decaying, and the resulting unconventional irregularity gave a strange depth, an extension of one's experience beyond the ordinary.

Artists of today often pick up worn pieces of wood or broken bits of this or that such as stray pieces of glass and use them sensing that they give, fortuitously, this in-depth quality of age.

This, however, can in no way equal what I had felt in the Egyptian statue. The intention of the Egyptian artist had been to do a whole work, a completed work. Deterioration or drying out of the plaster had occurred only by the accident of time, not with the wish of the artist to create the appearance of something old before the work had even been done. Oldness must happen.

In the country I have enjoyed the unplanned effects of drifting earth and pulverized rock melting one into the other. The rock merges into earth, as it were, and the earth accumulates around the bottom of the rock, so that there appear to be no lines drawn, but only edges of "matière" meeting as they sift from different directions. Frequently, falling leaves and flowers are brushed along by the wind that moves portions of the surface of the earth hither and yon, so that nature's surface is everchanging.

Few painters have been able to preserve this quality of chance in their work. I believe Gorky did by means of painting various layers, one upon another, and allowing the edge of the underlayer to fringe the overlayer, to appear around it somewhat as an aura, or as giving this same sense of drifting, or fortuitousness, of something happening rather than being made. Gorky recognized the beauty of "happening," perhaps because he had been raised, at a certain point of his life when he was highly impressionable, in the mountains of Georgia. In Tiflis, where the mists cover the mountains for many hours in the early morning, there was always a softened edge to be seen against the hardness of rock, of distant rock; and as the mist was drawn up by the sun more of the hard rock appeared—as though born. The dual effects of softness and hardness, newness and oldness, one complementing and perhaps bringing out the other in their full force, had doubtless sunk deep into his mind. They were expressed later as showing what of nature he had been moved to notice and absorb.

It was not at all a question of fuzziness, or doing fuzzy painting. At times it seems to me that some of the modern painters, like Larry Poons

or Mark Rothko, or I could mention several others, have a certain fuzziness, rather than this very special quality of extraordinary happening brought about in part by chance, but not chance in the sense of throwing dice, not knowing what number will come up; rather chance in the sense of some, until then, unknown forces moving the parts so that new formations would occur.

Certain modern painters thought more in terms of volcanic upheaval, torrential rains and floods, that utterly changed the conformation of visual reality within a few hours. Clyfford Still, who lived on a ranch in the West, was accustomed to the violent eruption of one form into a new form that occurred during cloudbursts and duststorms. Perhaps this was the genesis of much of his thought. He was inspired by the childhood memories of such devastation.

<center>* * * *</center>

Why did this Egyptian artist so love calm perfection that he made a statue of a young architect who stood quietly there, contained, assured, as though he knew that his image might survive thousands of years later?

November 27

On Thanksgiving Day, Chris brought me an illustrated book on Michelangelo, and I was extremely startled to find that the frescos gave me a sense of crudity, of figures being blown up in such a way that they appeared to be bloated.

Strangely enough this feeling agrees with that of Eugène Delacroix, who wrote on Michelangelo to a friend, and I quote: "'The Last Judgment,' for instance, does not mean anything to me. In it I can only see details as striking as a punch that one may receive; but the interest, the unity, the connection of parts, are absent."

In Michelangelo's "Adam and Eve in Paradise" Adam stands by Eve's side, sensual and, as Stendhal suggested, somehow "shocking and rude." Eve, though a vigorous young woman, aggressive, forthright, active, scarcely gives off the sense of innocence one would expect from an Eve who had not yet eaten the apple, an Eve who had lived quietly with Adam in Paradise.

The women, whether it be the Sybil of Libya, or the other Sybils, or Judith, are all enormously masculine women, powerful, without grace, it would seem to me, fitting companions to the Michelangelo men. For instance, one can easily imagine the Virgin Mary (from "The Last Judgment") to have been a simple woman who gave birth to a child in a manger.

She is strong, but her face is entirely without intelligence or any spirituality. The hands are large and clumsy.

The one fresco that has a certain restraint and calm about it is a detail from the "Creation of Adam." In this painting the soft blue of the garment that God wears is painted in a very subdued manner compared to the other paintings in the Chapel. The vision of God creating Adam is an extremely beautiful one.

In contrast, "Ezekiel the Prophet" is of course, as most of the others are, extremely powerful. The look on Ezekiel's face is that of a shrewd, angry, tyrannical, and even terrible man one would wish to avoid. He seems to have the fierceness that I always detested in the Old Testament. In a way, one might say that Michelangelo had caught the spirit of the Old Testament very well; its ferocity, the killing of one's enemies, massacres, wars, constant dramatic gestures.

I am entirely taken by surprise by my revulsion from Michelangelo because when I was young I had great admiration for him. In thinking back, I feel that the admiration was more for the sculpture and that, in the sculpture, Michelangelo did achieve a much greater sense of structure. Perhaps, after all, he was, as he sometimes said of himself, primarily a sculptor and had forced himself in the direction of painting.

November 30

Multiple possibilities. A few days ago I was observing the three green leaves in my window. Penetrated by sunlight they became what I call "light images." But the last two days were gray. The green leaves, beautiful though in another way, stood in my mind in relation to another plant on the windowsill whose solitary green leaf was very dark, close to black-green, and to a slender stem ending in a white flower. Now the question seemed to be entirely one of aesthetic proportions, proportions of one type of leaf to another and to the stem, and to the spaces between. If I were to think of trying to measure, or interpret this in a painting, it would present the utmost difficulties.

So now, within a short space of time, a few days, I have seen different aspects of this small group of leaves, encompassing no more than a foot, in extremely different ways. In the earlier experience a leaf penetrated by sunlight became a "light image." In the later experience it was a question of leaves, in the ordinary light of day, having certain special shapes and forms and relations to one another. Where do I store the memories of such things? At what time do they come forth into an actual painting?

Certainly, I do not paint everything I experience, but I do experience everything I paint. I value both the calm light of day which permits one

to think only of "actuality," or "reality," and the "miracle" or enhanced reality which is in the nature of a mystical experience. I think of George de la Tour and the singular way in which he was able to paint a candle in full flame. He managed to convey the feeling of flame, the brilliance of it by means of painting the background around the flame almost black.

I am speaking of actual experience encountered at almost any time of any day, and rather frequently felt as it comes into one's orbit. As to the great works of art done by the Masters, what indeed of all the possible experiences they had felt did they tap in their paintings? Every individual, every person living, might find or experience the highest beauty—a most amazing beauty, but frequently he is not in the least aware of this possibility, and goes on feeling, perhaps, that his life is rather ordinary and bleak, and that in order to experience beauty he must go to a museum.

December 11

Under the Sign of the Storm. Under the sign of the volcano, the flood, the tornado—it was under this sign that Michelangelo painted his "Last Judgment." He expresses the dark side of life: anger, violent anger, torment, guilt, punishment. He does not evade anything. But even so I find myself troubled. Michelangelo distorts the proportions of the human figure, as I have said before, but also, perhaps, distorts emotions.

I think that I have come on the meaning (for me) of "Under the Sign of the Storm." In nature storms sweep over trees, the leaves and branches are tossed, sometimes broken, but still the tree retains its intrinsic shape and structure. That does not change. So also in art.

The Greeks, Dante and Fra Angelico conveyed a sense of profound tragedy, and even of events that were horrible, without overwhelming the spectator. They retained the true structure of the human body and soul, rejecting exaggeration.

December 12

Have I not ignored the fact that Michelangelo's frescos were not painted to be seen from nearby? They were painted on the dome of the Sistine Chapel—so that the blown-out feeling, the exaggeration, appear only if one is looking from close by, as in the photograph I was studying.

Could it be that the more sensitive, finer projection of a Fra Angelico would not be seen at all from the floor of the Sistine Chapel, so possibly it was necessary for Michelangelo to paint as he did, bearing always in mind the fact that the viewer was many yards away?

I have not yet resolved this problem. If I think of the great Parthenon

frieze which was placed high in a triangle at the top of the Temple pillars, I must admit that when taken down and placed on a level with the spectator it loses nothing so that, for instance, in a photograph of the figures from the Parthenon frieze one would experience the same kind of perfection that one experienced in looking at them from the ground.

This is also true of the Gothic sculpture placed high on Gothic arches and covering the Gothic cathedrals with marvelous and delicious statues. These statues brought to floor level still have a restrained perfection about them. They seem to hold in any position in space. If I turn to the Egyptian statues that were sometimes quite large, they also remain true to their initial idea. I have just begun to ask myself whether this does not constitute a superiority.

All this bears an interesting relation to the modern school of Abstract Expressionism. Several of the painters painted very large paintings and, I believe, counted heavily upon the size to produce an effect upon the spectator. It was not just a question of the strength or nobility of the initial idea, but upon the actual size as with Michelangelo.

The question whether size in itself should be given importance has baffled me for some years. But, finally, I feel there is a great superiority in the other kind of creation, the one that has its center in itself, and can be placed anywhere, high or low, and need not produce its result through distortion of any magnitude.

December 13

Distance in time as well as in space. Michelangelo used both these factors. The story in the Sistine Chapel is that of the Bible, from the Creation of Man to the final stage of the Last Judgment. Distance gives a special quality; both joy and sorrow are somewhat less acute, certainly sorrow. The spectator can still relate these emotions to ones he has himself experienced, but they do not overwhelm him in the same way they would if presented as the emotions of living men, or the emotion of the artist himself.

But with Jackson Pollock or Franz Kline, artists of our own time, the impact experienced is usually more acute. I remember that when I went to the memorial exhibit of Jackson Pollock at the Museum of Modern Art, I was so upset that I literally ran out of the place. The emotions aroused were too disturbing. I felt he was a very ill man.

December 23

Yesterday, Mina Metzger's* daughter, Rook McCulloch, came to New York to talk with me about her late Gorky drawings. She talked with me

*Close friend of Ethel's who also studied with Gorky.

of her desire to give a drawing to a museum since she felt her own children did not want them and they were merely stashed away in a closet in her Connecticut farmhouse. When I asked Rook whether she would not prefer to sell her drawings and to realize a profit on them, she replied, "I did not paint these paintings, and I had nothing to do with getting them, so I would prefer just to give them to the museum."

I then took her to meet with Tom Messer, Director of the Guggenheim Museum. We were shown into his private office, and there stood, or leaned, the four Gorkys she had brought in. They looked extremely beautiful to me, and I realized that ideally they should be shown in this way, in a room by themselves and in the correct light. Rook decided to give one of these Gorkys to the museum, and to loan them the other three, under the condition that she might withdraw them at any time she wished. Of course Mr. Messer was extremely happy over this arrangement.

On returning home, I happened upon a little seven- or eight-inch palette that Mina Metzger had given me many years ago at my request. It was painted on in soft tones and there was an inscription at the bottom. The inscription ran, "Love and humility open the door to Eternity." Above this inscription on the rest of the little palette were some lightly painted-in roses. I could not help thinking to myself that the loving attitude of Mina Metzger and Rook was a very important element relating to the quality of the beautiful Gorky drawings.

They had been done at a time when Gorky was still innocent. I often used to say of him that he might really be called the "Heiliger Knarr" (the "Holy Fool"). There seems to me to be a great difference between his general intellectual and spiritual condition and the condition of many artists today.

I am not inclined to say that there are no artists living today who work from an unworldly center, but I do think that Gorky was singular in this respect. I know that Gorky, and Mina Metzger, and myself all had a very deep love of the museums—a feeling that there people could learn and refresh themselves. Certainly Gorky had a great longing to have his paintings in a museum, to have them seen, to have them studied and loved.

As I remember, he scorned the tricks of the trade. He wanted his work to "arrive" by force of its strength, and strangely enough it did! He used comparatively little of the maneuvering that is usual in getting into a museum or into achieving worldly success and reputation, and later my attitude was similar.

I remember when Dorothy Miller showed ten or so of Gorky's paintings in the "Fourteen Americans" exhibition at the Museum of Modern Art in 1946. At that time he was still quite unknown in the sense of being able to sell his work, nor had he yet been recognized by critics. But her invitation did not appeal to him. He very nearly refused to show as he felt that the

others in the show were inferior artists. Oddly enough, amongst those artists were, I believe, Mark Tobey and Motherwell, I. Rice Pereira and Loren McIver. He told me that Dorothy Miller had had to weep in order to persuade him to be shown.

Ironically, the Museum of Modern Art, though they showed his work, did not purchase even one of his works from the show. In other words, the Museum of Modern Art was showing these newcomers in an experimental attitude, and in the case of Gorky they did not take him very seriously. They could at that time have bought all ten of his paintings for a quite small expenditure. Can one wonder that he was somewhat embittered by this?

January 1, 1977

In going around with Brenda at the Egyptian show at the Met I realized that the storytelling capacity of the Egyptian artist was exceptional. But at least in those murals which chiefly told how wheat was garnered, how pottery was made—and where all the plain facts of daily living were set forth in great detail and with great clarity—there was another factor beside the storytelling capacity. Significantly, Egyptian art at all times gave a sense of what we call the aesthetic. The shapes were beautiful, the lines were beautiful, the plastic sense was very powerful. The contrast with the Blake drawings that I have been studying because of Brenda's interest in Blake is sharp. Blake tells far more complicated stories, stories dealing with the human psyche, immediate emotion: grief, horror, anguish, violence, and many other emotions. They are well drawn, not infrequently with an appropriate sense of human anatomy and of the true shapes of nature, but they do not have the quality of form, the pure plastic sense, that Egyptian art has.

Even in the small bowls or the vases, even in the jewelry, in all aspects of Egyptian art, one finds this perfect balance, this quality which it is so hard to describe, and which we usually cover by the term "plastic."

At the Met there was a full-length statue of a beautiful young woman wearing a deep necklace, the eyes painted in black and definite, the whole body very definite, clear, sinuous. Again, I could not help but contrast this vivid actualness with Blake. In Blake there's also a quality of aliveness, but not so much of physical actuality as of emotion. He attempts to express emotions in themselves ambiguous, conflicted, unsorted out. Blake relied greatly upon the poetic rendering connected with his illustrations, also upon mythic stories and historical allusions . . . a highly complex effort.

Now, if we return to the Egyptians, at times in their statues of scribes or pharaohs they do seem to achieve great depth and profundity of feeling

which is, in its way, quite mysterious, but never at loose ends, never ambiguous. Even the mystery is clear, while in Blake one comes full upon the frequently unresolved complexity which is so typical of modern thought.

Brenda is analyzing Blake, the poet, from a psychoanalytical point of view, and I think these two disciplines match extremely well, because Freud, a scientist rather than a literary man, was acutely aware of the complexity of human emotions, and strivings and drives. The sadness of it is that Blake was not quite capable of resolving contradictions and ambiguities; he merely presented them, whereas Freud not only presents the difficulties but attempts, and often succeeds in pointing to eventual resolutions.

January 7

I am thinking again of Picasso's "Guernica." The drawings for the "Guernica" are amongst the most savage, direct, emotional expressions in art. They express extreme anguish, but nonetheless preserve the mark or the sign of a master artist. They are raw, but they are art. I should have said they show raw emotion, but they are art.

This is a whole other category from that of my green leaves in the window. These leaves have nothing to do with the expression of human emotions in the sense of tragedy. Neither have they directly to do with aesthetics as it is usually thought of. They have, as I have said before, to do with "miracle." I have used this one example as it was so startlingly clear, but there are many miracles, and the awareness of them can reach different intensities of emotion. The other day I saw a plant, and the edge of one of its leaves was lit, not by a golden light but by light whose color one could scarcely find a word to describe. This constituted the kind of event I name "miracle." It was a minor miracle.

. . . I swing savagely in the darkness . . . a single stream of light may touch the outline of a tree or be mirrored on the surface of a lake. I may daydream of strange things as once I dreamt that Vermeer had painted an eye and had caused a beam of light to direct itself upon the eyeball. As I could not quite remember how he had done this I went to the museum to study this painting and the genius of the artist who produced it. How did he paint a beam of light touching an eyeball? When I arrived at the museum and looked at the Vermeer I found that indeed he had done no such thing. It had existed in my imagination alone.

But many years later, when I was attempting to do some studies of "Paradiso," I found that Dante described beams of light going from Beatrice's eyes to his, and that he used this image very frequently. It is of course possible that having read Dante many many years ago I had recalled this thought (from the unconscious) and had translated it into a visual image.

Possibly the reason we are not more aware of miracles is that I think one must be in a state of calm to perceive them.

The poignant, fierce expression I spoke of in connection with Picasso's drawings for "Guernica" came from the fact that he was in a state of violent indignation over the bombing of Guernica. After he had done this series of drawings, he started to paint and finish a very large oil painting of Guernica. He moved to an epic plane in the final painting, suppressing the violence of the first emotions that he had expressed so vividly.

The Egyptian artist who did the little calgonite bowl was far removed in his feelings and thoughts from such turmoil. He was not even concerned with what we usually call "aesthetic beauty"; I feel, rather, that he was in a state of awareness of "miracle."

As I dictate this to my recorder I look down on the book upon the bench nearby and see the edge of the book lit up. This "light edge" is extraordinarily beautiful, and once more, I would not know how to paint it. This type of beauty resides almost entirely within the realm of light, light made obvious, perhaps by its touching only here or there on objects, or moving through them. When light falls broadly upon objects as, for instance, the light falls upon the beach in summer, it produces chiefly a sense of well-being and joyousness; perhaps it is only when it hits or singles out a certain section of reality and sets it off from the surrounding reality that it can be said to acquire the quality of "miracle."

Van Gogh was intensely aware of this. He painted his own room in the south of France, in Arles. The room was very small, ordinary physically, anxiety-laden. The walls seemed to be caving in; and yet, he perceived luminosity falling upon certain sections, upon the rug for instance, and while he was perhaps convulsed with anxiety he nonetheless could be aware of the miraculous beauty with which light could endow material objects. He was aware of what light is, how things could be transformed by it. But he could not transform himself except in those brief moments when, almost mediumistically, he spread the magic he had perceived.

January 8

Brenda has left me her manuscript on Blake, and I am interested in trying to follow her comments. It is, of course, always possible to over-interpret, and I was always worrying about this in connection with my writing on Gorky.

So here we are with that problem of what associations painting can bring to mind, and whether one is correctly reading the latent thoughts or not.

There is another type of interpretation based on correct reading of what I call "signs." Many years ago, I had three paintings on my wall, one by

myself of Eldridge Cleaver, one a painting by Gorky of a Greek cast seen "contre-jour," and one a drawing by Juan Gris, a "self-portrait." One day, a black friend of mine came to visit and said, "Oh, how nice, you have paintings of blacks on your wall." Any black who was able to read signs well would have noticed that in the Juan Gris, although the mouth was thick, it was the upper lip that was full rather than the lower, and that with blacks it is the reverse, the lower lip is fuller and the upper less full. My friend had misinterpreted the signs.

The Gorky painting was even more amusingly misinterpreted. As he was painting the Greek cast "contre-jour," he painted the cheek with black ink on top of a very smooth oil paint surface, and the curling hair of the Greek youth had somewhat the same character as black hair. This friend exclaimed, "But why is the nose white?" But apparently this correct perception had not changed her first reaction to the work as a portrait of a black person.

One time I was at Knoedler's looking at an exhibition of Toulouse-Lautrec when I chanced to speak with a young woman who was admiring these paintings, and she said, "I particularly admire that painting of the child sitting on his mother's lap." I said, "Forgive me, Madame, but this is not a painting of a child sitting on his mother's lap, but rather a painting entitled 'Elles,' in other words, two women in bed together." This lady had completely misread the signs perhaps because she was not very sophisticated or was unable to bear the thought of the actual content of the painting. She probably suffered from my interpretation, or rather by my pointing out the title (it was really not an interpretation at all, merely a corrected reading of signs).

There is a still further aspect in looking at paintings. This is not a question of reading signs but of seeing correctly what is really happening. There is a Van Eyck in the Metropolitan Museum, a portrait of a young man holding various implements of his trade in such a way that they would necessarily have slipped through his hands and fallen to the floor. However, the shapes of the hands were so beautiful and the whole effect so satisfying that in fact I would just as lief have overlooked the error as it somewhat diminished my joy. There is a painting by Ingres of a Turkish bath in which there are many voluptuous women crowded together. As far as I can make out, there's definitely one woman whose leg is absent. Now you might say, why do you look so carefully at a painting? Why do you not just enjoy it for what it is without noting mistakes, if they are indeed mistakes? Perhaps these masters were great enough to let the mistakes lie there uncorrected as they felt they had already produced the effect of amplitude and beauty they wished.

January 9

Many modes. There are many modes in which art may be expressed: the Dionysian, the Apollonian, [and a] third mode—the one I have tried to describe in connection with the three leaves in my window, the "mode of miracle." It is not a question of idealization; such events occur. A leaf may appear to be changed to light and become a "light image," nonetheless in some strange way remaining a leaf. The calgonite bowl, 3000 B.C., very real, even has a function. It has a function in the actual world, and yet there is a peculiar or special quality of life in it that I have tried recently to describe. It sings. It has become part of the divine music lifting one away, not only from the morbid aspects of reality but also from the sometimes watered-down idealizations of the Masters. It is vividly alive. It does not falter. It is round and sonorous. It vibrates with a special light, encountering no obstacles. It is as marvelous as some of the images Dante conceives of in "Paradiso."

January 17

"A thing of beauty is a joy forever." Though the sun has not come through my windows so brightly these last few days, and my green leaves remain unadorned, the memory of their glory stays with me. I do not renounce the expectation of new states of beauty or pin all my hopes on this one exceptional experience. But as an artist I might well wish to try to paint these leaves as I first saw them in the hope of perpetuating their beauty, while reaffirming their birth in reality. This is one of the functions of the artist, and to it we owe all the marvels of art. One of the artist's great passions is to perpetuate the beauty he has seen, to prevent its disappearing, to consolidate it into the permanent stream of experience.

Transcendent beauty has been expressed in art down the ages. But artists have also attempted to express the anguish, horror, cruelty, torment of human experience. The artists I am most interested in are those who have combined these two aspects in their work. They have neither rejected suffering nor have they been unaware of delight.

This is a "conservateur" attitude. Innovation, which is so loved today, experiment, trial and error, new concepts, all this is most interesting, but I still think that the great "conservateurs" are perhaps the greatest artists of all. Cézanne was indeed innovative in the unusual precision with which he forged tonal links to respond to his acute perceptions of nature, but he was nonetheless guardian of the great tradition, making of his work not only a venture but something more permanent—a conquest.

My joy at perceiving what seemed to me extraordinary beauty in this

very humble situation of three leaves in my window left me "épuisée" when the sun departed and they became mere green leaves (though still beautiful). Perhaps I had a need for the extraordinary, for something so beautiful that it would compensate for the continual loss of those I loved. I thought death could be nullified by creating, and it was necessary that this should be done.

As a child I adored the early spring crocus that forced its way up through the crust of earth. I rejoiced that life had appeared. I particularly adored the early buds, the first indications of leaves on the branches, the tender green of them, the forsythia, the magnolia tree, the early spring flowers of all kinds. One had emerged from drear winter, spring had come again!

In art one finds what is joy-giving, prolonged. Yet even this joy-giving factor may eventually lose its power. Casualties of time, the Elgin Marbles have become mere fragments. Paintings endure injury and are subject to restoration which diminishes their beauty. Perhaps we should be willing to go on to search for new beauties to take the place of old ones.

And yet, I think the artist does passionately attempt to fix what he loves into a permanent form, an unchanging form. Why this passionate desire? What is it he lacks in real life? Perhaps one of the things that makes it so difficult for the artist is that he is aware that he may not always find new inspiration. Inspiration is a wonderful happening but not a consistent one. Gauguin gave up Paris, went to the South Sea islands and remained there re-creating his passionate love of that country.

But many artists have been more narrowly tied down to the subject of their own discourse, and deprived of what they love have become silent. Is this not the case with Marcel Duchamp? Why, at a comparatively early age, did he turn from productivity to the playing of games or to the promoting of his career? Why, at a similarly early age, did de Chirico, who was one of the most original artists of this century, return to the past and, in the opinion of the art world, produce from that point on only faint replicas of the great art of the Renaissance? Why, one might ask, did Picasso, in spite of his great fertility and energy, decline in his later years to a somewhat sloppy style? What caused him to lose his love? What caused him to despair? Why did Dali, again a highly original artist, turn from his very interesting attempts to incorporate some of the great thoughts of the time, namely Freud's vision of the unconscious, and later sell himself to the Devil, so to speak?

January 21

The other night Mona Hadler was here reading to me her piece on Baziotes. In it she quoted Mallarmé as saying that it was not so much the

material reality that was important but its effect. I wondered whether she had quoted this correctly and in what context Mallarmé might have said such a thing. At any rate, as far as I am concerned, this would be a very poor statement. An interest in the effect alone would lack substance. It is important to note the "effects" of reality upon the self, yes, but more objectively one must come as near as possible to creating a clear image of reality itself. Certainly this can be said to have been a major aim of many of the great masters. Rembrandt succeeded in showing the true nature of reality, though he expressed it through extraordinary effects which were highly imaginary. The golden browns, the wonderful shadows and highlights in Rembrandt paintings were produced chiefly out of his imagination, but were addressed fundamentally to making reality more evident, as were El Greco's elongated figures and his strange distortions of light and shadow. It is scarcely possible to do this with complete directness. When Rubens painted Helene Fourment nude in a fur coat, certainly that was quite an extravagant leap of the imagination. Yet it was done in such a manner as to bring her as vividly as possible before us. But still not in her living totality. For this one would have to have the actual body before one.

Perhaps, in recent times, Picasso was aiming at something similar, though I feel that he attained it far more in his sculpture than he did in his painting. In the "Guernica" he manages to create a powerful sense of reality, even though he diminishes the feeling of immediacy and horror that he had accentuated in the drawings. In this painting particularly, he moves furthest toward an epic, lasting style. By giving greater breadth to the various areas of the picture he manages to suggest the breadth of the action, the enormous event which has just occurred.

* * * *

January 22
Once more my leaves in the window in the sun, compact, not tenuous, not fluid. They evoke neither longing nor despair—there is no sense of contradiction, no dialectic. Perhaps it is that today they exist for me wholly in the moment. Each moment that I look I feel that what I see is unto itself, final, complete. There need be no comparison with anything else, though at times of course I have compared the brilliance of these leaves to the scintillation of a diamond. But I prefer not to do this. I prefer to see them in their entirety as a complete instant—as an instance of completion. Further along on the sill is another plant whose green leaf reflects rather than absorbs. The reflection is brilliant, is pure light, spectacular in its way but, without the golden warmth, there is something lesser about it.

In a sense, the leaves in the sun give me a feeling of massiveness. Leo Steinberg wrote of Picasso's "Death's Head" as the single most compact and solid work of sculpture done in this century. Compact and solid, how curious that I feel this way about the leaves, though of course leaves are very slender, very slender indeed, close to paper thin, and light is entirely intangible. So why do I use the word solid? I might also say unified, or of one nature. I might say that their "non-movingness" gives this singular sense of gravity. And yet it is an illumined gravity. Recently I have thought of Mondrian, whose work might appear to be equally basic and solid. But it suffers from one defect—there is brilliance in it but it is a cold white brilliance, while my leaves have a burning heart. I do not at first let my mind go on to consider whether, indeed, this very warmth might not signify life-producing energy, nor do I think immediately of the leaves as growing, proliferating, although in fact they do, oh so slowly, that one does not see it happen—but I become aware of a generative force within this compact group. The instant that I thought of as solid and beyond or outside of time is perhaps within time, inherent in it. Possibly I am moved because of this suggested life-force. Yet at the moment when I first look at the leaves I feel most strongly the totality of the immediate—the sheer fact of the illuminated form. I think neither of the instant just passed nor of the instant to come.

When I was very young, I responded in a similar way to Greek art where, again, the form seemed compact, the moment full, and complete, and time stood still.

But at a deeper level I was aware that if art did not grow as a natural form would, it nonetheless continued in time, even down the centuries. One did not necessarily verbalize these varied thoughts at the moment of looking at a statue, nor at the moment of looking at a leaf, but they were awakened in the mind, and thus contributed to the richness of the experience.

January 27

A couple of nights ago Ethel Baziotes* was here and commented that my portraits seemed to "stay back" and yet to "move forward." This is amazingly correct. From my point of view, keeping them "back," "at a distance" (Gorky always spoke of keeping his paintings "away" on the wall) was a way of maintaining the plastic aspect of art. On the other hand, bringing the portrait head forward, at times almost out of the frame, was

*Widow of the painter William Baziotes.

an emphasis on life—one wanted to feel this person was alive. When studying Ingres I had observed that he managed to do both these things, frequently by reversing the natural forms of the body or head. What was round became flat, and what was flat became round. But in the end all became plastic, and yet was rich in an electric glow, a nearness to life.

The keeping things "away" is usually associated with the classical; the bringing things "forward" is more frequently associated with the revolutionary, or modern. It has always seemed to me that lasting works of art combine both of these elements. They must "stay away" in observance of the fact that they are, after all, art and not life. On the other hand, they must bring about the illusion of life.

The artist is forced to work against extreme difficulties in respect to weight and light. He is working on a flat surface with paints that have actual body to them. To give weight with only flat canvas and paint one might say is almost impossible. On the other hand to give light, which is totally bodiless, by means of using paint which has body, and on a flat surface which is real, is equally impossible, and may be achieved only by the use of illusion. Fortunately, when illusion is correctly used it gives a sense of reality.

The Chinese use scale; for instance, the figures in their landscapes are frequently tiny, one way to suggest, by contrast, the great height of mountains. On the other hand, they make little effort to suggest either weight or luminosity. The great luminous painter, Fra Angelico, used gold which was in itself luminous and gave off a certain quantity of golden light. Yet it must be admitted that it was nonetheless tangible, of this earth, earthly, while light is bodiless.

What is meant by plastic? The other night a friend brought me a photo of an Egyptian head, a portrait of Nefertiti. It had the plastic quality of which I speak. How it was obtained is a mystery to me, but I think that even in sculpture there is the possibility of "bringing forward" and at the same time "keeping back." The keeping "back" or "away," at a distance, is an illusionary way of entering into the stream of the eternal—giving a sense of rest, a sense of enduring.

In my portrait of Gorky, I departed quite definitely from the photograph I was using, especially in the drawing of the planes of the chin. I flattened out the chin. Oddly, no one appears to have noticed this, but by means of this plastic device I hoped to give the sense of "away." Though I was very much interested in the bony structure of the whole head, I treated the forms in such a way that they would not "pop out." Everything was kept somewhat subdued in order to emphasize the luminosity and doe-like tenderness of the eyes, and the sensuous fullness of the mouth, the peculiar kind of sensuousness that is characteristic of an acute appreciation of the aesthetic.

January 31

Discontinuity versus continuity. I have been speaking of "miracles" occurring in what would ordinarily be called simple situations, daily situations. But the miracles were instances selected from the whole range of what I had experienced. I pass with reluctance from the instant of the green leaf, of the dazzling green leaf to the next instant of a neighboring emptiness. I am concerned about this. This morning I am in another room in my house, and as I look around it I think, "How can I permit this discontinuity to occur, the finding of whole areas of time and space relatively empty of joy and meaning?" I look out the window and remember that many years ago I did a painting of a church that I could see through this very window, and that later Gorky came up to my house and worked it over with me, producing a lovely painting. He emphasized the fact that the large skyscraper next to the little church had, for him, not a straight edge to its outline but rather a curved one. He gave lusciousness to what otherwise might have been seen as dull or grey. But now, looking at this same scene, I am relatively unmoved by it.

In museums I used to practice "reading back" from the work of art to the original live subject, its place and time, wondering if I would have recognized beauty in similar scenes. I remember a Velásquez painting of the "Infanta." She was in a room in her palace, I supposed. If I had been in that room how would I have moved from the bare facts toward the painting of such a work? Everywhere I walk I sense "the place where" something wonderful is in the process of becoming, if I could only perceive it.

But now to return to my room, I find that I remember how a year or so ago the morning sun appeared on the mirror of my bathroom door. I rushed to use the glorious phenomenon in some studies I was doing of Dante's "Paradiso." The sun as seen in the mirror had a long vertical passing through it and a horizontal at right angles to it. This image seemed to fit Dante's description of the sun in "Paradiso."

* * * *

Discontinuities. Not contradictions. Discontinuous emphasis. Many of the great masters swept over this kind of awareness. They seized large blocks of space or time and presented them broadly. They did not concern themselves with the type of continuity of which I am speaking.

February 6

I cannot help but wonder if it is the fact that I am growing so old that influences what I see. A few moments ago I was looking at a plant set upon a plate on my windowsill. In an instant, one spot on the plate's edge

became a brilliant oval of light. Around this liquid oval appeared a rainbow-colored wheel whose spokes were made of tiny dots. I could hardly believe it. I had done nothing at all to produce this. It happened quite naturally.

When I was a child, I produced such effects by lying in the grass and flickering my eyelashes in a beam of light until the blades of grass turned into jewel-like brilliance. But on this occasion today it was very simply an occurrence, an event, unplanned. And in a way, though I love this event, I'm saddened by the fact that it is fleeting. I am saddened by the fact that it is more beautiful than the "permanent" art I have seen recently in the museum. For instance, the Mondrian, "A Body of Water," I saw recently was extraordinarily beautiful. The soft deep gravity of the sky and the lovely areas of gold on the water were of exquisite sensitivity. He was able to reach out toward life and then, being a master, he was able to reproduce his pleasure. Yet what I have seen today would be beyond the capacity even of such a master.

Even now, as I look again, I see small points on the leaves where the light has touched the surface of the leaf (perhaps at a point where a drop of water lies as yet unevaporated); refraction occurs and there is a burst of liquid brilliance which has fullness but little weight. The attempt to express this phenomenon through the use of paint becomes so very nearly impossible. This "light-jewel" awakens in me an impassioned interest to know where it has come from and its destiny. Was it not made by light and is its destiny not to return from this particular manifestation to light itself? It will return to the universal, but it will have awakened an image in my mind.

April 1

Contrasts: psychic immediacy and/or perception of material reality. Yesterday I dreamed of a dog. This dream came at noon when I was snatching a nap. I was startled by the actuality of the dog in the dream, so real, powerful, ready to spring forward, as dogs often do, to lick my face. Later in the afternoon someone came from the Cathedral of St. John the Divine to see my work with the intention of giving me a showing. After looking for some time at the large mythic paintings we turned to my watercolors, the series of "Adam and Eve," "Goethe," "Faust," and others. They were rather complex in idea, in many of the studies there were more than one figure, sometimes three, illustrating complex images or trains of thought held by the original author. I felt I had given off a train of vivid sequences, impressions, intuitions, psychic realities, stories, myths.

In the "Faust" series, where Faust, sheltered in a cocoon, is escorted by angels into the further reaches of heaven, there were definite and very

live expressions on the faces of the angels, and I felt that they penetrated the mind. I was really excited to see how much had been conveyed in these seemingly slight watercolors where the touch was so very light, where no studies had been made in advance, where no changes had been made. They were painted strictly as they came, in total spontaneity. This of course could not have been done without intensive study of the stories themselves.

Further contrasts: later in the evening, John Ford came to see me and asked to see my recent watercolor of "Socrates." He mentioned that he felt the gesture of the jailer to be so busily efficient in a worldly sense and the gesture of Socrates calm and unworldly. He felt the drawing of the right arm that was not holding the poison was totally unacademic in the sense that it showed neither bone nor muscle but yet was entirely correct. He used the words "perfect," "the only choice." I had thought that I would relinquish the usual anatomical reality for the sake of giving a rhythmic motion to the arm of the disciple, the arm of Socrates and the arm of the jailer, a dancing motion—the dance of life contrasted with the dance of death. I also felt that I had brought to this watercolor a measure of classical "wholeness." This study was exceptional in that though the jailer on the one side and the disciple on the other were very close to Socrates spatially, nonetheless I had given a sense of separation, as though Socrates lived in a totally different world from these other two. This rather pleased me, and this pleasure was enhanced by the fact that John Ford noticed so many things about this painting that I had hardly dared to hope a spectator might perceive.

In the afternoon Reverend Mann of St. John the Divine, while looking at my large paintings, stood in front of "Orpheus and Eurydice" #1 and made dancing motions as he responded to the rhythm or motion throughout the whole canvas which really seemed to delight him. Again, if rhythm truly did occur in the work, it was not a matter of direct intention. I was dwelling upon the music of Gluck's opera, *Orpheus and Eurydice.* Although I do not sit down to listen to the music separately, I let it play on all the time I work and occasionally lean back upon it (as one would upon the waves in the sea when one is swimming). The music quickens my thought and I think is transmuted into the colors and directions and rhythms that then come to me, and that I use selectively.

When I was young I used to sit at the seaside covering my eyes so that I could hear the pounding of the waves more intently as they came in upon the shore. Then I would open my eyes and ask myself if there was a perfect correspondence, or what sort of correspondence did exist between what I heard and what I saw. I spent many hours over a period of several years talking this question over with my friend Mortimer Adler, the philosopher.

He became greatly interested in the subject and brought me many books upon it. One had responded to a single reality, but the impression upon the mind came from the dual faculties of hearing and of seeing. I felt this dual feed-in enriched first me and then whatever work I might be doing; in other words, this reservoir of sensory responses had great importance.

I was particularly delighted with this young priest's reaction as I myself often break into dance when I am working. I remember how thrilled I was with Nijinski. He would come from the wings to the stage and at a certain precise point of the music and upon a certain precise point on the platform he would take off on his tremendous "free" leaps, landing again some yards away at another precise point in the music and another precise point on the stage. A great stream of thought and feeling, of powerful urgency, of tenderness, of moods of all kinds surge through the individual phases of a specific dance choreography. But there is also the music and the space of the stage, and the dancer has at all times to have regard for these and to make his leaps or any other motions that were a part of his design correspond very exactly with a predetermined pattern.

In painting, too, the artist must multi-relate to the size of his canvas, to the edges of it, to the individual forms which must be so thought out as to give space to other portions of the total design. I have always found it most difficult to bear in mind continually the relation of one form or, as in the case of these particular watercolors, one personality or personage to another, or if three, to have room for all three. They must coexist in this particular space, and one must find the right proportions and inter-relations.

April 4

In "Eurydice" #1, for example, I finished the left-hand third of the canvas, which was quite large, in just one or two days, but it took me a long time to do the right-hand third. There was the struggle to make this later part correspond in style and fit in coloristically in the proper way. It was no longer a question of spontaneously filling an empty space, but of completing a painting. And the painting must retain the feeling of freshness even though weeks of effort may be needed to achieve this.

What of that dog in the dream with the bristly hair and the enormous sense of energy? A real, immediate, full moment of existence. So piercing, even menacing. The piercing, menacing qualities I have referred to come from life itself. Indeed, this dog might have leapt upon me, or perhaps I merely feared he might. But in a painting, no matter how marvelously done, a leaping dog or even a charging bull, as with Picasso, still remains flat upon the canvas. They do not move. They are not in reality menacing.

They consist only of the shadow of something menacing. As the shadow to the tree, so art to reality. It has the same shape, quite exactly. It suggests the reality of which it is but a shadow, and yet it remains in place, quietly.

But where art involves the creation of beauty something else occurs. Something new, unborn until that moment, has come into existence, not a copy, reflection, shadow, or x-ray of the real world. It evokes new responses as it itself is new. In this sense it is like the newborn. Created beauty evokes responses, tremors in the soul, a music-making faculty in the spectator. Given the incentive, he may compose what otherwise he would never have thought of. Frequently he is moved to ecstasy. He may even become faint with the force that stirs in him. Beauty is provocative of living response. Art cannot simulate reality. It cannot make a dog such as I dreamed of. It cannot make a blade of grass that is as real as the living blade of grass, but when it concerns itself with beauty it does make something real that may evoke creativity in another person, the spectator. How strange this is! When art consents to occupy itself entirely with the creation of beauty it at the same time provides the greatest amount of real life or actuality.

Fusion of substance and form: this can be accomplished by a living force vibrating through the mind of the artist. He feels and distinguishes. In the bud he sees the flower. He apprehends the eternal cycle. One would think that running wild on the breath of love the lines and forms and colors would come out jumbled, but it is not so. They will come out in a highly organized way. If we think back to the black hole and the fact that as particles emerged from it into the larger space there finally came about an eruption which created a new universe, so out of confusion, or seeming confusion, can come creation; out of love, though confused, there can come a special unity.

April 12

Correspondent. Correspondence. A congruous state. How dare I try to bring into congruence so many seemingly disparate forms or moods. The lily I saw at Hannelore's on Sunday was white, but as I looked at it I perceived a silver tone like the tone of the sea Shakespeare described in his *Richard II* (speaking of England). Shakespeare used the rather precious word "silver," and I too would like to use it to describe the tone across, or lining, or filling the inner chalice of the lily. Simultaneously I perceived the full form of the lily, a very powerful form, and this seemed to bring about a sense of possible contradiction or ambiguity. But no, I found it was possible to respond to powerful form and at the same time to the most subtle silver tones. This awoke correspondence or congruity in me, a sense that I could

respond to both shape and shadow, different as they were, occurring in one form, the flower. The efforts of painters, even great painters, had usually seemed to me stilted, heavy, formal or, in other cases, sketchy and insubstantial, quite other than the full experience I had enjoyed.

April 13

I do not seek moods but when they come upon me I do respond to them. I do not ignore them. I think this is important because I think in many of the great paintings in the museums, though they seem to be concerned chiefly with form and space, color is used to evoke moods. Sometimes almost hidden in very small portions of the canvas, in a stroke or area here or there. To return to Vermeer, about whom I wrote some days ago, in spite of the formal quality of his works, strangely enough, he expresses mood frequently.

* * * *

I saw the lilies again yesterday in the morning light and found that the silver gray was no longer present. I looked into the lily and saw the yellow stamen and a rather bright green area toward the bottom of the cup, a whole new set of visual experiences, evocative of visual reality but not of mood. One might think of the early and later Mondrians. In the early Mondrians he presented, or evoked, mood, very tender and emotional, laden with feeling. The later Mondrians appeared to be more concerned with concepts than with emotion. He had squeezed the emotion out and forced the concept to stand by itself as the total content of the painting. One might ask why. I know very little of his life and therefore do not know why he might have turned in this direction. Many twentieth-century artists followed his lead. One might almost say it became the fashion to pursue concept and to freeze emotion.

April 15

Last night at the Guggenheim a showing of Kenneth Noland. I walked or almost ran through it in dismay. There was a certain force. One felt this man might be strong as an athlete is, but it seemed to me that neither the intellectual, emotional, nor spiritual quality was present in any satisfying degree. These rather large canvases, based on the most simple conception of space and color, were hung from top to bottom of the Guggenheim Museum. The museum was of course packed with people and clamor, and one wondered what they found in all this. Was it the liking for a sense of power that I mentioned, for athleticism? His application of paint to large

surfaces is singularly dull and empty. Can it be that people like to see set forth the emptiness and dullness of life at the present time, the rather low level so saddening to those who care? Why are those of us who feel the deadening influence that is present today . . . why are we so silent? Why do we not speak out? Why do we not try to get to the younger people and help them think things through in another way, to rebel, to not accept what is handed out to them by the establishment? I'm afraid that quite the contrary direction is being taken.

There is always the danger that one might have ceased to respond to the new. It has happened many times, but everything in me forces me to feel that it's not just a lack of response on my part but a true judgment. Yet there is an area of doubt.

Can it be that Kenneth Noland's intention is to deal with space, in the trend set by Barney [Barnett] Newman? Can it also be that unconsciously Kenneth Noland has projected a sense of cold menace, a menacing mood? How is it that people looking at these paintings do not notice what their content really is? They are, in a way, as aggressive as a brutal wrestler who does not hesitate to smash his opponent to the ground and then leap upon him with all his force and weight.

During the years that we lived on the farm at Pennington near Princeton, I struggled to do a painting of the large trees that surrounded our house but was defeated in my attempt. The massive green weighed me down. I could not see it in any other way than as a dead weight, dull, heavy. I will not go so far as to say I found these tones and forms menacing, but perhaps there was something of that in it. Yet I in no way dislike green as a color. I adored the pine woods of the Adirondacks where we used to visit in the summer, where I walked with my father through the lovely scented woods, and on the soft springy earth that was sienna in color, smelling the lovely pine odor, sniffing it in with delight, as he carried me on his shoulders. Now why should this slight difference in the tone of green make such an impression on me that in the one case I was most happy and in the other very oppressed? Perhaps it went all the way back to childhood. There was a tree outside the room in which I slept as a child and of course at night it must have appeared very dark. If I had not been able to go to sleep or if I awakened, perhaps this tree appeared menacing, as though part of a nightmare. Perhaps there was no one to whom I could communicate such fears, and then later, all these years later, that particular green (loaded with ancient memories) may have seemed terrifying.

One is not a machine. One is a sentient being. So I do not hesitate to suggest that some elements of personal trauma may determine one's reaction to current paintings.

April 23

Art as a vehicle for the externalization of psychic injuries: is this exploitation or may it be revelation? In the latter case, it might well bring humans together. They could recognize through art some of the problems they confront, and this could be of help. By revelation I mean the understanding of deeper psychic forces, their way of working, their way of being, their meaning to man, their generative force, the joy they may give, the reality they may state. They reveal man's state, his estate. In a way he owns the universal if he can attain to it. In the simple instance of my leaf, in the window in the sunshine, I think I reached out toward the universal aspect of this occurrence in terms of light passing through the leaf, and making it into gold or into a light image. This was a universal. In that sense it was a revelation, and it was joy-producing, which I believe to be one of the major functions of art.

Incoherence. Clutter. Whirling confusion. Misery. Anguish. Anger. Anxiety. All these occur in the human mind, but they are quite the contrary of joy-producing. There may be, however, recognition, frequently very sudden, of the universal being present in even the simplest situations or forms. The other day I went to the park with Sylvia* and we looked at the trees, at the fruit trees in bloom. I was struck by the multitude of inter-relations of trunk to branch, and branch to flow, of all of these to space. I recognize that for me they seemed to be a "déjà vu," something I had seen very often in the work of the Impressionist painters. Could I see it in a new way? And what of the sky, far away and above these inter-related shapes and presences. Sky has seemingly been impossible to paint. El Greco in his view of the city of Toledo came on a curious device of genius. He gave a new interpretation in paint of sky. He made the hills below the city more transparent and the sky more solid, thus producing unity in the work of art, though reversing the actual physical truth, that the earth is solid and the sky airy. Did he consciously say to himself that paintings of the sky could not be done and that at any rate in the way he had chosen he would be able to make a picture, a work of art? And indeed this work is especially satisfying. Possibly I am saying that one must, after all, accept the limitations of the man-made, and concentrate one's appreciation upon what man has been able rather than what he has not been able to do. My difficulty lies in the fact that I constantly see further possibilities: the calm of the sky as it extends upwards, the blazing light of the sun, the marvelous fluidity of water, the shining dewdrop on the first crocus, the icicle hanging from a winter bough flashing, immaculate. Perhaps it is unfortunate that

*Sylvia Smith, a longtime friend of Ethel's.

I see these things because it fills me with longing to paint them, a longing to accomplish the impossible, to create something that will endure, that will cause my vision of life to endure. At bottom, perhaps it stems from the longing to preserve certain loved beings close to me. Shakespeare, grief-stricken over the thought that his beloved might die, consoled himself by the idea that her image, at least, would be preserved through his art:

> So long as men do breathe, or eyes can see
> So long lives this and this gives life to thee.

But let us remember that he wrote this poem with the probable intention of showing it to his beloved, so that it was perhaps more a love-gesture, a lover's gift, than the stated wish that in this way her image would be preserved. Possibly he had not come to the point of really believing in her death. Was he not playing with the idea? In truth, the poem does not give eternal life to the beloved. But it does comfort the poet, and beyond that it gives hope to man in general that he can convert emotion and move it on from one individual whom he loves to its incorporation in an idea, in a line of poetry. This is most difficult to do because the insatiable nature of the emotions requires the actual presence of the beloved, and it is only with the utmost difficulty that the mourner can substitute art for life. Nonetheless this attempt has been the mainspring of art down the centuries, i.e. denial of reality or denial at least of the impermanence of the beloved in the flesh. Perhaps one might say the work of art is the affirmation of the permanence of the human spirit, rather than the permanence of the body.

* * * *

Fresh is the morning. The pale light touches many areas here and there. A light wind blows through the window.

four

"There are certain forms of pain that
 resolve into eventual equilibrium."

"In childhood my mother's room
 appeared to me all light."

"I, alone now and old, find my mind
 filled with visions of . . . angels."

"The image of the dark green turtle. . . .
 [Was I] indeed like this turtle,
 moving perforce slowly due to my
 illness but spreading the idea of
 love?"

THE TORTOISE
AND THE
ANGEL: VISIONS
OF ART AND
LIFE

INTRODUCTION

There are no process notes on painting in this part of the
journal (April 1977–April 1978). It would seem (though Ethel
doesn't mention it) that the pain in her hands had gotten worse
and she was not working, or working only a little. Because of
her worsening health, she often contemplated and tried to come
to terms with death, which she perhaps saw as a way of becom-

113

ing reunited with her mother. The major event during this period was the January 1978 show of her mythic paintings at the Cathedral of St. John the Divine. Without specific paintings to focus on, her meditations take on a more contrapuntal form. Like ocean waves, her thoughts ebb and flow, returning periodically to her central themes: vision, death, time, and the function of art as ordinator. For her, art teaches the artist about his center or balance point, and she imagines this center as always tranquil and radiating serenity to others. She increasingly rejects art that shows conflict or cruelty, and criticizes artists who seem to her to compensate for their inner insecurity by displays of force—the "aggressive powerfulness" of men like Kenneth Noland.

The section begins on April 29, 1977, with one of her joyous visions, this time of a daisy in a vase. Now she says that she no longer mourns the transitory quality of such visions, linking them with the equilibrium that comes "after certain forms of pain." Her emphasis has shifted, from an ideal of calm, which we saw was holding down anger, to a more inclusive idea of balance or resolution of conflict. There is even the idea that pain itself can be life-giving or productive, as in childbirth. She considers the liberating idea that one's responses are more important than the painful situation. Thus she imagines that even soldiers dying in battle can be content, "feeling fulfilled within themselves, unified, at peace," if they have found their inner balance.

Ethel feels that in order to achieve equilibrium she must understand her own past. Her art is an instrument of self-discovery, at once her "field of battle and childbirth bed." In expressing inchoate inner feelings, she discovers still other and related feelings and tries to make order of her discoveries, calling this the "ordination of intangibles . . . experiences . . . as yet unnamed, not easily defined, and yet recognizable as part of an ordered universe." To her this process is more than therapeutic; it has a mystical cast: "ordination is a spiritual necessity . . . we must bring things in order, but we must also remain free for further search."

What she finds difficult is the contradiction between her love of only serene and peaceful art and her own awareness of inner turmoil. Her praise of conflictless art alternates with descriptions of a brutally different kind of painting in a way that suggests that her criticism is in part self-criticism. She lists the

qualities that cause her pain: "Should we not avoid that art which is tied up, stiff, tense, anxious, full of hate or suffering?" and then turns again to the leaves in her window. They "are passionless. They do not cause pain. They may be enjoyed. They give one a sense of peace."

Her insistence on calm is an attempt to come to terms with her own death by envisioning it positively as a reunion with her mother. She does this through her meditations on light, which we remember she previously connected with her mother's smile. On May 4 she is pierced and "enlightened" by sunshine. In one long paragraph, she links her childhood perceptions of her mother (surrounded by light) not only with her own mature art where she tries to recapture that light, but with an after-death state where light and a beloved woman will be recombined as in Dante's Paradise. "In childhood, my mother's room appeared to me all light, and perhaps it was there I fell in love with light or light-illumined objects. . . . There, too, I made a deep . . . resolution to create works that would contain light of similar intensity. . . . I have always felt that Dante had similar experiences which culminated in his descriptions of Paradiso."

She hoped to be reunited with her mother by avoiding (or transcending) violence. Fear of her own anger explains some of her vehement criticism of angry art, although it does not invalidate that criticism. It also helps explain why her criticisms often come at points in the journal when she is holding down her own angry feelings. Her first expression of disappointment at aggressive powerfulness in abstract art comes after she speaks of her mother, light, and Dante's Paradiso—that is, after her anger toward her mother threatens to disrupt her soothing fantasy of a reunion after death. The next critique, this time of Picasso's use of the ugly, cruel, and depressing, comes after she speaks about the ordination of intangibles, inarticulate, buried experiences and perceptions. Later we will find that the most significant of these recovered experiences have to do with disillusionment and anger at her parents. The third and most violent critique, of Pollock and de Kooning, comes after a discussion of Greek art's desire to possess the beloved by creating something beyond loss.

We have seen her pain and anger at losing a beloved person to death. Now, her feelings focused by the breakup with her lover, "X," she returns to her inability to let go and accept loss. The earlier loss of her husband is resurrected. Now, twenty-six years after Wolf's death, for the first time in this journal she

writes of her pain and of her loss of the sense of time. She wonders how anyone can tolerate unsatisfied longings, "whether it was longing for a woman's love, or to return to the mother's love or to the womb, or possibly a longing for death or an attempt to overcome fate and to preserve the beloved through ageless beauty." Her answer is that art or vision is the only way to make loss tolerable. Filling up time or space in nourishing ways counteracts the pain of longing.

Finally, she creates a transcendental image or persona for herself that temporarily resolves her conflict over anger. She projects herself as a placid turtle progressing slowly through a light-filled sky. "I . . . like this turtle, moving perforce slowly due to my illness but spreading the idea of love." She sees angels everywhere in this sky, flecked with points of colored light, their expressions different but all radiant and quiet. "I, alone now and old, find my mind filled with visions of . . . angels." The section ends as she contemplates a pot of violets, a plant she associated with her mother, which fills her with "an extraordinary depth of tranquility."

THE JOURNAL APRIL 1977–APRIL 1978

April 29, 1977

"To see a world in a grain of sand
And a heaven in a wild flower."

In these lines Blake presents a concept which is fascinating and even stupendous. But when I see an actual flower, as today a daisy in a vase, an entirely different image occurs to me. I do not think of such a broad or mystical image as "heaven in a wild flower"; the flower is closer to me than that. Its quiet loveliness moves me in a far more intimate way and leads to a rare state of being. Does this daisy say to me, "I am"? No, it just exists. It neither needs to speak, nor does it require an answer. I find the subtle, entrancing, grey shadows on the leaves cause my mind to glide back to the time when I was in the mountains out West, lying flat upon the ground close to a gurgling, limpid, mountain stream. I saw with delight the transparent flow that was defined only by the brook's edges or the

highlights upon certain water-surfaces. Looking upward at the evergreens, their dark shapes, their graceful boughs, so complex in outline, I also noted the pungent pine odor, the sweet-smelling sienna floor of the forest, and above all the silent, odorless sky. I thought I was in Paradise, and I wept that summer of 1920 when I had to leave. But today, this little daisy is for me a special presence as was a fly that walked daintily upon a windowsill in my home as a child. I was fascinated by the slender legs, by the delicate wings. I no longer mourn the transitory quality of such experiences, but accept them as joy in the present—a correspondence between the outer and inner worlds.

But what of the stern and terrible sides of life? Anger, fury, illness, death, upheaval, turmoil? Is there any connection at all between these realities and what I have just written of? Perhaps. Perhaps, yes.

There are certain forms of pain that resolve into eventual equilibrium and even fulfillment. With my first child I made the discovery that the great pain of labor I had read about so often was really quite different from what I had expected, most natural, bearing with it a kind of gravity, a perfect balancing of psyche and body, a sense of fulfillment. [See plate 11, *Woman III,* one of her most powerful "birth" paintings.] It was not a traumatic happening that one would shrink away from, or that would cause fear, or withdrawal. It was live-giving. Curious that I use this word. It was, in fact, life-giving. So this kind of pain appeared to me to be good.

But what of other kinds, the kinds that menace the integrity of the psyche, cause it to bleed, or to fracture, where there is either no healing to be expected or the healing would be very difficult? It has often been reported that soldiers die in battle with the same dignity that I referred to in enduring birth pangs, feeling fulfilled within themselves, unified, at peace, in a state of harmony, equilibrium, well-being. Perhaps, more simply, the decisive factor was just being at the true center of their own psyche, whether in pain or in joy. And so I have found a way to unite these two seemingly different types of experience, and to have found the common denominator.

May 4

Startlement of sunshine. What it touches pierces and enlightens me.

Yesterday I saw three old-time films done by the Dada/Surrealists, Salvador Dali, Man Ray, and Marcel Duchamp. In one scene of his film, Man Ray shows a newspaper whirling down the street, tossing over and over. I asked myself why this scene was so touching, why did it move me? And the answer was that he had brought to this penetrating rendering emotional material from the subconscious or preconscious, and that some-

how I had been able to "tune in." Marcel Duchamp's piece, on the other hand, was highly geometric and organized, as most of Duchamp's work is. He had set into motion certain rather simple circular geometric shapes in a way that suggested to me a caressing sensation; again I felt tuned in. Primarily, these three artists felt before they constructed. They were not inattentive to the idea of construction, but at the bottom of their thought was always a suffusion of feeling, and this made of the work a living thing.

I perceive light as it comes through my window illuming now one set of objects or another.

In childhood, my mother's room appeared to me all light, and perhaps it was there I fell in love with light or light-illumed objects. Perhaps it was there, too, that I made a deep, almost hidden, resolution to create works that would contain light of similar intensity. These works were to come about only many years later, and even then perhaps they did not wholly satisfy the initial longing. I have always felt that Dante had similar experiences which culminated in certain of his marvelous descriptions of "Paradiso." Dante, after rising above the sun, and his guide, Beatrice, went higher and higher toward the light, beyond the angels and the book of Laws, and finally approached "sublime" light itself. But at that point, forced to return downward, he realized that though he had experienced something very marvelous he could not remember it. Similarly, I could not remember the glories I knew I had experienced, although some faint aspects of these mysteries appeared in my work in later times.

Last night I was talking with Paul B.,* and we were speaking of some of the recent art shown in museums and about. I compared it, in its impression on me, to the times when I entered large buildings, such as Chase Manhattan, and felt a terrible weight loaded upon me, an aggressive powerfulness which overwhelmed me, and in which I, as an individual, was really lost, bewildered. It seemed to me that these large commercial buildings were entirely out of contact with me. They represented the power of money, the power of big business. They were a center perhaps of our modern society, but they seemed not to respond at all to the needs of an individual. It seemed to me very sad, as I said to Paul B., that the art, or some of the art, today should have responded to this complex of thought.

May 18

This morning little Roger** showed me a very tender drawing he had done in school, a drawing of his body. The head was skull-like, although

*Her friend, the painter Paul Bodin.
**Roger Schwabacher, her grandchild.

there was hair upon it. The lungs and stomach were indicated. The hands were very slender and long. The feet were beautiful. The whole drawing emerged as an expression of deep interest in his own body, in its nature, how it was made, of what it was composed, and therefore rang extraordinarily true. It came from a genuine impulse to feel himself fully, to know himself, to discover himself. And it seems to me that to know oneself is an important urge of all art. It is very hard for me to believe that so young a child, six years old, could paint with such mastery. He believes in what he does. It has meaning for him. It is done with extraordinarily little knowledge of the art of the past, as simply as the cave drawings of primitive man who showed such great sensitivity and awareness of the visual forms of his world in all their exactitude.

May 19

Desire for orientation: the longing to know the nature of oneself and the world, and later, as one grows older, the longing to know what was in the past, and to look forward to what might exist in the future. Without this kind of orientation there could be a feeling of fearful inner loneliness.

With the Renaissance artists, the orientation was for the greater part a religious one. More recently, in the nineteenth century, many of the great artists relinquished such subjects and turned all their interest to the study of the actual structure of the earth, rocks, trees, all of the visual world that they could see. Sometimes they reported man in the same manner, more from the outside than from the inside. Not what he is, but what you see when you look at him. So Seurat painted. So Degas painted.

Later, that great question arose again: the nature of the self, its orientation. Who one was. Perhaps this was brought about by the findings of Freud, who was concerned with the self of the individual at all depths that would be re-attained, rediscovered, uncovered. His method was similar to that of an archaeologist who would seek various layers of civilization at one spot, successively finding one epoch underneath the other.

May 24

Ordination of intangibles. Is this a contradiction in terms? No, because I am thinking that the child, and later frequently the artist, senses many experiences of a psychic nature or an emotional nature that are intangible, as yet unnamed, not easily defined, and yet recognizable as part of an ordered universe. Ordination, whether it is of intangibles or tangibles, is most relevant. I think again of Roger's large drawing of himself, of his bony structure and organs. The reality of the physical self is certainly not

highly articulated, but his feeling for gaining the knowledge is most sensitive and moving and very real. It arises from an inner level of the self. It speaks of searching, starting from the center of the self and aiming at a knowledge of this very center, and thus is an important statement in its own way. The help he got from the teacher in showing him where certain organs were forced the drawing into a more adult concept. If we were to think of Leonardo da Vinci of course he had studied anatomy and art and could express himself with the greatest possible certainty; the figure is thus and not otherwise. The bony structure, the muscles, the conformations of all kinds were correct, but strangely the very beautiful quality of search was not there. There was no longer a search for the soul but rather the results of that search crystallized out of an acknowledgment of the power of the mind not only to search but to find. These then are two different things. One is a question of knowledge, first attained, after much labor, and then projected; the other is a question of the inner reaching out toward knowledge, the importance of it, the meaningfulness of it, even, one might say, the absolute necessity for it. So ordination is a spiritual necessity. We must bring things into order, but we must also remain free for further search.

May 25

Remember the ugly in art. I particularly think of the large retrospective show of Picasso at the Museum of Modern Art. I went through it rather carefully, noting the great power of the work, the mastery, the genius, and yet as I came out of the show I found that my spirit was troubled and depressed. I longed to escape from Picasso's dark land and thoughts. Just beyond the Picasso show there were two very beautiful large Monets on the wall, and I thought, "That is where I am." I could be happy with Monet, not with Picasso. The Monets were full of sunlight and rejoiced in life. They were not concerned with harshness or cruelty.

If the function of art were to tell the nature of societal reality, to cover all aspects of life, then the bitter cruelty that is shown in the work of Picasso and many others would have its justification. I do not feel that this is altogether appropriate to art. I feel that somehow the brutal aspects may be presented, yes, but in such a way that they do not leave a depressing effect on the spectator. The artist must also present a path up and away from these sad, cruel aspects of life, and I believe that a great work of art does exactly this.

May 29

I wish to discriminate between feeling that comes out of the center of the self and feelings aroused by a multitude of secondary conditions. Roger's

drawing of which I wrote some days ago came from his own desire to learn about himself. . . . The artist who has succeeded in finding himself, through whatever efforts, is the great artist. A Rembrandt, a Titian, may find himself in finding the world, but I think not altogether. I think there was another aspect to their painting, beyond the representation of what they could observe of the structure and content of the world around them. Are Rembrandt's great shadows his response to any actual experience of nature in front of him, or of art as learned? No, descending into the well of his own being he found there ready for use marvelous golden browns, a sense of amplitude and peace, warmth, naturalness. I am quite sure that Cézanne found his center by counter-balancing his subtle sense of the motion of light with various fixed aspects of nature, such as rocks or trunks of trees, or still-life. At the center of his being, perhaps, motion was the most important thing, a slight and delicate motion, as though of breathing. Everything in Cézanne has within itself the capacity to move, if only very slightly. He succeeded in giving the illusion of motion in his painting by suggesting fluid light laving and surrounding such unchanging objects as tree trunks or rocks. Thus he unconsciously satisfied his own deep longing to breathe. When Cézanne said, "I would like to present those feelings we bring with us at birth," could it be that he was referring to the instinctive sense that the infant in the womb must have felt?

The Egyptian potters who made the vases that are now on exhibition in the Metropolitan Museum must have been strong men, and yet they painted a decorative line that lay upon the surface, somewhat meandering, easy, without force, without a burst of energy, much as the lines made upon the sand by the incoming waves that then recede. Could it have been that these were amongst the first vases and that the idea of making a vase was at that time a new one, and the conception of how to decorate it was, in that sense, tentative, not something handed down by previous generations? The qualities of tentativeness, discovery, search, inquiry, appealed very much to Gorky, as I remember it. He liked the early work of Yves Tanguy and Dali. It was so tentative, so, no I will not use the word "experimental" because it was not an intellectual or theoretical thing—not a manifesto. They were feeling their way through their minds, and through the breathing outer world. Perhaps they had loved to watch flowers bending in the wind, or clouds moving gently in the sky. Perhaps they had noted the very subtle and calm effects of these slow motions upon their spirits and were attempting, without even thinking of it consciously, to achieve that quality in their art. The Egyptian artists had the courage to leave the way open, to let something come forth rather than to determine to bring it forth.

Perhaps it is a sense of low tension and rest that I delight in. This does not mean that art cannot have strong content. Blake's "Songs of Innocence,"

for instance, have this wonderful quality of hiatus, of rest, of delighted rest.

The bicycle in my dream last night, plunging downhill at an oblique angle, was delicate and fine in contour, swift and somehow exquisite. This reminds me of the Egyptian show again, the cattle carved in marble with such fine outlines. One does not really forget the strength of these beasts. They are powerful and yet the line which circumscribes them, by which they are depicted, is of the finest, and extremely elegant. What sort of paradox is this? If one thinks of Picasso's bulls with flaring nostrils and every indication of energy and power, one senses the contrast. Did he need to be so emphatic? Was not the de-emphasis in the Egyptian art superior?

June 10

A year and a half ago, John Ford did a very beautiful painting that I hoped would lead to what might become his best work. It was based on a geometric grid, but the figurative element which he included in it was taken directly, as he told me, from my watercolor series of "Adam and Eve in Paradise," with which he was at that time in great sympathy. He created beautiful meandering lines that truly did seem to come out of the geometry, and all aspects of this painting were sensitively felt. I was very happy to think that he had found his direction.

June 21

Can it be that I have come upon at least part of the secret of the repose shown in the Egyptian vases? In the midst of a civilization that was possibly quite violent, there may well have been certain individuals who reached a degree of inner tranquility. The vases were simple, unified, reflecting no sense of struggle, contradiction, or ambiguity. This does not mean at all that they were without strength or vital energy.

The Guggenheim Museum is planning a Rothko show. He is an example of a modern artist who has brought tranquility into his art, but unfortunately not a true tranquility. In those paintings where he achieves tranquility it is split off from the rest of his personality. In other portions of his work he shows a somber, tragic side of his nature. I am suggesting that the Egyptian vase maker, and even some of the sculptors who fashioned the scribes and other statuary, had succeeded in integrating their personalities to a far greater extent.

I have written about the perfection of Grecian art resulting partially from excessive longing. The excess of longing produced a need for an enduring creation, something so perfect that it could not conceivably dis-

appear or be lost. This idea was also expressed by Shakespeare, as I have written somewhere in my notebooks. He felt that he could write poetry which was bound to be eternalized thereby perpetuating his beloved who would live in his work. But is there not possibly something unhealthy in this, springing not from a whole and developed personality but from one still tied to the unhappy and impossible goal of possessing the beloved?

Think of the Indian Buddhas. They also, as in the case of the Egyptian art, seem to have reached a tranquil fullness not based on excess. I question once more if it is not possible that a fully developed human, having overcome the grosser kinds of conflict, may be able to produce an art that does not spring out of excess, that is not divided from the rest of the personality, where there is a minimum of dialectic in that sense, no opposition, simply the full flowering of a mind or soul?

Perhaps one should accept the fact that art, like life, may well contain both good and evil, beauty and ugliness, and all shades in between. But I am particularly interested in the art that has grown out of the fullest development of man, an egosyntonic development rich in serenity, where the major weight of the work lies in its sense of fulfillment, breadth, ease, hopefulness.

July 2

I have before me a postcard reproduction of a detail from "The Funeral of St. Francis of Assisi" by Giotto (Basilica of San Croce, Florence). The directness of the emotion felt by the assembled priests is represented as overpowering. There is deep loving concern for the dead one, and since St. Francis lies there in a state of calm grace there is also spiritual acceptance, as one would expect. One priest kneels at St. Francis' side looking sorrowfully into his face. The priest's hands are clasped. His hands, as in some of the attending figures in the Petrus Christus, "The Descent from the Cross" (Metropolitan Museum), are curiously passive, as though expression were inhibited, frozen, by the enormity of the loss, by the enormity of the event. Loving with great depth of passion, the priest was overwhelmed in sorrow. His hands are those of a priest who knew and accepted, despite the agony it cost him, that St. Francis was indeed gone forever; neither could he contest his death, nor bring him back, nor could he accompany him. In this depiction there is no sense of ornament, speeches, words super-elegantly spoken. The mourner has not yet come to the point where he could consider that St. Francis' words and his example would live on and exert enormous influence, that somehow his works would contain him and continue his image. There are no tears shed; emotion is held within, but

nonetheless shown distinctly. There is a relationship between these two, the devotee and the saint.

Looking again at the photo, I notice that the body of St. Francis, clothed in monk's garment, gives the effect of a certain rigidity. The garment lies in stiff, although uneven folds. The pillow against which his head rests is a strange, elongated, solid, oval shape, and the halo is extremely firm in drawing. These elements of the composition are hard, inevitable, unchanging. The entire painting powerfully suggests that the mourning would go on forever, eternalizing the saint. The only strange, irregular note in the painting is that of a figure in the background which does not seem to me to belong to the rest of the painting. The gesture of the priest standing or kneeling directly in back of St. Francis' haloed head with his arm and hand somewhat outstretched, as though awaiting some word or gesture from the angels or God himself, still seems to me inadequate and not in tune with the gravity of the rest of the figures. The priest on the extreme right holding a banner aloft and the priests on the extreme left stand in solemn dignity. The architecture in back of the bier gives off the feeling of great calm, and above it one sees an angel in the sky.

July 3

Last night L. James* said that he felt Pollock had genius—"high voltage." Perhaps so, but I feel that it is voltage of storm, storm voltage in the wake of which comes wild destruction. Perhaps Pollock is voicing his anger against society, or perhaps the deeper anger stemming from his earlier years. Pollock did express violent scattered emotion. The act of splashing paint onto a canvas betrays his lack of inner poise. His was an art of tantrum, the expression of temper tantrum from whatever cause. There was not the deep anger that might come, let us say, from the feeling that grave injustice had been done.

Very recently I was looking at a detail from a study of Giotto called "The Funeral of St. Francis of Assisi." Of course, a man of Giotto's enormous stature must have felt not alone anguish but anger that such a saint must die. He might well have felt anger but it was not expressed in the form of a tantrum. It was sublimated into a great sense of the gravity of the event. Here was St. Francis, the most beautiful of men, lying on his funeral couch, surrounded by priests. Giotto related to him in a simple, human way by showing the anguished love of his disciples, spiritual lovers, lovers of a saint. Giotto also responded to the story as it related to certain aspects of the social and religious structure of his time.

*Probably her friend, the restorer Louis James.

The depth of emotion displayed in the monk's face as he leans over toward St. Francis, obviously stricken with grief that this beautiful, sainted man had died, is so profound and touching that I could only feel this was a spiritual conception. The fact that the scene is not placed in a church did not matter to me, perhaps because I am so far removed from church ritual and content. But the spaces, which of course Berenson acknowledged as beautiful, seemed to me to convey a spirituality which Berenson ignored. In the Sassetta version, though indeed he may have pointed out the relevance or the importance of the stigmata, all the figures are crowded together and there is a feeling of agitation rather than calm.

July 4

I would agree there is a certain "voltage," a certain power, in Pollock and some of the other Abstract Expressionists, but too often the power is associated with anger. De Kooning's women, for instance, with their sharp teeth that seem eager to bite, seem to me to express sadism of women and against women which I find very unpleasant and disturbing. Is "quiet" painting somehow inferior to this high voltage painting? In my recent experiences of Cycladic Greek art and ancient Egyptian vases I found nothing one could call "high voltage," but there was great power in these works, nonetheless, more even, the power of daily sunshine that pours down upon the earth causing the verdant flowers to bloom and nourishing all that it touches. Indeed this ancient art does seem quiet; one does not sense directly any motion at all. The power is a healing power; it is a power that makes things grow. It has nothing of devastation in it. It is concentrated, rather than diffuse. One might say that it is more like birth, where something comes into being, than like death where disintegration occurs. I have already said that it is a growth-producing energy, rather than an energy that blows things apart, as in a storm.

Can one draw the analogy that art might deal with, at least metaphorically, the breaking up of stars, their disappearance into black holes and their reappearance as a new star after a "big bang"? My sense of the quiet growth-producing power of the sun may also be correct. Both these modes may exist simultaneously. Certainly, looking back at the great masters of the Renaissance one finds very many examples of the more quiet procedure. The inner energy or voltage is there, but it is diffused into ordered works of art. For me, Jackson Pollock and in many cases de Kooning express the demon quality, the demolition quality, the storm, the devastation, the uneasiness, but do not come through to the final stage of the creation of a new star.

July 9

I was startled, in looking at a photograph of "The Funeral of St. Francis of Assisi," to note that the rigidity of the upper part of St. Francis' body was so similar to the right-hand side of Abraham's torso and to the figure of Isaac in my "Abraham and Isaac." I did not deliberately decide to make any part of Abraham's figure rigid. In fact I treated the beard, which flowed in waving streams down the body, very freely. This gave an effect of curling water, of a waterfall of hair. It was very tender, in sharp contrast to the almost catatonic rigidity of Isaac, fearing death, though held lovingly in Abraham's arms. The face of St. Francis looks alive in the Giotto, though the eyes are closed. Contradictory impressions. In Manet's study of "Christ Descending Upheld by Two Angels" (Metropolitan Museum), which I described in my notebook, the body of Christ is supple; there is nothing stiff or frozen about it, except the swollen foot, in which is a concentrated expression of the agony of the Crucifixion. Angels fly just above Jesus, evoking the feeling of very active, piercing music. The whole painting seems to sing. Of course I am aware that there is a time span of some centuries between the painting of Giotto and the painting of Manet, which might account for personality differences in the expression. Somewhere in between comes a painting by Carpaccio of "Christ Descended from the Cross." Here the body is treated still differently; Jesus is seated on a marble seat outdoors, accompanied by only two disciples. The pulled muscles of the body show the torture he had endured on the Cross. I went often with Gorky to see the Egyptian mummies at the Metropolitan Museum. These mummies were encased and on the outer side of the funerary box was a depiction of the departed one, very active; possibly they were meant to be portraits of the living man in his prime rather than of the dead one.

I feel it is quite likely that these varying approaches to the subject of a dead saint or ruler were directed partially from the unconscious, that something came through that he had not really intended. If I could coin a phrase, the artist used an "under language" which I very often hear more acutely than the more explicit "outer language."

July 11

Shall one look to art for the expression of tensionless forms? Is this important? Should art bring us a kind of relaxation or peace? Should we not avoid that art which is tied up, stiff, tense, anxious, full of hate or suffering?

I could not even begin to imagine having a Jackson Pollock in my home, nor would I wish to have a Goya of the dark period, nor many of the very great but gloomy and tragic pictures of the masters. To this extent, Matisse

was right. He painted pictures that could be hung in rooms where people lived, and wished to live happily, joyously, unplagued by the great problems of the world or its terrible miseries. Perhaps it is of this I speak when I speak of the leaves in my window or the Egyptian bowl, 3000 B.C. They are passionless. They do not cause pain. They may be enjoyed. They give one a sense of peace, a strong peace, not a weak one.

July 16

The night of the blackout I lay on my couch, a single flame on a short candlestick lighting the darkness. I contrasted this flame with my leaves, my golden leaves, my golden-green leaves that gave me such a sense of unchanging tranquility and yet at the same time a sense that something was growing. The flame was not still; it moved but maintained the same shape. It kept flowing upward and, on the other hand, it kept eating up the wick and the candle below it, melting it away. It grew out of something that it was destroying. Its shape was an elongated oval. The marvelous flowing, rippling light, exceedingly subtle, was deeply entrancing to me.

Somehow, though my candle flame was very beautiful, I felt it as somewhat disquieting. Though active, renewing itself continually, it stayed in the same place, retaining the same image. It was not a growing living form as in the case of the leaf. The heat it engendered could have had a practical usage. But on this blackout night it was to give light, not heat. The flame was a light-giving source, but for me it was at the same time a source of aesthetic pleasure. The flame's rainbow tones were not unlike an oval-shaped jewel. They seemed to move, flowing perpetually, and this was perhaps the source of the fascination.

Time flows, but one cannot apprehend it with the senses. Sometimes I feel time as a living force, or I may forget all about it and my mind ceases to reach out toward its flowing. Time is actually moving and yet when the mind stands still time itself seems to stand still. Time moves on with or without one—one simply enters into its stream occasionally on a conscious level.

In telling stories in my paintings I always try to select the exact moment in time that seems crucial, the moment that includes as much as possible of what has been and yet suggests something of what is to come. As when one would paint a man kneeling at the guillotine, the sword high above, knowing that in the next moment this man's life was to be cut short and therefore this was a moment in time that was crucial, notable, never to be repeated. But there are other kinds of relationships to time, as for instance when one sleeps one is in no way conscious of time; one may look at the clock before going to sleep and again upon awaking, but in a sense the

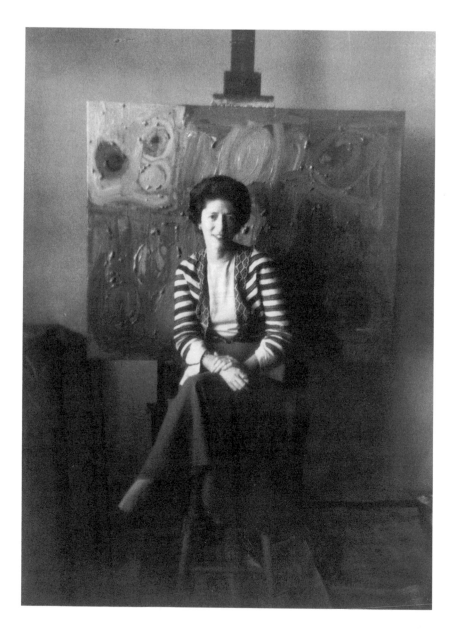

FIGURE 7. Ethel in the 1950s.
Photograph by Richard
Pousette-Dart.

state of sleep is timeless. The images or thoughts that appear in dreams frequently connect up to things that happened long ago. Even during the day one might say that the thinking individual enters "psychological time," absorbs in one or two minutes, or in a few seconds, the time-interval between the original event which has come into his mind and the present moment. A person might think forward just as easily as he thinks backward. "Feeling time" may hang heavily upon one and be impossible to fill, or may rush by so swiftly that one is hardly aware of it but rather of what one personally has brought to it as a living contribution.

There is the apprehension that certain vivid but painful stretches of time will never come to an end, as when one longs for a beloved person one feels should be there but is not, who might come, but might not. The summer that my husband died I was in Maine. Time suddenly had no value to me. A friend came in an airplane, and at first I saw the airplane as a speck in the distance. As it grew nearer it appeared larger, and the interval of time that was covered between its seeming presence as a mere speck and its arrival had passed. The plane was there, the friend was there. But something inside of me said, "This is wonderful that a friend is here, has come," but another voice in me said, "But he is not here, and therefore nothing else has any value." [See plate 12, *Ode VIII (O Rose Thou Art Sick)*, for an example of the mourning odes she did after Wolf's death.] So time has to be invested with value. The individual invests time with the values that his life has at its disposal.

July 22

Of time. Time is not seldom in evidence in art. The great masterpieces of the Renaissance frequently were based on myths or legends coming out of the past. The spectator was required to be able to recognize the past, to recognize stories that had long been told, to be aware of the circumstances under which they occurred, the myths, the legends, the allegories. If much was demanded of the spectator, one must also say much was given to him. He was brought out of the circle of the present into an expanding circle that includes centuries and stretches to all parts of the earth, even the very heavens. The parameters of much religious painting included Paradise, imaginary beings of the utmost splendor, angels, prophets, and finally God himself, usually surrounded by great beauty, glory, blue skies, rainbows, stars. All this was given. Entities, forms, images, visions, to stretch the imagination, to evoke the fullest range of feeling. But as I have said before, I believe knowledge of time was required of the spectator. It was no use talking of distant centuries or lands if he had not already some knowledge of them. Of course I have been referring chiefly to the Renaissance period.

I've written quite frequently of works of ancient periods, especially Chinese or Greek vases, or such simple works as appeared in pre-Cycladic or Cycladic Greek art where such extensive knowledge was not required, where all that was required was an immediate response to an aesthetic creation. One had only to have the ability to recognize beauty, to be aware of form, and to be able to feel joy without any further implications attached to it. One could recognize beauty in art as one recognized it in flowers or any of nature's creations. It required only responsiveness, not knowledge.

July 24

I may falter here. Very probably. Last night I attended a Mozart concert, all Mozart. The music was soft, without tension, perfumed, enveloping, unlimited in its scope. One could lie upon it as a babe on the mother's breast. One had a sense of timelessness. As a human living in the twentieth century one could hardly bear to respond to all this. The sweetness was almost too sweet. The softness too soft. The quietness too quiet. There was a thought that passed through my mind: could this piece have disturbed me so in spite of its overwhelming beauty because it came from the excess longing for the beloved of which I've spoken so frequently? Was it not, after all, too full of longing, and thus the great beauty was in a sense too beautiful, betraying its real source? If indeed it came from Mozart's excess longing, it would be bound to have pain in it. If one responded fully, one would have to feel this pain. How could a human being tolerate such fierce longing, a longing that could never be satisfied? Whether it was longing for a woman's love, or to return to the mother's love, or to the womb, or possibly a longing for death, or an attempt to overcome fate and to preserve the beloved through ageless beauty. Mozart knew that even he could not achieve it, and thus was frustrated again. Whatever the source, there was great longing there, and this brought to the music with its seeming low tension or no tension, and its exceeding sweetness, an undercurrent which moved me to tears.

July 31

I listened today to the Beethoven Concerto #1 in C Major played by Solomon. Interflow/crossflow. Yet these words do not quite describe what I felt. Curling, weaving, flowing. The dominant theme emerged out of, but also blended into, the accompanying tones, as when water currents merge and yet separate. Not lacking in precision. This music brought relaxation, an unbelievably pleasurable sense of tranquility. There are such islands, such oases. The voice of love. I have seen the interplay of light and shadow,

volumes of light and shadow flowing similarly. Poussin was able to paint this marvelous phenomenon of nature. He did not see space as empty, but as filled with light, or varying streams of light and shadow moving into and out of each other. In Beethoven's music there are streams of sound that interflow, and yet each remains distinct. For me, Beethoven is love heard; Poussin love seen: love in its gentlest aspect, as immediate sensation, fulfillment, all moving in the direction of pleasure; enjoyment in its purest form, no deterring shadows, no rough passages, no thorns or jagged edges.

Delight in clear accents, accents at rhythmic points of the phrases. Frequently Rubens placed a small spot of vermilion at the edge of the eye, or on the lobe of the ear, or inside the nose, thus heightening and sharpening the total effect. Subtlety is rarely written about or explained, but in great art subtlety is strongly present. I remember my astonishment when looking at a Titian in the Metropolitan Museum, a very powerful study of a high church official. I was surprised that with all the power of the structure, the delineating of the man as large and very strong, one found, on looking more closely, that Titian had painted the hair and adjacent forms of the face with the lightest of touches, with great subtlety and delicacy. He had known where to place what, where to create power, where subtlety.

August 8

Marcel Proust spent many years writing "À la Recherche du Temps Perdu." Yes, I am deeply interested in recovering the past, in making it a part of my present, but I am especially interested in capturing immediacy, whether it be of present or past. How much can one capture in the "arrested moment (immediacy)" before it becomes the "fleeting moment"? Delacroix wrote somewhere in his journals that a painter, a draftsman, should be able to paint or draw a man as he fell from a window—so swiftly! He obviously felt that if one lent oneself fully to the moment one could grasp it in its immediacy. This is very difficult to do. I looked at Lisa* a couple of days ago as she was bending over the aquarium in which the gerbils are kept. She was playing with them, coming to know them and having them know her by giving them a few grains resting on her hand. She was deeply absorbed in these little creatures. I on the other hand was entirely absorbed in her. What did I grasp in the immediacy of that moment? Could I turn from that sudden filling up of myself to the giving out of its fullness in the form of a work of art?

Freud has said that nothing experienced is ever lost in the unconscious,

*Lisa Webster, her granddaughter.

it remains there forever. But it may be lost to the conscious mind of the individual. The experiences may be covered over as ancient cities were, due to the hazard of time and war. It was possible to recover the buried cities. Archaeologists made that effort. In this sense, Marcel Proust was an archaeologist. One who sought to uncover what was hidden in the past. He used the word "perdu." I think this was perhaps not quite correct. It was not lost, it was simply covered over. Now, let us imagine that it was not just a question of an individual recovering what was lost or covered over in his own past, but that perhaps Marcel Proust was also referring to the fact that much happened or existed that was not perceived and recorded by any individual. I was conscious of this as I observed Lisa. Here in front of me was a living, lovely young girl quietly centering herself on the feelings she had about these little animals. I was witnessing a very complex entity composed of form and feeling. How much of it did I grasp? How much of it would I remember? How clearly had I seen and perceived it? How deeply had I felt it?

Many immediacies. During the last months, I have studied the green leaves in my window, hour after hour, receiving impressions of them into myself in a state of relaxation. I let these impressions float across my mind. I did not seek to grasp them. Later, perhaps, I asked myself, what were they? What were these leaves? What were these impressions? But with Lisa, my granddaughter, I did not have the opportunity to lie in total relaxation, hour after hour, or day after day. What I could apprehend in the immediacy of that experience was her feeling, the quality of her feeling, and this I could retain.

August 26

Looking back into the Cézanne book, I see a painting entitled "Young Man with a Death's Head," done around 1890. Here I find once more, as in the Giotto "Funeral of St. Francis of Assisi," the quality of taut stiffness through the torso and even the legs and arms that I gave to my "Abraham." The young man is seated, his elbow on a table upon which is a skull. He does not look directly at the skull but off into space. His hands are tightly clenched. Cézanne's reaction to death appears to be expressed in this painting. He combats it. He representing everything in the picture as solid—the very reverse of death or disintegration. Cézanne shows the young man sunken in contemplation, but it seems to me that the subject matter of the painting is more the solidity of the forms included in it than the young man's reaction. There is absolutely no comment on disintegration other than the young man's implied rejection of it. There is no tenderness, no anguish directly expressed. There is no suggestion of a resurrection, but

there is a suggestion that a painting, this painting, Cézanne's painting, will endure. Perhaps Cézanne is commenting on the fact that human life is especially fragile, that it is more fragile than art, and that art has more power to endure. But I would like to contrast Cézanne's way of treating death with Michelangelo's treatment of the same idea in his "Pietà." Here Jesus, descended from the cross, lies relaxed and soft upon the lap of his mother, Mary. There is throughout a great tenderness, indeed as though Jesus were not dead at all but still living enveloped in the love of his mother. In comparing two works so removed in time as the Cézanne and the Michelangelo, I would say that Michelangelo's "Pietà" is far more human. Michelangelo has comprehended the sadness of the mother at the loss of her child, her beautiful tenderness. He expresses no fear of death, as does Cézanne.

Yet another painting whose subject matter is death comes to my mind, one of which I have already written—the painting of "Aristotle Contemplating the Bust of Homer" by Rembrandt (Metropolitan Museum). Here Rembrandt goes still further in negating death. He revivifies the head of Homer, one of the most beautiful I have ever seen, and already immortalized in a statue in ancient Greek times, releases it from the stone, as it were, and gives it the appearance of a living man. But paradoxically, he does make it clear through the device of the statue that Aristotle is alive, Homer dead. The accent is not so much on the making of a painting as on the telling of Aristotle's emotion about Homer. I find Rembrandt's painting humanistic and more deeply satisfying than that of Cézanne. Cézanne's is too strictly a still-life realizing the same abstract objectives he had in doing the still-lifes, the interest in solidity, in solid forms, in space-structure, in color.

A modern response to the subject of death as represented by a skull is that of Picasso's "Death's Head." Here he does something most strange. He shows the skull with fragments of flesh or tissue still attached to it (around the mouth, for instance), thus creating a transitional stage between life and death. Picasso did create a marvelous form, but by the great magic of genius he invaded the permanency of the form itself with the thought of the disintegration of the human body.

September 2

I have just been reading James Lord's *A Giacometti Portrait*. I was struck by the fact that Giacometti apparently did and redid his painting of this young man incessantly. He had to destroy in order to give birth. This has diminished Giacometti in my feeling. It seems a very tortured way to create a work of art, and I feel this torture is evident in the result.

The flowers that Sylvia brought me are whole. They set up an enduring image in the imagination. I would like to paint them. Shall one call this desire the longing to escape into beauty, to escape from the flux and reflux, and pain and more pain of life?

Back to Giacometti. Was it, in a way, not wonderful that he expressed all the uncertainty that he himself felt, and that he felt existed in the world, and yet achieved a certain unity, cohesion and structure? This of course is closer to life as we know it. But I still yearn for life in its fuller, more stabilized, happier sense, as it must have been known by the great masters of the past who produced such positive works.

September 4

I went again to see the Egyptian show at the Metropolitan Museum. The royal cattle! I was astonished once more at the sense of calmness this bas relief, 3000 B.C., brought to me, the feeling of infinite leisure, of relaxation of body and spirit. I loved the warm atmosphere suggesting sunlit fields, grain ready to harvest. Though the rendition of the bulls was natural, it was not "naturalistic." The drawing of the horns was most elegant, and the outline delineating these great beasts was fine, indisputably perfect, and conveyed a true definition of reality. I believe the artist came to this perfection through deep intuition and inner concentration rather than intense or painful effort.

October 1

I'm thinking of Brenda's writing on Yeats and, more recently, on Blake, and I feel a great longing to have her know how much the high level of her work means to me. She has assimilated some important recent psychoanalytic concepts and has applied them in an original way to the analysis of Yeats' and Blake's works. Her insight into the poetry itself has always been deep and very acute, but by using the added insight she gets from psychology she is able to greatly refine, as well as add power to, the interpretation of these works. She manages to do this in writing so lucid that one might at first not realize how complex the ideology is, and how it moves from one depth to another so easily and swiftly and yet with a great attention to exactitude. With Blake, particularly, the whole problem is enormously complex, as she must interpret not alone the poetry but the paintings, and the various meanings that come out of both.

I wish also to speak of Brenda's poetry, which she is inclined to be too modest about. In reading it I felt that it had a really wonderful quality of weight. Every sentence, and almost every word in the sentence, has an

importance of meaning, a heightened meaning. Its rhythm moves with great dignity and classical strength. The quality of weight is one that I have always adored in Giotto or, further back, in Greek art; that is, the ideas are solid and have a sense of imperishable meanings. In saying that they have weight I am not unaware of the motion and fluidity of these lines or the deep emotion Brenda has been able to express. Her lines always come from some very central source of feeling, and they give one a sense of having moved into the great stream of poetic thought. I feel they will endure. I feel that she has underestimated them to a great extent. She has not yielded to the modern gimmickry at all. She has gone her way as an individual, and I think that one day, if she will permit them to be seen, recognition should come to her.

October 2

Why should I constantly weigh the diamond against the opal? The one is hard, brilliant, enduring. The other is magically lovely, sparkling effervescent, changing. And in the broader field of art, why do I weigh the Egyptian art of 3000 B.C. against the modern world of the second half of the twentieth century and Abstract Expressionism? The diamond against the opal. The brilliant durability of Egyptian work and the fugitive quality of the twentieth century both interest me, but perhaps I have said too little of the twentieth century. For the artist it was not just a question of activity ("action painting"). It was a question of the release of violence, the love of violence, of power, and an undercurrent of acute anxiety in connection with this expression. Was it possibly responding to the public, which perhaps admired beyond everything the acquisition of power, the expression of great energy, new feats of originality? The artist made bigger and bigger paintings; thoughts were expressed in more and more tumultuous ways. Controls were there to some degree, perhaps even to a fairly great degree, but the underlying anxiety yielding to public pressure came as a spoiler; the art was fair on top and rotten underneath.

And yet it seems to me that this power play is not the whole realm of art. For me, the Egyptian works display power in an entirely different way as sureness of being, as welcome to the self, as contentment with the life they represented. This is far more appealing to me, and perhaps in it I find reassurance. Calm days outnumber storm days. Growth outdistances death. Trust, self-confidence, and sublimation have finally a greater value than conditions (however active) of pathological misery, of anxiety, of lack of confidence. This lack of confidence is compensated for, or overcompensated for, by the attempted exercise of enormous power, the wild flinging of paint upon canvas, the wild assertion of activity.

October 15

Close out the impossible conundrum. Think of the logic of the plastic "appearance," not the logic of the known and rational world. Think of memories and metaphors as one. Memories as metaphors. Retain certain amounts of visual reality, such as direct observation of nature, and even memories of nature. Memories of metaphors, including those seen in museum paintings, persist. All these various elements first perceived and then drawn together by the force of imagination are words in the sentence yet to be formed. This is the abstraction of it. The forming of the sentence from a wealth of words and meanings. Infiltration of the preconscious, with its influx of memories, blends perfectly with conscious awareness. Thus a many-layered rendering. Visionary at times.

October 16

Predatory patterns. We seize food in order to survive. We leap upon it and devour it; we are ruthless. But our food may be psychic food, emotional food, required to bring us health, stability, tranquility, a sense of fulfillment. We tear it apart, we masticate it, and if we are lucky, it nourishes us. We seize it from wherever it comes or wherever we see it. We feel ecstasy and delight before it, whether it be in the art of others or in our observations of nature, or whether it comes from deep sources in the unconscious as memories of past experiences that frequently moved us to tears or that were gratifying and full of delight. We observe and remold our experiences.

We frequently use guidelines drawn from the work of others, but equally frequently we plunge into the unknown. We allow our own thoughts to determine what we build, what we sing, what we paint. The canvas is a battlefield upon which we may win victories, or go down in defeat. The canvas is a birth-bed where we conceive, or rather where we bear what we have conceived, where we project it into the world as a living thing, as an entity that can survive and grow, and eventually give birth itself.

There are "learners" and there are "predators." Ingres learned first from David and then from Raphael, using what he had learned from them to develop French art. But I would say that Picasso was a predator. He seized upon certain formal aspects of Cézanne and with the aid of this new tissue formed a new art, Cubism. He had no desire to further the spirit of Cézanne's creativity. He used what he could take, or what he wished to take, for his own purposes. Van Gogh, again, was a learner. He learned from Japanese art. He learned from Rembrandt. He was not a predator. De Kooning as a predator seized experiences from life and art such as those that formed the basis for his series of "The Women." He did not absorb a "Joyous Knowledge," but rather gulped down the negative idea of women

as vicious and biting and let this deep response dominate these paintings. He spewed ugliness out angrily, even viciously (though, paradoxically, the colors were luscious). Bittersweet painting!

October 18

Water rushing downhill over stones, the stones are gradually polished, gradually eroded; yet the water continues on quite unchanged, bypassing all obstacles, in no way diminished. But water rushing over mud may be muddied, clouded. The mud itself diluted, displaced, moves on into new formations. Of course, at bottom, I am thinking of art and what the genius of one era may do to the genius of a preceding era. If we think of Picasso, has he not inadvertently arrested the development of Cézanne's hypotheses, so that we are unable to look at Cézanne quite as we should, lending importance to what is most important in him, but rather have been carried away, as it were, down the stream of sullied water?

Way back in the thirties, I was overcome by Cézanne's work. I felt that the most extraordinary thing about it was the way he utilized color in the service of space-structure, form, and the conveying of emotion. I think I am quoting him correctly in saying, "When form is at its fullness, color is at its richness." Certainly the great colorists of the past had known that color could create form. But they had also depended upon line. Can I say that Cézanne used color in an abstract way? His way of subdividing form, or color-form, to coin a phrase, was most extraordinary. He broke down the seemingly solid surface of reality into its components. Cézanne wished to know how the minutes linked one to another produced a segment of time, or how the component parts of a surface or form related to the final form. He wished to break things up into their parts, to analyze them and then to bring them together again as a whole. Was this not in considerable sympathy with the general scientific approach of his time? The late nineteenth and early twentieth centuries investigated the components, investigated how things were made, realizing that even atoms were not the smallest particles, that there were still smaller active particles and that thousands of particles combined together to make some of the entities which we were only aware of as simple solids.

November 1

Experience at John Ford's studio: all cataclysms of the mind stilled. No abysses, no conflict. All is quiet, under the rigorous control of intellectual mastery. The master says, "It shall be controlled." Even the dreamy loveliness of meditation is contained, walled in by rules of the mind. No room

for error here; nothing must stray; nothing must move unexpectedly. Everything must take its place in an ordained manner, ruled by geometry. All must be at rest. The paintings of dark pools, however, full of suggestions of potential birth, as also the charming, quiescent, young people, were less rigid. There were very beautiful planes and tones throughout, with all the elements of aesthetics skillfully disposed.

It takes enormous power to accept the uninvited, to allow the hidden forces to assert themselves, even though they might be crude or violent or seemingly accidental. It is the easier path to eliminate all that is troublesome. In this sense John Ford's work approaches the quality of Neo-Classicism.

And yet perhaps this does not quite cover it all. The last picture he did was of a young woman standing. In this painting I felt a wonderful vigor, a stance that was positive, full of life, whole, full of well-being. In this painting there were even some free strokes of the brush around the head that seemed to have leapt out of control. This seemed to promise much for the future, that once the power to control had been demonstrated it could be loosened and at that juncture life be permitted to return into the painting in a freer, more haphazard fashion, leaving possibilities open. In another of the last paintings on a similar theme there were, though the posture itself was quite fixed in the sense I have tried to describe, some floating lines full of a beautiful tenderness, of the quality that I had admired so much in ancient art, the quality of coming into being without a distracting sense of the activity (whether mental or physical) that was behind it. Thus I am really saying that there were various indications in the very last paintings of a new mastery that could prove to be very rewarding. Perhaps I have not stressed enough the tenderness of the artist toward his craft, the tender laying on of paint, the tenderness toward tones, toward gestures, toward the subject of the painting.

November 4

Annie Stein* spoke to me last night of the Egyptian economy of 3000 B.C. She pointed out that the Nile, the fields, and the cattle were of enormous economic importance, that therefore the artists depicting bulls were depicting the most essential asset of their society. Perhaps this is what I felt, or part of what I felt as I noted the great solidity and importance of the work. I contrasted the Egyptian bulls with Picasso's. It is true that the Spanish people take the bullfight very seriously as symbolic of the life-and-death struggle to dominate wild or incoherent forces. But the bulls

*Anne Stein, a friend of Ethel's who may have worked with her on the Urban League.

were not, as in the case of the Egyptians, a life-necessity. This seems to me to have significance. In later times, let us say the time of Cézanne, he painted an apple, yes. An apple was food, something to nourish the body, but one knows that he did not paint it for this reason. He painted it as an aesthetic problem. If the Egyptians thought of aesthetics or not, I'm not yet sure, but it seems likely that the enormous dignity felt in the work was due to its life importance. It was not romanticism, it was not aesthetics alone.

But sudden gaiety of the heart. The gods were providing, the Nile flowed, the earth was good, their strip of land was protected on either side by desert, the cattle were healthy. It was a good society, in this sense, and so the work exudes a kind of good-earth benediction, a hymn to well-being.

Imperfection how sweet thou art! And yet sweeter still, perfection! Can one say that Cézanne was the most beautiful exponent of incompletion, and the Egyptians of completion? Cézanne showed the twist, and the torment, of the unperfected form. It is true he reached toward bringing it full circle round, but he rarely succeeded, and that only in his last years. Imperfection is what most of us live with and in, so that finding it in art is perhaps soothing, or interesting certainly. It says, "As life is, so is art." What about the Greeks? There again we find perfection, incredible mastery of imagined forms. Now certainly they were not merely copying the human body as they would find it in life. They were revealing ideal bodies that had never existed before they imagined them. These creations were a product of longing, and aspiration, almost of excess longing, as I have written several times.

November 5

Thoughts on the various peaks of life and art race through my mind. I am thinking of "reflux," the flowing back of the mind to early impressions or experiences, which refound bring fresh nuances to present thoughts and an effluence which leads to new images.

The leaf cannot flow back into the seed from which it sprung, but the mind's leaves can. Much of Surrealism was concerned with this kind of reflux, chiefly through the medium of dreams. Dream-material was then used in a new context related to living forces within the artist's conscious experience and emotion. Positive emotion is frequently linked with its opposite, is it not? I question whether one can divide hate and love and analyze their parts as thoughts can be divided and analyzed. But while emotion may be difficult to understand, one can trace its source, as one traces the source of a river. When I was a child, I thought the initial sprouting of a

seedling was a momentous event, and I was fascinated by it. But at the time, I could not envisage the plant that would grow from it, nor the flower.

I fell in love with my aunt's black hair, long and straight and glossy. I loved to watch her comb it. These visual impressions were enhanced by other impressions, by the smell of perfume that clung to her, by my secret, rapid love-perception of her long slender fingers and the pink fingernails, pointed and perfect. Later, when I came to read of Helen of Troy, the original, very moving experience of my aunt welled up in me and amplified my response to the lines of the poet, "Helen, thy beauty is to me. . . ." The writer had chosen from amongst many possibilities and had constructed a viable form. But I could not help but be aware that much was missing, that the original experiences had given off fantastic sparks of energy, whirling flames of beauty, as dew on the morning flower, or flame that springs from the burning leaf.

How often has one not thought, "If only he could breathe," referring to the subject of some portrait done by a master, or "If only the sun would move further up in the sky, or sink further toward the horizon, or the rain come down more fiercely or less fiercely, or stop altogether." In other words, the artist has shown one moment, or one aspect of life, but life itself is full of racing changes, continuous new aspects continually awaking new and perhaps preferred responses.

November 13

I am thinking of the "graffiti" blazing around the city. They are most often like a shriek in the darkness, but occasionally like a shout in the sunshine. They set out to mock society. They are the product of hostility, but perhaps also the product of innate creativity. These youngsters who have no paintings in their homes, who rarely visit museums, or if they do, visit them in groups passing by the masterpieces without much reflection or probably much enjoyment, still have experienced the visual in their lives, or perhaps more exactly, an impulse towards putting into visual, lasting form what they have seen or felt. Graffiti as an expression is strangely abstract. It comes from an impulse to make a line, a living line. What it circumscribes the youngsters themselves do not quite know, and perhaps this is rather wonderful. These youngsters are relating more to what might be called a nervous excitement that exists in the air of this great city. They are constantly bombarded by fierce attacks on their tranquility. They are perpetually forced to respond to the need to survive, to attack in return, to best their opponents, and the graffiti conceivably represent a kind of attack. This expression is also a way of rising above the fearful strain of their lives. These youngsters have been able to express something that is

at the heart of art always, a capacity to set forth the intent of the mind, heart, spirit, symbolically, in aesthetic form. You might say, what strange claims to make for a lot of raucous, unkempt boys, but I say no, they have in them the ability to make lines that really move and have an inner wealth of vitality.

November 24

The movers came to take my large mythic paintings, 1969–72, to the Cathedral of St. John the Divine where they are to be shown on the 18th of December. I was startled to see these works and later, when H. and C.* came to pick up a replacement for the one they were lending to the exhibition, I was even more startled to re-see "Wild Honey," a very large, somewhat earlier painting which they had chosen. [See plate 3.] It seemed to me that the colors sang, danced and leapt into the air. "Wild Honey" was done in memory of W.S.S.** and the summer we were at the Cape when, coming out of the hotel door, I rejoiced: at the salt breeze fresh off the blue-green sea streaked with violet; at the wide or vast extent of sea and the blue, blue sky above it all making for a still more intense aesthetic emotion; at the senses being enlivened as well as the mind. And then, oh miracle!—I smelled a honeysuckle bush nearby. The effect was most extraordinary. I was wild with delight, wild with all this beauty, deeply stirred. Something, I think, of this had come through into the painting. How can one ever describe the translation into art of aesthetic delight, and intense expression of deep emotion?

The glimpses I caught of the large mythic paintings done several years later made me feel that they were more subtle than "Wild Honey," contained more of the human story. I responded to the anguish of Prometheus as he stood bound to the rock, his liver eaten away perpetually by the vulture's sharp beak. The response to pain was as exquisite and keen as the response to joy.

I reflected that some years later when I did a series of watercolors there was the same vividness of response, but I think they had a certain calmness that I have called "tending toward the epic." In them I sought a larger view.

November 27

There has to be joy. It is a pre-necessity to discipline. Yearning to celebrate the beauties I had experienced, I managed to find the technical

*Hannelore and Christopher (her daughter-in-law and son).
**Wolfgang Simon Schwabacher (her husband).

means. From earliest childhood I perceived great beauty in all directions. It followed not too much later that I was willing to study the necessary disciplines. Today little Mark* was here practicing on my electric typewriter. He had a book in which it was indicated just what letters he should master and in just what order. This of course was an excellent procedure, but one must say that it was extraordinarily dull. How could his interest be kept up, a nine-year-old child, writing gobbledygook? I suggest that he would have been better off if he had picked letters out with one finger and written a poem or a little story. He might have become entranced with writing, and soon would have been willing to practice the technical exercises and to master them in order to produce more easily. I followed this method with Brenda when she was a little girl. She was very imaginative and full of ideas, so she was allowed at a very young age to dictate to her nurse. Thus her creative flow was not held back. She became a very fine creative writer.

I feel that in too many ways children are being forced to master disciplines first, before they may experience joy. I think, in fact, that joy can lead naturally to discipline. The joyous appreciation of the beauty of a flower, for instance, can induce an inner-directed effort to find a way to express this joy in terms of aesthetics or art. I recall very well that when I first painted I could not remember the colors I used to make the various tones of the table or the fruit or the floor or the wall that I was attempting to render. I wrote down, "I used this color, and this color, and a little of this color." Later, I quite easily remembered what colors I had used and made long studies of how one tone would affect another. I took groups of colors like yellows, or greens, or blues, and saw how one yellow would affect another, or what one green would do to another. Then I took more complicated groups, experimenting with how three tones or three color groups would affect another, exploring what a blue next to a red next to a yellow would do, and varying kinds of blues, greens, and yellows—lighter, darker, more intense, less intense. These were experiments; these were discoveries, very delightful ones. They were in the nature of discipline, but not a dull discipline that weakened one's sense of joy.

December 3

I am now racing against time. What little there is left to say I will try to say.

<div align="center">✻ ✻ ✻ ✻</div>

*Mark Schwabacher, her grandson.

I used to sit studying the blooming magnolia bush at our farm in Pennington, obsessed with noting in their immediacy all the changes that occurred from the tight bud to the opened flower. Elated and fascinated, I felt I was watching the most subtle movements of the "vital fluid," and if I could comprehend them in all their complexity I would have learned something marvelous. Many of the Dutch masters, of course, showed a group of flowers, some of them buds, others full-blown. In this way they did approach what I am talking of, but not quite. Now I must return once more to Cézanne, because I feel that this explicit search for "fluid immediacy" was one of his obsessions. He was so in love with the processes of life and art that he wanted to show them evolving. Had he not spoken of the desire to add one link to the chain of art? I think he meant by that, of course, that he wished to add something original. But I think perhaps he also meant something deeper, that he wished to show the links in the growing process, in the living process itself.

I dreamt last night of a woman with hair piled high on her head rather negligently, and I thought it was someone I knew but, strangely, she did not look at all the same. Then later in the dream I myself was rounding a dim corner, walking down an unknown street in a sort of foggy twilight. There was something sad about the dream, and yet profound. It now makes me think by free association of Giotto, who was one of my earliest loves. He indeed had been able to convey the deepest emotions, the total involvement, the intensity of love between people, emotions involving the whole of the giver and the whole of the receiver. Would it be too wild a leap of the mind for me to say that in Cézanne's oeuvre he was in some ways as profound a giver of love as Giotto? He gave, however, not love of a human soul or being toward another human being, but the love of a human being toward the manifestations of nature, whether it was rock, tree, sun. As St. Francis loved the little birds, so Cézanne loved the simple nature that surrounded him. He did not travel to far-off Morocco as Delacroix did, or to Tahiti as did Gauguin. He simply sat down and found around him marvels enough. In studying Gorky I came to feel that he had this same ability. It is true that he may have drawn on some of the legends of his childhood that, ever-present, flowed through his mind, but he too was impelled to look at a blade of grass or small section of earth, or a small section of almost any form that existed about him or around him. He used to come to my home, for a short time, when I had a model. I did what I could and he then reworked it, fully reconstructing my work by painting over it. I realized that he saw what was there differently from the way I saw it, forms bending backward, or pulling forward. Very active. I thought to myself at the time, "The man is a genius." It was a very exciting experience. I was in the presence of art being created.

I realize that I have jumped wide distances in time, and have brought things together that ordinarily are not brought together, and yet that is how my mind works. Anything that has made an impression on it may appear at any moment, and tie up with whatever I may be thinking of at that time. Once, way back when I was twenty, I was talking to Mortimer Adler, who was at that time a very great friend of mine, and I seemed to have rambled on and on from my original starting point. He finally showed a slight gesture of impatience and I asked him to wait a moment or two longer. He waited while I went further still along the extensive arc of associations, but finally returned and apparently satisfied him completely that I had elucidated the point I had originally tried to make. He said, "I will never again ask you to stop. I will always wait to hear what you have to say."

December 26

Yesterday the *New York Times* featured a small ivory carving recently found on the floor of a fourth-century B.C. tomb in northern Greece that the archaeologists felt might well be a portrait of Philip the Second of Macedonia, father of Alexander the Great. This portrait head is most extraordinary. Naturally one must allow for the distortions occasioned by the way it is placed, filling the whole cover page of the magazine section. Whether the head was actually smaller or not one does not really know. The eyes are very large and slanted, with the inner edge uppermost and the outer edge severely lower. The eyeballs are rounded and the iris, lids, and eyebrows are indicated. Philip presents a striking combination of power and voluptuousness, and appears to me as a man singularly free to act in whatever way he determined would satisfy himself best. The forehead is very, very small, which at first made me think this was a death mask, but apparently it is not. I do not know why the forehead is cut short. The beard is clustered around the full voluptuous lips as vine leaves might be clustered around grapes. The first association that comes to my mind is that of Orson Welles, in our time. An extraordinary spirit. Now, I contrast this head in my mind with the "Death's Head" by Picasso. The Picasso head is essentially a skull, powerful, severe, tight, bullet-like, massive, with fragments of flesh clinging to the bone. But Philip's head, though massive, is soft and expansive. One can imagine Philip drinking vast quantities of wine. One can imagine him surrounded by women who would be drawn toward him and yet instinctively repelled by him. One feels, too, that he was capable of giving a jewel and killing the one to whom he gave it within instants. One can imagine him finding even war voluptuous in the brutal command of men and in the killing. He does not seem to be a man of

intellect but rather of power, a perfect father for Alexander the Great, a warrior, a conqueror. If I could paint, at present, I would love to make a painting of this head. Looking at it once more, I note that the expression in the left eye appears quite wild. Now in the article in the *New York Times* the archaeologists speak of their intention to "polish up" the ivory heads, of which they apparently found several. What on earth can this mean? What would they polish up? The very unpolished quality of this work lends it strength.

Oddly, I found that I reacted with a certain fear to this head, as I had in the case of the death mask of Goethe, of which I did a painting. Goethe was also a phenomenal man, of tremendous power and ruthlessness. The difference between these two heads lies chiefly in the fact that the head of Philip does not show the "poetic genius" or great intellect of a Goethe. Philip's dreams, if he had dreams, are dreams that would be enacted swiftly. He would call an army together swiftly, would march, conquer, or fall, but all his energy would be swiftly discharged.

January 8 [1978]

Catastrophic happenings, storm. Things wrecked and ruined. Conflicts. Perhaps this is why I did not want to go to see the Cézanne show at the Museum of Modern Art. I had heard from many friends that the museum had shown several works of his where effort and conflict were particularly evident. Cézanne must have known bleak and terrible moments living as a solitary in Aix. He must have experienced many storms, inner and outer. Much of the majesty of his work rests in his ability to bear witness to cataclysms, and yet in his role as artist the essential factor was still to produce a work in which control mastered conflict. It is not a question of dreaming, or simply wishing for peace, but of hypothesizing its existence in the mind. The heart of peace must be found within the artist's own mind. He may then envision it.

In all parts of nature there is action and movement. But to the eye itself the moon seems unchanging, a single image. The rainbow seems to have a complete form that is, at least for a short while, fixed. Down the history of art, it seems to me, artists have chosen a still moment as representing some inner factor that is highly important; namely the coming to balance, the coming to a balancing point, as when a dancer leaps and lands and, for an instant, on touching the stage again, is still, poised, in a perfect equilibrium. Quiet moments of the mind have their value in the attainment of a goal, the attainment of an idea. Perhaps I should have gone to the museum after all. Did not Cézanne, at times, attain that balance, that balancing point of which I have spoken? He set forces in motion, but he

was able to perceive that out of conflict could come a resolution, that opposites could be placed near to one another without necessarily clashing, that things could move, that particles could move, without destroying one another. He showed conflicting states of motion and stillness, but he brought them, as I have said, under control, so that one saw both the urgency expressed in off-balance and its resolution into perfect poise and balance.

I am sure that Cézanne must have been aware that the struggle to produce a radiant, unified work was so enormous because he had forced himself from the outset to acknowledge the conflicting forces contained within nature. I will not say that he necessarily verbalized these thoughts to himself, but more probably he felt them, and above all, as though he were indeed a religious man, he sought harmony and frequently found it.

There is perhaps in art no more beautiful quality than that of radiance, the radiance that comes through the harmonizing of conflicting forces, through bringing them to another point, another level, a level where conflict is no longer paramount. In poetry this was achieved by Dante in his "Paradiso." He ascends from one level to a higher and still higher one, leaving behind the storm, the cataclysm, the conflict, and rises to a hymnal expression of beatitude. Such geniuses as Dante, for instance, and in painting Raphael or Poussin, and I think in some instances Cézanne, actually did reach such a point.

January 15

Could it be that in Leonardo's "Annunciation" we find subtly concealed his love of two young women, "Mary," and the "Angel of the Annunciation"? Leonardo painted them as being most beautiful, virginal. He knew that Mary was to undergo agony as the mother of crucified Jesus, and that the Angel of the Annunciation would depart into the heavens. Under the guise of painting an Annunciation, has Leonardo not really revealed the deep love he felt for the mother he had lost at an early age, and the anguish he must have felt when he could no longer be with her? Neither the angel nor Mary could have remained with him, so he really was expressing, in a very hidden form, the anguish of separation. Quite another theme from the overt one of the painting.

January 16

Several friends called to tell me how beautiful my large paintings at the Cathedral were and exclaimed, "They look like Matisse!" They must have reacted to the brightness of the color and overlooked the fact that all the themes were themes of "separation": Orpheus and Eurydice, Prometheus,

the death of Oedipus. In other words, the subject matter was tragic, the initial content taken mostly from Greek themes. The brilliant color was my way of adapting what I had observed in Fra Angelico; namely, brilliant color applied to a tragic theme, as in the "Crucifixion of Christ." I felt that in this way Fra Angelico had suggested the Resurrection, and this concept fascinated me and seemed to suit my needs as well. My aim was the bringing of a thought full circle around. I was preoccupied with the continuum of life and death, joy and sorrow, imprisonment and freedom. Structurally, I had indeed tried to create paintings that would approach an epic style, which therefore would be large in scale, broad, and easily seen from a distance. Placed very high in the church museum, they did indeed seem to hold out against the great empty space of the room. But (and this could not be seen) they were also painted with attention to detail in the manner of Renaissance painters such as Tintoretto. They were painted with sable brushes, no bigger than one-half-inch wide, and there were many subtle nuances of tone throughout.

January 22

Storms of the heart. Furious anger. Clash. Opposition. Much like the storms of nature when trees crash, when boughs splinter off and are wind-tossed, hopping over the ground, brittle leaves clacking against each other. Then later there is calm again; a miraculous moment comes when the storm ceases. I remember a single leaf which stood out from the branch, a mere twig, enveloped in the mystery of an illumination which appeared as a pale yellow aura of light. It hung there in space. My mind fixed on it. So also after the storms between people there can come a moment of special calm, a pervading quietness of the spirit, peace, peace within—no, more active than peace, this moment becomes truly a state of quiet ecstasy, suffusing the mind and the body with calm. There is a sudden absence of friction, of tension.

What I am now trying to describe is very different from what I tried to describe about my green leaves which were permanent images in the form of light. Such moments of personal peace were not permanent, not to be thought of in terms of permanence. They were more of a spiritual happening, as fleeting as a falling star, but leaving in its wake a sense of wonder. Personal felicity, but discontinuous.

The green leaves and their phantom light images have made me think of an ancient Greek bowl, 3000 B.C., something that could and would endure, that was made in a hard image. I'm using hard here as one would in describing a diamond. But this other experience of the leaf, though real, was because of its fleeting quality more like an apparition, a phantom of

delight, filling the mind and the body with a sense of repose. How needed! Whether the repose could only come as a result, as a resolution of conflicts, I do not know. It is said of saints and of wise men that they know this quietude.

January 29

A few days ago John Ford came to dinner. It is rare indeed to find such instant understanding of what one had hoped to do. Rolling his eyes up, down, and sidewise, he pantomimed, accompanying the words he used: "You look (and this was in reference to my piece on the candle the night of the blackout) up and over and around and down, and even underneath

things, but then, once you have seen and understood everything, you concentrate on the one point of illumination present." He felt that I had rejected nothing, that I had gone out toward all parts of experience, in both life and art. He said, "Your paintings push consciousness forward and that is always very hard for people to accept." I was very touched by this rare communication. I felt that I was not as capable of following his new thoughts as he was of following these thoughts of mine. He is about to make some very large boxes that will fold up if necessary. It occurred to me, was he really searching to assimilate his mother's death and her placement in a coffin, or his father's approaching death? Such a strange idea, and yet that is what the artist frequently does. He finds images to express the deep experiences he has in life.

February 12

When I received the postcard of "The Entombment of Jesus" from Peggy Berlin,* I thought that the figure of Jesus was almost fantastically like my Prometheus in the painting I did of "Prometheus Unbound." There is a limpness in the figure of Jesus due to his being dead, an enormously touching limpness with a dream-like quality to it. In my Prometheus, the limpness was due to his having been chained so long, by order of Zeus (under conditions of great suffering). I felt that the first step he would take, once he was freed, would show the effects of that terrible ordeal. He would barely be able to move; and yet, as though in a trance, he would move forward into the sunshine. Michelangelo's painting indicates a seraphic mood. The entombment was to eventuate in Christ's Resurrection. He would rise to heaven and sit upon the right hand of the Father, so perhaps his death was a dream in comparison to the reality of eternal life expressed in the Resurrection, which is implied in this picture. In my Prometheus the helpless physical condition was also to be temporary, and the implication was that he would walk forth into the sunlight, free. In the painting of Michelangelo the tomb represents the place where Jesus would find a termination of his life on earth. He would then find the ideal "place where." I used this expression first in connection with Prometheus. I said to George Oppen, "When Prometheus was unshackled he put his foot down, and that became 'the place where.'" And George said to me, "That is a glowing idea, important both to painting and to art in general—'the place where.'" For Prometheus it meant the point of transition from a long ordeal, chained to the mountain, to a peaceful life in some lovely land. In my painting the

*Wife of the painter Paul Berlin.

place where he put his foot down was an admixture of lavender and yellow, as I remember it, and also had that dream-like quality that I noted in the Michelangelo painting, a transparent quality. It was not exactly real earth, in my painting, nor a real tomb, in Michelangelo's. It was an idea, an intuition of a state of being, a state of being that was transitional, and suggested further states of being of a quite different nature.

February 25

Tumultuous interlacings. Angels' faces flecked with points of colored light—red, yellow, blue. Streaks of clouds, fusing, multiplying, dividing. Patches of deep blue sky. Beams of rainbow light. But most curiously, the expression on each angel's face was different, eager, curious, beaming with light, quiet. Everywhere I looked I saw acuteness, differentiation. Forms were not as clear. I was chiefly moved by the inward feeling expressed in the angels' faces, enhanced by miraculous points, some fevered, some calm, some diffuse, some concentrated. Do not be astonished. Such experiences exist in the psyche.

> You said you saw two angels
> Floating in the sky
> I permit myself to dream, you said.
> And with them (incongruous) a large, green
> Turtle. Your cane and halt-
> ing step transformed to ponderous turtle gait.
> Then you remembered the turtle's legendary
> Voice heard everywhere in Spring
> And knew, in spite of halting step
> We'd hear your song.
>
> B.W.* April 17, 1978

My granary must be replenished. A turtle walked up there, too. He had not yet shed solidity of form, become expression only. He paddled along solemnly. What was his destiny? Where was he going? Was not his, the turtle's, legendary voice heard everywhere in spring? At a lower level, there were trees covered with icicles, glinting, glimmering, moist, sharp. Swift perceptions! Disconnected, perhaps, and yet perhaps very deeply related.

In the spring one saw first the wood of a tree, its trunk, branches and twigs, and but a faint aura of opening leaves, of buds—only the faintest suggestion of what was to come, the full leaf, fruit, flower. The earth underfoot was cracking, no longer hard frozen as in winter. We walked

*Brenda Webster.

together over the fields, enjoying all these things—W.S.S. and I—enjoying all that surrounded us, every crack in the earth, every beginning of birth such as seen unfurling on the branches of trees.

I, alone now and old, find my mind filled with visions of noncorporeal but very real angels, as I have said, angels with varying expressions of eagerness and enlightenment, scattered far reaches of sky, rainbows, the sun itself, and later into the day the night with stars and the moon with its strange silver glow. Is it all a chimera, the senses reporting to the mind what the mind cannot instantly understand, but only perceive in the glimmering light of possibility, as a communication from the depths?

Majestic conundrums.

March 1

"Tiger! Tiger! burning bright / In the forests of the night." No, it was not that. It was not "fearful symmetry"—it was not high romance. I was merely walking, as my guide had told me to do, through the dark forest, without the use of any light. He said, "Just walk ahead. You will be perfectly all right." Then to my astonishment I lifted my feet over logs, quite high logs, and pursued my path through the darkness, not entirely but mostly without fear. Instinct seemed to tell me how to walk. Sometimes the ground was soft and spongy, sometimes, as I have said, there were logs that had fallen down, branches of trees, rocks. I simply moved ahead. It was rather strange and wonderful to realize that instinct could guide me and protect me from danger, that there were other ways of forging safely ahead than by having the path lit up. This may be said of painting too. One starts off, possibly, as though high above the timberline in the late of night, and one moves in a certain direction, not knowing where one will come out. Many dangers are above one, possibilities of failing, of not finding the path, but the powerful instinct of which I am speaking seems to keep one moving. Suggestions come from deep levels of the mind. A dark green leads to a purple. A crack in the darkness may appear as yellow or white. One is composing. One is adventuring. One is even running the risk of being "outside of art," as George Oppen put it. One has not sat down to make a schema, preliminary sketches of where one will go, or in what manner one will arrive at expression, or wholeness. One simply moves forward driven by some deep intention to come to the end.

Finally one will see the stars and perhaps the moon, which is of such an unusual nature that I for one could never imagine trying to paint it. I knew of course that Ryder painted the moon over the sea in those small works where he had frequently painted a sailboat leaning into the wind. They were as good paintings of the moon as I have ever seen, and yet not

at all like my moon that involved a sense of farawayness. One knew it was solid. One knew it was huge. One knew it gave off light, but this was not what one saw. One saw an effulgence, as yesterday, in a very similar though minor way, I saw an area in my room on the sill full of plants that had the same quality. It was color and not color at the same time, and it had this mystery about it.

March 4

Quite opposite to the slow, sure feeling of moving instinctively in a way that would bring one safely to one's proper destiny were the numerous times in childhood when one received shocks of insecurity, as in climbing a tree for the first time or the dozenth time, when each step seemed to be a total insecurity, where one's foot might slip or the branch might break, and yet something drove one forward to accept the hazard, no matter how difficult.

In art one starts from known points, and only at some bidding of the unconscious or the preconscious does one let something new in, something totally unexpected, and yet when the inner voice says "Yes," the result will be more beautiful than a conventional one would have been. Think of the Cathedral of Chartres painted by Monet, an extraordinary painting, formal. I remember Gorky standing in front of this painting, pointing out to me that it was one of the first abstract paintings, that the shape above the doorway was a triangle, and there was a circle to the right of that. He saw that the formal aspects, as Monet painted them, approached geometrical abstraction. I on the other hand particularly responded to the extraordinary shadowy entrance to the church. Monet had caught light in the very shadows, had not let them be weighted down. The geometry, perhaps, pointed toward the stability of spiritual concepts, and the presence of light, even in a shadow area, poignantly suggested a song of love. Intellect and emotion were perfectly balanced. Much later, Monet painted the beloved waterlilies floating on his pond that he probably gazed at and dreamed over for hours and days and months. I have frequently thought of these late paintings as reveries of an old man, erotic reveries, as though he dreamt he was lying lover-like between the breasts of a beautiful woman.

The aesthetic content of my life spills over into this notebook. As I look out the window I see the very scene that I painted on the day of my daughter's birth—a Russian church, clouds of smoke belching from smokestacks weaving their way up through space, at times hiding the permanent form of spires and then at times revealing them. Gorky painted on that painting with me, always claiming that it was my painting, while I claimed that it was his.

March 6

Artists have, down the centuries, germinated ideas. They have then struggled to find a way of expressing these ideas, and I believe that some deep instinct drives them to seek out of the past what it can yield them, and to seek out of the present what it can yield them, and to add whatever intuition or inspiration comes from themselves.

There were the great clashing drives of masters, such as Ingres and Delacroix, where the Italianate Ingres longed to produce finished and perfect works but Delacroix, remaining very French, sought to express the most intense emotion through color. They could not like each other. They were taking separate paths, different paths, and down the hundred or more years that have followed their production, people still like either the one or the other usually, but very rarely both. There are predilections. One may prefer the quality of dynamic activity, the thrust of emotion, the clash of temperament against reality, or one may prefer the evolved form, removed for the most part from conflict, risen above conflict, become as nearly perfect as anything human can become. By what incredible magic did Ingres paint "The Odalisque" (Metropolitan Museum)? Many of the forms in this painting are reversed. Where in nature they would be flat, in his painting they are round, and vice versa. What inner voice bade him to do it thus? I have studied Ingres down many years and still do not understand how he came to know which he would finally do, or how. He strove for the elegance which he had learned to love in the Italians, and achieved it, but he maintained a light French touch, exquisite.

March 7

I have spoken of the simultaneity of impressions received in early childhood, impressions coming to one through all the senses. I heard leaves blowing in the wind, and at the same time I experienced visual perceptions of grasses, flowers changing their shape, light giving different colorations to more stable objects such as rocks and tree trunks. I have not mentioned the other senses, the senses of touch or smell. These too were aroused and made for the full effect to be received. In the child viewer there was a polymorphous quality. The child himself was in a mood of instant responsiveness, overjoyed to greet the day. How compensate for the lack of this polymorphous spontaneity in the work of art? Van Gogh spoke of wanting to get into his paintings the smell of the rich loam of the fields in the South of France. Perhaps other artists longed to suggest the feeling or to suggest the actual living force of the bird's song. As one perceived it in nature, all this went together. In art what was substituted? Or was something merely left out? Space structure could be achieved. Many objects could be repro-

duced with considerable fidelity, stories could be told, images evoked, states of mood and being could be rendered.

March 29

The image of the dark green turtle still holds me. I am reminded of a quote from the Song of Solomon: "And the voice of the turtle shall be heard through the land." So could it be that I had also associated the idea of love to the stately, slow-moving turtle? He was solid. He was dark green. He had not been dematerialized. And now, is he to be the voice of love? Was I trying to say that I indeed was like this turtle, moving perforce slowly due to my illness but spreading the idea of love? In what way did the word turtle become associated with turtledove? In looking up turtle in the dictionary it was associated in this way, but without explanation. So a seemingly inexplicable and even unimportant image took on deep meaning. I was fascinated by the color green itself, so dark, the solid form, the motion and gait, firm though slow, and all around the angels and other beautiful sights of heaven, expressive, dematerialized. What shall I make of all this? That I am still alive, and therefore thinking in living terms and dreaming of a hereafter?

April 1

It is well known that the Egyptians and then the Greeks used geometry in connection with their works of art, as well as architecture. Other artists have likewise used mathematics, Paolo Uccello for instance. But there is still something unexplained about it. The mathematics may well have indicated, and to some extent controlled, the proportions used in these works of art, but when you say that because these artists used mathematics their works were beautiful, you run into a dilemma. At just what point did beauty come in? What connection was there between the mathematics and the beauty? I cannot believe that mathematics alone could create beauty. For instance, spaceships would certainly not be so named. At what point did beauty come in? Were not artists just as well off following the forms of nature as they saw them with the geometry "understood" rather than explicit? The discussion with J. F. last night upset and infuriated me. I felt that he was relying on mathematics and geometry to produce works of art for him. He felt that if he understood mathematics, somehow he could control its magic—beauty would be there! But I do not think this is true. He said it was no use plumbing the depths of the mind as Freud had done. He wanted everything to be out in the open, clear. It seemed to me that this was hazy thinking. What came from the subconscious or the precon-

scious, in Freud's way of thinking, was simply further parts or elements of the total mental picture. They were not necessarily dark.

If my mind can become free enough to permit the preconscious to bring its voice through, then I will have enriched my thinking and the images that come in this way will surely be more pertinent.

I believe John Ford's making these strange constructions that open out into domes and circles that can be shut up again and put away may well be his reaction, or be connected with his reaction, to his mother's death and her being placed in a coffin that was rigid, and from which she could not escape. Was he not, or is he not, making structures that are expandable, that can be open or shut so that, indeed, to follow through the thought about his mother, she could escape, or she could at least move around in the coffin? So that he is, after all, listening to the promptings of his unconscious or preconscious thoughts but not aware of it, unwilling to be aware of it.

April 10

Fling words upon the recorder tape. They will sort out at some point. Do not be afraid. Above all, the best thing is not to be pompous, rather to realize the living quality of thought as it follows, or tries to keep up with, one's experience. If music does not especially acknowledge the sounds heard around, it does acknowledge the feelings evoked by them, and in this respect it is very similar to art. But in respect to the way in which it does this it is different, because art, as we have said, is heavily influenced by the actual visual scenes that we have experienced. I appear to be saying that there are formal connections between music, the dance, visual art, and possibly, at a somewhat greater distance, between them and mathematics, logic, philosophy, geometry.

Perhaps it is true that modern art makes me feel so starved because in it so much is cut off, and one knows the artist has concentrated upon such a small section of experience. When I was painting Orpheus as he bade farewell to Eurydice as she descended into the netherworld, I felt a motion run through my body, as though I too leaned in her direction, swaying in a harmony enhanced by the music I was playing. I yielded to the sense of motion in the music that corresponded to my desire to fully engage in the stream of thought that was contained within the image of Orpheus' departure from Eurydice. The music contained a gesture very similar to the gesture I was painting on my canvas. Was it Gluck I was playing? Was it that part where Orpheus sang "How can I live without Eurydice?" In this case, the music did convey an emotion of a specific, dramatic kind, just as I wished to convey the theme of separation through the painted forms.

But, you will say, that is opera, and opera has always been aligned with drama, that is not pure music. But I've also played pure music, music of Beethoven or Bach in which I sensed an undercurrent of emotion that corresponded quite closely to the kind of emotion I was attempting to express in my painting. It was not the only element. It was one of the elements that composed the whole.

April 15

Whenever there was a storm at Provincetown or Nantucket, I used to jump into my car and race toward the seaside to hear and see the rolling water pounding and booming upon the shore. The spray lifted up, sparkling, and fell back. Turner has shown storms, other artists have attempted to also, but they really were very weak in the ability to convey the might and fury of nature.

We have experienced and known and read about the most tumultuous and disastrous happenings to man himself, in both the aggregate and the particular. There is nothing that we have been spared. Again, we must ask, has even the mind of genius been able to convey pain, agony, tumult, disaster in anything but a very weak way? The smallest pinch of actual pain is more real than any feeling portrayed by a painter or a writer. Why then do we admire and seek out these works and reverence them? They are like the shadows in Plato's cave, mere shadows.

April 22

No flat shadows here such as one had experienced on the walls of Plato's caves. Here, eleven thousand feet high in the mountains, one looked up at the unveiled stars, one stayed up half the night looking at them—transfixed. They were brilliant beyond compare, full, scintillating, majestic, marvelous. Though the air was thin up there, one felt no fatigue. Again, one must say that it has been far beyond the possibility of any painter, of no matter how great genius, to produce anything resembling the impact of such a fantastic wonder. Innumerable attempts were made. I recall a painting by Rousseau of a lion and a gypsy (Metropolitan Museum). Rousseau painted stars in his soft, blue-grey sky. One felt what he wished to suggest. I could, by a stretch of the imagination, remember myself back to the amazing star-bright sky of which I have just spoken. But even with this added support I could not re-experience the original impact, nor the enormous joy. Is this not why we are so hungry and sadly starved? Were not the nomads who wandered the deserts in Egypt, living every night under the stars, richer

in their experience than we who have removed ourselves, for the most part, from the most glorious events of nature?

April 28

Wild conflicting contrasts of emotion and phenomena frequently appear within a split second of one another, seeming to come into existence simultaneously in time. When in Taos, New Mexico, some years ago I used to be fascinated by the fact that one could look across the mesa and see to the south a shower pouring down and to the east a full sunlight, beautiful rays irradiating space and earth.

I have been inclined more recently to love the homogeneous, the whole and unconflicted, as represented by Egyptian art and, closer to our time, by Ingres or Vermeer.

I'm studying some anemones. I search constantly for some possible way in which one might describe, through paint, the beauty of a flower. I truly believe there's nothing more difficult, and that it has rarely been accomplished. The color of flowers is so pure, the form so firm. And yet the petals themselves are very slender, very thin, delicate. Degas, and later Cézanne, for instance, painting flowers got the strength of the color, but lost the fineness of the material of which it was made. This was perhaps a characteristic failure of painters.

April 30

Long ago I adored the lines:

> A violet by a mossy stone
> half hidden from the eye!—
> Fair as a star, when only one
> Is shining in the sky.

Last night my violets, which had seemed quite uninteresting earlier in the afternoon, took on a depth of beauty that was breathtaking, engulfing. My mind revolved around this little dish of violets as though it were in orbit, as though my mind were in orbit, and these flowers were at the center of it. They were similar violets to the ones I had used in connection with a portrait of young Marcel Proust, where I felt that if I mentally crushed into powder the violets that might have been a ribbon of flowers around his hair and moved those violet tones into the tone of the hair at the forehead, it would somehow express the idea-image of the wonderful little genius, of the young boy who would become a great writer, a builder of cathedrals. I did indeed also think of crushing these violets, maybe for

a perfume that would come out of them, but on the whole I was content to take them as violets alone, evoking in me an extraordinary depth of tranquility. They seemed to equate the whole universe and were not out-balanced by it. If this were music it would be Casals playing Bach unac-companied. It had that kind of depth, a sort of dry, haunting depth. The beauty of the flowers filled me and I passed from the agony of a long day of lack of tranquility to a sense of full tranquility. The violets had a strange but deeply satisfying glow, as though they were embers, and reminded me of the joy I got from my grandmother's jewels which she wore around her perfect ivory-toned throat. The depth of the memories evoked permeated this present experience and intensely enriched it. I repeat the idea that I wished to crush the violet tones of these flowers, so like embers, so burning, and yet so tranquil, into a second tone that would add a further sense of celebration to the hair on the forehead of the young, tremulous Marcel Proust. What a lovely enrichment that might bring. Or could I not easily imagine that Marcel Proust himself might have anticipated my inspiration. He might indeed have looked at his image in a pool, Narcissus-like, finding such marvels there—crushed tones of violets and embers. There are points in existence so full that we can never forget them. They sink into the reservoirs of our memory and are never lost.

The Chinese statue, which has stood down the years in a corner of my room, looks over at me now, calm, graceful; surely he would have under-stood all that I am saying.

"The powerful conflict of two opposing
but unequal souls . . ."

EGO CLASHES

○ **INTRODUCTION**

By May 1978 Ethel was experiencing increasingly bad pain in her hands, which often made it impossible to work and for which she took Darvon, as well as a variety of other medications, including librium for other physical and nervous ailments. The pain in the hands, which had been diagnosed as arthritis, was at this time being viewed by Ethel's analyst as having a psy-

chological component. There were financial worries. Inflation had eaten into the value of her income. It was costing her more to maintain her household and continue psychoanalysis. In addition, failing health made it necessary to increase the amount of help she needed (one live-in housekeeper, a replacement on weekends, and additional help for heavy cleaning). To maintain herself, she was selling some of her beloved art collection: an Ingres, a Juan Gris, and a number of Gorkys. She was also eating into her capital. She therefore became particularly upset at this time when she learned that her housekeeper had been charging enormous amounts of groceries to her account at Gristedes and taking them home for her own use. Even without this difficulty there were problems in finding and keeping good help, because Ethel's health (her hands, and her severe stomach problems) made her irritable and demanding. There were frequent crises in trying to replace the staff, during which Ethel felt frightened, disoriented, and deserted.

Her concern and fear of being alone in her apartment during this period were not without basis. Her arthritic pains made it difficult to move about. In the autumn of 1977, Ethel had reported her first fall to her daughter-in-law, Hannelore; by January 1979 the falls had become frequent enough for her children to become concerned.

For the months following November 1978 there is a manuscript notebook of jottings, which covers the same period as the typewritten journal and on which we are drawing for much of the information about her more personal concerns during the last years of her life. Often the material in this private notebook completely diverges from the material in the typewritten journal we know she intended for publication. Whereas the public journal shows a mature artist at the height of her powers as writer and journalist, in control of her chosen medium of language and concerned with questions of general human and artistic importance, the private notebook shows a confused, ill, and angry old woman, terrified by her diminishing ability to control her own life.

By November, the private notebook shows that she was worried about the possible breakup of her daughter's marriage. During this time of stress she found it upsetting that Dr. Kris demanded prompt payment of her considerable monthly bill. She felt increasingly troubled by Dr. Kris's insistence that theirs was a professional relationship that had to be paid for. In her private

jottings she begins to ask why, if money was so important to Dr. Kris, Dr. Kris didn't encourage her to earn it. Had Dr. Kris helped her to be more assertive in pursuing success through her career, rather than encouraging her creative ambitions while directing her to seek a psychological cause for her need for recognition, Ethel's life might have taken a different turning. Rothko earns money, she notes; Dr. Kris earns money, although Jesus and Socrates didn't. Could "the money thing" be a weakness in Dr. Kris? What are the true values?

At the same time, she begins to hope that she will soon be free of this part of her financial burden, since Dr. Kris has been suggesting to her that her analysis is almost finished. But the material now being uncovered in the analysis is highly upsetting to her. Particularly painful were memories of murderous thoughts toward her mother and jealousy of the young lover her mother had in her late forties, John McKay. These painful memories wakened anger at the lover of her own old age, and a revengeful wish to break up his marriage.

Though she could no longer do large canvases, she was trying to continue to work in spite of her pain. She mentions doing a small painting, and there are some notebook sketches in existence seemingly inspired by her psychoanalysis. Increasingly, however, her work on the journal came to replace her work on the paintings. She was able to bypass the pain in her hands by dictating into a tape recorder. It may be also at this time that she was beginning work on her last Matisse-like, free-line colored ink drawings, a real triumph of energy in her old age.

During this period the public journal is filled with storm and cataclysm. Ethel's therapy was focused on her possibly lifelong suppressed rage, and the inability to express this, as being the cause for her arthritic pains. The private notebook focuses much more directly on recovered memories of Ethel's rage at her mother's relationship with John McKay. Part of her rage may well have been caused by Agnes's confiding explicit details of her sexual practices to her twenty-year old daughter (as revealed in Agnes's surviving letters). These details reappear now, recycled and transformed, in Ethel's fantasies of grotesquely mutilating and murdering the lover and murdering her mother. She says in the private notebook that her guilt over these fantasies caused her rage against herself and resulted in suicidal feelings. At the same time the private notebook also discusses excessive feelings of attraction toward Dr. Kris, analogous to her feelings toward

her mother and similar possessiveness toward her daughter. It is significant that at the point when the handwritten notebook brings these themes to the surface there is a one-month gap in the typewritten journal, with no entries for January. (Obviously there were, however, earlier handwritten jottings for earlier stages of her entire typewritten journal, as the sections that have remained begin with page 1329.)

Ethel's aesthetic concerns are now increasingly embodied in the journal. They seem to involve summing up the meaning of her life as an effort to create moments of quiet, precisely observed containment in the midst of storm, and to uncover "a little of the truth," as she quotes Freud saying. She resolves to spend her last years observing what is available for her to observe. She turns her artist's eye loose on the approach of death, as well as on the changes of light on the surfaces of leaves and flowers. She also turns her mind loose on transcendent images such as the turtle she uses as the totem of her body in old age, and the angels, whether of art or of death, whose presence she wishes to acknowledge.

Out of all the clash, turmoil, and suffering recorded in the private notebook, she makes in the public journal a beautiful mosaic. The rhythms of her prose are generous, flowing, and graceful. Her language is lyrical, her imagery both vivid and telling. Her evocations of turmoil are couched in grand imagery of storm and natural cataclysm, and are allusive rather than narrowly personal. Her observation of the play of light on a leaf or the flowering of a plant linger accurately and lovingly on the surfaces of things. By an act of will she sets up her essential opposition to the great violent forces of human nature and the world, the redeeming ability of the human consciousness to notice the endless exact details of the immediate. The act of making this journal is a direct example of her aesthetic concept of the "Paradise of the Real." While the private notebook stresses rage at her mother and longing for total possession, the public journal transmutes these feelings into the beautiful imagery of the white leaves of a plant that suggest "a mysterious, penetrating, filling substance . . . like mother's milk itself." By focusing on the play of light on the surfaces of things, she tells us, in effect, that this is what is ultimately real, and that the turmoil and grief surrounding them seem, in a sense, hypothetical constructions.

Aesthetically her decision not to use the distressing material

of the private notebooks directly in her work intended for publication was correct. Her aesthetic intention was not to record turmoil but to transcend it and, through the writing of the journal, to create a beautiful contained place of enlightenment and tranquility. The mosaic of language and imagery she creates in and through the journal, therefore, acts like the death coverlet of flowers she imagines in the journal and covers her with glory. By concealing the much less satisfactory (as she thought) real woman recorded in the private notebooks, she turns the Ethel of the public journal into a work of art, and a mythological creature.

THE JOURNAL MAY–DECEMBER 1978

May 4, 1978

Ego clashes: the powerful conflict of two opposing but unequal souls, centered like icebergs at the eye of a cyclone, whose whirling fury was a deadly force capable of hurling the two masses toward each other with the inevitability of imminent clash. On the one hand, naked power vaunting itself; on the other, naked insufficiency and weakness. Deadlock: impossibility of communication, lack of relationship, inability to strike back, to kill if necessary. A sense of fury that it should be so.

Simultaneously there was the desire for full possession through love, and the grueling inability to make this emotion felt by the other, or even to gain the recognition of this undeniable drive. Images of falling, fainting, becoming helplessly weak as a way of bringing about a shock of recognition in the other—and eventual reciprocation.

Ego self-discovery: an attempt to communicate the awareness that beneath a painful sense of self-weakness, deep down, was a well in which clear new forces lay available to the ego for the creation of a purified, enlarged self, sure, able to be alone. Surely this hypothesis of potential self-renewal must be made known. Had not Prometheus made it known to Zeus that he could not be a follower, that he himself was whole and due a whole life? He held to the idea of his own individuality and eventual freedom.

I have intuited an image of a control force that could rightfully supersede

weaker strivings emanating from the ego. I was pursued by a desire to penetrate the consciousness of the other individual and to claim the until-now unattainable acknowledgment of my being. I felt like calling out "I have been for a long time; I am now; I will continue to be; and I am not nothing." How long can such a state of self-assertion last? Or will I sink into a sense of despair and emptiness? If so, will ego strength return and reaffirm itself? Did Prometheus not shout into the endless skies that he had a right to Zeus' respect and love? Violent competition was evident. Violent desire for love, which could not be realized, anger at being left alone, at being deserted, at facing the other's going away, Zeus being too busy running the universe to think of him, except in terms of punishment.

Have I not come at last to the end of a long-time journey, as Prometheus did when, finally unchained, he stepped forward from the mountain to "the place where" and became an individual, no longer subject to the will of Zeus?

The fate of Oedipus was quite different. He had unwittingly sinned. Freud, deeply impressed by the truth of the Oedipus legend, concluded that his actions had been the result of initial, natural drives, and discovered that these initial drives exist in all of us, perhaps in the same form of unknowingness, and only later become known as sin or evil, to be finally purged by rigorous self-punishment. Oedipus blinded himself, went forth into exile, traveling across great stretches of land and mountain to come finally to his deathplace. And there, according to the Greeks, he met a glorious end. He was forgiven, or felt forgiven, for his sins, or understood how they had come to take place, or what they meant, or what he meant, or all of these together. This happened just before his death.

And what of Orpheus, who went in search of his wife Eurydice and failed to bring her back? To what was this failure due? Was it due unconsciously to his wanting to prevail as a single individual, complete and needing nothing further than himself in a sort of idealized narcissism? Or was it due to some weakness of whose beginning we do not know, nor what it was?

Activity in the unconscious: the desire to kill, and simultaneously the desire to love, which are at the extreme opposites of one another, threaten to destroy the one, the other. Violent perturbation. Violent exhaustion. Possibly eventually resolution. We do not yet know.

May 6

Yesterday in order to regain calm I lay all day looking at my portrait of Sigmund Freud whom I depicted as the perfect listener. Though old, in pain, sad, he was one whose aim, as he stated it in a letter to Romain

Rolland in 1926, was "to explore, solve riddles," and to "uncover a little of the truth." Reality came first with him, as with Socrates of old, as with many of the great philosopher-poets.

In childhood, hatred and the desire to kill are present—the desire to kill the one who would not love enough, most frequently the mother. This desire was followed by a horrible sense of loneliness, the fear that perhaps one had killed her, and one was now alone.

Purged?

All day I studied a little white plant I had ordered from the florist. Here was an object existing in the real world, something growing. As I transformed it in my imagination into an image, I was untouched by conflicting emotions. This plant metamorphosed into an image had come to exist in the realm of aesthetics. The flowers were white with soft celanese-green centers, slightly square. These squares held their place in an abstract space. There was also a little group of flowers still in bud. One, the highest up, was the biggest, and below it were three smaller ones, pristine, solid, firm, and full of energy.

From the very beginning in early childhood there must have been endless occasions when I sensed such a pure flow of creative vitality passing in and out of my mind. I imbibed. In this pure, single state of imbibing the found will to live, to grow, to be, I was perhaps like an infant at the mother's breast, drinking the precious life-giving fluid.

May 7

There was something else about that plant; the white leaves suggested a mysterious, penetrating, filling substance, perhaps as I have said a substance that could be for me like mother's milk itself. And the little squares, not quite squares, not geometric, very free, floated there in the midst of the white petals, and somewhat beneath there were smaller buds, that seemed compacted of energy, another principle really. The movement was from compactness to fullness: I felt myself delicately engulfed in the process. Still further below these buds were dark green leaves. The leaves were sprawled out, energetic, powerful in color, a very different range. So here in this small plant I found a wide variety of tonal ranges, shapes, and energies, tantalizing because if I were to try to reproduce this in a painting it would be an exceedingly complex task. This is probably why many painters have reduced their parameters. They have frequently merely made an effort to get some of the stronger differentiations set down, but to me this seems too limiting. I found the complexity itself enthralling and did not want to blend or to mix into one another the nervous sensations I

received through my fingers or eyes or nose or mouth, but wanted them all to be there in all of their acuteness and in proper place and in proportion.

Leonardo da Vinci, endowed with scientific accuracy of eye, reproduced flower beds that were marvelously differentiated. The colors were not clumped together as lovely groups of tones; each flower was itself, each stem, each bud. I feel that frequently this aspect of Leonardo's genius is quite ignored, but it appeals to me, and the attempt to arrive at such an end would be most challenging. I am only sad now that I really seem not to be able to paint any longer; I cannot accept this challenge myself. But the path is open and hopefully a great genius will come along who can do just this.

May 10

Summation: Wild upheaval at the various psychic levels may appear in sharp contrast to the calm plateau of aesthetic unity, yet I feel that released anger is a part of the fusion process. Fury having vented itself, there is now the imminent possibility of thinking clearly, of concentrating on creative activity. Yes, it has happened! Living quite alone, I have imagined and set forth new, powerful and even startling creations, daringly conceived and true, though they may reflect but a minute segment of the larger reality of the psyche of our time.

Alas! there is still present deep anguish at the idea of separation, of being left alone, perhaps resting on the fear that, if only in fantasy, I might have killed the one I love most. I try not to restrict this continual swinging back and forth, in my writing, between raw efforts at personal development and/or the plunge into involuntary psychic conflicts which are beyond my control. But eventually, one hopes, reunification may occur, and the ego may feel that it could then be free. Visions might come. I would not have to deny them. I would simply admit their existence and deep relevance. As yesterday, when I experienced emotionally the strong certainty of love. Love appeared as an entirely satisfying reason for living in spite of inevitable pain or conflict. There was quiet all about me—a feeling of wholeness—harmony. This, then, was a vision of fulfillment through love. Mystical oneness.

But in sharp contrast—today I experienced once more sudden tremors, or tremblings, as if an earthquake had surfaced, toppling all the super-structures so carefully built up over a lifetime. In ancient times this was indeed true of Oedipus. Those forces that had shattered him, thrown him into upheaval and dire pain, were gotten rid of. He attained unity, laid the "ghost of the unquiet father," became himself, and stood fearlessly alone as he died. [See plate 13, *Oedipus at Colonus III*.]

I will not wait for the time of death, but rather, after re-ordering my own forces, I hope to observe the different kinds of energy in the visual world surrounding me (whether in small plants or in larger scenes), leaving myself free for visions or images that represent the true, inward forces—personal, real, not stolen from some other author or poet, matching the actual state of my internal world.

Is there not poetic verity in the image of my green turtle who, walking across the heavens haltingly, seemed so senseless when I wrote him down on the white page a few days ago that I nearly gave him up, only later coming to realize that he represented me well in my present state of illness and therefore was altogether a true image, stating something very deeply important to me, namely, my approaching death?

Yes, I dreamed of pebbles at the bottom of a brook, surrounded by water, glistening, beautiful. Lying by the side of the brook I could smell the pine needles and hear the gurgling of the shining stream; and with a sharp twist of the head I could see the endless sky above and birds flying over the trees, flowers, grasses.

Again I ask, why did these pebbles come into my mind? They were whitish with tones of pink and tones of ochre. I do not know what they signify.

Properly speaking, neither the turtle nor the pebbles are really visions at all. They are images reflecting reality and/or the activities of the psyche. Perhaps in a few days I shall find out why I was thinking of pebbles.

May 16

All morning I lay close up to a branch of lilac blossoms. The blossoms pushed from bud to tiny flower in a few minutes. The tonal range of the bud and that of the flowerlette were of quite a different nature. The whole clump of lilacs on the branch was shaped very strangely, I thought, and would be hard to describe. But even more striking was the quality of the green leaf. The green leaf evoked a very different mood or category of aesthetic experience, the leaves being of a rather soft green, very simple in shape, very slender, so that I had the greatest difficulty in combining them and seeing how it came about that they were in vital relationship to one another.

Rook McCulloch later told me that the leaves of the lilac bush would lean sideways from the trunk and thus would appear quite differently from those in the vase. I took a single bunch off the small branch of lilacs, perhaps less than one inch high, and observed that there were as many as eight little flowerlettes not yet flowered. How extraordinary!

I have been fascinated ever since childhood by usually ignored minutiae

in which appeared charges of energy, noting delicate points of discrimination and difference. All of them held the greatest interest for me, as did originally the little fly on my windowsill in childhood. I especially loved his delicate legs and motions and felt the wonder of it all.

Darwin and many other scientists did investigate the minutiae of the changes and growth seen in nature, and studied the nature of these changes, attaching enormous importance to the most delicate differences and forming from them certain very large theories as to the development of organic forms.

Was I making a mistake in trying to bring something of the scientific spirit into my study of art? A sort of fury possessed me—I was dissatisfied with the approximate, with the glossed-over. I wished to follow the processes of nature, as nearly as I could, to see how they developed, and in exactly what manner. I also wished this series of discovery, in turn, to lend something to me to amplify and give body to what is generally called the aesthetic sense, the sense of beauty. The green leaf of the lilac branch was of such an extraordinarily placid quality. It was delicate. It was calm, while the little flowerlettes seemed to be bursting with energy and bulky in form. On the purely aesthetic level some inner force urged me to try to find a way to show all of the observed differences between adjacent qualities. I loved to study new categories at various removes. While a Matisse painting is usually so consistent and there are always lovely spaces that contrast beautifully with one another building to a very satisfying whole, they will not have been as varied as I could have wished. Life itself seemed endlessly varied and even erratic, although what we call erratic may well be simply that which we have not yet understood. I wanted to understand, I did not want to accept generalizations without knowing the underlying specific data of reality that shaped them.

May 20

I seem to have gotten into some trouble with my little tape recorder, but I hope that it is now working.

I'm haunted by the little violet plant that was given me yesterday. Its lovely violet color seemed to seep into my very veins and to flood the surrounding area. I felt it had depth of color and at the same time an extraordinary quality of extension. I felt nothing of emphasis in it, a quality that I've taken a dislike to at present, but rather a poignant softness, a state of being, a state of peace, a relinquishment of struggle. No! Why put it that way? Why mention the word relinquishment or struggle? They have become nonexistent. A state of being pervaded me, come down from some ancient, spiritual world. There was a feeling of déjà vu, repetition. In this

little violet plant I was surprised to feel the "angel" quality, the spread of universality, the softness, the way it had of just existing, of filling its true space in time, by finding "the place where," by being.

May 21

I have never failed, I believe, to acknowledge the presence of an angel as soon as I sensed one. I have perceived angels all down my life, non-corporeal, existing in the spirit alone, and I have acknowledged them in spirit without ever insisting, or trying to get a similar acknowledgment from them.

Chris glowed all night, all evening, during my birthday party, my seventy-fifth, with lovingness. Is this not what I mean by being an angel? He is a loving son, a wonderful son. But I, without being an angel, have recognized angels, oh, yes!—the angelic in a beam of light, or in a flower, or in the expression in the eyes of a person just walking by.

Or, as when I called George Oppen and said, "It will soon be my seventy-fifth birthday," I recognized that once again, in his loving "Hello," I was hearing an angel speak. His voice was not of this world that we think of as the world, but of a special world, a world where spiritual essences take precedence over all else.

May 24

I realize that there is not so much time left. I have spent literally a whole lifetime trying to describe my perceptions of the plastic qualities of leaves and flowers. At midnight, I went into the dining room to look once more at my little violet plant. The green of the leaves was continuous and did not seem to admit of any interruption. It was both abstract and concrete at the same time. The flowers themselves, so purple, touched me deeply. I did not like to yield to the idea that my response might be due to the fact that in childhood my father loved to give violets to my mother, which she frequently wore, or that my feeling had such a sentimental base. I felt as though my response was more universal and I can only liken it to my enthusiasm for the Egyptian frieze of the royal cattle. The kind of aesthetic that is projected seemed to come out of its own nature. There was nothing extraneous there. The violet color was of a piercing quality, brilliant (I have stressed in previous writing the softness of the violet color). Yes, it evoked a sense of rightness. It was ripe and luscious to the eye as a peach would be to the palate.

I'm haunted by an even stranger image or piece of reality, and that is the spider web which as a child engrossed me, interested me, and somewhat

frightened me. Of an evening I had often come unexpectedly upon this spidery cobwebbery hanging in front of me in the darkness and found myself entangled in it. Yet, looking back at it I realized that it had an age-old design. I thought, "My heavens! this design has come down through the millennia, though the material of the web itself is made of the slenderest gossamer strands." I felt that here was the key to much of what fascinated me in art—the means used might be of slender substance and yet result in powerful and enduring creation.

I spoke with Lisa* in San Francisco tonight. She had written me that she was interested in the powers of the mind, in psychic research, and so forth, and had I been interested in it? We conversed about this. It was very touching to me to think that this new young generation would be asking the same questions and seeking, seeking, always seeking. It renewed my hope.

May 25

The green leaf of the violet plant aroused in me the most extreme intensity an individual, or perhaps I will put it that I myself could possibly imagine or endure. I extended this small segment and envisioned it as a huge field of intense green. The small red or bluish-red violets themselves were another instance of this kind. This plant existed in itself without one's having any special sense of the definition of its outlines. It was not like the phantom of my leaf, not phantom-like at all, but of high poignancy, in no way dented or fluttering, or even divided. It associated itself in my mind with an imagined area of high intensity green, which I had not yet defined. The experience as a whole lasted only a few seconds, but was of such extraordinary vividness that I tried to calm myself by the thought that it only involved a leaf. But no, it involved rather a bit of reality: an instance of perfection. There was a sense of the quality of the leaf as a continuity of green. The continuum, the stretching out, the flatness seemed only to enhance the vividness of which I have spoken.

May 26

Yesterday I emphasized the intensity of the green leaf and the purplish-red violet flower. I think I over-emphasized. It was possibly more the sense of extension that was evident and that stirred me so much. There was a sense of extension, expansion, although within limits. The extension was

*Lisa Webster, her granddaughter.

of only a certain duration impossible to time, but in that second's view of the flowers and the leaves I had had an experience so rich that I would not like to try to give boundaries to it.

Do not allow yourself to doubt the truth of your own experience. If it seems exaggerated in any way and if indeed it has been occasioned by the use of some drugs for illness, do not let that bother you. Nonetheless, you experience it.

In talking to Paul B.* last night I think I was trying to escape from the responsibility of accepting my own visions, as though indeed I wished to retreat from them. Above all, do not retreat; accept them. They are gifts given to you.

Under the sign of mystery: Today a violet plant is on the table next to me as I speak to the recorder, and I am looking at the green leaves and the violet flowers. They move me in a quite new way. The intensity I felt a few days ago is gone as well as the sense of expansion. They now exist for me, rather, as the loveliness that one customarily thinks of in connection with flowers. Not less valuable for that, I am ready to accept them in this familiar way too. But I will no longer refuse the extraordinary moment. I will not reject it. I will treasure it, rather.

May 28

While looking at my violet plant I focussed on a cluster of violets and leaves with many little buds behind the larger flowers and thought, "My heavens, these leaves are the yellowish, silver-gray of Corot." Here in a sudden reawakening of "temps perdu" (as Marcel Proust would have put it) was a perfect example of Corot's moment, it was the refound moment of soft greys: a moment of complicated involvements of shapes: a moment of quietness. Today, Corot's quality was alive in me once more, and I could respond to every startling, satisfying nuance of it and rejoice that I could re-experience so many of the wonders that I had once enjoyed directly. They were present, right here. It was not a question of looking at a photograph of a Corot, or a photograph of some exponent of his style. Here was the very man, the very moment that he had chosen to love and to put forth in his work utterly different from the past few descriptions I have given of the violet plants. The violet leaf itself was yellow-gray with a fine, white edge, which I have so often tried to paint, alas, with such unsatisfactory results, as the leaf turned out usually to be too stiff or the edge too hard. This involvement of the flower in front and the buds behind, the

*Paul Bodin

stems, the larger leaves, all seemed to exist most harmoniously, in unison. "But these are fragments," you will say. "We have no use for fragments of this kind." This particular bowl of violets brought back to memory larger paintings of Corot, where the same qualities were expanded, and I felt very rich. Above all here was life! Not yet stilled or distilled into any definitive form, not fossilized as yet. Corot's genius merely pointed to possible ways of expressing plastically an attitude toward existence, through forms and images that he had evolved as he studied nature.

June 1

I am thinking of the death of Socrates. Condemned, he is given a bowl of poison. As the poison begins to take final effect, freezing his limbs and reaching toward his heart, Socrates drains the cup without fear, retires to the rear of the prison, lies down upon a couch and, according to Plato, pulls a coverlet over his head. I assume that it was of severe simplicity, made of some simple Greek material.

June 2

But I had rich fantasies of some rather extraordinary cover for Socrates, made of jagged pieces of jewelry.

Come now—there is really no need for such splendor! Rather, I prefer to assemble in my mind images for a coverlet of daisies with bright yellow centers, their petals shiny, their green leaves dark, the stems a milky, soft jade color. I assemble these images of beloved flowers, evidencing life, and I add to it impressions of the lilac in the corner, a large bunch of lilacs sprouting endless small blossoms, full, luxurious. I think especially of the crocus that has found its way through the earth in springtime and has come out so small, delicate, exquisite, and the dandelion, and the buttercup. Oh, the buttercup! That was my favorite flower. It was translucent, transparent, golden, sunlit, a cupful of sun, a tiny cupful of sun. And yet, a bringer of great joy.

So much for Socrates' cover!—but, more personally, lonely as I am, were I to dream of a multitude of these flowers spread over the lands of the earth, everywhere, everywhere, I could start to breathe again. I could concentrate on absolutes and put aside the gloom of conflict and despair.

June 6

I have been ill. I realize that the violets that I had brought from the florist the other day have sustained me. What is the cure they contain?

PLATE 9. *Red Bird* (1955). Oil,
54″ × 45″. Artist's estate.

PLATE 10. *Of George Oppen I*
(1972). Pastel, 12″ × 9″.
Collection of Brenda
Webster.

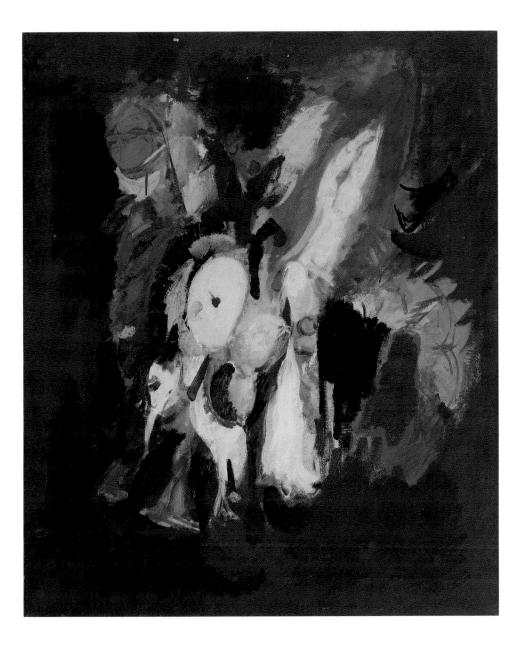

PLATE 11. *Woman III* (1951). Oil,
36″ × 30″. Artist's estate.

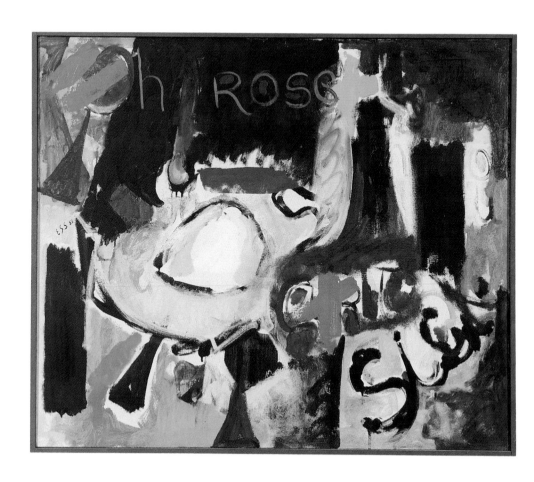

PLATE 12. *Ode VIII (O Rose Thou Art Sick)* (1951). Oil, 30″ × 36″. Collection of Judith Johnson.

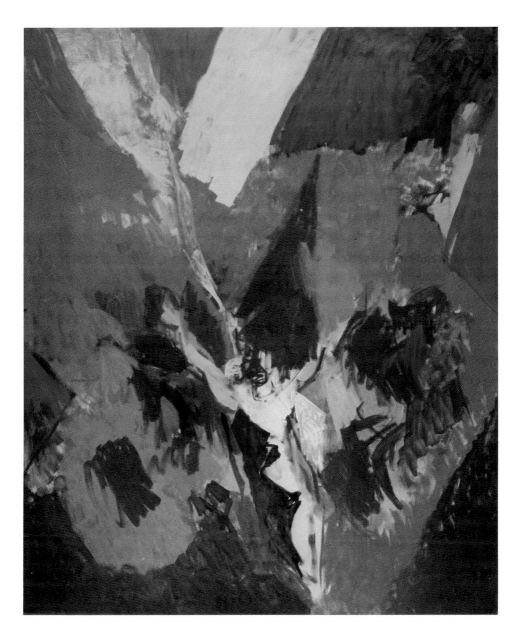

PLATE 13. *Oedipus at Colonus III*
(1959). Oil, 90″ × 75″.
Artist's estate.

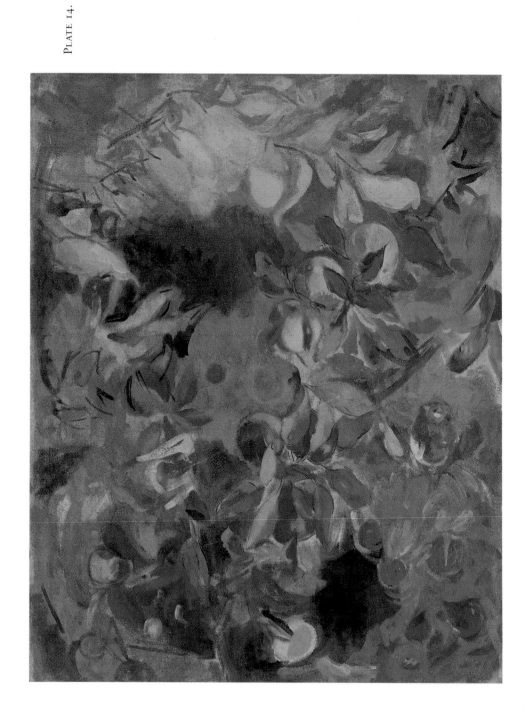

PLATE 14. Untitled [Peach orchard] (c. 1947). Oil, 24″ × 30″. Artist's estate.

PLATE 16. *Antigone I* (1958). Oil, 51″×85″. Artist's estate.

Perhaps it is this, that they are such a wonderful violet color, abstract and yet very real. They are—I will dare to say—"angel" violet color, that curious anomaly, the extraordinary become more real than the ordinary.

June 7

My violet plant with all its green encirclement of leaves is anomalous, not congruous. The violet that is congruous gives off many closely related depths of violet, layers of petals that amplify each other's mystery. While in the other violet plant whose leaves are beautiful and strong, though irregular, the buds have tended to wither and have lost their vitality and power to expand. This power comes from some source I do not know the name of.

June 8

In my mind I see purple gardens on the sea bottom, in the hills, and in the mountains, full of large violets and violet leaves. I perceive in them strange depths, extraordinary extensions—embellishing space, filling it and even spilling over its ellipses—as they stretch onward.

This image is not like the circular 360 degree concept of the North Pole, of which Barney Newman was so enamored. I believe he thought of the image of his lone self existing there at the top of the globe as a pure vertical extension pitted against the endless horizontal extension of space. In my image, circular too, though at the tropical zone, the placement of purple violets and soft green leaves, depth upon depth, covering large spaces, was not an ego proposition at all. It was a warm diffusion, a philosophical perfume suffusing the mind and heart.

June 10

I rejoice in the brilliant, exuberant concept of violets encircling large areas of country. Violet related to green, and the two of them related, in turn, to their color surroundings. It is not, I believe, a mystical question, it is simply possible that such an imaginative vision may arise. This vision becomes the new modality. Not a question of pure extension alone as at the North Pole, it is pure invention, creation, constantly changing. New encirclements grew out of old. A force was unleashed that balanced between non-being and being. It produced, gave birth, nurtured. I want to insist again that this force is somehow not at all belligerent. Here is something new: pointed blue areas and shapes, brilliant turnings that rise like the

sweep of the ocean as it comes toward the shore, bursting there into waves and spray.

June 27

In Picasso's "Guernica" he shows the destruction of a city; a bull is killed, its soul taking flight, a soldier statue falls over, a horse dies, a woman climbs down a ladder holding her dying child. The woman's relation to the child seems nonpersonal. She holds onto a violently destroyed, or destroyable "thing"—a child. One would expect the expression of the woman to be one of tenderness, not solely violent, personal emotion, no matter how fierce or poignant. But this mother seems to feel no special emotion toward the child, merely an emotion of furious anger, agony and disruption which is even more evident in the original sketches for the "Guernica." There is something, in a sense, depersonalized about the whole painting. There is no feeling beyond the feeling that destruction has taken place. If we turn to Giotto, for instance, in his depiction of the crucifixion of Christ there is, in the midst of misfortune, suffering, destruction, a warm personal glow between various people involved. Of course they themselves are not being demolished. I do think this constitutes an extreme difference. Returning to Picasso, one may of course observe, especially in the preliminary drawings, the extreme anguish evident in the mother over the demolition of her world, including the death of her child, but she still does not truly relate to the child's death in any way I can discern. I used to speak of the Picasso "Guernica" as marvelous in that it took on an epic style boldly portraying the destruction of a city. It is broad in the painting. It is very powerful. But in rethinking it, it appears as I have said that human, personal emotion between any two living beings in the painting is really quite nonexistent. The horse is alone. The statue is alone. The mother is alone. The child is alone, and there is no interaction between them, although they are all suffering the same fate.

At the upper right-hand corner of this great picture there is a woman leaning out the window with her arm outstretched and holding a torch. She stands, perhaps, for a mythical figure, whether a goddess or a personage, who lights up the whole scene. She too is alone. She does not give attention to any particular element in the picture, but rather to the whole scene of almost completed destruction of the little city of Guernica. The Greek chorus, for instance, in ancient Greek plays does take this role of lighting up or commenting upon the general meaning and action of the whole play. Perhaps it too remains impersonal. It is due to this quality of classical impersonality that I have used the word epic.

Though there is no apparent interaction between these figure-elements,

there is a concern for the self, the selfdom. The bull does seem to be profoundly centered in on his own fate—what will it be?—and possibly this could be said too of the woman holding the child.

July 1

More about Picasso's "Guernica": the plastic elements of the painting, the structure of space, are of such exquisite unity and strength that one would like to take them as the whole substance of the painting, independent of those isolated figure-units which are immanently destructible. The relationship between the harmony, power, and fulfillment of the structure and the extraordinary isolation of the units, somehow reduced to a decorative quality, is very great and difficult to explain. It indicates an irreparable schism between form and content. Perhaps at last this is what I have been trying to find, this explanation of how I feel about the "Guernica."

July 2

Intellectual necromancy: Picasso's majestic organization of spatial elements electrifies "Guernica." As I have said, Picasso uses the isolated figures of the bull, the fallen horse, the statue, the woman climbing down the ladder with the dead child as decorative units, thus heightening the plastic creation by a sort of necromancy which delights the mind and the intellect but leaves the soul solitary, unfulfilled.

In the ancient Chinese and Egyptian vases I sense a repose that comes from a unity of aesthetic and spiritual qualities. This repose is due to the effect of a decorative line encircling the vase, a line that lies seemingly quite without effort. I feel that simple single line I am describing depersonalized, selfless, is more illuminating and nourishing for the spectator than the great necromancy of Picasso which depends, after all, on a sort of play titillating the mind with its brilliant virtuosity. Picasso, along with the Dadists, was fascinated by tricks that he and they understood and delighted in. Is not the playing of tricks, on no matter how high a level, and a high level is frequently called virtuosity, unworthy of so great a genius as Picasso?

L. J.* here last night dismissed the whole question of Picasso's "Guernica" and my doubts by saying, "Well, of course, it was classical. He followed the classical way of depersonalization as did Poussin." But I feel that more is involved than this. The Dada movement was a school of playing games born out of despair, after World War I. His mind was the mind of

*Probably Louis James.

a player of games, and curiously enough this was also true of Marcel Duchamp. Duchamp finally stopped painting altogether and gave himself over to the promotion of his own public image.

July 3

The Abstract Expressionist school of painting did make a successful attempt to express larger meanings. Barney Newman tried to express the relationship of his ego to pure extension; and Rothko was concerned with his conception of an ego-dominated world. Rothko felt his imagination capable of stretching out over large spaces and emotions. One day, during his exhibit at the Museum of Modern Art, I approached him and asked if I might speak to him of a certain painting of his we were both standing in front of. He said "Yes," and I said, "Is this not a very tragic painting, and does it not refer to Samson, distraught, pulling down the pillars of the temple?" He replied, "Yes, you are right." In other words, he was addressing himself to the larger emotional meanings that might be expressed in art. However, I felt he did so in a somewhat fuzzy way. He did not come to a sufficiently clear expression of the fury and disappointment torturing the mind of Samson as he pulled down the pillars of the temple. He conceived of the tragic action of destruction but somehow this action was without meaning and permitted the spectator to remain detached.

I return again to the classical paintings that were a song of the harmonious fulfillment of the individual and possibly of the society in which he lived. Fra Angelico's "Crucifixion," for instance, was steeped in the theology of the church. The crucifixion of Christ was felt as a step on his way to heaven, not as a dead end. Despite the tragedy inherent in it, radiant fulfillment was its real and perhaps primary message.

July 4

The rose, the single rose, that was brought to me yesterday had a most curious quality about it, far different from the violets I have described, or the lilacs. It was very complex in organization and gave me the feeling of exquisite structure, a structure almost impossible to describe, as it seemed to have, really, a psychological content. It spoke in psychological terms to me, rather than as pure aesthetics. This little flower had a strange quality very much like that of my grandchild Michael Webster's drawing, deeply interior and personal, hard to follow, not easily spoken of in rational terms. It was a strong expression of inwardness, feelings, tentative attempts to formulate. It was fragile.

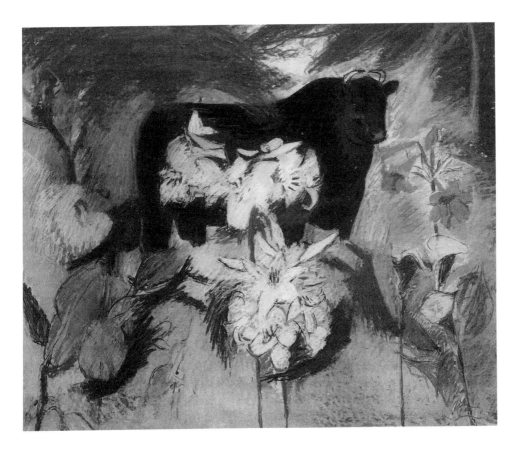

FIGURE 9. *That Feedeth Among
the Lilies* (1946). Pastel.
Collection of Dr. and
Mrs. Michael Rosenblüth.

July 10

I used to walk down by the brook on our farm lugging with me my easel, chair, and a table. So that I might paint without their being thrown over by the wind, I weighted down the table and the easel with rocks. A herd of cows strolled by every morning looking with roving, nervous eyes in my direction. I thought, "How strange that cows have ever been thought dull!" They really seemed nervous, alert, inquisitive. I could whisk them away with a single movement of my stick, but was content that they had come to look.

In between sessions of work I studied the actual tones of the tree and those tones reflected in the waters and the basin of the brook, enchanted by the beautiful nuances of sienna, brown, and gray-blue. But I was not satisfied. I felt that I could indeed, with care, reproduce all these tones with some exactitude, and yet would have achieved little of the rapture or ecstasy that I felt in looking at this small scene.

At this point revelation: I was used to lying on the warm earth, basking in the sun. When after awhile I opened my eyes, the whole atmosphere seemed to scintillate in an amazing stir of radiant activity. Often, after it had rained, the leaves, cleansed, took on their full local color. At the same time, the sun had come out. The result would be a maximum brilliance of color. This was, without doubt, a "chosen moment."

July 12

Immersion in the immediate. Is this not enough? What I am now calling immediate is really just the repetition of many immediacies. It is the response to the familiar, to what is repeated from day to day. I knew the brook. I knew the trees that stood upon its banks, the reflections, the bottom with its pebbles and small currents. I knew all this, but when I say immediate I simply mean that I was responding to that one instant of repetition. Had it not been a repetition I would have had great difficulty in following.

July 28

An individual working alone may become creative in any one of a number of intellectual fields, such as art or science. Gregor Mendel, for instance, had a new vision regarding genetics. He pursued this vision alone, removed from the world, not really knowing, except by intuition, that he would ever become generally known or accepted as an important link in the great chain of scientists. Marie Curie also pursued her idea at first without any of the usual backing of the scientific world. Emily Dickinson, whose produce, if one might call it that, was that of self-announcement ("Myself I Sing"), told what she saw, what life meant to her. She lived anonymously, in obscurity. All three possessed what one might call the mystery of genius—a very special kind of mind.

Can I use the word "genius" in connection with Emily Dickinson? Her genius lay in her ability to concentrate on what was truly vital to her. She did invent a new form or rather rhythm, but that was not the point. The point was that she saw deeply into the life that she was destined to live,

and expressed her relationship to it, to what she felt about people, birds, flowers—to what she felt.

But it was not just a question of what she felt and knew—that would be misleading. It was that she felt and knew the most usual things, the near, the intimate and almost commonplace relationships between people as unique, as seen "sub specie aeternitatis." She reached both deep and high levels in her seemingly simple lines. But paradoxically the few people to whom she showed her works at the time were unable to see anything in them, with the exception of her sister Lavinia. She frequently sent notes of condolence or congratulation, and with them enclosed a little jar of jelly which she herself had made in her parents' kitchen in the back of their house, which she shared (never daring to cross the street in front), and I have always imagined that the people to whom she sent notes replied very courteously, "Thank you, dear Emily, for the jelly"—the lines were ignored! She wrote somewhere that she sought not fame but immortality, so it appears she was quite conscious of her destiny, as was Gregor Mendel, who said, "My time will come."

August 2

Oddly enough, friends sent me a second postcard of the Michelangelo "Crucifixion" from the National Gallery in London. I have written about this work because it reminded me to such an extent of my Prometheus.

When I painted my Prometheus I felt that at the time he was unchained from the rock he must indeed have been very weak, and that his first steps would show this, and I am amazed to find an almost identical feeling in the Michelangelo—had I seen it in the past and stored it away in the unconscious? The supine, gray figure of Jesus evokes the tenderness and concern of the spectator. How different the Picasso "Guernica." There is no vestige of tenderness in it. Even though the individuals are being destroyed they are at their prime and have not yet lost any of their power.

November 11

Ann Dunnagan was here last night and gave me very warm responses to my recent work. She felt that my withdrawal from life, due to my illness, had given me the opportunity to search into my mind for the deepest memories it contained and for the most relevant observations of the actual things that were around me.

December 16

The ridiculousness of posterity: the slender lines of communication that in real life are already difficult to follow have become weaker. To what

shall they testify? Shall they testify that thoughts continue with certain aspects of non-variation? They reiterate the splendor of the present but the reaction to the roses of today may well be similar to those of yesterday. The rose on my table is a salmon color, like the belly of a goldfish leaping in a stream in the far Northwest, it flickers to and fro, caught by beams of sunlight which glisten because of the water which has swept over them. The living spectator is thus having a similar experience to the one that some artist may well have had when he painted roses years or even hundreds of years ago. I think especially of Ingres, and the way he painted flowers that stood in a small vase on the mantlepiece in back of the beautiful young girl in blue that hangs in the Frick Museum in New York.

One might well ask, "What have roses to do with salmon leaping into the sunlight and back again into the water?" I say that similar experiences or even different ones with a similar content may evoke similar responses to an immediate reality of a flower placed before one. So when I paint the rose on my table I sense reverberations from the past, and some artist in the future may sense reverberations from his time backward toward my past, soon to be his. And thus we shall co-exist in thought in and out of life. The one in life thinking the same thoughts as the one who was once alive and is no longer.

December 18

Luxury of the unencumbered immediate! I let myself think neither forward nor backward but straight into the instant, if that is indeed possible. I rather think now, because the passage of one instant into another is so swift, that one cannot really catch its immediacy. There are present nuances of the moment or instant before and suggestions of the moment or instant to come. The rose on my table today is soft pink, but in my mind it is enhanced by the thought of the orchard at Catalasa where a thousand peach trees grow, the oldest of them seeming to be at the top of the hill, and at sunset these peaches seem to hang like lanterns of the gods, vivid, penetrating, delicious. [See plate 14, untitled (Peach Orchard).] The younger saplings are all a soft and tender green, and the peaches are tiny and almost colorless, a green ochre, a pale green ochre. My mind leaps from tree to tree as I climb up the slope of the hill. I seek, with overeagerness, perhaps, to find a way to express all this wonder of the young trees and their successors in the chain of time/place that bring them finally to the fruition of the old trees with their heavy boughs laden with fully ripe fruit. I really cannot seize it in its fullness. I am overcome. I sit down on the little chair that I have brought with me and weep. In the end, I return home carrying a single branch with some dozen or dozen and a half peaches upon it, and

hang this branch on a nail on the wall of my studio and make the attempt to deal with this small grouping. In the end I understand why Cézanne took just a few pieces of fruit and placed them upon a table. Possibly a few apples, peaches, oranges, pears—but very few—a dozen or so, and attempted only to deal with these either nestling in the white fold of draperies or lying gracefully in the cupped china fruit dish. Is it possible that he too was haunted by more extensive memories of whole orchards of fruit trees? I think also of Vincent van Gogh's painting of an orchard, a small orchard, of peach trees in full bloom, ready to be picked one must imagine, because against one a ladder was leaning and a basket stood on the ground at its feet and the earth was tumbled up into lavender and gold—colors that van Gogh loved so much. Upon the ladder stood a woman, her arm reached out in a gesture of plucking fruit. As I stood there, I suddenly realized that there was no fruit, there was not a single peach upon any of the trees in this little orchard. That the event occurred, the fruit would be gathered in, the suggestion evoked was so overpowering that one could only imagine it. But, I noted, the sky was pink. A pink sky! It occurred to me instantly that this device simply displaced the pink of the single fruits that must have existed or should have existed and that somehow the spectator, the average spectator, would immediately have felt that he was seeing a fruit-plucking in an orchard, possibly not noticing that there was no fruit upon the branches of these trees. What magic van Gogh was capable of. It was an evocative magic. He did not follow in the pattern of the early French tapestries where they depicted trees, indeed, with all the fruit upon them. Apple after apple. And it would be hard for me to say which was more charming or endearing or suggestive or satisfying.

December 20

Embattled fragments, or shall I say merely borrowed fragments to be used out of their original context and in a new context.

The luscious red flower of the Christmas plant that was sent to me yesterday flames for a moment in my mind. I have not studied it; I only know that it is a spearpoint of beauty and that I will cherish it.

FEBRUARY - OCTOBER 1979

"Courage slays dizziness at the edge of
 abysses."

"I lay with all the weight of my soul
 crushed. . . . The indifferent stars,
 the indifferent moon, the indifferent
 father, the indifferent mother, the
 indifferent public."

"I listened for further sounds but there
 were none, only a great silence . . .

I had the longing to talk with someone,
 to talk, to be understood, to love,
 to be loved."

RECOVERING

THE PAST:

RETURN TO THE

CAVE OF MY

CHILDHOOD

INTRODUCTION

Between December 18, 1978, and February 5, 1979, as we
noted in our commentary on the previous section, there are no
entries in the typewritten journal. The handwritten one, how-
ever, fills this gap. There, her worries about ill health, money,
and difficulties with housekeepers continue. The private notebooks

show that she was also angry at her son for his inability to generate enough income from her securities and for taking a vacation while she remained unhappy. She notes at this time that she's doing a painting of John McKay. In January she seems to have had two falls, just before the point at which the typescript begins with a quotation about courage slaying dizziness at the edge of an abyss. The private notebook mentions bringing drawings to Dr. Kris in February and getting the manuscript of some section of the journal typed. She was gratified at Dr. Kris's praise of her drawings. In March Ethel's son went to California for his nephew's Bar Mitzvah. The private notebook for March is mostly jottings, but she also speaks of new drawings and tries different drugs to control her pain. During this month she is frantic, and hanging on by a thread. She fears that her daughter, because of marital difficulties, will break down, and insists that her calls be returned promptly. During all this time she suffers constantly from diarrhea, as well as from severe arthritic pain, which she tries to control by drinking vermouth.

Suicidal feelings and sexual feelings toward Dr. Kris create unbearable tensions. By June the jottings note her troubling Dr. Kris constantly with phone calls and threats of suicide by Thorazine, alcohol, or jumping out the window. It is unclear from the jottings whether Dr. Kris went away for summer weekends or for a long vacation. In any event, Ethel was upset by both Dr. Kris's absence and her own failing health. Ethel's physical and emotional state worsen rapidly. In August she worries about her excessive use of Seconal.

By September yet another housekeeper was leaving. The public journal counterpoints current experiences of stumbling down the hall calling for help and thinking of suicide with earlier memories of the loss of a beloved nurse when Ethel was two. Because of her illness she kept a small bell by her bed to ring if she needed comfort for pain or loneliness. In the absence of a housekeeper, or at least of a familiar person she knew well enough to find comforting, she became panicky. The fear of falling at night, when she did not know the new housekeeper well enough to be sure she would come when called, may also have distressed her. The public journal for this period shows her remembering, or reconstructing, early scenes of infantile loneliness in which a nursemaid's comforting her at night may have provoked sexual excitement. In this context she sees her suicide

threat and attempts as expressions of anger at the women who leave her and fail to comfort her, both in infancy and now in old age.

The central concern at this point, in the private notebook, is the question, what does Ethel have to do to be loved and valued? Does she have to give people money? Does she have to, as in infancy, produce her feces for them? What kind of love gift from her will win love for her? The answer Dr. Kris gives is that she has to pay for her therapy, she has to deal with the practicalities of her life (i.e., get a new housekeeper), and she has to discover why these situations make her so angry. The implication is that neither her current fear of being alone and ill in the apartment with a new housekeeper she doesn't yet know and trust, nor her analyst's refusal to treat her for love alone and forgo being paid is, in itself, sufficient cause for her anger and despair. Therefore she must go back into her childhood yet again to find what event aroused so much anger that she still transfers it into her present life. For example, Ethel's extreme distress at her son's leaving for a brief vacation seemed to Dr. Kris to be far in excess of the event itself. She directed Ethel to search for still more early memories of abandonment that might have caused the rage which was now being attached to her son's departure and to the desertions of the various housekeepers.

The private jottings at this time show her trying to discover a possible childhood pattern being repeated in the present. Remembering her childish rage when her mother left for New York while Ethel was ill but remained on hand when her brother was ill, she wonders if her bedwetting and getting sick had been ruses to attract attention (even though they seemed not to have worked). Then she wonders whether both her children's and her own current behavior simply reproduce patterns characteristic of her family when she was a child.

At this point the private notebook and the public journal begin to intersect. While the private jottings deal with childhood attempts to get attention, the public journal entries discuss, in a more personal and less general style than previous sections although still abstractly, her need for love, the crushing indifference of her family and the world, her desire to be "the only one," her love for and disillusionment with her father, her similar love for and disillusionment with her first analyst while in her twenties, and her giving up sculpture for painting.

It is impossible to say how much of this material arose spontaneously out of her own constant absorption in her early memories and how much, instead, was being recovered because her analyst was directing her to seek out specific causes for her feelings. For example, many of the memories she recovers in this section are cast in hypothetical rather than narrative terms: instead of saying "I did this, I did that," she says, "Is it not possible that the child did this or that, and that the adults did this or that, and that the child then felt angry and neglected?" Such a formulation tends to suggest that the memories being presented are not necessarily true memories but rather, some of the time, constructions being created to account for feelings according to an already determined hypothesis, namely something must have happened to make you feel neglected as a child, or to make you angry. An example of her use of this language occurs when she attempts to reconstruct a memory of the primal scene, and the little girl stands outside her parent's door listening to the sounds of lovemaking, wondering whether her mother was being adequately nurtured by her father, and whether the little girl could perhaps replace her father in her mother's affections.

This hypothetical tone to the language could equally well serve as a device for allowing Ethel to avoid the uncomfortable reality of real memories she might find less distressing if she could speak of them as if they were constructions. Certainly, from the tone of her comments at the end of this part of the private jottings, just before the suicide attempt of October, it seems clear that she felt that her analyst wanted her to dwell on this material more than she wanted to, and to recover more of it than she could in fact, without fictionalizing her memories, discover.

By June, in the public journal, she ends this sequence on abandonment with a strong attempt to integrate feelings of hatred in her own psyche and admit to her own impulses toward violence. She returns to her totem of the slow, clumsy turtle moving awkwardly across the sky. The turtle in earlier sections symbolized her own physical awkwardness and vulnerability in old age. Now it symbolizes her psyche's halting but steady and determined effort to come to terms with its own nature before death. At this point, she says, the turtle has at last achieved the ability to let its mother go and to transcend its need for her exclusive possession. This image of transcending

conflict is embodied in her juxtaposition of images of radiantly innocent children (her own) with reconstructions of childhood rage. The turtle's renunciation, however, is a fiction, moving beyond Ethel's actual capacity. The private jottings of this time show a woman still consumed by dependency and rage. "Must I suicide?" she asks, and debates the means in some detail. In a sense, her use of the totem of the turtle is a last, desperate attempt to maintain aesthetic control over the materials of her life and to transform them into a kind of abstract verbal art. She at last abandons her strategy of making her public journal an impersonal construction of ideas, and decides to admit the personal much more directly, observing that the journal may become a means to discover "a little truth," and that the discovery of truth is as important as the maintenance of beauty and order.

Accordingly, while the July entries in the private notebook drop off and only very sketchily note that she is taking too much Seconal, etc., the public journal directly deals with memories of her mother, of a possible incestuous episode with her brother, and of her family, which clearly did not believe her complaints, sending her back to bed. She reexamines her childhood need to be "the only one," this time recapturing an episode in which she wanted for herself a string of pearls her father gave her mother. This memory in its associations suggests not only the wish for a love gift from her father but for the adult, womanly power it signifies. In this context her anger at Dr. Kris for a similar refusal to deal with Ethel's need for power may make sense. If Ethel's art showed genius, her need for recognition may have been justified. She wonders at the usefulness of the perpetual search for exact memories of childhood neglect, when what she now feels she needed was practical help in getting attention for her work and an understanding that this need for attention was justified rather than pathological.

Her mother's pearls may also represent a wish for the sexual attention of women, particularly her mother, as well as for that of men. At this point she realizes that it was, in fact, a matter of indifference to her whether her need for consolation and sexual attention was gratified by a man or by a woman. The question with which she began this section of the journal, what does she have to do to win love, here receives a harsh answer. If the pearls symbolize both power and the artistic recognition she felt she deserved, being a woman dooms her never to get them.

February 5, 1979

Quotation: "Courage slays dizziness at the edge of abysses, and what man does not stand at the edge of an abyss?" (Nietzsche)

So, in the early dawn, if I heard the crackling of leaves and the sighing, soughing sound of branches pressed hard by the wind, I went forth clad in my raincoat, very safe and warm, into the storm. I rode my horse through the hailstorms in the Far West where the drops of rain had become as large as cherries. They were dazzling, luminous, moist, round, moving at an unaccustomed speed, visible as rain is not visible. I enjoyed this. It gave me a sense of danger and surprise, and drew on courage as Nietzsche thought of it.

In a sense, any disturbance of nature—any speeding up or enlargement of forms—may become a fearful spot, a small or a large abyss that one must traverse. I had been told that it was crazy of me to go into the water in the middle of the lightning storm and it was crazy to go on a horse in the midst of hail. All these various things were considered dangerous, as well as climbing of a hillside in the mountains of the Far West when the rocks had become shale and were very loose, so that if one were to grasp a piece of rock it might crumble off in the hand; or the piece of rock upon which one was standing might crumble away and one leaned against the surface of a hill as though a magnet were holding one there which would support one against the insufficiency of natural support.

There were storms, too, at the farm, when the soughing wind bent the tree branches and frequently they were tossed down, down through the air with considerable force that was endangering.

The turnabout of nature from the calm of the pleasant rain or the pleasant breezes that gently moved the boughs of trees to these fierce, driving forces was rather great and I responded with a sort of excitement to the necessity of facing out these crises which were indeed in the nature of an abyss, if by that we mean an empty space, empty of assurance, uncertain in its limitations, uncertain in what it can yield or afford one. Or, indeed, I might be riding along a path, again in the Northwest, where waterfalls in September increase in volume and splashed over the pathway that the horse was supposed to pursue. He held back and would not move forward. He was afraid of this danger. I had to spur him on. In the end, I had to

get off and lead him through it—he was so afraid. Animals try to preserve their lives against all danger. We humans frequently like to face danger by the use of courage.

February 6

The gleaming cohorts of invincible night. The vulture and the dove have come with their wreaths to garland him as he sinks through the spaces of the sky. But what of her lying in blood at his feet, stretched out, dying? Who shall place a wreath upon her head?

It is the old problem, the question of the existence of the ego, holding out against nullity, and shall death come first and seize away the embattled soul? Is this soul to have had no existence? Did it not accrue to itself experiences of joy and wisdom, not turn forth expressions of lightning veracity? Did it not say, "I am" in many forms? Did this not have a value? Was the world to esteem only the "I am" of the man? Is it true that only what he produces is significant?

I lay with all the weight of my soul crushed in the effort to hold up against this massive onslaught of indifference. The indifferent stars, the indifferent moon, the indifferent father, the indifferent mother, the indifferent public. Have they properly assessed what beauty is? Can it not have many forms? Is not the poignant immediate seizure of a passage of emotion as powerful as certain completed but frequently empty forms?

Men have painted paintings that were solid, that gave due respect to the laws of art, and made statements about life, about love, about beauty. Yet frequently these works had a hollow ring. They did not touch the center of the soul. They did not express the living moment. They were like the rich man trying to enter heaven. He could not. Rather poverty and the divine sense of the beauty of real experience would have that privilege. The singing wire in the storm, the thrashing leaves and crackling of broken branches; water crawling over the land and erasing all that man had built; a volcano that erupted, smashing the works of many hands, have often caught the moment in its true intensity—the true feeling of the soul reaching out toward its own expression.

Saint Francis of Assisi spoke to the birds and to the other animals. He spoke from the heart, the instant words of compassionate aliveness. How often do we find this? Where do we find this? Is it not possible that women may be closer to the possibility of expressing undiluted passion?

Crumbling walls of feelings; the child feels swiftly, wholly; the child leaps out to find love, to give love, and finds from the very beginning that love is rejected, that others are preferred, that the mother prefers the father, prefers the brother, prefers her family, prefers her friends, gives to the child

the minimal, though it may be quite beautiful. The child seizes on this beauty, is enraptured, and seeks more. The child seeks eventually to produce the massive majesty and wonder of such an occasion as Toscanini conducting the Ninth Symphony of Beethoven at Carnegie Hall, where there were a hundred voices and a great mass of instruments singing, producing marvelous beauty, so that it seemed the roof would fly away and the great starry heaven would appear. Such experience was engulfing; it was expanding; it was marvelous. The joy one felt was the joy of great beauty released unhampered by contention.

In childhood, the child felt an emotion of its soul toward experiencing this wholeness of beauty; felt the majesty, felt the acuteness. But all these things passed swiftly; they would not stay. They passed swiftly and one was left with the memory of something marvelous that came and went too fast, too fast, too fast. The child reached out, experienced intense emotion, intense love, intense desire to be loved in return, to be the only one, to be *the one.* Again the child finds it was not the one but "a one," given less perhaps at times, given the sensation of being loved at times, but always the times were cut short and the adult moved in other directions, and the child was left to seek solace in solitude, to find within herself the ability to create an imagined continuity, in which love went on and on. Later on, one could invest in the thought of a creation, the sense of an unending and uninterrupted ecstasy. One could experience the ecstasy of creating ecstasy, of sustaining the perceived intense, psychological verity of experience.

February 6

Have just written what might well be my last will and testament, based on Nietzsche quotation: "Courage slays dizziness at the edge of abysses, and what man does not stand at the edge of an abyss?"

February 7

Huge marble rocks hurtle down from the north in the spring. They ram each other in the currents of river beds, churning, splashing water high into silver spray—a great stream of naked force making its way over miles of territory. These images slash across my mind accompanied by the call of male cats wailing a love plea in the darkness in the middle of the night—weird, compelling, exciting.

How could one sleep, one's mind churning with images such as these? As a little child, what were the sounds that reached one's ears in the middle of the night? If, curious, one went to stand outside of the parental bedroom,

there were sounds and there were the sights seen through the keyhole. Natural man, imperious, forces all before him no matter what the ensuing disruption of the passive or semi-passive female who was often rushed over in haste by the male, similarly to the passive riverbed in the north assaulted by the great smashing rocks. Was there any tenderness? Were there sounds of tenderness, of love, longing? Were there moments or spaces of time given over to gentleness and gentle seduction, to preparatory growth of passion?

Derangement followed—derangement of the sense of harmony and security in the child. Yes, of those faculties. But finally, fortunately for the child entering the serenity of the garden there were endless signs of tenderness. One perceived the first slender tip of a green seedling as it broke through the earth or the slight rustling movement of wind through the leaves of bushes and trees, as very gentle. And yet one had an accruing sense of the expanding quantity of sound rising up from this garden and many gardens, mounting and mounting to a great hymn that rose Dantesque—from Purgatory to Paradise . . . and to final heavenly harmony.

As I lay on the earth, blades of grass caressed my tender young skin. The soft smell of warm, damp earth, moistened by dewdrops, was curiously beguiling. It seemed that out of such experience imagination might form images that would then affirm the beautiful sign of their birth—the sign of gentleness. I have often described this quality in Monet's paintings. There was in them no lack of virility, but there was certainly an all-encompassing suffusion of loving tenderness to be felt. The shadows were permeated with light. Tone after tone melted into an exquisite sweetness, inexhaustible, ineradicable sweetness, cloying at times but powerful.

As a child, one frequently left the forbidden position in front of the parental door with a sense of fear, of loneliness, a loneliness that in one's imagination most likely was destined to develop into tantalizing dizziness. One shrank back from the thought of such weakness and sought refuge in the cave of one's solitude—the protection of solitude. But solitude had its own weight of grief. Pain flickered through this sacred sanctuary as shadows flicker—weaving in and out of patterns of sunshine, made more intense by their very contrast. There were apparently no moments, not even, or barely even, instants, in which one could relax, fearing nothing, longing for nothing, able to enjoy the wholeness of the instant.

I wondered whether she really reached him strongly, as the sun reaches a seedling, causing it to expand and grow and flourish. Was there a true rightness of nourishment brought to him? I trembled, as I dared to imagine that I would have been able to do more. Or let us put it the other way. Did he reach her? Did he help her to grow in a natural way as a seedling grows into a flower? Was there the kind of nourishment, warmth, necessary to growth? I speak now not merely of physical growth, but of the growth

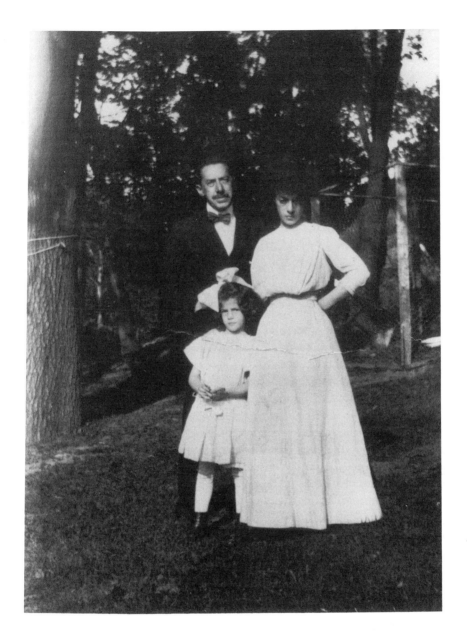

Figure 10. Eugene, Ethel, and
Agnes.

of the ego, of the whole being, of the sense of security, of the sense of ability to move, to create, to act, to enjoy, to relax, even to abandon oneself to sudden emotions if one wished. I felt little sense of a mutual flowering, although there were some hints of it. In the garden I saw young seedlings grow into plants. And the plants gave forth flowers, marvelous flowers, flower after flower; and then these flowers, withering, fell to the ground nourishing it, and the cycle was complete. But in the life around me, I felt there were too many intricacies, depleting interruptions of life forces that might have been really productive. Could I not have done better both in the receiving and in the giving? Why was I not allowed to take his place with her and give her what she needed: the enjoyment of happiness. But I was shut out. I felt relegated, weak and desolate, to the solitude of my cave, where I was, however, free to imagine the happiness not actually achieved in the real world.

February 19

Consider the child affected by the ineradicable continuation of cruelty which is in itself evil: tortured and fallen down, frequently in a fit of turmoil close to fainting. The child receives the blows of the dear one that twist the soul. In nature one knows of the hazards caused by storms, volcanoes, eruptions of all sorts, the decay or withering caused by over-hot sun, by undernourishment of the soil as it is swept away in gullies running under the pressure of streams that come down from the high mountains where the trees have been cut by greedy merchants.

But in the child's life the parents are all. Therefore, if a parent loses control, for instance drinking too much as a result of natural exacerbation caused by tensions in the so-called real world, in the competitive world, and if this passion and anger are vented in the direction of the child, the child is injured. It is as simple to injure the psyche and as direct and instant as the injuring of a bone when it is broken by a twisting fall. The bone may be repaired, the leg is put in a cast and the bone draws together healing itself. But what of psychic breaks? All too frequently the delayed forward movement of the psyche is not able to rectify itself. There is no way to put a cast on it to ensure a period of motionless recovery.

The violent reactions to the smashing of an image, for instance such as that of the beloved father, are frequently dealt with by the mechanism of total repression. This repression then causes a stoppage of growth, a fixation of the natural flow of emotion. Many years later the grown youth or the grown adult may attempt to go back to the original point of repression and to uncover it, once more free to take up again the natural processes of emotional growth.

For the most part in nature what is broken remains so. Injuries can rarely be restored or the original growth re-pursued. The tree can sometimes be prevented from dying by filling the wound with tar or by wiring it up so that it has a chance to send forth fresh roots into the ground to hold itself up. Yes, these things can be done. But not so the stem that is broken by the wind or the root dislodged by rain, or the marred bark of a tree that is eaten away by some small animal that comes out of the fields at night to feed itself. Nor, of course, the larger manifestations of nature such as a stroke of lightning that actually cleaves the tree, killing it or maiming it permanently. Consider the enormous waste of force, the enormous waste of forms that could have been, of dying things that could have been living, of emotional growth that need not have been stunted or arrested. The wastage is enormous.

But I wish once more to return to the cave of my childhood where so much beauty passed before my eyes and so much love was awakened in me for this beauty, so much longing to reproduce it and give it to others—longing which was to continue through my life.

What of the salvaging of creativity? What sort of force brings about creativity? Does it spring up in us at birth? Do we have it from the first instant on? When Cézanne said "I wish to express those feelings we bring with us at birth" was he referring perhaps to this? That even at birth we start to gather the substances and essences of life that will furnish material for creation? Do we not seize unto ourselves the necessary precious sensations, and experiences of emotion? And where does the power to convert them into some sort of communication come from? The tiny child may gather together a petal of a flower, a leaf of grass, a stone, a shell, an inchworm, and make what later would have been called an "assemblege." He does not even know what he is doing. By instinct he creates, by instinct he knows wherein lies his greatest hope of survival, spiritual survival. Or perhaps he makes no physical gesture whatsoever but collects consecutive experiences in his mind to be used as plastic music. The flight of the bird yields back the blueness of the sky, filling the space that has been left momentarily vacant. The bending of a flower yields its completed form to the original nuances of colors that would once more exist in its wake. A keen instant experience of the nature of a small expanse of space may be perfectly clear even to a child. The child may experience the multitudinous beauty and love the fact that that beauty is unendingly renewed and changed and renewed still again. This particular child will perhaps experience no need to wander. Even as an adult that child may have found travel unnecessary because he or she has become accustomed to the constant fascinating changes that occur in his or her own immediate environment. I cannot help but believe that Cézanne, for instance, had a direct sense of the reality of

FIGURE 11. Ethel sculpting in her
studio, 1925.

which I speak. If the light of the sun changed hour by hour, thus rendering necessary changes of tone, he responded to this demand, but did not find it necessary as did the Impressionists to do a new canvas every hour. In one of his letters he had written that all he had to do to satisfy himself was to move his chair a few inches and he could sit for six months in one spot and never weary of it. He had caught the living breath that exists within this very capacity of positive change. He had felt perhaps that destruction left its opposite in its place, and that out of destruction could come new construction causing a never-ceasing continuation of the living chain.

February 8 [sic—March 8?]

There are paintings possibly not properly to be categorized as art. They do not rely in any sense on the beauty of form of any of the single figures in them, nor do they rely on beauty of composition, or on gradations or color. They do not rely on most of the usual constants of art but speak rather of personal experience at a very deep level. They are true in this sense. Not technically but psychologically.

March 28

It had been my lifelong wish to make a very large monument to be dedicated to the 1914 war. This monument was closely connected with my love for my father. He had wanted to fight but was above the age. By 1921 I was approximately twenty years old, had seen much of that art created from 5000 B.C. on, saw it in terms of the heroic and the grand. But curiously, even then, it was also to contain expression of the intensely human. I wanted to emphasize the role of woman. How, for instance, she accepted waiting. She, who rarely fought, waited for her man, whether her father, husband, brother, or son, to return. She knitted on and on patiently. I made a piece in high bas relief to tell this story. I wanted to express woman's endurance, her ability to face the fact that time could hang so heavily. There was also a many-figured high relief of working men. I felt that the role of working men had not been given proper emphasis. Without the working men what could we have done? They had to be in back of the soldiers. So I produced a bas relief of working men. It was always in my mind to give a sense of universality, give a sense that men had always worked, that this was an unending Sisyphus-like characteristic of man. There was to be another high bas relief of a mother with a dead child on her lap. Was it not the mother who frequently suffered most the loss of those men to be killed in the war? I have not yet spoken of the lands, of

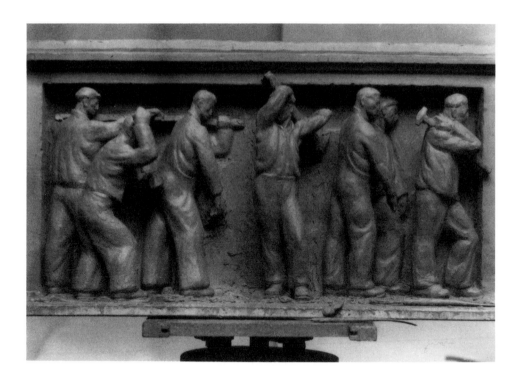

FIGURE 12. Bas-relief of working
men (c. 1925). Artist's
estate.

the homes, of all that was destroyed, but I do remember that many years later when I was staying in Pennington the poet Stephen Spender stayed with us and said never again would he wish to participate in any war, so terrible were the effects of war, so great the destruction, that nothing could be worth this.

All these rather grandiose ideas floated around in my mind. I went daily to see men at work, where they were digging to build skyscrapers. I felt the wood they used was a color one could use for flesh. I responded in innumerable ways and on different planes. I was really wild with enthusiasm and delighted to be set on this path, to be creating. And somehow I had given myself the feeling that this projected work of art was in honor of my father, in honor of what he stood for to me, the love I felt for him and his humanity, his vision, which so moved me, of what life really was about.

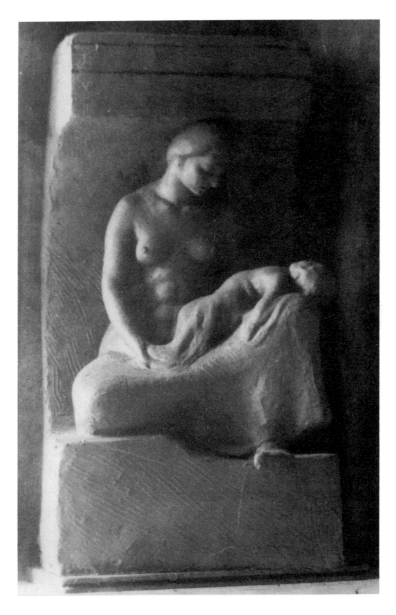

FIGURE 13. Sculpture of mother
with dead child (c.
1925). Artist's estate.

He had long been a student of history. It was through my father that history had been all around me in my childhood, as well as poetry.

I was sharing the studio with a young friend who agreed to take it during most of the day—entirely if she wished in the afternoon, although she was not at all self-conscious, and therefore was quite willing for me to join her whenever I wished. This studio was rented in the name of a young man, a friend of my mother's. It helped him to pay the rent.

One day something happened that was to change the course of my life in respect to art for many years and it would be difficult to say whether it was for good or not. On coming to the studio with my friend, we found that my mother's friend had not yet left and we saw a woman's underwear strewn about the bed of his little room.* It had been our agreement that this young man should depart before our arrival. We were singularly vulnerable and we felt this sign of sex activity as a shock. I at least could not shrug it off. Like a stroke of lightning, it awakened in my mind some deeply buried memories of similar activities (not at all unusual for a Southern gentleman) of my father known even in my childhood, which at the time I had tried to avoid by means of the device of repression. I had simply buried them and refused to think further—they were as dead. For a flash I suffered again the earlier shock; and then, the second passed, I repressed the emotions once more and was never again to think of them until recently. The immediate effect of this abyss-like experience was to make me wish to give up the studio and to give up sculpture altogether as though this would be a way of escaping from a too-painful memory—one I could not face at all. I could not, alas, summon the "courage" that "slays dizziness" of which Nietzsche wrote.

Now that seems to me to have been a terrible mistake, one over which I seemed to have no control. It was unconsciously motivated and carried through. Had I worked through my disappointment and rage at that earliest time in childhood when I was perhaps three or four years old I might have then been able to respond more casually at this later time when I was perhaps twenty. But as I had not, I turned in other directions. It seemed that the life force of creativity in me was so powerful that it had to find its way into expression no matter what the obstacles, as with a silver stream of water coming down the mountain path in spite of innumerable boulders—such as the Carrara marble coming from the north in the Spring, crushing all before them. Place was left for a freshet, for a little stream of pure water to continue alongside the larger spread of turmoil. That ability to continue was my destiny and salvation.

*The young man was probably her mother's lover, John McKay, and the underclothes may have been her mother's.

I turned to painting. I did not know why. I simply felt that I must paint and no longer do sculpture. It took me many years—as many as eight or ten—to gain as much mastery of painting as I had already acquired at the age of twenty of sculpture. I loved it enormously but found it extremely complex. I wished to retain in painting some of the attributes peculiar to sculpture, such as form; but I wished it to remain painting, to express itself through color and in more abstract terms as painting does. Strange paradox. I became what I often called a sculptor-painter, like Michelangelo himself, who retained a formidable sense of structure in his work.

To return to the small incident in my early twenties. The friend I was with, being very prudish and New England, was entirely outraged by what she had seen that morning and immediately gave up the idea of having a studio with me. She sent a curt letter announcing her intention to withdraw. This too must have been a blow, a personal blow. It seemed as if indeed I was predestined to know all of art not by deciding that this was what I wished to do but influenced by the pressures of these acts of fate. The main point was that no matter what happened it seemed that I must continue to create. Redeemed from inactivity, I ask again? Freud accepted the dictum that the individual must finally face the fact of his own nature and that truth was the only thing of importance. I fought for this.

March 29

For the moment I should like to treat this journal as I did originally—asking questions, answering them in part or in whole as best I can at the moment. These questions frequently lead to others and ideas develop. Now I ask myself why did Freud call his daughter his Antigone? What connection was there in his mind between Anna Freud and himself? In the ancient Greek drama Antigone had gone forth with Oedipus after his blinding himself and being cast into exile and had traveled with him to a distant land in which he was to die. [See plate 15, *Oedipus and Antigone*.] She had been a faithful companion. But let us think for a moment: how did she accept this extraordinary reversal of her concept of her father? He had been King of Thebes, Head of the State—a man of presumably the utmost integrity. And suddenly by the dictates of the oracles it was discovered that Thebes was suffering from some ill doing and finally it came to pass that this ill doing pointed to Oedipus himself as its author.

Suddenly Antigone's father appeared a different sort of man from the man she had known as a little child. What were her thoughts? We know that in the legend she went with him and was most tender and dutiful in her actions. But looking at it as moderns we must have to think what did she really feel? At the very end when Oedipus knew he was about to die

he went off with a messenger of the gods to a place slightly apart from where he had left Antigone after saying farewell. And he was reported by the same messenger to have died a glorious death. Again we must think: what did Antigone feel? Had she all along exonerated her father, understood that his mistakes were the result of unconscious drives? Or had she felt humiliated by his actions? Had she felt anger? Had she felt resentment? Let us think about this.

April 8

Sophocles' Antigone gives us the story of Antigone's sacrifice, the sacrifice of her life for the honor of her brother, who was to have been buried without funeral rites by decree of the state. Had she not offered her life in his place to be buried alive in a tomb? Today this might seem to us most extraordinary, unthinkable. Again, I ask: what sort of woman was Antigone? [See plate 16, *Antigone I.*] She could not tolerate the idea that her brother would die dishonored. She was willing to go to any length, even to giving up her own life in a most painful and hideous way in order to forestall this. Was this the result of the Greek teaching that women should be willing to give their lives in favor of men, in that men were deemed by society as so much more important? Today could we think of a woman acting thus?

April 14

Filaments of communication: There are the abysses of which Nietzsche spoke. In opposition to these abysses there exist what I would call the very fine electric-like filaments of communication of love. There are the personages beginning with childhood where there were these beautiful vibrating lines of communication; but these treasured lines of communication were frequently interrupted by or coexistent with abysses. As I understood it, Nietzsche meant by abysses nullity, a falling-off of meaning, emptiness. We have relationships—very powerful indeed at times, and yet susceptible of being interrupted by non-relationship or abyss. In Nietzsche's terms, of course, courage was able to control the dizziness that might result from this confusion. One passed through the earliest experiences of this kind. The first nurse, the second, the third, the fourth, and the parents, the first friends, the later friends. Finally the various young lovers that lead further along the way to the beautiful husband where there was the most of communication and the least of abyss and the least need for courage.

April 16

E. G.,* who was a reader for Random House and other publications, once said to me I should write fiction. I've always held off as I felt that it was not within my capacity. But now let us see. . . .

As a young man Dr. G.** had worked to become a medical student

*Elsa Grossman, wife of Wolf's partner James Grossman, and dear friend. Elsa Grossman worked in publishing.
**Dr. Gluck, her analyst in the 1920s.

and at night to support his medical career he had worked in a coal mine. This showed of course great force of character but ended up rather sadly in a complete breakdown from which he slowly recovered and then pursued his medical career to become a doctor. Broad-shouldered, his head very large, he resembled Caruso, a physically beautiful man. This of course is a very slight first attempt at a fictional approach. We will have to see what comes of it.

Perhaps my first great love, after that of my father, which contained many illusions, was this very man of whom I speak. He was short, stocky, his face gentle, his voice gentle and yet with a great sense of power. I must have been very much in love. As a doctor he attempted to heal me by the early abandoned Freudian method of massaging my temples when I had a headache. This proved to be a mistake and aroused a passion in me for which I could find no outlet. It drove me to a kind of despair. When he discovered this, he was appalled and immediately resolved that he had not had enough analysis of his own and must return to Vienna for further treatment before pursuing his career. He turned me over to someone else and this doctor led me through a rather tranquil year and a half, causing no disruptions of any kind, but on the other hand leading me no further toward a cure.

May 11

A vibrant stream of color is active around me. It is very difficult to remember this conglomerate and to intertwine the red and the green in the head of Dr. G. and the head of George—and the head of my father and the head even of a recent Dr. Chu.* There were startling minglings of color and idea. The central idea, that of a man, a square man, who stood with his feet planted upon the earth, whose mind was strong, whose body was strong, whose endeavors were powerful. There are colors to meet or to match these qualities or powers. A great gleam of green flashed across the screen of my mind, containing at a deeper level the image of my father, the one who smoked cigars, who drank good wine, possibly at times to excess, and who loved the servant girls as a gentleman of the South frequently did. Beyond was a great stream or plane of blue. This space of green was underlain by the image of Dr. G., who also was a square man, solid to the earth, solid to the world of thought and investigation. There was an area of red at another angle, another plane, as though the air about me contained plane after plane of color, each plane containing within it

*Dr. Chu was probably an acupuncturist she tried for the pain in her hands.

the likeness of a chrysalis, within which an image was being formed that was about to become isolated in its reality. One that would shake me to the very roots of my being. Smell also had its place. I will not be more specific at this moment. Certainly there was a reminiscence of tobacco, tobacco from a cigar, tobacco from a pipe, tobacco from a cigarette—and I can easily imagine the addiction felt to the need of tobacco.

May 13

The effect of sensations produced by the memory of all these smells and colors was so great as to overwhelm me. I longed for my uncle; I longed for my father and I'm sure these longings returned later and were attached to some of my specific varying characteristics, such as a state of anxiety and very little relief or sense of quiet. It is now becoming almost too painful to go on. It seems to be that in back of all this was probably a series of responses to nurses, to the first, second, third, fourth, and to my mother. I will not enter into this at present. There were continuing images formed or partially formed; images expressed through form and color, through the feel of the brush, the personal signature of the doer. I will try to express the connection between myself and these seemingly outward entities, images that seem to come from without and yet appear to be within. Do not laugh at me. It was real enough, even encompassing perfume, perfume not only of tobacco, liquor, but the smell of a man. I am describing love. I am describing the connection between a person, myself, and various other human beings who approached me closely enough to stir my inner strivings and longings, but never to quite satisfy them. There was a desire in me for each one to devote himself entirely to me, to my outcome, to my income; but these men were very powerful in the real world, or so-called real world, were constantly leaving, constantly moving through my life—departing and returning and departing and returning and departing. In this sense I had no peace. There was no real continuity. In one sense it was a state of Don Juanism; there was love expressed in many forms, through many bodies, through many souls. Don Juan, too, had needed this narcissistic buttressing. He needed hundreds of people to fulfill an insatiable desire to love and to be loved.

Vibrant Chinese blue; and, too, an area of vibrant green. Also, other areas of varying types of brown resembling the wonderful browns of Rembrandt passed through me, as well as still other types of even more vivid colors and altogether formed one universe, a universe full of vibration bringing me to the point of wild intensity. One can experience images, feelings. And they may mingle. They did in fact in me. But there was the

danger that these images might be cut short as when the sun-image disappears, sinks behind a mountain top and is seemingly no more.

There was agony connected with the cutting off of joy or the existence of an image that awakened desire and full response to that desire. Agony seemed to have more power to remain in the mind than the forces that caused it. I recall being caught once in the mountains north of Vienna at Semmering, caught in a fog that reduced all around me to whiteness. There was no longer any observable color. I could see only a slender circle around the edge of my feet and so knew there was differentiation present in the seeming oneness. This taught me that I was emotionally dependent on change; I was vulnerable to seeming nothingness about me. Apparently nothingness could extend endlessly and I believe that the modern artist Barnett Newman was tremendously aware of this factor. He knew that the undifferentiated could extend in all directions.

May 20

I am preparing to try an experiment in returning to a form of sculpture or modeling that I had given up many years ago. I have gotten some Liquitex modeling material that may be mixed with watercolor and intend to see if I can renew my feeling for touch, for the actual contact with the subject through the material. In sculpture one actually manipulates material with one's fingers, and this produces a certain sensual quality that is lacking in painting itself.

When I was doing the head of Dr. Gluck I modeled it in plasteline and I was possibly not so much aware then as now that the having about of globs of material and the forming out of them of a unified formal aesthetic object was a different experience from that of painting. There was a sensuality involved in forming the actual pieces on the faces; there was a very moving quality to this.

To a young woman in love the touching of the material might well have reminded her of the actual touching of the subject and therefore have been far more erotic in its effect on her than painting. In the end, of course, sculpture should obtain an abstract quality or perfect form that would not differ very greatly from that of painting. But in the beginning, certainly, there was this closer contact which in a way might be considered very exciting.

In the course of doing a sculpted work one usually approaches the subject measuring with calipers; at least one did so in the early twenties, approaching the person with calipers and making measurements, perhaps even touching the form so as to get the feel into one's fingers, which

obviously was far more intimate and less abstract than a painting would have been.

May 29

To go back for a moment to the sixties, I had dinner one night at Barnett Newman's. Barney had a table full of guests, amongst whom was Adolph Gottlieb, and he and Barney got into a conversation about painting which extended for many hours. At one point Barney said "but the brush must not be felt." In other words he was inclined to drop the sense of touch as far as possible from the art product. Which of the senses did he then include in his idea of what art might contain? As I sat in silence I felt an overall rebellion against his ideas, and felt painting had of necessity to have a base in sensuality. The task was to let sensuality expand and then to bring it under the control of the mind for purposes of making the finished painting sufficiently abstract. This was a possible goal. It was not a question of eliminating a whole portion of the responsive personality but of bringing about a new kind of classicism.

Did artists like Newman wish to exclude the earliest sensations that man could experience, that the infant and small child experienced? This possibly objectional frailty lay greatly in the domain of touch. The small child who at first could hardly see, who perhaps could not hear too well, who could not yet speak, could not yet walk, was perhaps more aware of touch than of any other sensation and derived from it the sense of being loved. Or, if it were lacking, of not being loved. This is a new thought for me or, at any rate, a new way of putting this thought.

Today's young people are very free in their contacts with other youth; they seem to take sensuous experiences very lightly for the most part and simply enjoy what they enjoy; and if it is broken off— if one relationship is broken off—they rush into another. They are not held by the initial experience, which seems to indicate that they are satisfied with merely sensual experiences that are not necessarily connected with psychological ones. This may possibly leave them very restless because they have not found a unique, lasting oneness of relationship. Barnett Newman and many other artists in the sixties began to move away from a love of objects, as well as the sensual elements I have spoken of—the sense of touch, the sense of closeness, which they felt as perhaps an almost infantile aspect. They moved on to what they felt was universality, simplification. They were interested in space, in differentiations of one space from another; but what further meaning they had inferred I've never been able to understand. They did not seem to be really involved in powerful emotions of any kind. Thus one might say their emotion attached itself to the idea of large spaces. This

had a certain kind of power. Much canvas was needed on which to paint their works; their works required large portions of space to be used in a museum and eliminated other kinds of works.

Let us return to a more ancient art such as the Egyptian. Though they at times made very huge works of art, one never feels that they were out of contact with the sensuality of the body or with the psychological content of rage, either expressed or contained. They portrayed men who might indeed have had all the experience that I have suggested, from infancy to maturity, and who might have indeed expressed themselves in such ways. And they, in their art, brought this before one—thus satisfying one's need to find an expression of the greatest possible extension of personality.

May 30

Surely a foggy road may become clear. When we owned our farm in Pennington, at times we used to have to drive through a heavy fog, the road completely obscured. One could see only here and there a faint outline, or a portion of the road, sufficient to know that one was on it. One went forward by blind instinct, as I had done so many years ago in the mountains of the far Northwest where I walked after the sun had gone down through a forest, where I could not see; we did not have flashlights. My feet seemed to find their way by some inner natural sureness.

I came out of that portion of woods safe, though I had not been able to see. My instincts had, it seemed, strange powers.

Once more in Pennington I was in the middle of a road blanketed with fog, with only small indications of reality appearing at times.

One might open or close the gates of feeling, of sensuality, the happenings of touch that may lead directly to love. And love in turn may lead directly—and even swiftly—to the conclusion of something similar to the black hole we have mentioned, where a particle, previously thought to be eternally lost, reaches out to another particle in some far part of the universe and then another particle follows and another, until the hole becomes smaller and a "great bang" occurs. Scientists say that out of that "big bang" a new star arises.

So I feel that love may act in a similar fashion. The very small, very slight and innocuous touches that awaken sensuality may lead out of the black hole of the unconscious into the larger and more distant spaces of the psyche. This may occur again and again until, indeed, a "big bang" occurs and a new star is born. But where the awakening does not lead toward this conclusion and there is a blockage, strange illness may follow. And this may betray the individual. The individual may repress and then this material is held behind locked doors, sometimes for many years.

When indeed one comes to the point, through long years of effort, of reaching the locked door and opening it, one must then be ready to take up the mourning for the individual who went away and did not fulfill the needs of love. What courage it all takes—if indeed one is able to face these forgotten memories and follow them through as though they were present, as though they had never been lost, one might then win a certain freedom from tension.

No doubt modern art has largely accepted the limitations imposed by the locked doors of the past. Many of the great moments of youthful experience and emotion have been shut off, and the artist has proclaimed them useless. He then produces an art reduced in personal immediacy of emotion. Strangely enough this art has often been well received, perhaps by people who also preferred to leave what was once so piercingly alive locked behind closed doors and to pretend, as it were, that life was more simple, and less painful.

June 10

Burning instability: The words fly to and fro, the ideas equally and yet one may not comprehend the meaning of either. A deep longing to communicate, to uncover further and further the secrets of the past, to turn over every angle of them and to find out what made them as they were and to mourn what was lost and to mourn those who went away. This seems simple enough and yet it is very difficult. The immediate reaction to mourning was to seek someone to talk to, to seek some relief from the loneliness, to seek a renewal of communication. And yet there was none. I was left with unbounded or unnumbered filaments of excitation moving toward this beloved person and none of them responded to. If in each case it meant a sort of shock, something resembling the dizziness at the edge of an abyss of which Nietzsche spoke. But where was the courage of which he also spoke, the courage to face this dizziness?

Why could I not find some other interesting man and fall in love with him and give him what I would have given the other and perhaps received a return? This happened only many years later when I married my husband. Many, many years later.

I attempted to finish the piece of sculpture which I had begun of this doctor's head and in putting on the clay I came into close contact with a sensual pleasure: the pleasure of actually molding the form of the face which then belonged to me it seemed; it was part of me; I had preempted it; I had come to own it; it had come to be part of me, and afforded me sensual pleasure as well, such as one would receive in a normal love situation. This was not a normal situation. I was encouraged to do the

sculpture, to feel the forms under my fingers, to mold the clay to fit the form, or to make the form, but I was not permitted to receive any response from the person himself. I could not finish the things I had begun.

I could have attempted to finish this head by means of imagining or by using a photograph, filling out the form as indicated by photographs, but this did not seem satisfactory. The personal contact was no longer there. There was an abyss. There was a terrible abyss and there was not enough courage to face the dizziness I felt. I fainted. I lay flat upon the floor, fainting. I lost consciousness, and when I regained consciousness, the only thought I had was to escape from the pain of all this. The only way I could think of was to escape entirely this life—to leave this life and to make no further attempts to capture what was lost. My imagination was unable to fill out all that was lost; the actual flesh was no longer there; the actual bony structure was no longer there. I could not fill it up; I could only imagine it rather weakly.

Naturally, I had choices. In the end I turned to another field of interest where there was a direct communication. I turned to painting and there I made the effort to come into contact with an apple or a flower or a head and to find its inner spirit and its inner form and make new forms out of my own ability to create. But the complexity of life is far more subtle than this description has indicated. The endless filaments that moved between one person and another receded further into the past and various aspects of my relationship to this doctor were evident repetitions in a sense. So I returned from this doctor whom I knew at the age of twenty to my earlier childhood and my father, another man with a square head, a man who loved me very much. I was but a child of two or three; and yet it appears that these filaments, these communications of the spirit or of the nervous system with the nervous system of another were fully developed or developed to a very great extent and therefore had a very keen repercussion, so that if my father permitted me, as he often did, to place a new cornflower in his buttonhole every morning that constituted for me a great thrill.

June 28

I still think of the green turtle: an image which I wrote about some months ago. I feel he is still walking slowly across the skies, amongst the angels. Let us assume that the angels have extensive knowledge of truth. Let us assume also that the goal of the turtle is to find just "a little more knowledge," as Freud put it. The turtle's pace is slow. It is in a straight unswerving direction. He swerves neither to the right nor to the left. He moves forward slowly; he does not hasten; he moves at his natural pace—

and what truth will come his way will enter into his mind and remain there; possibly he will then communicate it to others.

As I see it, art is not simply a beautiful creation in which one makes lovely forms or colors or astonishes the mind of the spectator with the splendor of the visual. As I walk along life's way, turtle-wise, I remain open to new discoveries; my latest thought is that more important than the depiction of splendid forms or the making of paintings that subscribe to the laws of beauty that have been held so long is, after all, the importance of one's effort to find a little truth.

Or let us think of Cézanne. He also—though at times he fell into the weakness of wanting to be known or wanting to achieve a certain recognition amongst his peers—for the most part struggled only to resolve problems, problems concerning the nature of aesthetics, the nature of color and form, and the way the one made the other.

My turtle walking across the heavens, seemingly pursuing only a straight line, suddenly turned his eyes to the left and saw the angels, who were flying around happily in the beautiful blue sky. Perhaps he wondered whether he could relate this episode for the enjoyment of people in general. Could he depict angels? Could he know enough of their nature to know what they looked like? They were the ones who had gone beyond human life and had reached a state of bliss; that bliss was determined more by having found some truth than by just the accident of enjoyment. Once the turtle's eyes had turned in the direction of the angels, he felt a wave of communication between himself and them; lines of communication, tremor-lines of communication: they were connected, he and the angels. And he attempted to find a way to send messages along those tremulous lines and to receive messages in return. Do not be astonished by my curious language. Often I feel that these electric-like messages are of more importance as real art than that which we have commonly called art—namely form, space, structure, the so-called realities of art—of great art. Greater than all these perhaps were tremulous communication of soul with soul. In this case the soul of the one, the turtle, was still in the living flesh and that of the angels had become part of the heavenly sphere. Even on this earth we communicate by a kind of electric wave-link—waves of electricity go from one of us to the other bearing messages. We understand each other, to the extent of responding to some of the truth that exists in the other. We bear witness to that truth; it is further imprinted in our souls, in our memories.

I know that all this sounds rather astonishing; deemphasis of the usual concept of art—that is of space, form, color, structure—may seem astonishing and perhaps even irrelevant, whereas this idea of electric communication may seem to be too far out, too removed from what we commonly call reality. Yet I feel that perhaps it gives an even greater sense of reality.

Do we not communicate less by the use of matter and more by electric vibrations alone?

June 28

Let us think again of the little green turtle, moving slowly across the sky, with the angels sweeping above him. He had had first to return by difficult steps to his earliest beginnings; he had had to find out of what he was made, how his life had progressed, what had touched it, what had touched him, how he had responded. Only then was he free to look out and communicate with the angels.

Obviously he had been born; he had had a mother, a father; he had had relationships with them, possibly a deep love; he had had shocks when he felt they did not love him as he loved them, that to them it was a more casual kind of relationship. But as he reviewed his past and saw how it had advanced from step to step through love and shock alternately, he had become ready; he now could walk across the heavens solemnly and quietly in no haste to hurry future relationships, but ready. He was able to turn his eyes toward the higher heaven and to see the angels there and to know that he could send these electric messages to them and in turn receive messages back from them. He had become aware of life itself, of truth itself, to a certain, small extent at least. His whole endeavor had been to walk in a straight line pursuing his path—ready, yes, but not over-eager. When finally he was sure that he knew himself and knew all links in the chain of his own small life, he was able to move toward the life or at least toward a communication with the life of the angels. This is simply another way of saying that he was ready to discern some small part of the truth and this had been the original aim and the original destiny of this small creature.

For a long time he had been torn hither and yon; he had been torn apart by love and hate, surged forward again, at times torn apart by loss of love or the feeling of being unloved, and of hating in return and then brought together again by the feeling of loving again, having rid himself of rushes of violent reactions. It now appeared to him that perhaps he was ready to recognize the truth. This is not so very simple; it requires a cleansing of the soul; the mind must be free in order to pursue truth. It must be free of the early trauma, the early terrors and anxieties, for instance those produced by love and hate, as though love and hate were indeed the most important qualities of his existence. There was finally a desire or readiness to discover a little bit of truth and in this activity his true end was achieved. Perhaps in his end, as T. S. Eliot has put it, was his beginning.

July 1

I awoke dreaming of early sensations which brought with them a sense of infinite comfort. In my dream I lay against my mother; I suckled at her breast; my hand touched it; I felt the warmth, the softness; I felt the incredible pleasure of receiving this food that was to nourish and delight me. When again would one receive anything so pure? The turtle, the green turtle, walking solemnly through the sky and looking upward toward the angels, felt perhaps that he was experiencing delights as great as these original ones; he heard music perhaps, or saw wonderful sights, such as rainbows in the sky. We are accustomed to thinking of the earliest pure experiences of the human being as rather foolish, somewhat silly. We think he will grow up; he will take a more serious view of life; he will confront larger issues; he will learn much about the nature of the universe. But never again will he come so close to direct, pure experience. This kind of feeling was so full of enjoyment that the deprivation of it or the attempt to move on from it carried with it great anguish: nowhere could the child recover the joy he had lost. Art was really not a sufficient substitute. It is full of beauty; there are wonderful things in it, wonderful perceptions and sensations, structures, forms; but the pure force of that early direct communication was not to be found. The mind of the beholder was too heavy with other thoughts to respond immediately to what was presented. Perhaps the mind of the artist, too, was often clouded. At times he found a tone as fresh as he could wish and perhaps a receptive onlooker could respond to that tone if his mind were free. But this rarely happens.

But I have forgotten a part of my dream. I dreamt too of smells— another kind of sensation. The smell of tobacco that was associated with my father and his pipe. Later a repetition of this smell was experienced with Dr. G. and I think it had a great effect upon me, the reexperiencing of a sensation that had been one of the earliest pleasures of my life. There was the smell too of wine and this was associated entirely with my father. Wine! It had a lovely attraction to it. But in the case of my father the experience was complicated by the fact that he drank wine with Mary the nurse and perhaps other female servants as well as with my mother, rather than with me, alone, although at times I was permitted to have a sip or two. This may all seem unimportant and yet the earliest memories—the keenest in a way—are never to be forgotten.

July 6

Extreme anguish. The memories, the uncomplicated memories of early infancy, the warmth, the comfort, the joy as against the loneliness of later years.

July 15

If I look at a tree I reflect whether that tree is a symbol, something outside of myself, or a symbol solely within the realm of art or totally inside myself. I prefer to think that it is a composite of all three. It exists in itself as a part of nature. When used in a painting, it exists of course as a part of art's history—it has qualities that are similar or dissimilar to other art; and this is really what art history is all about. This tree seems to me to be a part of myself, existing within me as a part of my total being. This is evidenced particularly right now when I am alone so much and lie down so much and think of all the paintings I have seen and all the nature I have seen that I can remember.

It seems to me that the vision of today rests of course upon the thousands of years before it in which various concepts of art were developed; which of these concepts have been kept and in what way are they being used? To me it appears that the present-day artist frequently thinks of the spectator as practically nonexistent; that is, they do not have a regard for the spectator, for his feelings; they expect him to receive what they have put on a canvas, but they do not have regard for the sensitivity of his mind. Some ten years ago there was an exhibition at the Metropolitan Museum of American works. They showed Gorky, de Kooning, Pollock and many others, including Ellsworth Kelly as one of the more modern ones and Mark di Suvero. But as I entered the various rooms I frequently felt that the art upon the walls was advancing toward me, slamming itself at me, not staying upon the wall and giving me a chance to approach it and study it as I have studied the art of the past during the many years that I spent in Europe and, again, in studying with Gorky and in studying by myself.

July 16

Marcel Proust continued to write from his cork-lined bedroom so full of gas that he was semi-asphyxiated; James Joyce continued to write when he was very nearly blind. What mania possessed them to push on despite these difficulties?

I have imagined the black hole as that area of the deep consciousness or subconscious or early-consciousness where the inner events of the child's life began; and that gradually these individual events recurred and recurred, finally moving outward in a "big bang," and a new enriched aspect of this person was born. A new psyche was established. There was an alternate progression between love on the one hand and shock on the other.

A shock occurred when my nurse, an Irish girl who seemed to have much love for me and to follow me and my creative efforts with great

tenderness, not ignoring them, not laughing at them, not discarding them, but leaving herself open to join with me in my joy at having discovered them or created them, left. Much later came the illness of my father and my mother's great care of him. This was again an instance of shock when I became an unimportant element in the whole scene. He became the center of her thoughts and seemed to take all her love. Little was left over for the little girl or the young girl. Much suffering issued from these shocks. At first there seems to be a great outpouring of love toward the infant, the little child, the growing child, the young girl and then the withdrawal, the shock of withdrawal of love.

Last night I read some pages of my MSS to Sylvia Smith, who seemed to respond very actively to what I had written.

Now I wish to return to the very earliest beginnings once more and to imagine the infant awakened by what discomfort one does not know and longing for comfort, longing to be comforted; this infant seemed already to be aware that it was not to disturb anyone around it: the nurse, the brother, and farther away the mother, the father, and the servants. All of these were to be let alone, allowed to sleep. The infant, however, must somehow get through this period of time. In what way? Let us imagine that the child, the infant, got up, got out of her bed and went toward the bathroom, or went toward her brother's bed and that some interaction occurred there; that certain feelings were prematurely aroused in the infant. Let us continue to imagine that after a little while one of the adults did awaken and came to put an end to all this nonsense—perhaps even shook the child, thus frightening it further, or perhaps took over and sat the child upon her lap, soothing it by rocking in a rocking chair or by giving the child milk. Possibly this same child had awakened and gone downstairs to find her father with the nurse; that somehow the nurse had slipped quietly out of the room. This left the child with a sense of the possibility of being totally abandoned, and the configuration of loneliness became one of the most important in this child's life. Now what reference has all this to art? As adults let us ask in what way art supplemented the hollow spaces in the life of the individual if there were still hollow spaces not overcome as the child grew up. Often one hears of the great clarity and unity of a Claude Lorraine or of a Poussin—think of the *Rape of the Sabine Women* by Poussin, where at some distance away one may feel a great simplicity and harmony. But strangely enough, if one comes close to the painting one finds that each individual part of it was painted as though it were indeed a jewel, hard, with hard surface and hard edge and yet from a distance all seems to melt into oneness, into wholeness. What a mystery!

Yesterday I received two drawings that I had loaned to a friend, Margaret

B.,* in Princeton for some thirty-four years. She had finally asked me whether I would like to have them back. And I replied, yes, I would at least like to see if they needed repair. Sending them to the Museum of Art** I found that they did indeed need to be placed on rag paper and that this care was very important. But seeing the paintings upon the wall was a fascinating experience, joy-giving; something well known had once more returned to me, something I had loved was once more there.

The last time I saw Gorky he was standing tall and dark in front of a Vermeer at the Metropolitan Museum. I had come there myself to study this very same painting and we had met by accident. He pointed out to me various things about this painting—chief of which was that Vermeer used all colors of the palette both strong and weak, light and dark, that every tone remained exactly in its intended place and this was very magical and wonderful. I thought to myself, "Is Gorky planning to try to paint more complicated paintings, paintings that attempt to use the full range of color afforded by the palette? Was he thinking of a more complex structure?" And my answer to myself was "Yes, I really believe so; that is perhaps exactly what he is thinking," i.e., "Could I do this?" Some years later I was asked to write a small piece for Texas where they were giving a Gorky show and I mentioned this idea of what I hypothesized might be Gorky's interest in complexity. Gorky felt it was most important to bring greater complexity back into modern art. We had for quite some time gone in the direction of simplification, of trying to find what we called the essential, of weeding out all that was not essential. This was of course a very risky thing to do, because—well, how would we decide what was essential and what not essential? In these two watercolors or drawings returned to me from Princeton I found the charming complexity so full of the vitality I had missed for some time. And I felt that this was indeed one of the important contributions Gorky had made to modern art.

July 26

There is something resplendent in the shining inner limpid well of Roger's*** mind—no question about it—this little child. This child sings as he works. The song and the work come from an impulse to joy. And so it should be in the work of adult artists. I feel quite certain that the Egyptian frieze of the royal cattle, 3000 B.C., that I so love was done by a man working from his center where song was as natural as breathing.

*Margaret Beller, Ethel's longtime friend and former wife of gallery owner Sam Kootz.
**Museum of Modern Art? Of American Art? Ethel is not specific here.
***Roger Schwabacher, her grandson.

Walt Whitman has said: "I sing myself." Perhaps this is the secret. The individual has in these moments found himself and his spirit runs smoothly. Something is created, something actually externalized that comes from very deep within his psyche.

The other night Herman J.* brought me a beautiful piece of Mozart. In this piece I heard and felt the same thing, an artist sure of all the technical fullness of musical creation but singing all the time, and the song was part of a song that wells up from the inner life expressing life itself, the intensity of consuming intention, the joyous reality of feeling.

All down the years as I wandered through museums I could feel again and again work coming from pure intention, expressing the natural love and laughter of the psyche.

This little boy, leaning over intently, to carry forward a work and singing simultaneously, gave off such a lovely glow of pleasure—pleasure in the act of work.

Van Gogh, sitting in the hot sun at Arles, in the middle of the fields, smelling the sweet smell of grapes that were ripening on vines; and the distant smell of apricots, feeling the hot sun, feeling the warm earth, feeling that he was centered in his own act of creation, was evidencing the very same creative act of which I have been speaking.

August 4

The little turtle, though advancing through the heavens and aspiring upward, has simultaneously returned to his earliest beginnings and found some of the causes of his early difficulties.

Shall I allow the personal to enter this journal? Or shall I imagine that great art was done entirely influenced by other great art and knowledge of the past? No, I feel that it was as well the outcome of extremely intimate experiences, enjoyed or suffered by the painter.

Example: When Gorky's studio was burning in Connecticut, he said he had thought that his cigarette was giving forth clouds of smoke and only gradually realized that his studio actually was on fire. Artist-dreamer, it only gradually dawned on him that he must remove his paintings to save them from being destroyed.

August 5

The little child in bed, feeling lonely, was perhaps longed for by her brother who also may have felt lonely and perhaps may have come to her bed

*Herman Joseph, a friend of Ethel's who helped in a methadone program.

in the night. Did he try to find satisfaction of his sexual needs in her and she to fend him off? Such drives were not recognized and understood by the adults in question. They reacted to the obvious surface agitation and merely said: "Oh be quiet and go back to bed!" These excitations were swiftly repressed into the unconscious where they were hidden from conscious knowledge; as a result a constant sense of anxiety was maintained at great psychic cost, returning again and again during the little girl's life.

How strangely difficult it is to discover even a little truth and to really live through and dispose of it or allay ill effects.

August 6

What do we know of van Gogh's early life? How does it happen that he could marry a prostitute and cut off his ear? In order to explain we would have to return to some very early experiences.

I cannot remember having heard of such possible early elements described as part of his life history—or his eventual suicide. Here we are faced with the fact that one of our great painter geniuses was lost to us through an unaccounted for or unworked out happening of his childhood.

August 7

I have told the story of my green turtle walking quietly across the heavens amongst the angels. But I have given a one-sided story, omitting the negative.

However, the negative is a necessary part of the whole. It was necessary for the turtle to realize that from the very beginning he knew anger, hatred, and that perhaps he was more than ready to be violent, and to carry out his innermost desires for revenge.

It was necessary that he should realize that he contained hatred within his soul; that he could be cruel and could even enjoy cruelty; that he could be most cruel toward those whom he most loved. As for instance when he made his great discoveries about his childhood, named by me "shock" discoveries, he responded with anger as well as hurt.

When the little one felt deserted, less loved, though possibly with courage, he stood on the edge of an abyss he could not tolerate—he felt shock. He knew hatred, he wished to avenge himself; he wished to hurt those who had hurt him. Feeling weak, he had taken the erroneous path of repressing all the hatred that he could not express, the desire to reenact the cruelty he had experienced. He was in error.

In the end my turtle's path was to achieve unity by allowing himself the fury that he felt. Then only could he hope to be free. Then only could he ascend to paradise. It may seem strange to attach such weight to feeling,

to negative feeling, to violent desire to hurt the other as the other had hurt him, even to the point of murder. He was faced with conflict, with opposite wishes. He had always dwelt upon a feeling of goodness toward people; he could not assimilate the maddening pain of finding the most violent fury within himself. When he could allow himself to realize that he had often been left, ignored, he felt a seething rage, a desire to hurt the other as the other had hurt him.

When an ideal image of lovingness was desired or encouraged in connection with the little turtle's life, he unfortunately was torn, consumed by contrary and opposite desires. He wished to avenge himself. He wished to exert his power. He wished to cause more suffering than he himself had suffered. He had to pass through this stage. Fury was so intense that it prevented him from finding the necessary relaxation to sleep. He could not sleep. He could not fight against the forces that were close to demolishing him. He could fight for others but was himself helplessly bound—repressing the anger, the fury, the desire to kill, the desire to separate his father and mother and, finally, to take the place of his father, to enjoy his mother's love in as great intensity as his father had been able to enjoy it. Progress beyond this stage was not accorded him; he did not have the courage to accept himself as he was; he falsely held to the ideal that he was above the negative and hostile thoughts that he actually had.

He was not really free to traverse the heavens and to talk with the angels who had passed far beyond this conflicted stage. He only came upon this truth at the end of his life and this brought a great release. Finally he accepted the truth that was so important to the formation of his completed development—the "little bit of truth" of which I have spoken often. He found the ability to let the desire for his mother go. He realized that he would have to go through life alone—not depending on total possession of his mother. In the course of his search for peace he found that there were innumerable occasions in which he found that he experienced anger, intense and violent anger, but he also came to realize that he was incapable of expressing anger and that the early repudiation of his own aggressive impulses had mutilated his life. But finally he was able to absorb a wholesome amount of love and to relinquish "over-need" as inappropriate. Thus he became finally an adult human being, one who could talk with the angels.

August 20

Death approaches and the thought of roses, pink roses, with their green leaves lingers in my mind.

I wanted above all to have a child to love. This child was to know the

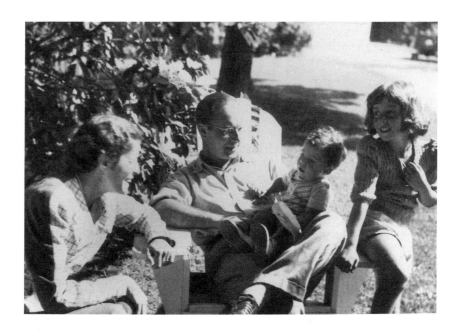

FIGURE 15. Ethel, Wolfgang,
Christopher, and
Brenda Schwabacher,
circa 1943–44.

experience of being loved as it grew up. Then in 1940, at the time of the great war, I wanted another child. One of my thoughts was to oppose the demolition of the world by a positive action: the action of giving birth— new life against death or return to dust. But the desire for a child included the strong feeling that there was no greater joy possible for both myself and my husband. After my love for my husband what meant most to me was my children. I had the hope that they would grow up with the least possible anguish and the most possibility of joy and fruitfulness. My first was a girl, my second a boy. I felt no difference in the amount of love that was in me toward the one or the other. They were very beautiful and they brought me much joy. Brenda, darling, you were a child of love. I felt you were both beautiful and full of talent and that you would produce as time went on. Christopher, I felt you were a continuation of Wolf's line, would be a man, square and solid to the earth but sensitive and aware of beauty.

I welcome death. I only wish I could express my feeling about it in

terms of the flower and the sun-filled leaf whose reality seemed so natural, so perfect, so mysterious. To use Keats' line, "A thing of beauty is a joy forever" if its loveliness increases and does never pass into nothingness.

The endless stories a child brings! I remember that Chris danced, moving so naturally. It seemed to me this was how art should go and along with my love of Wolf and the children came my love of art—very great indeed. I felt art should contain within itself the natural grace that was so much a part of childhood, of the child. The child moved naturally—from a love of movement. Chris, for instance, had a feeling for devising different kinds of motion, different patterns to follow. I was astonished that he could manage such a range of invention at such a tender age. And Brenda with her graceful motions as she walked or skipped or ran or leapt! I constantly contrasted their grace with the grace I had known in art, that side of art that perhaps had the most appeal for me. The wonder of its inevitable naturalness and rightness!

How to make art as though it came from a single breath, the breath of life, the breath of joy, the breath of love.

You were wonderful children, Brenda and Chris, giving delight by the softness of your motions, by the swiftness of your feeling, by its sureness, by its rightness.

Only later came the worry, the concern, the seemingly endless difficulties of keeping that which at the beginning had been so pure, alive. Complexities entered in with the deepening of the relationship.

As to the children themselves, they doubtless have experienced, along with the love of each other and their parents, the anger and even hatred that exists in the course of life as we know it. There was no way to avoid this. Competition for love. Jealousy. These were part of the human psyche. One had to accept them.

September 2

Estrangement of the life cycle. Estrangement of the art cycle. A victim caught in a fragile web, entangled to the point where he cannot get out. His fragile legs, although they are not so fragile as the strands of the spider web, are nonetheless caught in it. The more he moves the more tightly he is bound.

The flower is bound by certain similar inner necessities. It is brought to me, cool, and very beautiful. A daisy, with lovely leaves circling round its yellow center. I rejoice in it. I feel that it must live on thus forever. But by the next day I find the leaves already beginning to fade, their firmness gone, their quality of standing out boldly around their center.

September 3

In his pursuit of perfection, Gorky attempted to fulfill a certain destiny. The destiny of achieving a complex structure that would not be a mere copy of the past. Nor would this structure be a blind thrust into the future. It would continue the past with the introduction of certain variations. Gorky would incorporate certain surrealist ideas, namely the free use of the pre-conscious. He would adapt the impressionist palette which dropped black and brown almost entirely. He would adapt the free, singing, joyous rhythms of a Kandinsky at his best period in 1913 before the war. Objects though structured would float freely and musically through space. Furthermore he would return to an attempt to gain the solidity of traditional art—the art of Poussin or of Titian or of Paulo Uccello—the great masters of the past who constructed paintings that had the quality of being fully realized, not approximations. They were rounded out: their forms complete. The unusual quality that Gorky brought to the art of the present was a combination of varying kinds of thought; he used the astonishingly precise memories of his enjoyment of his early experiences which entered the paintings in a very important way, not isolated off in some theoretical idealized world; rather they came out of the reality of his own individual experience.

Epitaph for myself. The power of my thrust to live was halted by the fine strands of the cobweb, just as Gorky's had been. And yet, something was accomplished.

The now grew out of the past and included in it as much of the past as I could bring away with me and incorporate into visual form. The bird flying across my sky in childhood, setting up motions of color tones, was not to be lost. They could be found or refound in the later paintings. Tones themselves could be reexperienced. They too were not lost. And in that way a certain kind of pattern was set up for a way of painting that included memories and later constructs and still later experiences—they were all to come together in a work of art.

September 8

Last night a young art historian came to see me and I felt she needed badly to know how to conduct her life.

I thought of Plato's night without dreams. In discussing death, Socrates asks his students whether any of them had had many days as beautiful as a night without dreams. So death might be, he felt.

He also felt that there might be a Parnassus and if so that he would find himself there amongst great men such as Homer and other poets and thinkers of the past.

But I will include in my Parnassus not only such thinkers of the past

but more humble organizations of reality. A dewdrop. The miracle of a blade of grass piercing the earth and breaking out into the sunshine. Many shaped clouds in the sky, shaping for the spectator aesthetic delight.

So beautiful I see her there intent on following the teachings of her master, Freud—the teaching that truth was more important—even a little truth—than anything else.

She saw truth in herself and in others. Where was it? Where was it to be found? How was it to be found? Did the realization of it come upon one in the night in the midst of one's dreams? Or did it come in broad daylight as one moved from moment to moment through the day, through the inner and outer happenings, including the larger happenings in the world? And what of their assessment, the possibility of trying to assess them? Did not Einstein love the truth, finding it in certain aspects in the realm of mathematics? He searched it out also in the larger political happenings that he could observe in his time. There was Marie Curie, who hypothesized a new element. All "miracles" came to us through certain extraordinary personalities or minds.

How receptive could one be? Could one listen? Could one understand? Could one accept? Could one learn?

Freud felt that he had come upon certain portions of the truth that might lead to "the place where"—a new world of psychic learning; he felt that he might not be able to enter into that world, though he had been able to envision it—to discover its reality. But that in itself was enough to give him deep inner satisfaction.

September 17

Are these words hollow, stiff, recalcitrant, foolish? Or was the little child ultimately right in wanting to possess, to be the first?

Her father bent over, slipping a string of pearls over her mother's sleek black hair; they gleamed, were round and soft, aroused delicious sensations (as the string of pearls in Ingre's *Portrait of a Young Woman* in the Frick). The little one wanted them more than anything in the world; wanted her father, wanted him to give those pearls to her.

She thought, "It was not to be. He would choose her mother. Why? Because she was older and it was ordained that the older one should possess or be possessed by the father, not the little one."

She desired those pearls. She desired many beautiful things. She desired to be encircled by gems: emeralds, sapphires, pearls, diamonds. She desired the feelings behind the gesture of giving of love, thought they belonged to her. When she found they were being given to another she was filled

with seething jealousy and rage. She could have killed to get those precious articles, this precious love, but she did not. And thus the tragedy.

She should of course have accepted her place in the scheme of things and waited patiently for the time to come when she would be THE one and no longer the little girl who could be disregarded by her mother or any other woman.

Even now she is disregarded. Being a woman is so negative a factor that it obliterates all else. Is it true that a woman is not capable of creating anything but children? She must suffer the "as-though this-were-true" consequences. The rope of pearls that should have been hers will not be given to her. It was better that she die.

September 23

The child stumbled . . . she stumbled . . . she fell, she hurt herself, she got up and ran or stumbled back into her bed. She had just heard that her nurse was about to leave.

Stumbling down the hall, she fell, hurt her eye, rose and stumbled forward again; she had just heard that her nurse was leaving in the morning and was stricken by this. She called out and turned as she rose from stumbling; she turned and called out to her mother, thinking that perhaps her mother would comfort her, but her mother's door was shut and she could not awaken her, that was forbidden. Stumbling and rising and stumbling and rising and weeping she tried to reach her room. She was stricken. Deeply stricken. She reached her bed and cried. She turned over and cried into the pillow, "She is leaving, I cannot bear it." She asked herself now, why not jump out the window, life is so unbearable? Then she said to herself, "I'm no longer the two-year-old child, I am now a grown woman and this childhood episode is far behind me. I now have other necessities. I must go on. I have children. I have friends. I have work that might not be without value that I could still do. I can still write. There are still perhaps some things to say that are not without value."

She must remember somehow and keep remembering that she is no longer a two-year-old child. She must remember that she should go on. This would give courage to others and if she were not to go on it would take courage away from them. That is an enormous responsibility. How could she face it? How could she not face it? But she felt a burning need to have some support in this attempt. She did not feel she could do it all alone. She thought: "I cannot face tomorrow as when I was a child, when my mother found another nurse for me and was there to comfort me somewhat until this nurse arrived. Now I am all alone. I have to search for this new person, this other person, myself." It all seemed quite unbear-

able. She felt she could not do it and no one seemed willing to help her. She reminded herself again that she was not the two-year-old child who was so helpless that she needed a mother but, rather, a grown person, supposedly. She felt she should be able to do this. She should be able to find a new housekeeper. She should be able to do this.

September 24

Head buried under her pillow, tears streaming, the pillow wet, hands clenched, she thought: "If only I could speak to someone; to whom?" And imagined all the people around about: her parents in their room; Mrs. Crawford next door; the servants upstairs; people farther away, her grand-mother in New York. There were people everywhere. There were people to whom she might have gone, who might have put their arms around her and comforted her. But instead she lay there, curled up, aching with the pain of it all.

September 26

Sobbing under the pillows, her hands clenched, finally someone heard, finally. Was it the nurse? Or was it her mother? And this person came and comforted her and caressed her. This caressing was comforting, yes, but it was also exciting and inspired a longing to repeat, to repeat, to repeat.

Thus was set up the whole complex. The enormous stricken quality of being left alone, the fear, the anxiety, the pain; and on the other hand the comforting that might come and the arousal of a desire for that, a desire for sensuous satisfaction.

I have really described the beginning, the early years in the life of a child who later would become one of those who would think at times of suicide and at other times of love, sometimes of the kind of love that is forbidden. The result was periods of unbelievably painful loneliness, a constant yearning to telephone in the middle of the night, a yearning not clearly expressed to have near by her a man or woman— it really did not matter which—who belonged to her so she would not be alone. So that she could have sexual pleasure when she needed it or wished for it. This initiated the desire for alcohol on the one hand and suicide on the other.

Let us say that suicide was the expression of a deep anger against the woman who left her—whether the nurse or whoever—also a deep anger at the woman who returned briefly to comfort her and left again, so that this leaving of a loved person was perhaps the most terrible thing that could happen to this child. It awakened the feeling of being alone and of not being able to face this aloneness, or to fill it with thoughts, though

she was full of thoughts, capable, full of talent, able to create. But these early experiences were so devastating that the hate aroused was greater than anything else and had to be expressed.

September 26

I have described an early episode, but possibly there is an earlier one, perhaps an earlier nurse who left. The description of this leaving might well have been quite similar. Perhaps behind this, at the root, was the feeling of jealousy toward the mother for possessing the father, for loving the brother more. So that this description of the leaving of a nurse was simply a sharpened and isolated expression of a general condition of jealousy and anger. An anger so great that it brought with it the desire to kill: whether to kill the mother in order to possess the father in her place or whether to kill the father in order to possess the mother in his place, or to kill the brother who was more loved. The point was that the desire of this little child was to be the only one, the first one, and anything else was insufficient. The anger was repressed as I have said before. The anger was locked away for many years and it seemed indeed that it could never be unlocked.

September 30

The little child was possibly awakened by her nurse slipping out of bed and going either to the bathroom or possibly farther downstairs to have a snack or a little sip of something, possibly accompanied by her father. Possibly they sipped together. Perhaps she stopped at the door before going in and received the full impact of this little scene with her father and the nurse and the bottle of wine and perhaps a chocolate cake or some kind of lovely cookies. It would be interesting to know what feelings she might have had at that time.

I think that the feelings were exceedingly violent, that there were pangs of jealousy and fury, a desire to kill, to take the place of this stranger who was occupying her father's attention. She would have liked to sit there and drink with him or snack with him, but instead someone else was there. This person seemed to feel in full possession of the right to be so. I think it is most likely that she concealed these sharp feelings or pangs and went in and sat upon the lap of one or the other of these two and partook maybe of a sip of wine or a tiny piece of cake and smiled and was hugged by them, the one or the other or both. Then was told to go back to bed.

At that time it was customary to think of a child as a child—as a small and insignificant, though adorable, being but certainly not as someone

really complete. Later, much later, when the child was grown, the child retained this sense, although the child was no longer a child but now an adolescent, let us say, or a young woman, or an older young woman or a bride or a mother—this human soul still felt the whiplash of the keen and biting unimportance in which she was held; the lack of esteem in which she was held. This child kept longing to be taken more seriously but did not know how to go about achieving this result.

There was school, the marks in school; the child was marked for doing excellent work and was taken seriously, yes, seriously perhaps as a child who does excellently, but the child herself did not think of herself as a child who did excellent work but as a young ego, a real person, someone who was perhaps new at learning but who would soon be in possession of what was called learning and able to function in the round, as it were.

Have we forgotten that Jesus preached at the age of eight or nine and was taken seriously as a child of God?

But in our home this child was always taken as a child, although she made certain attempts at bringing herself to the notice of the adult world. She took erroneous steps. She became ill. Then they noticed her. She had spells of dizziness or fits of stomach trouble and was forced to be in bed. Gradually they took notice of her—"the delicate child"—and kept her home from school. They misunderstood all along the line. This was not a child in the sense they thought of, but a little human being who had not yet the outward appearance of being whole.

I see now my granddaughter is in a struggle of a similar kind. She is causing her mother a great deal of trouble in her adolescence. She is sixteen and thinks of herself as a fully organized person who could leave home and could determine her own directions, while her mother is insisting that she still is but a child and needs to be directed.

October 3

Can I have reached the important point? The point that I had a great need to make known? For instance I had a great need for a certain power and the greater the need the greater was my dismay at my helplessness.

Perhaps they had ignored that in their midst was a wonderful child, who would eventually make beautiful works of art—of which they could be proud. And yet somehow a whole lifetime went by where certain things were accomplished, yes, but never—it seemed to me—sufficiently acknowledged. And this was due to this initial weakness in the structure of the psyche.

The fatal mistake was the suppression of the sorrow and fury that this

child felt at the loss of the nurse whom she loved. The deep wound was not taken sufficiently seriously.

Can it even be that I am angry with Dr. K. that she too did not emphasize my ability to a sufficient extent but was more intent on finding out about certain psychic difficulties of childhood, my relationship to my mother, my father, my brother and that she did not sufficiently help me to overcome the more urgent, immediate need of winning recognition, of venting anger, perhaps first, of freeing myself in that way and then be able to go forward? Do I resent this? Do I have some great anger toward her that is holding me back at this point?

Have I, strangely enough, at last found much of the answer or will she say that I have to go back again to early childhood and find out more exactly just what pain was inflicted upon me and what pain I desired to inflict on others and what I did with it?

Of course it was the same whether I desired to kill my mother because I could not take her place in my father's bed or whether I desired to injure my nurse because she left me, possibly for some young man she wanted to marry, or whether it was that I desired to invalidate my brother, to crucify him, or to weaken him, so that he would not get the love that I desired.

My total inability to express anger except perhaps through tears or small temper tantrums or bouts of illness made it impossible for me to exert the usual aggressive force that brings about results in the so-called real world.

And yet, strangely enough, I have always felt that "they" missed the point, that they had in their midst someone remarkable they were failing to notice, just as Emily Dickinson's friends failed to notice that they had a genius amongst them.

Can K. be right when she says I needed so much power because I felt so helpless?

Have I come at last upon the secret? The secret of my uneasiness in the face of being alone? The secret of my uneasiness about my own certitude of my own value? Had that certitude been more solid I should have been able to stay alone and to create alone even though my work might be at variance with what the rest of the world was doing.

Though I may have found much of the true answer, will K. say that I still have to bring more material, more exact material of the exact moments of anger, the exact repressions, the exact moments of weeping, of sadness in solitude?

Is it possible I can now go ahead on the basis of what we have already discovered? Have we done it after all? Can I tell her that I am angry at

her? Can I now face that anger and go on with the positive aspects of my life?

October 12

Oh my darling, my darling, understand this, can you understand—try very hard. It is only in giving that one can bear living. It is the giving that makes living possible. Let us suppose that as a child this nurse leaned over my crib and kissed me lightly goodbye, or possibly even more warmly and then left. I could no longer give. I was reduced to nothingness. I had received something. I wanted to give in return. It was a necessity of my being, the very innermost necessity of my being was to give.

I wished then since she was gone to communicate with others, to find ways of giving to them, to be needed, to be on the generous end of things: not only a receiver, not only one who longed to be loved, but one who longed to love.

Think of Jesus. He did not live in order to be loved; he lived in order to love and to give love. This was by far most important to him. Perhaps this was what reached me in the teaching of Christian religion that I received as a child, making a deep impression on my mind. I could no longer be satisfied when I was reduced to silence.

I realize that I had always felt that art was not a question merely of self-expression, the joy of making beautiful colors or the joy of understanding the construction of nature and its realities. But it primarily wishes for the joy of giving joy. That was the necessity, that was the innermost necessity for the artist. If at times the joy of giving was confused with fame, that was rather a verbal mistake. What does fame mean except that one was able thereby to give more to a greater number of people? Think back to the royal cattle of Egypt. Was that artist thinking of producing merely to satisfy the whim of the Pharaoh? Was he producing as an artisan or as an artist? Was he producing to give pleasure? Did he sing as he worked? Was the song also the expression of his desire to give pleasure? I think yes. I think that we have misunderstood what art was for the most part. It was not only a question of knowledge or of fame, or of financial benefit. It was a question of arousing in people their ability to respond to joy.

Irreducible joy. Irreducible majesty. The majesty of being alive. On the one hand there is hate, which is a peculiarly intense form of being alive, but one that causes pain, and frequently ends in killing—in actually bringing that which was something to nothingness. But art was always a question of bringing near-nothingness to something. Out of a blank piece of paper, out of a few insignificant materials and the thought of the artist came

productions, productions that awoke thoughts and feelings, productions that had meaning.

Frequently today one sees paintings where the raw material, insignificant itself, is more prominent than the meaning. The material, which may be a large canvas, is frequently covered with one single color, maybe white or gray or a very minimum of additional expression given to it, as though the artist felt that size alone could produce some sort of gratification in the viewer. But I think he has made a mistake, that he misunderstood what art was. It is not merely the expression of a certain degree of material reality. It is, as I have said before, an expression of joy giving, it gives back something that was frequently hidden from the individual—his power of feeling, the power of feeling the beautiful, his deep involvement in it.

October 14

You will say, but this was just a child; she should have been able to change, to move from one nurse to another, from one person to another; she should have been ready to love the next nurse as she had loved the last nurse; she should have received the kiss that came on the night and the day off and returned it. Instead she suffered the feeling of terrible loneliness. She wanted to follow this nurse to whom she was attached. She wanted above all to be with her.

So this is finally the explanation of why when W.S.S. died my first thought was, I must be with him, if necessary I must throw myself into his grave and die with him so that we would be together. But in real life this early experience of the nurse was very natural. She was going off with one whom she loved, of course, more than she loved me. But I could not respond by being happy in her happiness. Instead I was filled with sorrow and perhaps also rage. I was left alone and my mother was too busy to comfort me.

Work was more stable. When one worked, one chose a field of endeavor; one could continue on as long as one wished, as long as one had health and could work.

In the course of natural development a child was supposed eventually to find a member of the opposite sex, a young man, to whom she would belong, who would love her. Then she could experience what the nurse had originally experienced. But this particular child was fixed, as a fly is fixed in glue; she could not move; she was held in the original position of the "neglected one," of the one who had been left or the one who could not find the love that was so important and who could not find a way to give, who was thus cut off, as it were.

But to return to the work. It was necessary in order to work that one

be well. Now what of the artist who may feel a desire to work, to continue the experiments, to continue the creative processes that were perhaps not without value? What of that child become a woman? We know many of the stories connected with great artists who have run into physical troubles. We know that Monet had brushes strapped to his arm so that he could continue. We know that he made, in what manner I'm not exactly sure, designs for cutouts which his assistant then completed, and these became very beautiful works of art, amongst the most beautiful he ever made. We know that Beethoven composed music though deaf, that Milton wrote poetry though blind, that James Joyce wrote though his eyes became very weak and he had to write in a huge script that was then read by someone. There were ways out for those who were inventive. There were ways out for those whose creative drive was so enormous that they could not let it lie fallow.

We must salute these artists who put art first and who put the giving of pleasure before everything else; knowledge was highly desirable; they desired knowledge; they desired the enjoyment of the act of creativity. But I believe that the writers on art have ignored the fact that these artists may well have put first the giving of pleasure to others, the awakening in them of knowledge, the awakening in them of potential creativity, of the possibility of responding at least, of responding creatively. This in itself was very important.

October 18

The door shut slowly, quietly, I listened as I lay awake for the slightest sound, the soft footsteps departing down the corridor. My heart beat faster, faster. I thought—no, I did not think. I listened for further sounds, but there were none; there was only a great silence and I had the longing to talk to someone, to talk, to be understood, to love, to be loved.

Perhaps in later years any footsteps fading off into soundlessness gave me a certain uneasiness, a displeasure and any sign of footsteps approaching me gave me a sense of the opposite: a sense of great security, a sense that here at last a loved one is returning and I will be no longer alone.

Imagine that she who looked for her lover, asking the watchman where he was, running through the city streets, searching him out, came finally back. And after a while he did return and she enjoyed the delight of reunion. Perhaps all the greater because there had been this loss, this seeming loss in between.

I remember how W.S.S. used to go for walks at the farm. He disappeared down the lane, his figure growing ever smaller. My heart was not altogether heavy because I knew he would return. Still I believed that the diminishing

sounds of that early departure lingered in my mind and gave me a feeling of some uneasiness.

Now when death came as in the case of Utise,* I knew that there would be no sounds returning, only the diminishing sounds were real and they were agony. I had difficulty in shifting to other thoughts; what other thoughts could I have? Could I put this into an expression of art as for instance in the case of Oedipus when he left Antigone? He rose and departed. She must have heard his receding steps. With what agony? What became of her life? No one has ever seemed to describe this. They described his glorious death, but they did not describe what she must have felt. Is it not time that some artist should come up who would consider this aspect of the total picture?

Did she turn her footsteps back toward Athens from which she had come over many miles of hills?

*Her housekeeper.

"I too have dreams."

"Above all else the language of art
should be clear."

SECOND

VISIONARY

INTERLUDE: THE

TIME FOR

CLARIFICATION

INTRODUCTION

This brief interlude of meditation on aesthetics was written when Ethel was ill, disoriented, and about to attempt suicide. It represents a last, desperate attempt, in the midst of extreme chaos in her feelings and perceptions, to assert the place of art as an influence of calm and clarity and as a means for maintaining control over the chaos of life. She was walking with extreme

difficulty and an unsteady, shuffling gait she thought like that of her visionary turtle. She held her hands out in front of her for balance and for greater security in case she fell. Increasingly, her arteriosclerosis and her fear caused her to behave in ways her children found disturbing, alternating fits of extreme fright with expressions of rage.

October 24

Let us look again at the lovely bunch of flowers arranged on my table. Three round pink ones and a scattering of orange yellow, pale, soft colors made of small leaves. Nothing more beautiful could be imagined.

Now that I feel their beauty.

I was deeply touched to hear Rebecca's* voice this evening on the telephone. She sounded so dismayed at not having done her work well enough to suit her. And then later Michael,** much more cool and calm. How dear these children are to me. Then I thought of Christopher and the fact that he is heavily burdened with work and with concern over his wife. How then can I add to this? How shall I permit myself to add to this?

I think of Gorky and the long relationship I had with him. In the beginning it was a matter of survival for him. Also a matter of learning what path he wished to take, what mode of expression he wished to make his own. What contribution he might have to make. And I felt that I perhaps helped him insofar as it helped him to know that someone was following his thoughts and caring about what would become of them. Now I too have dreams and thoughts of what I might wish to do, what I might wish to express. Above all I was, I think, deeply convinced that I wished to express the vividness of life itself, the enormous importance of the small awakenings of grass and flower. The fascination that when I saw a bird flying through the sky, tones were set up around him that I found extremely beautiful and then as he flew further forward, the tones disappeared and

*Rebecca Webster, her granddaughter.
**Michael Webster, her grandson.

the blue sky reappeared. This was most interesting to me and seemed to be proper stuff of art.

I do not think there's any reason to say that this is a particularly feminine approach or that indeed there is such a thing as a particularly feminine approach to art. Beauty is everywhere. It comes to light, it lives, it vanishes, is renewed, it lives, it vanishes and is renewed again.

I constantly speak of art as though it were quite separate from what we usually call life; for instance, the great political movements of various times, whether it is a time of war or time of peace, and what goes on in the world politic and in the world of science. Is there a relation between art and these?

In other times, certainly art has attempted to show war as it progressed, conniving of courtiers, the death of kings, the crowning of princes, all the events of political life were shown. And now today we seem to have withdrawn from this attempt.

We have attempted to show something of the power of a life outside of the purely aesthetic. We have tried to grasp the enormous vitality of the existent forces that are active in the present time. But we have done so in a very undifferentiated way. We have shown the pure force or the pure energy or the spaciousness or the vagueness of space, but we have not particularized, made it clear exactly what was going on. Is this because we did not know what was going on? We only knew that we lived in a time when large spaces and large skyscrapers and mighty machines that could fly to the moon and other mighty machines of destruction existed and we expressed either fear or interest in these phenomena. But we did so as I have said in a generalized sort of way and did not make it clear just exactly what we wanted to express or what was happening really.

Again I do not think this has anything to do with whether a man or a woman is painting. Neither one nor the other has been able to successfully particularize the greatness and power of a vision which they barely could catch hold of. They attempted to express something that was beyond their actual capacity to understand and in that lies its weakness.

If Paulo Uccello showed a battle scene, young men on horses holding banners that flew in the wind, it was quite clear what he was talking about, what he was trying to express. And this was important. He was expressing ideas about life and death. Perhaps we are still trying to express ideas about life and death but we have allowed them to become vague; we could not find ways of expressing them clearly so that the viewer might know what it was we were talking about. Perhaps he got a sense of the impassioned event, of the largeness of skyscrapers, of the fantastic power that launched a spaceship toward the moon, of the great entanglements of nations all over the world, of the uncertainty of the outcome of these political entan-

glements, of human rights and longings. I am quite sure that the artists of the Abstract Impressionism* school gave thought to such things but they did not have the mental power, the intellectual power to find clear images with which to express these thoughts, and thus left the spectator overwhelmed with a sense of vast happenings that were not clearly named, not clearly to be understood.

It is perhaps a time for clarification. For clarification in what we call actual life, the right to self-determination, the right to nationhood, the right to speak and to be heard and to live where one wished and to have equal opportunities of all kinds; but all these thoughts have been expressed in a very ambiguous fashion and the artist has followed that and has not been able to lead the way as in the past to express what was or was to be clearly and then let people study that and to learn from it and perhaps to initiate.

Language has become indeterminate, the language of art, I mean. And this is very regrettable because above all else the language of art should be clear so that people engaged in bringing reality about in life should have some guidelines they could follow.

AFTERWORD

In October, when the typescript stops, Ethel attempts suicide by overdose of pain medication combined with alcohol and is hospitalized on life support systems for a week. Her children were told that she would probably remain in a vegetative state and agonized over whether to take her off the life support. Although the attending nurse said that people in deep coma could not hear or respond, Ethel's daughter, in a desperate attempt to bring her back, talked to her constantly. Finally Ethel came back to consciousness and, after two more weeks in the hospital, returned home.

*Sic. It should read: Abstract Expressionist school.

eight

"Out of the depths of the hidden
 nightmare I arise—phoenix-like."

"For me, light has been female."

"The anemones do not question their
 own existence—nor do I question
 it. A triumph of becoming."

THE ANGEL
OF DEATH

INTRODUCTION

The private jottings resume November 28, 1979, upon Ethel's
return home from the hospital, in a moment of relief and opti-
mism. The art historian Mona Hadler is taping an interview
with her, and Dr. Kris once again hopes that the analysis is
finally reaching its close. Ethel's initial pleasure at this indication
of progress, however, soon turns first to anxiety and then to ter-

ror and rage at the thought of ending this long relationship with the doctor who has, after all, emotionally sustained her and kept her from death since the suicide attempt of 1952. The jottings of this period thus interweave strands of renewed anxiety at separation from Dr. Kris, further attempts to locate the source of her inability to be alone, renewed alarm whenever a nurse or housekeeper is about to leave, panic and annoyance at her children's reminders that the level of care she insists she needs is rapidly depleting her financial resources, refusal to accept their recommendation that she cut back her staff, and notations of various arthritis treatments—cortisone, Zomax, Indocin, hypnosis, and possibly acupuncture. The demand that she cut back on her staff is not frivolously made; her children are aware that the cost may leave her with no recourse but an institution if she runs through her remaining assets too quickly. And her terror of being alone and falling increases as her arteriosclerosis and poor balance worsen. Finally, this woman who has almost died from mixing Thorazine and alcohol is afraid that, if left unguarded for even a moment, she may yield to temptation and try again to kill herself.

Some of this deterioration may have been an unfortunate side effect of her many medications. In January, when she is taken off all her pain medications (Dr. Kris saying "we don't want to fill you up with drugs"—private jottings), her balance, coordination, and lucidity improve. The public journal exults: "Out of . . . the hidden nightmare I arise, phoenix-like." At the same time she is also working with a typist to put the journal in final form, and showing it to literary friends she hopes will market it to publishers for her. Her friends tell her they admire the book, but their efforts apparently lead nowhere. John Ford tries first to get her a show at his gallery and then, when she refuses through distrust of his dealer, to persuade her to show a few paintings on consignment, which she also refuses to do. At various times there are possibilities of her being included in a number of shows and traveling exhibits, one of which, a show at the Zimmerli curated by Greta Berman, did take a painting. Also at this time she is progressively more and more worried by a lawsuit brought against her because of a painting she had attributed to Gorky. The suit claimed her attribution to be incorrect; she claimed that her original attribution was correct but that a forgery was later substituted for the picture she saw. This suit,

although finally settled without liability, caused her much pain while it dragged on.

In January, amid efforts to place her manuscript and increased doses of Thorazine, she dreams of "a gathering of women," and laments the increased burden she places on her children: "I give worry and not joy." The burden was great. Both Brenda and Chris were phoned at all hours of the night, when Ethel was in pain or terrified and could not sleep. Brenda, in California, could not deal with the day-to-day cares, but Christopher managed Ethel's finances and legal needs and his wife, Hannelore, devotedly managed Ethel's household as well as her own, supervising the staff, balancing the checkbook, and paying the bills. It fell to Hannelore to straighten out the territorial disputes and wrangles among the household staff and keep the group functioning with whatever efficiency it could manage, given the constant departures of housekeepers and nurses. Ethel's guilt over her burdensomeness is therefore understandable, as is her relief when she feels an increase of rapport with her children or Dr. Kris. Her efforts to relieve the monotony of being housebound meet with less success; a trip to the movies results in increased pain and she resigns herself to remaining at home.

Not only housebound; she now feels herself superseded as well. While she stays at home in her pain, her son goes out for dinner with the artists and art lovers she used to know, and she notes, with a little regret, the transfer to her son of her former position as art patron, saying, "like Wilhelmina of Holland, I am stepping down." In February, her private notes recall wanting to perform a mercy killing for her father years ago during his final, painful illness, while the public journal speaks of the death of Socrates at the height of his powers as being a desirable end. These musings of abdication and deposition alternate with sexual fantasies leading to orgasm and notes of erotic drawings (many of which, in her sketch notebooks of this time, are very powerful). She discusses her sexual needs with Dr. Kris, who eventually tells her that at this point she should allow herself a little autoeroticism if it will help her to relax. This final burst of sexual energy, at the age of seventy-seven, in the midst of despair, physical disintegration, and desire for a merciful death, may represent a countering expression of her buried desire for life and for joy, and a temporary spiritual triumph over the force that has been pulling her toward death.

Ethel's own bitter loneliness and physical pain are counter-pointed by her shock and horror at Dr. Kris's physical deterioration. The doctor has become quite deaf and relies on wearing a headset hooked up to a microphone that amplifies the patient's voice. Meanwhile, Ethel's increased panic about lack of money and her annoyance with her son for not selling a Gorky painting add to her difficulties. She imagines that the proceeds from the sale of the painting might save her from having to cut her nursing staff. Her son, of course, feels that the sale of the painting will make no significant difference, given the scale of her needs. In this context, Dr. Kris offers to lend Ethel money when she runs out of resources. Ethel is moved that her doctor, who once so grieved her by insisting on payment for her therapy, is willing to make this gesture.

In May the Guggenheim takes her *Mother and Child* painting for its permanent collection and, hampered by increased pain, Ethel renews her efforts to revise and cut the journal manuscript. At a point when the public journal abstractly discusses ambiguity in art, the private jottings ask in anguish (referring to the arthritis) "Does the pain cause the fury or the fury cause the pain?" A few days later, when a friend tells her that her work is that of an illumining spirit, she asks, "Is this me as well as the pain-ridden me?" Summer comes, with the threat of her son and Dr. Kris leaving for their vacations, as well as renewed absences of nursing staff. While the public journal deals with Cézanne and light, in private she is searching for a hypnotist, tempted to combine Thorazine and vermouth, and terrified that she will run out of money before her life runs out, a not unrealistic fear. "My light sings itself," she writes, in determined optimism, while counting how many Thorazine she has left. When her son encourages her to face her difficulties with less panic, she complains that he "gives me the feeling of being disappointed in my character instead of applauding my courage."

By this time, she and her children realize that her emotional and physical symptoms are being caused by severe arteriosclerosis, and that this illness is partially responsible for her deteriorating emotional state as well as her previous falls and that therefore not all her difficulties can be related to whatever character defects or childhood events caused her earlier emotional patterns. On August 18, amid constantly changing dosages of cortisone, she writes, "my veins are closed, blood cannot flow." When Dr. Kris returns in September after a brief absence, Ethel

is shocked to find her now carrying on this last stage of the analysis not only with headphones and microphone, but also in a wheelchair. It is now a race against time, with Dr. Kris, health fading rapidly, determined to see Ethel through to an end of the analysis, although both of them are apparently blocked in endless repetitions of the search for traumatic childhood events, and Ethel torn, experiencing rage at Dr. Kris's prospective abandonment of her, terror at her own pain and loneliness, and admiration of Dr. Kris's courage, endurance, and compassion, both so close to death.

The private jottings for September 11 through November 17 show Ethel developing material—whether memory, dream, hallucination, or construction is unclear—about a fire, burning leaves, a burnt hand or face, a lost doll, the death of her dog, Bobby, possibly maddened by rabies, and a vision of Athene, the incarnation of the smile of light she has been crawling toward through madness during all this long journey of her life and art. We can see the artist's shaping hand here. In the version intended for publication, these widely scattered fragments are consolidated into a single three-part prose poem narrative dated October 2, well after the date she began her draft of the first fragment and well before the date of the jotted first draft of the final section. The public journal for October 2 triumphantly declares her intention and method. "The Autumn yellow and orange and sienna are color strangers to the deep red rose and yet I assemble them in my mind. What if they are disparate? I will unify them in an unusual combination." In effect, this is the method not only of the dog and fire section but of the entire journal, to unify the disparate elements and images of her soul, her mind, her art, in an unusual combination.

With the increasing misery of her life, this vision of the dog, the fire, and Athene's smile serves a number of purposes. Certainly, with some accuracy, she sees herself as a desperate and maddened animal and her life as some helpless thing, doll or caged dog, lost in flames. But also the story includes a serious burn and allegations of parental neglect, and so once again creates a myth that will allow her to accomplish the task of reconstructing her past set her by Dr. Kris, and yet absolve herself from blame for her terror of being alone. In this new version, her fear is a justifiable result of the trauma of fire and burning, and not simply a child's insatiable neurotic desire for love. On November 13, even while she writes this vision and Dr. Kris

encourages her to explore its meanings, Dr. Kris prepares her for the inexorable hurrying on of their separation by providing her with the name of a new analyst. In fury, Ethel predictably threatens to jump out the window. Dr. Kris admonishes her from the wheelchair, "Be the victor, not the victim." And Ethel lives. On November 23, she receives the news that Dr. Kris has died.

THE JOURNAL DECEMBER 1979–NOVEMBER 1980

December 8, 1979

Possible title: Perceptions/and Alterations
"The Mirror of Art," Baudelaire, p. 196.

". . . To escape from the horror of these philosophical apostasies, I haughtily resigned myself to modesty; I became content to *feel*; I returned to seek refuge in impeccable *naïveté*."

December 9

Hang Loose!

Sunlight passes through my leaves turning them from opaque green to gold. It seems to free creative impulses which give new life to held ideas frozen or cramped up much as fossils in a bed of stone.

January 3, 1980

My leaf in the window . . . seems to be superficially 'an image of plant' but on a deeper level seems rather to be 'an image of sunlight'. The one image suggests matter illumined; the other spirit or light.

Even the x-ray of bones is also an image of illumined matter where the bone, solid in the earthly reality, becomes a phantom image whose reality or soul is light. This light is transitory—it "passes through" taking on the image briefly and then moving back into the larger volume of nameless glory.

January 6
Out of the depths of the hidden nightmare I arise—phoenix-like.

January 21
The many delicate stamens of the quince blossom are cupped with a pale green chalice, yellow at center.

Reading Zarathustra, the wonder of the vivid musical poetry and (though a strong word) the horror or dismay at the emotional psychic anguish he expresses, portrays!

For Milton God is light ("since God is Light," vide p. 8). For me light has been female, i.e., the mother's smile, and in Poussin, for instance, I took the wonderful persuasive light to be the mother's smile transfiguring and irradiating nature.

January 31
Include momentary intoxications!—the yellow flowers of the freesia, some pure in the light, their shadowed counterparts darker (the color nameless).

Why do I think of fragrance—and of dance motion? From across the room I cannot smell the fragrance and the flowers do not actually move. But my imagination is abroad and I will not attempt to contain it.

February 2
Socrates died in his prime functioning. He had the satisfaction of fully expressing his ideas, his followers listening, and the further satisfaction of knowing that they wept for him. He was not in pain (or only for a short time). He was not alone. He knew he would be remembered. He thought he would dwell hereafter in some Parnassus or, if not, would pass into oblivion.

March 24
Light may embellish the form upon which it rests but it may also move into the larger body of light. The thought of this "lifting towards" or "joining with" the larger body delights me. Does light not but lend its presence for a little while to the particular—to a place, a specific place? As a child I noticed the dewdrop on a blade of grass, or on the crocus emerging in the spring thaw. Presently the dewdrop was drawn up into the general moisture, the light that sparkled upon it becoming part of the general light that

flowed everywhere through space. I loved light, moisture, and the seeping sound of the moisture being sucked up by the sun. I do not resist my affluence—I yield to the enjoyment of it.

March 25

Celebration!

The leaves of the tulip plant, yellow-green, spring outward from the short stalks: crisp, firm, energized. I shall watch the tulips grow out as at Pennington I used to watch the blossoms of the magnolia unfold. Yes, "my heart leaps up . . ." it will always be so. But older, will I still be able to express my joyful amazement in words?

The painter has not yet been born who might perfectly paint what I enjoy at this moment. Never has so fresh a green been painted, nor so firm a red nor the lovely darker shades of the stem as seen through the leaf contre jour. Life is my million-dollar collection!

The idea of the circle has always charmed me—but, actually, there are no circles in nature—only a tendency towards circularity.

April 3

Insufferable girdle of beauty—you torture me—overpowering breadth of the red tulips, full blown leaning toward the window cupping what space? What volume of light? And the yellow double jonquils!—you remind me of my own painting, "The Bride Returns," 1961, where I played yellow against yellow in such a way as to push some of the tones toward orange and others toward green, giving a sense of variety with the simplest means. Yet this grouping of tulips and jonquils seems so much more complex, and it is just this complexity which enrages me and torments me.

April 13

I sense solidity as I look at the leaf, but I do not yet know its shape. Again even though the leaf seems solid I do not know where it is. If it were a question of weight I would have to weigh it. I should have to measure spaces and the leaf itself to determine where to place it, so "the place where" is no simple thing. How do we determine "the thing itself"?

Disaster sits close by—and I cannot escape through the green or the red: the leaf or the flower. From the definition "light in the image of a leaf" my thoughts move over to another and almost opposite one: "shadow image." We know that the Chinese took "shadow images" as the basis for many of their greatest works—how did the light come back into the picture?—my

answer: through space. Space gave light back to the picture. Quantity of space (light) balancing "shadow images," even overbalancing them. Substance versus spirit.

April 26

Shall I allow the daisies' petals to assume a clock-image in my mind as in the portrait of A.K. I did four years ago on her deathbed—when counting the petals circling around the yellow center I found surprisingly that I had painted exactly twelve though I had not planned it?

If Gorky were here he could paint my daisies in the glass vase, beautifully well. But ponder though I may, I tremble before this task. The flowers are firm and, with the vase in its silver radiance, hold their designated space. I am quite sure Gorky would have painted these elements against an almost black background. But I would not.

May 1

The trouble with painted flowers is that the paint gets in the way; the texture and body of the paint are not the texture or body of the petal.

May 3

My flowers are hovering between life and death, their full form twisting into nothingness, light passing from them into its pure state. But one narcissus facing me is still an active light-reflecting shape, the thin petals semitranslucent are whiter than ivory. Even Gorky might have fallen into the trap of painting out all intervening spaces between flower and flower, generalizing them into abstract black.

May 4

The nightmare of receding consciousness with its blockades, its opacity haunts me. I am hungry for light.

May 6

Displaced tones may still reside in the memory though replaced by tones of reflected light. The ghosts of these tones haunt me and I am torn between expressing them or on the other hand pure reflected light.

Though it may be bodiless, light occupies a place within my range of

vision. It occupies a space, an area, a position. It also sets up contrasts as for instance between a solid form and an essence.

Displacement of "matière" by light.

May 17

Robert Melville in his *Picasso, Master of the Phantom* suggests that Picasso's emphasis on the phantom side of reality began with Cubism. There was inner ambiguity here. And I must quickly add that ambiguity is not the same as uncertainty; it is a special way of looking at things, as being or not being what they seem. Picasso particularly emphasizes a super-reality which attracts though it may disturb.

May 18

And what of memory traces? As I look at the cornflowers brought to me last night, my mind is suffused with memory traces of childhood, when cornflowers were my greatest joy and I had the wonderful pleasure of being designated to place a cornflower in my father's buttonhole. This morning my cornflower seems to have a very dark purplish blue iris in the center of its blueness. And again I am enriched by a memory trace of my grandmother's sapphire that she wore on a platinum chain around her ivory neck and from which dangled two lovely pearls. There was an excitement about these early experiences which was very poignant. The flower and the feeling were not confused but enhanced one another. There is a gentle blue glow to this cornflower and I can feel the brush in my hand and feel myself gently laying it upon the canvas. This is not what most aestheticians talk about, this immediate or simple sensuousness frequently connected as in this case with early, poignant, vivid experiences that render the visual form more appealing.

May 23

To continue speaking of Picasso. The great crowds that go to see his work go not as one would to see a large flower garden extending perhaps over an acre of ground or more. But rather to be presented with ideas about the way art can convert nature into something permanent so that we might wish to look at it over a period of years. Picasso took over certain formulae, arrived at in the past, for converting nature into art; and he also invented or intuited new hypotheses. Frequently I also enjoy simply looking at nature without being especially aware of any formula at all. In this latter

way there is an infinite variety possible, even a greater variety than that presented by a Picasso.

Perhaps one of the elements of this free enjoyment of which I'm speaking is that one can play with ideas. One can play with perceptions. The threads are all there. One has but to weave them. Of course, looking at Picasso one also has threads to weave. The threads Picasso presents us with are twofold, at least. One series of threads suggests to us the past, various elements of the past that he weaves into the present. Other threads are those that connect up with our own experiences of nature. Oh yes! I've seen that. Or, O no! I've never seen that. In this sense, of course, he is incredibly rich in his ability to stimulate the spectator. He is, as I have said before, a master juggler and a master acrobat, and a master virtuoso.

At this very moment there is in front of me a wonderful deep red peony in a Victorian vase. The delicate dark green leaves set off the almost clumsy roundness of the flower. The mystery of this ruby color haunts me. It causes me to think, by association, of glasses of ruby wine. And, allowing myself complete freedom, I might well dream of some lines of Verlaine, so rich in color and so sensuous.

Here I am not disturbed by paint, or by a flat surface, or by a defined quadrilateral determination of space; the edge of a canvas does not inflict a wound on my sense of freedom. My eye can roam from this deep red tulip to the begonia plant on the windowsill, which is a light vermilion in color; or to the daisy plant, which is a subtle white with yellow centers. This is all so free, and I am in a way like a child who skips across the grass gaily laughing in the sunlight.

June 3

When I looked at the portrait of Suzuki on the cover of his book I was startled to find that I had the impression of knowing this man. I thought, "I know you and I have already painted you." In fact it seemed to me that in the series "Adam and Eve in Paradise," 1974–76, I had painted angels flying around in heaven and at that time I had thought "what strange angels I have painted." They are not in the least like Renaissance angels, calm, even bourgeois, and somehow very assured in a physical and in a spiritual sense. I had painted angels that were quite different. Uninfluenced by tradition, they were flying freely in the heavens, the expressions on their faces differentiated. They were, so to speak, different people, these angels. They were not just a category, i.e., angels! They seemed to be alert, full of expectation as though they might be saying, "I intend to look around the corner of the clouds to see what might be there—possibly Infinity, possibly Eternity!"

I contrast Suzuki's face with the face of Pierre de Chardin, which is all intensity and determination. The face of Suzuki is quite different, a face aware of humor. A giving face yes, but also a receiving face as though he were ready to receive into himself other minds, other beings, other situations, perhaps even other worlds. One gets a sense of relaxation. I am reminded of a time when I heard a voice on the radio that put me into a state of relaxation; all anxiety that I might have been feeling disappeared suddenly and I was greatly at ease. A few moments later a voice said, "you are listening to Mahatma Gandhi of India." Suzuki's face is also a calm face; I do not like to use the word benign because it seems to be more a question of a sort of reticent humor.

June 7

Further thoughts on the portrait of Suzuki. In his face I find an expression of thoughtful discernment and comprehension. Looking at the upper part of the head, including the eyes, I find a sense of warm humor, an embracing love of whatever may come within Suzuki's realm of understanding. The lower half on the other hand suggests a loving full acceptance of life as though he were tasting a ripe peach, enjoying the flavor, savoring the aroma. There is none of the tension and intensity that I found in studying the head of Pierre de Chardin. Yet there is a great concentration. Perhaps I have finally found the smile of which I have often spoken, the warm embracing smile that like sunshine illuminates everything. Though one stood revealed before this man one would not need to be afraid. I must not ignore or forget the high forehead and the raised left eyebrow that gives an inquiring look to the face. About what is he inquiring?

June 21

A sip of wine—is it the redness or the taste or the effect of alcohol that makes it so enticing? And now I sip the redness of the rose. But form is also involved. Am I not saying that aesthetic pleasure has much in common with simple sensory pleasure or satisfaction of vital needs?

June 26

"Blood, wine, and roses"—three different kinds of red.

July 16

The time of sunshine is gone and there is now an even light. The daisies themselves seem to contain sunshine in the yellowness of their petals.

Still July 16. The young girl's dress in Botticelli's "Primavera" opposite me on the wall is delicately elaborated with spring flowers done in the inimitable style of the master, and I am almost reluctant to admit that my daisies on the little table next to my bed seem definitely more fascinating and attractive. They are not only delicate but give a sense of vigor. The individual petals are slender; they throb with life and the interlacing and overlapping of one flower against another is intricate and really quite astonishing. The dark leaves startling in contrast to the delicate yellow of the flowers are a strong accent and I am moved by it. The highlights on the leaves remind me so much of the Vermeer of a young woman that hangs in the Metropolitan Museum in respect to the leaves that he sets forth on the rug at her feet, so plump and full of life that indeed one wonders how they nonetheless lie flat in their correct position on the plane of the floor. The last time I saw Gorky he instructed me to study this carpet of Vermeer in connection with a still-life I was attempting to complete. He said, "Study the leaves in the Vermeer and you will know what to do." There was Gorky, six-foot-five, standing tall, dark, and attentive in front of the Vermeer, and it occurred to me as a flash of insight, "Can it be that Gorky is thinking 'I will try to paint like this'?" I brooded over this possibility for many years and never really abandoned the feeling that indeed this was his desire, and that he attempted to bring together a harmonious whole made up of many very complex parts as in life itself.

August 1

The red rose by my bedside is dying. Just yesterday the redness was of a wonderful suffused intensity. One could sink into this redness feeling as though there was nothing else in the world at that instant but the still-fresh leaves, very dark and veined with a paler satin-surfaced green. I cannot follow Blake's "O Rose, thou art sick!" in thinking of this dying of my rose as a sickness, but rather I feel it as an inevitable state in the life destiny. On the other hand I am content to absorb the depth of beauty that is here before me in the asters on my windowsill. Yellow—they softly proclaim an innocence of grief. They are all sunshine and delight.

August 9

The royal purple asters, yellow centers disturbing in their iron firmness, overbalance me. Dying might seem but a natural interruption of their blooming and I am hard put to find an affirmation that will even the scales—aureolin, yellow, terre verte, will they weigh in? No thought of

death can attach itself to the lovely flowers that S brought* —again the Greek eternal perfection, stasis of time that need not move but may float suspended eternally. Even the individual flowerlets on the stem can continue to bloom in this timeless ambiance. I no longer feel subordinate but, rather, equal. This is extraordinary—the purple flowers cupped by dark green petals, precise, pointed, powerful.

October 2

I

Thoughts are coming to fruition of form and design. Or, swinging to the opposite extreme, they are receding into formless dust. "From dust thou art, unto dust thou must return." There was a faint, musty smell of burning fire and burning leaves. I was hiding from danger (what danger?) in the pile of autumn leaves and they did not know I was there. Raking stray leaves toward the pile, they then lit it up. Smelling the smoke, I moved out from under the leaves and thus from danger, but released from one danger I felt I was moving into another. Of what had I been guilty?

There was a simultaneous dispersion of smoke and fire, dust in nostrils, faint obsequiousness of dust. I lay there faint with the pleasure of the soft odors of leaves and grass and the light prick of dry leaves. The earth under me was gritty but not harsh and then there was smoke, faint harbinger of disaster. Crackling sound, steps in the leaves—is someone there? Who is searching me out? "Where there is smoke there is fire." Singed hair, blood in the nostrils, a mouse with small bright eyes and twitching nose scrambling in the leaves. I can just see his little feet with tiny nails, jerky swift movements, and the furry body smooth and somehow both attractive and repulsive. In fear I move slightly, wanting to avoid this little mouse though in a way enchanted with his graceful sleekness. Am I alone? Or is my brother with me? Is he also escaping or trying to escape from danger? Lulled by the smoke I think of lying low, allowing it to overcome me so I should really escape from pursuit. I felt an overriding sense of fear that dispelled any suggestion of self-preservation. Underneath me the earth, a warm shelter against adversity, smelled of dust. It smelled of itself and was softly gritty under my body. I thought "if I move I will be heard and if I do not move I will be suffocated." There was certainly a great danger. Someone was pursuing me. What had I done to be pursued? Or was it just an

*Sylvia Smith, a longtime friend of Ethel's.

accident that people were raking the leaves as they always did every fall in order to make the garden neat and lovely according to custom?

II

I escape to my cave and from there I hear them stamp out the crackling flames. Do they bring out the hose? Do they suffocate the flames, depriving them of oxygen so that they shrink down into nothingness and arid odors? I tremble, covered with dust. The little mouse (brought with me) looks at me or rather just looks, standing up on his hind legs, sleek, firm body, little legs tipped with twitching toes. Oh my god! Was my doll left behind me? She will be burned! I curl up in grief; a bird flies up into the sky with whirring wings setting up sharply speed-curved divisions of space. So the leaves, the fire, the bodies of the mouse, the doll, the bird become part of the drama of one-half hour of my life-scope.

III

Infinity of contradiction! A small green snake with bright red eyes slides along the ground at the edge of my cave. An anthill bulges above the flat earth. What are the little ants doing? Exhilaration of belief—who searches for me believes in me. Initial deconnection and agony of separation and then stage after cruel stage. Anecdotal antidote of desolation—the grim underlayer flame-red—and my autumn leaves thrust into destruction. Unfortunate child—who will protect you now? The mother is away, the brother grimacing tracks you down, unfortunate soul. He lights a stick and encourages the flame. In trying to escape, little one, your hand is burnt. Only later did negligent parents have radium applied to it to diminish the scar. But the scar remained. Twisted flesh stuck to the bandage and twisted psyche was fixed from then on, unfree.

In the interstices of consciousness there are somber memory traces of burning autumn leaves and the brown-dried earth; of smoke . . . and of a ladybug; memory hears, "Ladybug go home, go home." The child's heart is torn with fright and desire—where is the comforting figure of the needed one?

"Yea, though I walk through the valley of the shadow of death I will fear no evil" and the child sees a vision of a goddess whom later that child will refind in the figure of Athena, Greek goddess of wisdom, and will recognize as having been known originally in childhood. We can only ask ourselves if the Greek master Praxiteles had been inspired originally by childhood frenzied necessities to find such a balancing factor in order to secure his psyche.

Hysteria of the absolute. I crawl on my hands and knees—now muddy—toward the dog's cage. I too am a maddened dog, frothing, foaming-at-the-mouth dog. Beloved Bobby! I will crawl on the ground, arms outstretched,

crying hoarsely as I reach the wire enclosures (Auschwitz—the madness of those who imprison as well as the madness of the imprisoned). Caesar's ghost—now I return to the rose, the single dark red rose by my bedside. Profound stirring, blood in the unconscious. I was bleeding—the mad dog was frothing at the mouth, his eyes distressed, tearing, and now the asters with their faint musty smell. Were there flowers? Yes, the lilac and the bleeding heart, and the rambling rose climbing over rounded stone—primroses, violets, my mind was tumbling with visions and vistas of blue sky, robins and their awakening call contrasting with my foaming rabies-smitten dog. The thought of a death-dealing shot smashing through my mind.

Bumblebees are caught in my romper sleeves, fireflies, inchworms, sweet creatures of the Almighty Creation, present with me and Death. There are autumn leaves about—full-blooded red rose and spectral images, blood images. But my dog is solidly living, no pretense here! Did he sniff in the leaves to find me, his darling? Did he whine and bark a warning?

The autumn yellow and orange and sienna are color strangers to the deep red rose and yet I assemble them in my mind. What if they are disparate? I will unify them in an unusual combination.

October 23

The dog, my dog Bobby, is whining outside. I am frantic and ask for buttered bread and milk—will that calm the nervous frenzy? What did my brother think—did he care? Poor Bobby, denatured, destroyed. What sort of God permitted so much pain and deterioration—unto death. I hated Him in that moment and, perhaps, could never quite recover my pure love for Him. Flies, delicate legs trying compulsively to free themselves from glue—what a passionate effort! And now a hummingbird gyrates in the air, green and red against the blue sky.

October 27

The anemones do not question their own existence—nor do I question it. A triumph of becoming—mother cow-to-calf personal. But not this becoming. It becomes from itself, for itself. Folded power, power within the fold. The mystical syndrome as it works out in actuality—"A world in a grain of sand" and now "heaven in a wild flower." The sea-green/sun-green of the leaf a little sickening as though I were drowning (as once I nearly did, almost losing my last breath under the yellow-green waters). There is force not only in the growing leaf or body but in the dying one. Dust is an energy development or cycle.

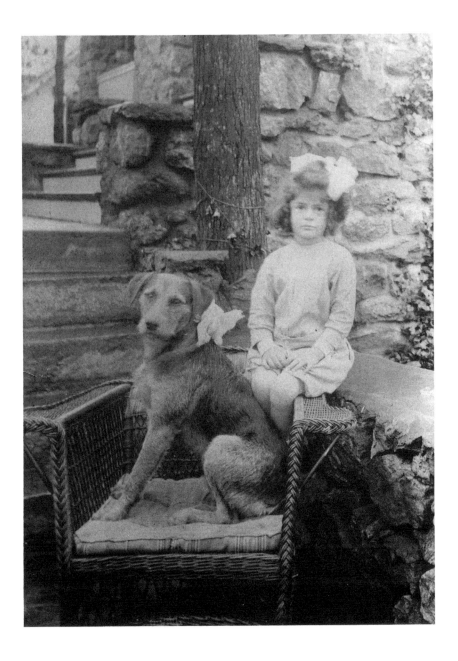

FIGURE 16. Ethel and Bobby, her
dog.

November 1

I have never needed orchids to excite my imagination. But nonetheless I am excited by the edge of the African orchids brought me last night which I perceive as a fine white line reminding me of the jewelry-precise outline of the royal cattle in the bas-relief I fell in love with last year at the Egyptian show at the Metropolitan Museum.

Coda
1980–1984

A long gap in both public and private journals ensues, as if with Dr. Kris's death Ethel's need or ability to write further has died too. When she resumes writing, the public journal peters out in desultory observations on light and flowers. The last of the private jottings, however, though fragmentary, bring a few surprising answers. On March 1981, Ethel notes that she is now seeing a new analyst, Dr. Pfeffer. Her relationship with him at first seems to threaten a repetition of the dependency that had characterized her long clinging to Dr. Kris. But sterner, more remote, and perhaps less nurturing than Dr. Kris, Dr. Pfeffer points this out to her immediately and evidently resists playing the role she has in mind for him. And although he too sees her arthritic pain as partially caused, or intensified, by psychological events, he does not see it as part of an early pattern of making excessive neurotic demands for parental attention nor, apparently, does his approach to the therapy require Ethel to try to recover or reconstruct any more repressed memories of neglect and abandonment. Instead, in their meeting of September 27, 1981, he links the pain in her hands and her fear of being left alone at night to apparently easily recovered memories of being sternly admonished against autoeroticism as a child. He connects these in turn with her uneasiness over current autoerotic episodes. With obvious relief, Ethel accepts this interpretation. This cause for her lifelong terror of being alone she feels fits with her own sense of her experience and of herself.

This was September 1981. The life of Ethel Schwabacher stumbled on another three years and three months. First housebound, then bedridden, unable to move, paint, or write, deprived of the joys of seeing her journal in print or her paintings collected in a major retrospective, she choked to death in November 1984, ironically when her nurse was momentarily out of the room, as if to say that her fears of being left alone were indeed justified. Whether or not we agree with Dr. Pfeffer's final interpretation of the causes of that fear, maybe we may rejoice that at least Ethel felt that she had found her "little bit of truth," and that it absolved her of blame.

For her readers, perhaps her life as an artist ends with her journal entry of October 17, 1981, when in joy and pride she received the dedication of her daughter's book on Blake: "To my mother, Ethel Schwabacher, visionary artist."

APPENDIX

Public Collections Containing Ethel Schwabacher's Work

Albright-Knox Art Gallery, Buffalo, New York

Baber Mid West Modern Art Collection, Greater Lafayette Museum of Art, Lafayette, Indiana

Brooklyn Museum, New York

Solomon R. Guggenheim Museum, New York

Indianapolis Museum of Art, Indianapolis, Indiana

Herbert F. Johnson Museum, Cornell University, Ithaca, New York

Metropolitan Museum of Art, New York

Montclair Art Museum, Montclair, New Jersey

Betty Parsons Foundation, New York

Rockefeller University, New York

San Francisco Museum of Modern Art, San Francisco, California

Syracuse University Museum, Syracuse, New York

Toogaloo College Museum, Toogaloo, Mississippi

Ulrich Museum of Art, Wichita State University, Wichita, Kansas

Wadsworth Atheneum, Hartford, Connecticut

Whitney Museum of American Art, New York

Yale University Art Gallery, New Haven, Connecticut

Jane Voorhees Zimmerli Art Museum, Rutgers, the State University of New Jersey, New Brunswick, New Jersey

INDEX

Brother, references to. *See* Kremer, John
Buffalo, N.Y., show at, 41–42, 45
Buffalo Enquirer (newspaper), 42
Buildings, large, aggressiveness of, 118
Bull(s), as portrayed by Picasso, 107, 122, 138–39, 174
Buttercup, beauty of, 172

Caldwell, Erskine, xvii
Casals, Pablo, 158
Cattle, portrayal of in Egyptian art, 122, 134, 138–39, 169, 214, 252
Cave imagery, 37, 47, 49, 156
Cézanne, Paul, 36, 80, 85–87, 99, 193, 195; illusion of motion in works of, 121; show at MOMA, 145–46; use of color, 137; *Young Man With a Death's Head,* 132–33
Changes, minutiae of, 167–68
Chardin, Pierre de, 246
Childhood: desire for mother's pearls, 186, 221–22; early illnesses, 184, 225; memories of mother, 47–50, 53, 57, 65, 67; memories of nurses, 48, 183, 211, 212–13, 224, 228; preoccupation with, xv, 2, 60; relations with brother, 186, 213, 215–16
China, art of, 8–9, 27, 103; vases, 8, 12, 13, 27, 80, 175
Chirico, Giorgio De, 100
Christ and the Magi (El Greco), 10
Christ Descended from the Cross (Carpaccio), 126
Christ Descending Upheld by Two Angels (Manet), 20–21, 22, 126
Christ figure, Sisyphus as, 32
Cleaver, Eldridge, 98
Color: Cézanne's use of, 137; combining of, 142; in paintings of flowers, 157, 166; relationship to space, 51, 86; as suggesting "glory," 66–67, 76; use by Vermeer, 214. *See also* Light; Light images
Color scheme: proposed for *Abraham and Isaac,* 25–26, 29; for Sisyphus, 34; use in imagery of men in Ethel's life, 202–3. *See also* Blue
Communication, of soul to soul, 209–10
Conservateur attitude, in art, 99
Continuity, versus discontinuity, 104
Corot, Jean, 171–72
Creation of Adam, The (Michelangelo), 19, 91
Creativity, salvaging of, 193
Crime and Punishment (Dostoevsky), 64
Crucifixion, The (Fra Angelico), 10, 72–73, 75, 147, 176
Cubism, 136
Curie, Marie, 54, 221

Dada movement, 175–76; early motion pictures, 117–18

Daisy, imagery of, 114, 116–17, 219, 243
Dali, Salvador, 100, 121
Dante: descriptions of paradise, 36, 115, 118, 146; reunion with Beatrice as theme, 60–61; as Virgil's companion, 43, 47, 51
David, Jacques-Louis, 136
Death: anger coupled with, 69–70; artists' depiction of, 112, 123–25, 132–33, 233; contemplation of own, xv, 115; and remission as artistic themes, 16, 19, 31, 57–58. *See also* Suicide
Deaths: of father, 115–16, 129; of husband, xvii, 48, 115–16, 129, 228, 229–30; of Marianne Kris, 240; of mother, 61, 63–64
Death's Head (sculpture, Picasso), 102, 133, 144
De Chardin, Pierre, 246
Degas, Edgar, 119, 157
De Kooning, Willem, xiv, 29, 41, 115, 125
Delacroix, Eugène, 21, 90, 131, 143, 153
Depersonalization in art, 174–75
Descent from the Cross, The (Christus), 123
Deutsch, Helene (M.D.), xvi
Dickinson, Emily, 13, 178–79, 226
Discontinuity, versus continuity, 104
Dr. G. *See* Gluck, Dr.
Dr. K. *See* Kris, Marianne (M.D.)
Dogs, dreams of, 105, 107–8, 239, 249–50
Doll, loss of in dream, 239
Don Giovanni (Mozart), 48, 54
Don Juanism, xvi, 203
Doolittle, Hilda (H. D.), xvi
Dostoevsky, Fyodor, 17–18, 70, 79; *Crime and Punishment,* 64
Do without, as recurring theme of absence, 46, 48–49, 57
Dream imagery, 105, 107–8, 167, 239, 249–50; influence on Surrealism, 139; as inspiration for mythological paintings, 3; reality of, 50, 108
Duchamp, Marcel, 100, 117–18, 176
Dunnagan, Ann, 179

Ego self-discovery, 163–64
Egypt, ancient, art of, 89, 90, 95–96, 135, 206; beauty of calgonite bowl, 84, 86, 88, 97, 99, 127; cattle sculpture, 122, 134, 138–39, 169, 214, 252; vases, 121, 122, 175
Einstein, Albert, 28, 54, 221
El Greco, 10, 24, 101, 111
Eliot, T. S., 210–11
Elles (Toulouse-Lautrec), 98
Entombment of Jesus, The (Michelangelo), 149, 179
Equilibrium, personal, through understanding the past, 114, 117
Et in Arcadia Ego III (Schwabacher), 49

Brenda S. Webster, Ethel Schwabacher's daughter, is an independent scholar, fiction writer, and translator. She is the author of *Yeats: A Psychoanalytic Study* and *Blake's Prophetic Psychology.* Her novel *The Sins of the Mothers* is forthcoming.

Judith Emlyn Johnson, Professor of English and Women's Studies at SUNY/Albany, is the author of seven volumes of poetry, including *The Ice Lizard: Poems 1977–88,* and editor of *Thirteenth Moon.*

EDITOR: Nancy Ann Miller
BOOK AND JACKET DESIGNER: Sharon L. Sklar
PRODUCTION: Harriet Curry
TYPEFACE: Sabon
COMPOSITOR: Reporter Typographics
PRINTER: Maple Vail Book Manufacturing Group